Visualizing Modern China

AsiaWorld

Series Editor: Mark Selden

This series charts the frontiers of Asia in global perspective. Central to its concerns are Asian interactions—political, economic, social, cultural, and historical—that are transnational and global, that cross and redefine borders and networks, including those of nation, region, ethnicity, gender, technology, and demography. It looks to multiple methodologies to chart the dynamics of a region that has been the home to major civilizations and is central to global processes of war, peace, and development in the new millennium.

Titles in the Series

Visualizing Modern China

Image, History, and Memory, 1750–Present

Edited by
James A. Cook, Joshua Goldstein,
Matthew D. Johnson, and Sigrid Schmalzer

LEXINGTON BOOKS
Lanham • Boulder • New York • London

Top left: Xu Yang, Qianlong nanxun tu juan [Illustrated Scrolls of the Qianlong Emperor's Southern Tour]. c. 1770. Scroll six detail. The Metropolitan Museum of Art, New York. Used with permission.
Top right: Qinfen tiyu yuebao [Diligent Struggle Sport Monthly] 3.2 (November 1935)
Bottom left: Zhang Fei competing for reserve tickets for Expo 2010. From: http://www.zonaeuropa.com/20100505_1.htm [accessed August 31, 2011].
Bottom right: Popular Film (Dazhong Dianying), August 9, 1964.

Published by Lexington Books
An imprint of The Rowman & Littlefield Publishing Group, Inc.
4501 Forbes Boulevard, Suite 200, Lanham, Maryland 20706
www.rowman.com

16 Carlisle Street, London W1D 3BT, United Kingdom

British Library Cataloguing in Publication Information Available

Library of Congress Cataloging-in-Publication Data
Visualizing modern China : image, history, and memory, 1750-present / edited by James A. Cook, Joshua Goldstein, Matthew Johnson, and Sigrid Schmalzer.
 pages cm.—(Asiaworld)
Summary: "This book is a teaching textbook for both lower and upper level courses on modern Chinese history and/or modern visual culture. The introduction provides an overview of key issues in the development of visual culture in China over the last 200-300 years, while each chapter is an original scholarly study of a specific topic providing chronological coverage for that period. Topics include: Qing court ritual, peasant rebellions, folk art, modern urban media such as illustrated sports magazines and movies, Great Leap Forward film, visual commemorations of the Cultural Revolution, and the Shanghai 2010 expo"—Provided by publisher.
Includes bibliographical references and index.
ISBN 978-0-7391-9043-2 (cloth : alkaline paper)—ISBN 978-0-7391-9044-9 (electronic)
1. Popular culture—China—History. 2. Visual communication—China—History. 3. Arts, Chinese—History. 4. Memory—Social aspects—China—History.
5. China—Intellectual life. 6. China—Social life and customs. 7. China—Social conditions. I. Cook, James A. II. Goldstein, Joshua L. III. Johnson, Matthew D. IV. Schmalzer, Sigrid.
DS727.V57 2014
951—dc23 2014024587
ISBN 978-1-4985-0143-9 (pbk : alk. paper)

⊗™ The paper used in this publication meets the minimum requirements of American National Standard for Information Sciences—Permanence of Paper for Printed Library Materials, ANSI/NISO Z39.48-1992.

Printed in the United States of America

Contents

Acknowledgments

All the editors and authors whose work has gone into this volume were formerly the doctoral students of an extraordinary pair of advisors: Joseph W. Esherick and Paul G. Pickowicz. The program in modern Chinese history that they built at the University of California, San Diego, was a unique experience for all who participated. The countless talks, research trips, conferences, and wonderful gatherings they put together infused the program with a spirit of human warmth and intellectual dialogue that extended well beyond the classroom. But the most important element of Joe and Paul's approach to graduate teaching was their commitment to collaborative mentorship. Their cooperative ethic made them truly equal professional partners—they served as co-advisors for every student—and provided a model of teamwork and selflessness to their many grateful advisees. We offer this volume, designed primarily for use in the classroom, as a tribute to our experiences in Joe and Paul's program, and to their amazing capacity for investing boundless energy in each and every student.

Joe and Paul, we thank you.

Chapter 1

Introduction

James A. Cook, Joshua Goldstein,
Matthew D. Johnson, and Sigrid Schmalzer

If a single image could be said to be *the* icon of modern Chinese history, it would probably be this portrait of Chairman Mao (Figure 1.1). Mao's portrait has been reproduced literally hundreds of billions of times: on untold millions of Mao buttons and propaganda posters of the Cultural Revolution (1966–1976); on rearview mirror ornaments, tee-shirts and cigarette lighters; on Chinese currency (his gentle smile graces every bill of legal tender in China today); and, most famously, on Tiananmen Gate in the heart of Beijing, where he surveys the enormous public square beneath and all who pass through it. This portrait of Mao has been charged with so many vital political and cultural meanings that we would be remiss to discuss modern Chinese visual culture without at least giving a respectful nod to his all-but-disembodied head. Travelers from all over China and the world have made sure to get their photos taken beneath Mao's oversized portrait. The acclaimed author Yu Hua recalls how important that photo op was for him as a teenager during the Cultural Revolution:

> I used to have a photograph of myself when I was fifteen, standing in the middle of Tiananmen Square with Mao's huge portrait visible in the background. It was taken not in Beijing but in the photography studio of our town a thousand miles away. The room in which I was standing cannot have been more than twenty feet wide, and the square was just a theatrical backdrop painted on the wall. When you looked at the photo, you might almost have believed I was really standing in Tiananmen Square—except for the complete absence of people in the acres of space behind me. This photograph crystallized the dreams of my childhood years—and indeed, the dreams of most Chinese children who lived in other places than Beijing. Almost all studios then were equipped with this same tableau of Tiananmen . . .[1]

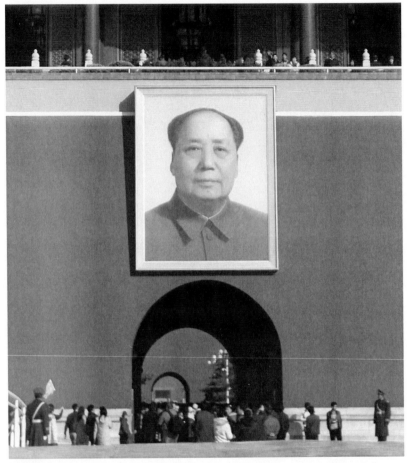

Figure 1.1 Portrait of Mao Zedong overlooking Tiananmen Square. Diego Delso, Gate of Heavenly Peace, Beijing, China. 2006. Available from: Wikimedia Commons, License CC-BY-SA 3.0 (accessed December 19, 2013).

A potent icon indeed, when an image (a photo) of an image (a painted backdrop) of the image (the portrait in Tiananmen), is still powerful enough to "crystallize a dream."

What was that dream? Chinese people who experienced the political maelstrom of the Cultural Revolution have devoted memoirs, essays, novels, artworks, and films to unraveling the dreams and conflicts of that era, many highlighting the role that Mao played in Chinese peoples' lives and psyches at the time—not just as a political leader, but as an idea and an image. The portrait that still hangs over Tiananmen today has long outlived that era, but over the ensuing decades it has accrued many new and often contradictory meanings,

and Mao's bust continues to provoke and inspire today, spawning a global-scale cottage industry of Mao-themed art that offers contradictory perspectives on the man, the revolution, and its aftermath. The reader will find dozens of these artworks and other images related to Mao and his iconic Tiananmen portrait (as well as a great deal of scholarly analysis of these images) on the website that accompanies this volume (http://visualizingmodernchina.org).

We live, today, in an intensely visual culture. We learn, communicate, create, and seek leisurely escape through ever-proliferating modes of visual stimulation—TV, film, smart phones, video games, online media, etc. Yet we rarely pause to consider that this experience of "becoming visual" has unfolded very differently throughout the world and thus bears the indelible marks of unique and specific histories. This volume is intended to encourage just such a consideration of the multiple forms and transformations of visual culture in another time and place—China from the Qing empire (1644–1911) through the Republican era (1912–1949) to the People's Republic of China (1949–present).

The chapters in this volume work explore key moments and themes in China's modern history through an analysis of visual records. Together, they challenge the common assumption that visual materials are merely ephemeral images that supplement the substance of history. Rather, the study of visual images requires that we think more broadly about *visual culture* and engage in critical analysis of *image-making* as a force in shaping historical dynamics. The study of visual culture has arisen fairly recently. Historians usually emphasize written texts over pictures; art historians, on the other hand, tend to elevate "art" over all other forms of media and experience. But throughout history both written texts and works of art have typically had quite limited audiences and functioned in quite limited contexts. Other forms of display and visuality—parades and processions; domestic and public architecture; everyday clothing and decorations; nature, landscape, and its reconfigurations; and (more recently) magazine ads, personal photographs, and internet websites—have had greater impact on a larger range of creators, viewers, and participants. The idea of visual culture encompasses this vast and changing range of visual materials.

Our goal as historians is not only to understand what certain historical images depict, but also to understand the changing ways that images have been produced, distributed, and experienced, as well as the intentions of their creators, the audiences they sought to address or to shape (loyal subjects, conscious citizens, nations, etc.), and the responses they elicited from those audiences. Of course, "image-makers"—be they governments, commercial interests, or individual artisans—rarely leave records of what they meant to convey when commissioning or crafting particular images. Nor is it easy to uncover the conditions under which historical audiences may have

encountered images, how they reacted to those images, and what effects images might have produced in their everyday lives. The analysis of historical images requires great care and ingenuity, hence the strong emphasis on methodology in this introduction and the chapters that follow.

While the subjects described in the essays here cover the eighteenth century to the present, visual culture in China is far from a mere three-hundred-year young. For at least two millennia, Chinese emperors used sumptuous court ritual and elaborate visual displays to establish their authority. In China, as elsewhere, political rulers and social elites sought to control symbols, and with them, culture. Moreover, China was historically on the cutting edge in developing printed media, with woodblock printing spreading both texts and images on a large scale from at least the Song dynasty (960–1279), if not earlier. Still, this primarily text-based media reached mainly an elite literate minority. Often far more influential were cultural displays that could reach literate and illiterate populations alike, such as the massive commissioned statues, temples, and palaces that contributed to a visually opulent elite culture in imperial capitals like Chang'an, Kaifeng, Hangzhou, and Beijing.

But the imperial state was not the only, perhaps not even the primary, image-maker in Chinese history. Since the third century, Buddhism has furnished a vibrant pantheon studded with gods and demons whose riveting tales of spiritual and moral efficacy were believed to redound upon all who spread them. Visual media such as stone carvings and paintings were a favored means for celebrating and conveying these teachings. By far the most magnificent repository of such images is the Mogao Caves of Dunhuang on the famed silk road, a complex of 492 caves replete with stone statues, the walls and ceilings covered in elaborate murals documenting over seven centuries of Buddhist worship, the earliest of which date back to 366 CE. These caves constitute arguably the single greatest treasury of visual culture in Chinese history. (For links to images see the book website). Over those same centuries imperial governments and elites attempted to ride the wave of religious spectacle as well, sponsoring the creation of towering stone Buddhas in grottos throughout China (Shaanxi, Sichuan, Henan) that were open to public worship and pilgrimage. And, while less permanent, religious festivals and ceremonial activities contributed to a rich spectrum of visual imagery through which ordinary people pictured both this world and the worlds beyond.

Many of these forms of visual culture survive in one form or another today, but their functions and meanings have often changed significantly, particularly as they have had to compete with newer forms of visual media. The chapters that follow chart a series of revolutionary changes in image production and dissemination in modern Chinese history, including the emergence and spread of color lithography, photography, movies, and the internet. As historians our task is to investigate how these new media were shaped by

and—perhaps even more importantly—how they have reshaped political, economic, social, and cultural practices in modern China.

METHODOLOGICAL ISSUES IN THE HISTORICAL ANALYSIS OF VISUAL IMAGES

It is often said that "seeing is believing." The cliché suggests that while words may distort the truth, visual evidence is objective and trustworthy. But, as anyone who has worked with Photoshop knows, images are also the products of human effort. Like written documents, visual records carry their own assumptions, obfuscations, and self-serving narratives. Images can be exaggerated, distorted, hastily or carefully composed, forged, copied, edited, and reinterpreted. These decisions are made consciously and unconsciously, seasoned by both society and culture; they might be demanded by authorities or constrained by the image-maker's own views as to what is worthy of being recorded and what conventions or rules should be followed. Thus, when looking to the past or present, we must interrogate images rather than taking them for granted—a crucial lesson not only for historians but for all those inhabiting our contemporary, image-saturated world. A simple example makes this obvious: imagine that historians two hundred years in the future discover a television commercial showing women in bikinis smiling and holding cans of beer. They would be mistaken to infer from the commercial that in our time women typically wore bikinis to drink beer, that the particular brand of beer was actually popular among women, or that the images constituted an innocent record of people in their leisure.

This highlights a second assumption: that the act of seeing is a simple phenomenon and that all people in all times and places have used their eyes to see in basically the same way. Certainly, seeing is in part a natural process involving the anatomy of the eyes and the physics of light. But it is also a mental and cultural process and, as such, it varies greatly over time and space, societies and cultures. To return to our example, in order to interpret that same beer TV ad, future historians would have to understand *how* we watch TV. At the very least, they would need to understand that the image was an advertisement, that such ads were broadcast most frequently during certain kinds of programs (like sporting events) and that they were targeted at specific audience demographics. It would also be helpful if they understood habits of TV viewing, for example that ads were frequently ignored by viewers—hence their simplistic, vivid, and often repetitive nature. (Without such knowledge those future historians might conclude that twenty-first-century humans were dolts.) In other words, we have developed specific habits of seeing in relation to TV and, even more specifically, in relation to TV ads (channel-surf, space

out, mute button, etc.), and we would not want to confuse this sort of seeing with the type done by, say, a visitor to an art museum, a luggage inspector at an X-ray machine, or a religious worshipper viewing a statue in a temple. Changing technologies and changing contexts have radically changed how we experience seeing and how we process and interpret visual information.

Visual culture is also deeply related to social identity. How others perceive us and how we perceive ourselves is often based upon the image we present, the clothes we wear, the way we decorate our homes, or the photographs we post of ourselves on Facebook. Beer advertisers use images of scantily clothed women as eye-candy to sell their product because their target demographic finds such women appealing and flattering to their self-image. Such commercials reinforce expectations not only about ideal women, but also about the ideal men who cavort with them. The men and women who view such commercials may be profoundly influenced by such messages; alternatively, of course, they may resist them and strive to assert other identities and present themselves in another light. But in either case, visual images and media are important shapers and markers of who we are, and this phenomenon may be as true of other cultures as it is of our own.

Finally, and perhaps most importantly, images both mask and are suffused with power. When we accept images at face value we often miss the ways in which they work to support or challenge existing power relationships. For example, some would argue that using images of women in bikinis to sell beer increases the likelihood that men will see women as sexual objects available to satisfy their desires; or, further, that linking sex with alcohol in this way might increase the probability of sexual violence against women. According to this interpretation, such images support and reflect the existing power structure in which men dominate and abuse women. At the same time, the fact that the people in the commercial (and all beer commercials) are merely holding their beers and not actually drinking them represents a victory (however small) for people concerned about the dangers of alcohol against the powerful alcohol companies, which would prefer to portray people consuming their products and not merely holding them. Clearly the power dynamics that shape an image can be complex, and how we interpret them can vary according to the perspective we bring to bear.

In sum, the meanings within images are contingent on the processes by which, and contexts in which, they are produced and consumed. Images are always embedded within (and often play a crucial role in shaping) social, cultural, economic, and political relationships. Thus, to understand images, we must first understand the multifaceted history of their production and consumption in cultural and political context. With this in mind, the remainder of this introduction will use examples from the chapters that follow to offer an overview of the transformation of visual culture in modern Chinese history.

PROJECTING VISUAL POWER: STATE-SOCIETY RELATIONS FROM EMPIRE TO NATION

As was true of earlier Chinese imperial dynasties, the last great dynasty to rule China (and to dramatically expand the realm that we call China today), the Manchu-ruled Qing dynasty (1644–1911) was profoundly shaped by images of authority projected outward by the emperor, the imperial bureaucracy, and the court. Michael Chang's chapter examines one of the most famous imperial spectacles, a series of six "southern tours" undertaken by the Qianlong emperor, during which the Manchu ruler, accompanied by an enormous retinue, toured throughout the Jiangnan region—the center of elite Chinese culture where the alien Manchu conquest had met with fierce resistance only a century before. Chang begins his chapter with a simple question: "What did an imperial southern tour actually look like?" It would seem that history has provided a simple answer as well, for the court commissioned the painter Xu Yang to document the tours. But visual records, just as much as written ones, can disguise as much as they illuminate, so Chang checks Xu's paintings against available documents as well as court paintings of other imperial events. What Chang finds in Xu's renderings are vivid depictions of the emperor's majestic and orchestrated movement across the landscapes of south China (Figure 1.2). But perhaps even more interesting is what Chang finds is *missing* from Xu's paintings, a glaring absence that cuts to the heart of the Qing dynasty's ethnic politics: There are no yurts! An enormous imperial compound with hundreds of tents and Mongolian-style yurts was a central feature of the southern tours, yet these encampments are completely missing from Xu's depictions. Why? Chang surmises that Xu's selective representations are reflective of Qing ethnic politics and the different audiences that viewed these different presentations. The southern tours themselves were a huge, complex, and highly orchestrated series of events choreographed for literati elites and common villagers alike. With their military-style encampments and thousands-strong Mongol and Manchu horsemen in military attire, the tours were intended, in part, to impress upon the general public the martial authority of this non-Chinese dynastic ruler. But the court paintings—produced by an elite Chinese artist, in a style epitomizing Chinese court culture, for the eyes of only top officials—served the very different purpose of providing an esthetic rendering of the tours' majesty and grandeur for elite consumption. In this context a focused rendering of yurts and military camps would have seemed esthetically jarring, alien, and even somewhat barbaric to Chinese eyes. Thus, as Chang notes, "The irony and the lesson is that when we think about the *visual impact* of the southern tours, we actually *cannot* simply rely upon visual sources, such as court paintings," because the

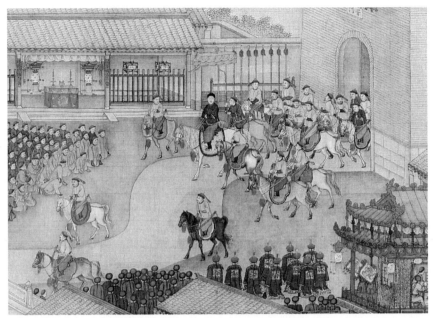

Figure 1.2 The Qianlong Emperor's Entry into Suzhou in 1751, featuring the emperor on horseback surrounded by his most loyal and stalwart Manchu and Mongolian troops. From: Xu Yang, Qianlong nanxun tu juan [Illustrated Scrolls of the Qianlong Emperor's Southern Tour]. c. 1770. Scroll six detail. The Metropolitan Museum of Art, New York. Used with permission.

images owe their appearance to a careful process of esthetic and political editing.

The example of Qianlong's southern tours demonstrates how careful historians must be in analyzing visual evidence. For Cecily McCaffrey, however, the obstacles may be even greater. She is trying to write history from "below," from a perspective that is almost completely absent from the archive—the perspective of peasant rebels. Peasant rebellions plagued the Qing government throughout the 1800s. The largest involved up to a dozen provinces, left millions dead in their wake, and are considered among the most important events of that century. Yet the search for the rebels' perspective in the archival record rarely meets with success. First of all, visual materials depicting rebellions in the eighteenth and nineteenth centuries are few and far between. Moreover, just as history is written by the victor, it is often illustrated by the victor as well, so what images do exist mainly depict rebels as the state saw or wished to depict them through its biased lens. Despite these constraints, McCaffrey asks us to imagine what a rebellion might have looked like to those who actually participated in it. Sifting

through archival sources for visual descriptions when elites or government officials actually confronted rebel armies, McCaffrey reads these texts against the grain, finding clues of organized behavior and potent religious and visual symbolism amid the chaos of battle. As her chapter reminds us, much is left out of the historical record if one focuses solely on evidence gleaned from official records. In analyzing evidence, historians must therefore pay attention not only to what is there, but also to what is absent. The state's failure to attend to certain subjects does not mean they were unimportant, but it speaks volumes to the ways in which the state structured its understanding of these subjects.

As we move into the late nineteenth and early twentieth century, however, we find Chinese political leaders attempting to expand their reach to the "masses" by reading and shaping public perceptions, as shown in Charles Musgrove's chapter on the late 1920s construction of the Sun Yat-sen Mausoleum (Figure 1.3). The mausoleum's architect created a space where 50,000 people could observe rituals honoring Sun, transforming traditional funerary rites into visual ceremonies aimed at displaying citizens' loyalty to the memory of the "Father of the Nation" and, by extension, the Guomindang (Nationalist Party) state. This aim stood in marked contrast to imperialera tomb building, which was conducted in semi-secrecy on sites forbidden to commoners. In the transition from Qing empire to Chinese republic, politics had changed, and the visual imagery of politics had changed along with it. While both political forms—empire and nation-state—gave rise to elaborate, elite-sponsored public displays of authority, republican monumentalism invited the public itself to take part in state ceremonies as citizens and to gaze upon the symbols of political ritual and power in ways that commoners living under the Qing would have found incomprehensible.

DISSEMINATING IMAGES: URBANIZATION, IDENTITY, NATIONALISM

The public participation in state image-making Musgrove describes depended to no small extent upon emerging technologies of mass image production and the design of explicitly public spaces for mass gatherings, modern phenomena that were overwhelmingly urban centered. Cities were becoming the places where images were produced for dissemination to the rest of the country, and *where* people get their images often in turn shapes their identity. Think, for instance, of the distinctive roles played by cities like Paris, New York, and Tokyo in creating fashion icons, or Hollywood, Hong Kong, and Bombay in creating movie stars: those cities have had disproportionate influence in defining what the ideal "man," "woman," "American," "Chinese,"

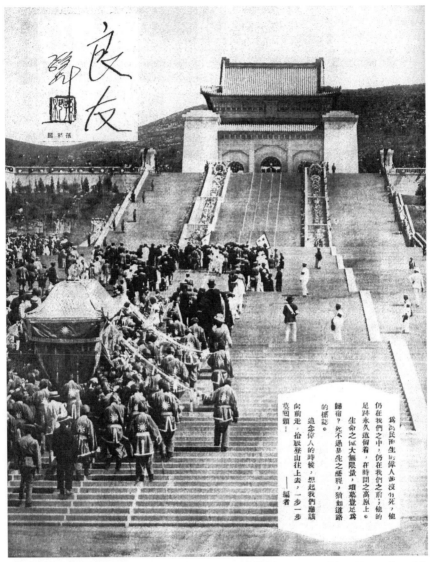

Figure 1.3 This full-page photo of the ceremonial internment of Sun Yat-sen's at his memorial outside Nanjing graced page one of the China's most cosmopolitan pictorial magazine, the Young Companion in June 1929. The towering grandeur of the monument is highlighted both by the perspective of the photograph and by the caption "Under blue skies and brilliant sunshine the Chinese Republic sorrowfully and reverently placed its creator at rest in the magnificent mausoleum at Purple Mountain at noon on June 1."
From: *Liangyou Huabao*, June 1929.

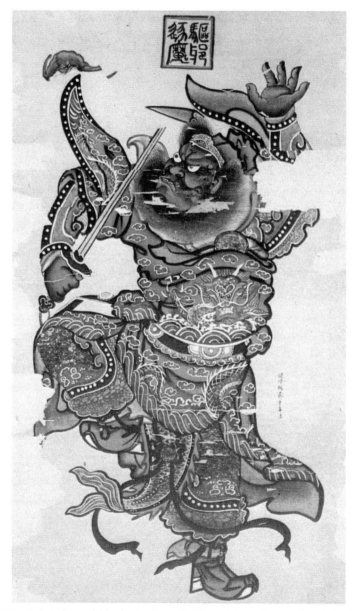

Figure 1.4 Painted wood block of Zhong Kui (auspicious demon slayer) in the form of a door god, produced in Yangliuqing area, Kangxi era. In addition to New Years pictures, Yangliuqing's artisan produced images of household deities such as door and kitchen gods that were also customarily hung during New Year celebrations. This rendering demonstrates the refined style for which Yangliuqing was so renowned. Artist **anonymous.** From: Pan Yuanshi and Wang Lixia, *Yangliuqing ban hua* [Yangliuqing Prints]. Taipei: Xiongshi tushu gufen youliang gongsi, 1975.

"Indian," "Japanese," etc. is supposed to look like. In China, Shanghai ("the Paris of the East") led the way in producing a plethora of new and exciting visual images, coming for many to represent the epitome of modern cosmopolitan culture.

This process did not happen overnight. Rural areas continued to produce nationally significant visual culture in the late nineteenth and early twentieth centuries, as Madeleine Yue Dong's chapter reminds us. The Qing dynasty's promotion of an agricultural and handicraft economy had resulted in the flow of cultural production from villages into the cities. One example of such a rural-to-urban cultural current was the woodblock printmaking industry centering on the town of Yangliuqing, not far from the city of Tianjin. Here the production of *nianhua*, or New Year's Paintings (Figure 1.4)—hand-colored woodblock prints for ritual and celebratory display—was a thriving industry, generating thousands of original illustration designs and tens of millions of prints annually. Dong argues that the industry's success was inextricably tied to its location on the northern end of the Grand Canal, the central artery for shipping in the Ming and Qing dynasties. This location meant that print shops not only had easy access to paper and pigments shipped from the south, but also were proximate to the major urban centers of Beijing and Tianjin, large and elite markets for their artworks. Yet, by the 1930s the printing industry in Yangliuqing had shriveled: print shops closed, thousands lost their jobs, and the few remaining prints produced in the area were of inferior quality and sold poorly. What caused this thriving visual cultural industry to vanish? Dong shows that the radical reorganization of transportation and economic infrastructure—including the demise of the Grand Canal, the rise of railroads and ocean shipping, and an economic reorientation toward urban-centered modernization—combined with the rise of new urban-based printing technologies of lithography, essentially reversed the economic and cultural flows that made Yangliuqing New Year's Paintings possible. In sum, Yangliuqing's folk visual culture was distinctive of a Qing cultural economy produced in and flowing out of the countryside into market towns and cities; but twentieth-century processes of modernization and urbanization reversed this flow of visual cultural production, and Yangliuqing simply could not compete economically.

Coastal cities and urban mass production soon gained supremacy within China's cultural economy, a theme picked up in Andrew Morris's chapter. In the 1920s and 1930s, photography, popular magazines, and mass sporting spectacles emerged as important shapers of visual culture and identity. For example, during their heyday in the Republican era, Shanghai periodicals transformed women's physical culture and expectations about the socially and culturally prescribed roles that men and women were supposed to follow. The Republican era brought expanded opportunities for Chinese

women, including a potentially liberating public mobility that would have been unthinkable only a decade earlier, while the concerns and desires of urban women in particular commanded increasing attention from a burgeoning media market of photo-laden magazines and journals. But this new public role and visibility came along with considerable objectification and commodification by a media enchanted with female images. While girls and women were exercising new freedoms as athletes, newspapers and magazines coopted their images and marketed them to the male public (Figure 1.5).

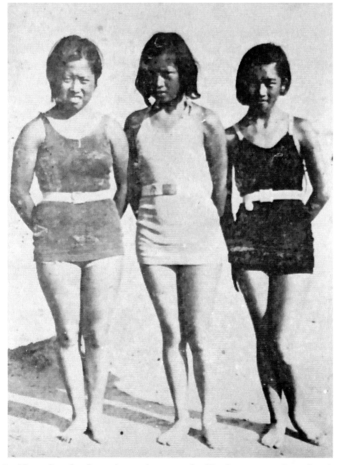

Figure 1.5 Three female champion swimmers, the He sisters, pose here for the camera.
From: Qingdao shi Tiyu xiejinhui, *Liang zhounian gongzuo zongbaogao* [Two Year Anniversary Official Work Report]. Qingdao: Qingdao Tiyu xiejinhui chuban weiyuanhui, 1935, n.p.

Morris shows that new visual media were important mechanisms for shaping not only how the public perceived sportswomen, but also how Republican-era women experienced their own identities—their physical and psychological selves.

Of course the impact of visual culture on identity formation in the Republican era was not confined to the realm of gender; nationality and ethnicity were also crucial. James Cook explores the strong connections among place, national identity, and image in China's large overseas Chinese communities. Sometimes feelings of national identity emerge most strongly when people are physically remote from their place of origin, especially if they face discrimination in their new communities. Numbering more than ten million by 1920, overseas Chinese in places ranging from the Dutch East Indies and French Indochina to England and the United States often found themselves living in very hostile, anti-Chinese climates. Here, everyday images and symbols embedded in architecture, newspapers, and ceremonies at local temples and voluntary associations were powerful connecting points that linked Chinese people living abroad with their homeland. For example, the architectural design of many overseas residences, the standard two-story shophouse or *qilou*, visually blended overseas Chinese economic life with references to traditional village life back in China (Figure 1.6). The image

Figure 1.6 A shophouse in Xiamen. From: Hong Puren, *Xiamen jiu jing* [Old Photographs of Xiamen]. Beijing: Renmin meishu chuban she, 1999. Used with permission.

of China, embodied in construction, helped overseas Chinese to define themselves as "Chinese."

THE POWER AND LIMITS OF THE STATE'S GAZE: ENVISIONING CHINA

But the forging of national identity is not only propelled through voluntary acts of community expression; more "top-down" acts of state promotion and intervention may have greater influence, and nation-states all work in various ways to shape identities via visual and mass media. As Zhiwei Xiao demonstrates in his analysis of 1930s cinema and censorship practices, the Guomindang government routinely intervened in film production at the studio level. Consistent with the New Life Movement, Guomindang censors focused on moral and behavioral issues. In regulating citizen behavior they sought

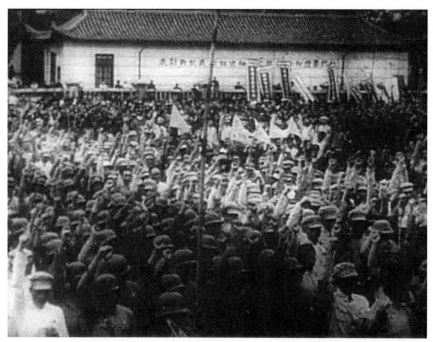

Figure 1.7 This still is from footage produced by a Guomindang film company and included in Frank Capra's famous *Why We Fight* film series, which was shown in both China and the United States. The image portrays the Chinese as united against the onslaught of Japanese aggression. From: *Why We Fight: The Battle for China.* Directed by Frank Capra. 1944; Los Angeles, CA: U.S. Army Signal Corps.

to forge a Chinese identity that embraced modern notions of hygiene along with supposedly "Chinese" values regarding sexual propriety and adherence to social hierarchies. While it is easy to scoff at Guomindang efforts to politicize such things as politeness and grooming, Xiao's chapter reminds us that urban cinematic culture could actually be quite ribald and diverse, prior to the arrival of party-state censors. Censorship aimed at creating a cohesive national "body" that drew its strength from the physical and moral purity of each citizen.

With the outbreak of full-scale war between China and Japan in 1937, the Guomindang's energies shifted from cultivating moral citizens to surviving a massive military onslaught. Lu Liu's chapter deals with the national government's desperate attempts to mobilize popular support in handling a disaster that remains one of the most iconic and devastating moments in China's national history. The propaganda images they produced highlighted not only the misery of conditions in wartime China but perhaps still more importantly their ability to organize in their struggle to survive as a nation. Some of these images were immortalized in Frank Capra's classic propaganda film "Why We Fight: The Battle of China," co-produced with Chinese filmmakers in the wartime capital of Chongqing. This film, shown widely in the United States and in other countries, including China, portrayed the Chinese people as worthy allies and helped galvanize support for them in their time of need (Figure 1.7).

To maintain its power, a state cannot rely solely on producing images for popular consumption; it must also learn to "see" its population. The techniques governments use to oversee populations are often inherently visual and entail, to use James Scott's term, *seeing like a state*. The unprecedented migration of tens of millions of Chinese refugees who fled with the Nationalist state from eastern to western China during the war of resistance against Japan involved an extraordinary effort on the part of the state to "see" its citizenry in rational, bureaucratic terms—numbers of needy, tons of available supplies, dollars spent—in order to relocate, employ, and enroll millions of people along with entire universities and factories. The high degree of regimentation, even militarization, of society this entailed is well captured in Figure 1.7. We must remember, however, that "seeing" is always a two-way street. In other words, while the state is always trying to see, it is also being watched by its citizens, as well as by citizens of other countries. The massive upheaval of the anti-Japanese war provided some of the most heart-breaking images of World War II. Accounts of wartime suffering were potent ammunition for propaganda, and Liu shows how they could be used both to sway public opinion and pressure the government to take action. The experience of migration helped transform people's expectations of the state, which in

turn forced the Nationalist government to respond by taking on far greater responsibilities over public and refugee welfare.

THE POWER AND LIMITS OF THE STATE'S GAZE 2: ENVISIONING SOCIALIST CHINA

Despite the defeat of Japan in 1945, the Guomindang's days in mainland China were numbered. During the late 1940s, the Communists increased the territory under their control; in 1949, Mao Zedong proclaimed victory, and the Guomindang retreated to Taiwan. When the Chinese Communist Party (CCP) came to power, it built on foundations the Guomindang had laid in its attempts to cultivate patriotic citizens and its administrative efforts to "see like a state." However, its aims went far beyond stepping into the old government's shoes. The CCP sought to recreate Chinese society in a social-ist mold where ideal citizenship and patriotic sacrifice were linked to, if not synonymous with, class struggle and overcoming the legacies of capitalism and imperialism.

This necessitated transforming what people saw and how they saw it. Where possible, the new leadership sought to replace images associated with the old society with new socialist imagery. However, in many cases this was impossible. For example, large structures associated either with the colonial powers or with the Guomindang were too valuable to tear down, and a great many visual markers were too embedded in daily life to be transformed all at once. And so the state often had to attempt to change the way people saw these things—in other words, the meanings they attached to them.

Christian Hess's chapter brings us to the city of Dalian in China's North-east in the 1940s to examine how the socialist state attempted to eliminate vestiges of colonialism from urban life. Occupied by Russia and then by Japan, Dalian had for decades presented one of the most striking public facades of colonialism. Japanese planners had designed a rational city of segregated neighborhoods. As a result, longtime residents and first-time visi-tors to Dalian knew at a glance who belonged where: poor Chinese laborers lived in the shanties by the docks; Japanese colonizers resided in attractive neighborhoods; government and business leaders worked among edifices that visually symbolized their power. Urban planning in Dalian was thus a visual practice aimed at making political identities—who were the conquerors and who were the conquered—immediately visible and legible to everyone who entered the city.

After the Japanese defeat in 1945, Dalian came under joint Soviet and CCP control. The new government viewed the people of Dalian through a very

different lens: the ideals of socialism rather than capitalist imperialism. Leaders faced an immediate conundrum. They wanted to transform Dalian from a model colonial city into a modern Chinese socialist city, but the logic of the colonial social order was quite literally built into the city itself. The medium of Dalian's redesign would not be stone and concrete but rather political spectacle. Through attention-grabbing campaigns of housing redistribution, Dalian's new socialist government tried to create a new urban image. Redistribution followed a statistical analysis of individual families' economic conditions and the application of class labels. Dalian's housing campaign culminated in "moving day," marked by huge parades and media fanfare when Chinese residents, having been officially stamped as the oppressed poor, were ushered by the new socialist government from their shanties into the fashionable modern houses formerly occupied by the Japanese. The spectacle of "moving day" was an impressive attempt to mobilize the population to envision a new socialist Chinese Dalian and bolster support for the new government (Figure 1.8).

But how effective were such attempts? Jeremy Brown's chapter returns us to issues of rural/urban relations. He finds that despite pervasive socialist state rhetoric about the need to eliminate the rural/urban divide, stereotypes

Figure 1.8 Photograph of a moving-day celebration orchestrated by the Chinese Communist Party in 1946 in the city of Dalian. From: Dalian shi shizhi bangongshi, ed., *Dalian shizhi wenhua zhi* (Dalian city cultural gazetteer). Dalian: Dalian chubanshe, 2003.

about the differences between peasants and city dwellers proved remarkably durable. Moreover, the gap between town and country was maintained not just through institutional means (such as the household registration system), but also through a visual process that Brown calls *spatial profiling*, in which both state and non-state actors participated. Visual markers like clothing, skin color, and personal hygiene coded people as either rural or urban. These markers identified peasants with a host of stereotypes (e. g., simple-minded, naïve, and unhygienic) that had important consequences for the treatment rural folk could expect to receive. This culture of seeing was already deeply entrenched well before the founding of the People's Republic, and as much as the official propaganda of the Mao era professed to refute these stereotypes, they continued without any significant weakening. Indeed, the Beijing government's efforts during the 2008 Olympics to rid the city of rural migrants confirms Brown's argument that spatial profiling remains alive and well, and this particular form of visual stereotyping continues to play a powerful role in Chinese politics and society.

Matthew Johnson's essay further explores the urban/rural gap from the vantage point of Great Leap Forward (1958–1960) films. Though narrowing the divide between city and countryside was always an important principle on the CCP's agenda, the Great Leap Forward was unprecedented in its utopian aims (and claims) of bringing industrial and modern living to China's rural areas veritably overnight. It was quite befitting then, that during this period millions of villagers were exposed for the first time to the powerful—and up to then preeminently urban—medium of film. The effort to bring film directly to the communities of tens of millions of rural residents for the first time shook up the film world, prompting changes in personnel and administrative priorities that are relatively easy for a historian to document. But Johnson moves a step further to ponder a more difficult question: How might Chinese audiences, and particularly those new rural audiences, have responded to these films? Without the benefit of Nielsen ratings, Johnson uses interviews, archival documents and images, and an analysis of unique aspects of Great Leap Forward film production, distribution, and genre to gauge the 1950s viewing habits of rural Chinese people. He finds that film-viewing experience in rural areas differed from that in the cities: films were screened outdoors, often to very large crowds, and were subject to a variety of interventions by projection crews. Rural filmgoing was not simply about watching the film: "talking, eating, meeting potential romantic partners, getting together with one's friends and family, or just watching the general excitement were also important draws for audience members." However, the propagandistic messages of the films could not be missed. The very fact that the Chinese state was making such efforts to introduce film to the hinterlands supported its claim to be bringing modernity to everyone, everywhere in China. In this

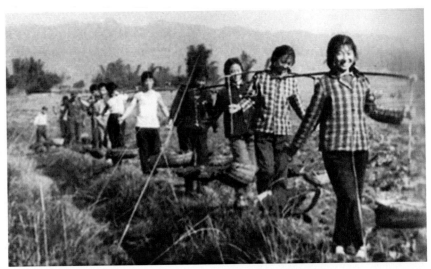

Figure 1.9 This photograph, by a photographer of a brigade propaganda team in Yunnan, presents a happy image of sent-down youth laboring in the countryside. Today such images are often used to bolster the idea that former sent-down youth should have "no-regrets" about their experiences. From: Personal collection of Xie Guangzhi.

sense it might be apt to apply to Great Leap Forward-era film Marshall McLuhan's famous insight: the medium *is* the message.

NARRATING EXPERIENCE: VISUAL TEXTS AND METAPHORS

If the medium is the message, what of the medium of historical narrative itself? Increasingly, historians are recognizing that the human penchant for creating narratives (i.e., telling stories) has a profound impact on how we derive meanings from specific historical events. This operates at the levels of personal memory, official commemoration, and professional history writing alike. Images do not function merely to "illustrate" existing historical narratives like the pictures for assembly in an Ikea instruction manual. Instead, they often inspire contradictory narratives; or they can spark the reorganizing of memories into stories that are meaningful to people in their contemporary context. Analysis of the relationship between narrative and image demonstrates the inevitability of multiple perspectives on history, even as the state (and not only the socialist state) seeks to imprint a single definitive set of images.

Xiaowei Zheng's essay explains that histories of the Cultural Revolution typically use photographs to tell one of two different stories: violent images

of youths destroying cultural artifacts or attacking authority figures portray a "scarred youth" narrative, while old propaganda images of exuberant youth participating in rural labor or bringing revolution to the countryside tell a tale of "no-regrets" (Figure 1.9). Uncovering a trove of stories and visual artifacts preserved by "ordinary" urban youth "sent down" to the countryside during the Cultural Revolution, Zheng is able to move beyond these polar-opposite dominant narratives and bring to light a richer, more personal history. Combining oral history interviews with analysis of photographs and art created by the former "sent-downers," she captures both the drama and the everyday experiences of ordinary people who lived through extraordinary historical events.

Zheng's chapter asks us to think about the relationships among visual images, memory, and history. By examining both the Cultural Revolution-era events depicted in the images and the later circulation of those images in the present, this chapter charts the movement of images across two historical periods (the Mao and post-Mao eras) and two distinct cultures of seeing. The people she interviewed meet regularly to share memories of their days as sent-down youth in the countryside. They often interpret images from the Cultural Revolution in distinctive ways, and they also share images from their specific experiences that have not found their way into the dominant literatures. As Zheng demonstrates, these former sent-downers are using images not only to reminisce about the past but also to bind them together as a community in the present. The meaning of the images has thus changed over time: the images serve as evidence of present as well as past experiences of community.

Historians are trained to be skeptical, ask questions, and maintain a certain distance from the historical actors we study. Indeed, some of the authors in this volume wish to turn this skepticism on the discipline of history itself. Historians (in this volume and elsewhere) frequently employ such metaphors as "take something as a window on a historical period," "view something through a certain lens," or "offer a different perspective on something." Sigrid Schmalzer and Elena Songster pursue the implications of this language to investigate "the powers and limits of historical sight." Using the metaphor of the telescope, they show that the picture one gets of history depends on the case, or lens, one selects for study. State writings and images on panda preservation offer a very optimistic view of the Deng-era Four Modernizations program and its effects on wilderness, while those by non-state actors on the search for the Chinese version of Bigfoot frequently present a much more critical perspective on the same subject. The co-authors leave us with a set of related questions: Can two such cases be understood together, and if so, does historical vision thus become more objective? Or is history inherently subjective, with the picture rotating as in a kaleidoscope each time we shift our gaze? Can the contradictions between simultaneous visions be resolved,

or must historians simply accept that tensions will always remain to prevent us from achieving a single clear picture of history?

Sue Fernsebner's chapter on the 2010 Shanghai World Exposition serves as a combination case study and epilogue, bringing this volume up to the present Internet era in a global economy in which China is one of the most powerful players. The reader will find many of the volume's themes (rural/urban, state society) reverberating here. Most importantly, with regard to questions of historical narrative, we find what in many ways amounts to a real-time struggle over what the Expo represents. The Expo itself, Fernsebner observes, is a complex congeries of image-producing media, from built sites in Shanghai (many of which themselves incorporated imaging systems), to promotional videos and ads, to online virtual tours, to Expo-themed video games. But the internet is raising the old problems of narrative interpretation to a new level, for it opens to the public not just the ability to consume state- or corporate-sanctioned images with clarity and convenience. Netizens can now capture, comment upon, doctor, and redistribute images as quickly as they are made. Image consumers are now also image-makers. But is it perhaps naïve to think that this significantly shifts the balance of power in the state-society equation? Does the Expo mark the Chinese state's triumphant arrival on the global cultural stage? Or should we see it (following some netizens' depictions) as yet another opportunity for crony elites to enjoy their VIP privileges at the expense of the general public? Which images will prevail?

TOWARD A VISUAL HISTORY OF CHINA

With their focus on visuality and visual media, the essays in this volume contribute to a richer, more nuanced picture of modern China's history. Over the course of the modern era we see popular participation in politics increasing alongside state efforts to control daily life; we also see the influence of non-state forces, including commercial activities and popular resistance; and we see profound transformations in the relationship between urban and rural areas.

Through the nineteenth and twentieth centuries, the relationship between the state and the Chinese people underwent radical change. The Qing dynasty monarchy that invited little participation in politics by the Chinese people became, after 1949, a revolutionary state that attempted to mobilize every individual. A crowd of admiring villagers was an important prop in the spectacle of Qianlong's southern tours, but it was in no way Qianlong's main audience. By contrast, Sun Yat-sen's Mausoleum and Republican-era sporting events were designed with the central purpose of encouraging greater citizen participation. Yet Republican-era public spectacles and the visual

media that publicized them reached primarily urban audiences; the rural millions hardly played a role. The CCP was more committed not only to recruit both rural and urban publics, but also to put them in far more active roles, not merely as viewers but as active participants in the public spectacles at the heart of their political campaigns. Like the housing redistribution campaign discussed in Christian Hess's chapter, the land reform movement, the Great Leap Forward, and the Cultural Revolution all involved myriad public spectacles, parades, and mass rallies that aimed to recruit nearly every social group into visibly public action. Moreover, the CCP was extraordinarily committed to bringing forms of visual media to poor and rural publics that previously had little access to them. Taking these points together, the CCP was clearly extremely savvy about the power and uses of visual culture. Fast-forward to the 2008 Olympics and the 2010 Shanghai World Expo, we find the state continuing to master new interactive technologies—including 3-D film, video game design, and sophisticated websites—to mobilize and monitor public participation in China's self-promotion on the world stage.

Yet alongside this massive participation and mobilization has been a second trend: a growing effort by the Chinese government to limit how people use and interpret the visual culture available to them. Even though its efforts often failed, the Guomindang repeatedly tried to limit the political and moral interpretations of 1930s popular film. And after the 1949 revolution, the new state's effort to control visual culture only increased. Xiao's discussion of film historiography, Johnson's study of Great Leap-era films, and Zheng's analysis of Cultural Revolution images all confirm that the state's greatest stake in visual culture lay in tightly controlling not simply image content, but perhaps even more importantly, how image content was *interpreted*. What becomes of this attempt to police interpretation in the age of the internet, when image consumers can also just as easily act as image producers armed with mobile phone cameras, wireless communication, and Photoshop? The chapters here comprise a historical primer for unraveling the many strands of this complex and pressing question.

One of the repeated lessons of this volume is that images do not have a single inherent meaning: whether we like it or not, whether we notice it or not, we are always imposing interpretations on them. Moreover, interpretations often change profoundly over time as people re-envision the present and the past, and rarely is there one single lens through which an entire society agrees to view an historical image. History is often written by the victors, but victory does not end debate. Historical debate may pit a dominant narrative, created by the victors or ruling powers, against one or more oppositional narrative. Historians and historical actors alike repeatedly reinterpret accepted images of history, and we are not limited to "seeing like a state." Indeed, our goal may be to overcome distortions by state or other powerful actors by

incorporating new accounts or evidence and highlighting the perspectives of people neglected in standard histories. In revising our understanding of history, the authors of these essays spur us to look again—and look differently—upon images of the past that we thought we had understood.

NOTE

1. Yu Hua, *China in Ten Words* (New York: Pantheon Books, 2011) p. 31.

Chapter 2

Envisioning the Spectacle of Emperor Qianlong's Tours of Southern China

An Exercise in Historical Imagination

Michael G. Chang

A picture is worth a thousand words. The camera does not lie. Seeing is believing. Such are the deeply ingrained platitudes of our own historically situated ways of seeing, shaped by an age of mechanical reproduction and mass mediated visual culture. But what are we, as critically minded students of history, to make of the visual evidence we encounter in our romps through the archives and in our everyday lives? If historical imagination is also a visual exercise, how are we to envision the past(s) that we study and attempt to know? This paper addresses such questions by focusing on the well-known southern tours of the Qianlong emperor (1711–1799, r. 1736–1795), the fourth Manchu emperor to rule over China proper.

Each of Qianlong's six southern tours, which took place between 1751 and 1784,[1] were extended affairs, during which the emperor and his rather size-able entourage spent anywhere from three to five months traveling through one of the empire's most prosperous and critical regions—the Lower Yangtze delta (Jiangnan) (Figure 2.1). "Jiangnan" literally means "south of the (Yangtze) River," but actually refers to a more broadly defined geocultural region straddling the boundary of two key provinces: Jiangsu and Zhejiang. During the seventeenth and eighteenth centuries, these two provinces were vital to the Qing empire in a number of ways.[2] Politically, Han Chinese literati from Jiangsu and Zhejiang comprised the majority of officials who staffed the lower echelons of the civil administration. Economically, these two provinces generated the bulk of the empire's commercial and agricultural wealth, supplying it with surplus (tribute) grain and the lion's share of tax revenues, not to mention other critical staples and luxury items such as salt, silk, and porcelain. Culturally, Jiangnan was not only the undisputed center of Han literati scholarship and refinement, but also, from the Qing conquest

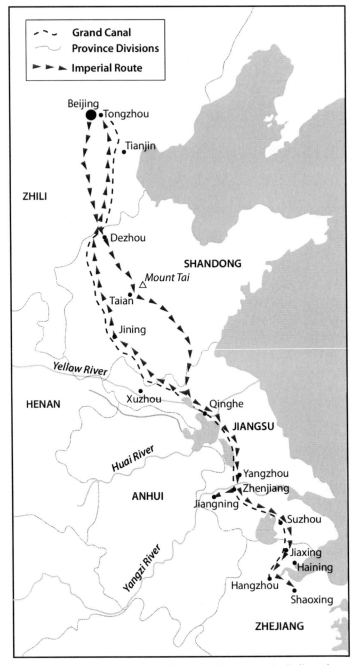

Figure 2.1 The Lower Yangtze River delta (or Jiangnan), including the emperor's imperial route and the Grand Canal. From: Stephanie R. Hurter, George Mason University Center for History and New Media. Used with permission.

in the mid-seventeenth century onward, a bastion of Ming loyalism and anti-Manchu sentiment.

Qianlong engaged in a wide range of activities on his visits to the Lower Yangtze region. He inspected hydraulic infrastructure, presented obeisance to local deities, evaluated local officials, held audiences with local notables, showered individual officials and subjects with imperial favor and recognition, recruited scholarly and literary talents, conducted military reviews, visited scenic and historic sites, and even received tribal envoys from Inner Asia.

But what did a southern tour actually look like? Such deceptively simple questions provide the starting points of most historical inquiry; they are born of a certain degree of ignorance, which is a necessary precondition of curiosity. The answers at which we arrive depend upon our capacity to both critically evaluate and creatively interpret the range of perspectives offered by sources at hand. In the pages that follow, we will consider a variety of sources including court paintings, imperial poetry, literati accounts, administrative regulations, and archival documents. By reading this wide array of sources in conjunction with and against each other, we may conclude, somewhat counter-intuitively and paradoxically, that the court paintings of the Qianlong emperor's southern tours, while helpful in many respects, do not necessarily provide us with a complete picture (pardon the pun) of those spectacular events.

THE MOBILE COURT AS ETHNIC DETACHMENT

One way of envisioning Qianlong's southern tours is to ask ourselves: What was the visual impact and symbolic meaning of the mobile court in the Lower Yangtze delta?

When thinking about and imagining Qianlong's trips to the South, some of the most persistent images that come to mind are those of the Qianlong emperor as a consummate literati tourist, visiting the scenic sites of Jiangnan and littering the landscape with specimens of his poetry. This makes perfect sense. After all, Qianlong was in Jiangnan—a "land of rice and fish" and a bastion of Han literati refinement and poetic sensibility. Moreover, Qianlong's poetic output during his southern tours was, indeed, prodigious.

We will return to Qianlong's poetry in a later section. But let us begin by noting that rarely does the mention of a southern tour lead us to imagine the more prosaic problems involved in transforming the Qing court into a mobile entity. River crossings like that seen in Figure 2.2 (website) are usually not the first things to come to mind when we think of the southern tours.

The logistics of the imperial procession and imperial camps seem somewhat secondary, so much backdrop to the "real" business of the southern tours. We would do well to remember, however, that the hallmark, and indeed the central spectacle, of any southern tour was the physical presence of a mobile court in Jiangnan, both on horseback and in camp. More to the point, during the eighteenth century, the moving court, in and of itself, was an emblem of frontier-style mobility and martial prowess that alluded to the Qing dynasty's non-Chinese provenance. The logistical management of the two most basic forms of the mobile court—that is, imperial bivouacs and the imperial procession—deserves further consideration precisely because they were ethnically imbued projections of imperial authority in Jiangnan.

The Qianlong court approached the logistical management of the imperial procession and encampments as a military endeavor to be dominated by members of the metropolitan conquest elite, who would be in charge of providing for the emperor's most basic needs and security while he was away from Beijing. Chief among these were the six Grand Ministerial and Princely Superintendents of the Imperial Encampment (*zongli xingying wang dachen*), an *ad hoc* body, whose members were selected from the ranks of the Imperial Clan, the Mongolian nobility, and senior Manchu officials. Han Chinese officials were strictly excluded.

Even more crucial to the on-the-ground planning and logistics of the southern tours were the Imperial Escorts (*xiangdao*; Manchu: *yarhūdai be kadalara amban*). This elite detachment of bannermen performed the actual legwork of scouting and reconnaissance both before and during all imperial tours of inspection, including the southern tours.

Two high-ranking Manchu bannermen named Joohoi (Zhao-hui; 1708–1764) and Nusan (Nu-san; d. 1778) served as commanders of the Imperial Escorts for Qianlong's earliest southern tours in the 1750s and 1760s.[3] Both hailed from the Manchu Plain Yellow banner; both were highly decorated and experienced field commanders as well as experts in military supply; and both saw frontline action in Qianlong's famed "Western Campaigns" (1755–1759).[4] Figure 2.3 (website) is a portrait of Joohoi in full battle armor, painted in commemoration of his military service during the conquest of the Ili River Valley (Dzungaria) and the oases towns of the Tarim Basin (Altishahr)—both of which have been known since 1760 as Xinjiang or the "New Dominions." The Chinese inscription reads: "Great Achievement in Pacifying the Frontier" (*suijiang maoji*). This was one in a series of a hundred portraits of military heroes displayed in Beijing's Hall of Purple Brilliance (*Ziguang ge*)—a ceremonial pavilion which Qianlong ordered rebuilt in 1761 for the purpose of feting Inner Asian tributaries, who sometimes also accompanied Qianlong during his visits to the south.[5] Tribal prelates and potentates would have had occasion to see portraits such as this while in the capital, and

the military background of men such as Joohoi and Nusan was unlikely to have been missed.

Besides providing scouting and reconnaissance services during the southern tours, the Imperial Escorts under the command of bannermen such as Joohoi also played a pivotal role in the annual imperial hunts at the Mulan hunting reserve (*Mulan weichang*; Manchu: *Muran-i aba*), located north of the Great Wall. Here the Imperial Escorts were responsible for scouting specific hunting areas and then setting up the emperor's main base camp at an appropriate site within the larger Mulan complex.[6] The continuity of personnel in charge of logistics for both the Mulan hunts and imperial tours meant that when the Qianlong court visited the Lower Yangtze region it resembled an ethnic detachment of Inner Asian elites engaging in a form of military exercise.

"FELT QUARTERS" AND "BOATS OF THE STEPPE": ENCAMPMENTS AS EMBLEMS OF ETHNIC AUTHORITY

The imperial encampment was perhaps the most conspicuous projection of the Qing court's claim to an Inner Asian heritage of martial mobility and prowess. Figure 2.4 is a schematic overview of an overnight or main imperial encampment (*daying*). A centrally located rectangular wall called the "yellow perimeter" (*huangcheng*) defined the core of the camp, the emperor's personal quarters (Figure 2.5, website). One hundred and seventy-five simple pup-tents (or "officials' tents" *zhiguan zhangfang*; Figure 2.6, website) arrayed in a circle constituted an "inner perimeter" (*neicheng*). A second larger ring of 254 officials' tents together with this first ring formed a security cordon. Detachments of imperial bodyguards (such as those in Figure 2.7, website) stood as sentries at the various camp entrances. As seen in Figure 2.5 (website), the imperial quarters where the emperor actually spent the night consisted mostly of circular tents, commonly known as "yurts" (*qionglu* or *Menggu bao*; Manchu: *Monggoi boo*; Mongolian: *ger*).

Mongolian *ger* (yurts) of various sizes figured prominently in court paintings such as Giuseppe Castiglione's "Gathering for a Meal during the Hunt" (Figure 2.8, website) and the "Imperial Banquet in the Garden of Ten-Thousand Trees" (Figure 2.9, website), the latter of which was imperially commissioned in 1754 to commemorate the submission of the "Three Cerings" (Cering, Cering Ubaši, and Cering Mongke) and featured a "Great Yurt" (*Yuwo da Menggu bao*). Finally, Figure 2.10 (website) is a less schematic picture of an encampment in which we see some *ger* (yurts) and the bunting that was used for the yellow perimeter.

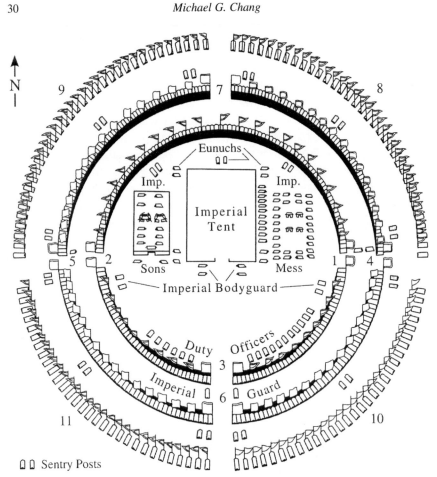

Figure 2.4 **Main imperial encampment which was used during imperial hunts and during other imperial tours of inspection, but which *does not* appear in the court paintings of the Qianlong emperor's southern tours. *Qing huidian tu* [Illustrations of the Qing Huidian]. c. 1899.** From: *Qing huidian tu*, Beijing: Zhonghua shuju, 1991, v. 1, p. 1026, *juan* 104, 3a-b.

Figures 2.7 (website) and 2.10 (website), which depict bodyguards and *ger* (yurts), are actually details from a set of official court paintings, four large scrolls collectively known as "Illustrations of the Mulan Hunt" (*Mulan tu*), produced by court painters sometime during the 1750s under the direction of the Italian Jesuit, Giuseppe Castiglione (Lang Shining, 1688–1766).[7]

Encampments such as these were a quintessential symbol of martial prowess and the projection of Qing power into Inner Asia. Figures 2.11 (website) and 2.12 show two camps in which Qing commanders received the surrender of the Beg of Ush in 1758 and the Khan of Badakhshan in 1759, respectively.

These two images of encampments are from a larger set of sixteen court paintings known as "Illustrations of the Pacification of Ili and the Muslim Tribes" (*Pingding Yili Huibu zhantu*) completed in 1766, again under the direction of Jesuit missionaries at the Qianlong court. For the sake of clarity and convenience, I will refer to these pacification paintings as *Desheng tu* or "Illustrations of Military Victories," a shorter title which was used from the 1770s onward. These sixteen "Illustrations of Military Victories" were painted on the walls of the aforementioned *Ziguang ge*—the ceremonial hall in Beijing where portraits of military heroes were also displayed.[8] As the various images under discussion demonstrate, large, circular encampments along with Mongolian *ger* (yurts) were part and parcel of an Inner Asian political culture that centered upon hunting as well as the conduct of actual warfare and diplomacy on the Inner Asian steppe.

But were tent encampments such as those featured in Figures 2.4–2.11 (website) and 2.12 also used in the Lower Yangtze delta during the Qianlong emperor's southern tours? In addressing this question, our first inclination might be to turn to yet another group of court paintings known as "Illustrations of Southern Tours" (*Nanxun tu*). Two sets of southern tour paintings, each consisting of twelve large scrolls, were produced by the Qing court. The first set commemorated the earliest southern tours of the Kangxi emperor (1654–1722, r. 1661–1722), Qianlong's grandfather, and was completed in 1691 under the direction of Wang Hui (1632–1717), a Han Chinese court painter and native of Suzhou prefecture. Never to be outdone, the Qianlong emperor commissioned a second set of southern tour scrolls to commemorate his own trips to the south. This second set of southern tour scrolls was completed in the 1750s and 1760s under the direction of one Xu Yang, another Han Chinese court painter who hailed from the Suzhou area.

A close examination of both published images and existing scholarship suggests that depictions of imperial camps are conspicuously absent in both the Kangxi- and Qianlong-era southern tour scrolls.[9] The closest that one comes to even seeing a single *ger* (yurt), let alone an entire imperial encampment, in the southern tour paintings is at the bottom of Figure 2.13 (website), a detail from the first scroll of the Kangxi-era southern tour paintings, which shows two camels with collapsed *ger*-frames packed on their backs.

A naïve or straightforward reading of the southern tour paintings as mirror-like reflections of historical reality might lead us to conclude that imperial encampments like those portrayed in Figures 2.4–2.11 (website) and Figure 2.12 were in fact *not* used during the southern tours. However, both archival and published sources provide incontrovertible evidence that two sets of equipment for these large sorts of circular camps were in fact used in a "leap-frogging" manner as the Qianlong emperor traveled through the South.[10]

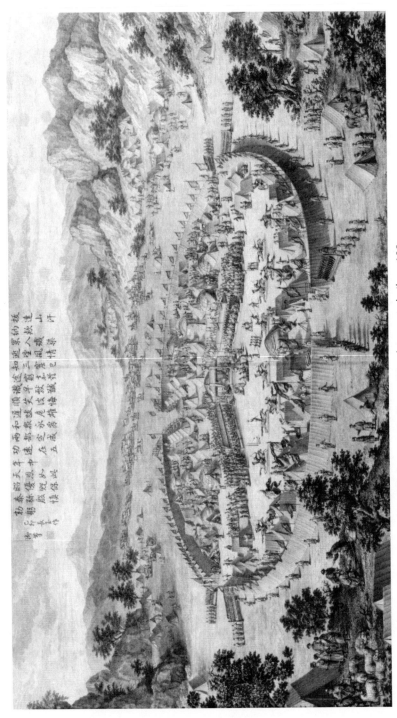

Figure 2.12 Surrender of the Khan of Badakhshan. 1759. From: *Qingdai gongtu huihua*, 190.

Of course, encampments were not the only form of lodging available to the emperor during a southern tour; he might also stay in more permanent structures designated as imperial lodges or travel-palaces (Ch. *xinggong*, Man. *tatara gurung*). Indeed, Qianlong increasingly resided in imperial lodges as more and more were constructed during the late-1750s and 1760s. But this did *not* obviate the need for tents and encampments during his visits to Jiangnan. After all, even the most elaborate imperial lodges were not large enough to accommodate Qianlong's entire retinue of some 2,000–3,000 people. For example, archival documents reveal that during Qianlong's third and fourth southern tours of 1762 and 1765, the Grand Council, other metropolitan ministers, and high provincial officials all frequently camped in tents. Indeed, a total of 1,100 extra tents were needed at five overnight stops even though imperial lodges were already built there.

In addition, during each day's travels the emperor would take meals and receive local officials at one or two intermediate rest stops (*jianying, dunying,* or *wu-dun*; Manchu: *uden-i ba*) where bannermen would set up secondary day camps.[11] As Figure 2.14 illustrates, the main structure of these intermediate camps was a Mongolian *ger* (yurt).[12] Here we may appreciate how the intermediate camp in Figure 2.14 resembles the scene portrayed in Giuseppe

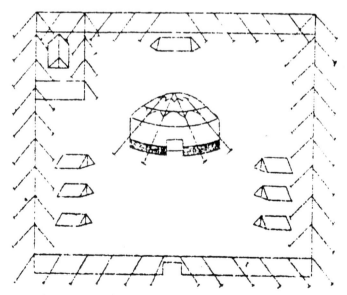

Figure 2.14 Intermediate day camp *(jianying, dunying,* or *wu-dun*; Manchu: *uden-I ba*), where the emperor and his guards would rest and take midday meals and which resembled the hunting camp depicted in Figure 12.8 (see website). Qing huidian tu [Illustrations of the Qing Huidian]. c. 1899. From: *Qing huidian tu*. Beijing: Zhonghua shuju, 1991, v. 1, p. 1028, *juan* 104, 8a.

Castiglione's "Gathering for a Meal during the Hunt" (Figure 2.7, website). Also worth noting is Qianlong's order in 1755 that of the four colonels and sixty guardsmen in charge of logistics and security for intermediate encampments, one colonel and twenty guardsmen were to be drawn *specifically* from Mongol units. So, even though the Qianlong reign witnessed an increase in the number of imperial lodges along the route of the southern tours, camps and Mongolian *ger* (yurts) did not disappear. On the contrary, the Qianlong emperor became even more insistent that they continue to be used. In short, imperial encampments and Mongolian *ger* (yurts) were symbolically significant, even in the most densely populated and Chinese-dominated urban areas of the Lower Yangtze delta.

Here the irony and the lesson is that when we think about the *visual impact* of the southern tours, we actually *cannot* simply rely upon the court paintings of the southern tours. As we have seen, southern tour scrolls alone do not necessarily reveal whether encampments were used on Qianlong's southern tours. Instead, the historian must rely upon written sources (administrative regulations, archival documents, imperial poetry, etc.) for that information.

So what use are Qing court paintings and other types of visual sources to us as students of history? What *can* or what *do* they reveal about the past? Clearly none of the court paintings necessarily represent reality in any direct (or positivistic) manner. On the contrary, they are themselves ideologically imbued documents that serve to maintain strict and stereotypical boundaries between northern and southern landscapes, between civil and military spheres, and between Chinese and Inner Asian cultural and political sensibilities. Curiously enough, Qianlong put Jesuits—namely, Giuseppe Castiglione, Ignatius Sichelbart (Ai Qimeng, 1708–1780), Denis Attiret (Wang Zhicheng, 1702–1768), and Jean-Damascène Salusti (An Deyi, d. 1781)—in charge of the "Illustrations of the Mulan Hunt" as well as the "Illustrations of Military Victories." Meanwhile, he left Xu Yang, a court (artisan) painter from Suzhou, to direct the "Illustrations of the Southern Tours." Might this rather stark division of labor between Jesuit and court (artisan) painters on the one hand, and Han literati painters on the other stem from Qianlong's presumption that the latter group (Chinese literati) harbored some sort of cultural aversion (or at the very least a sensitivity) toward the painterly depiction of triumphantly martial motifs? This question is beyond the scope of the present study and is perhaps best left for more qualified colleagues to take up in future research.

In any case, the three sets of court paintings allow us to unravel an important skein of cultural reference, from which we might reconstruct important *meanings* associated with the use of encampments and *ger* (yurts) during the southern tours, a fact corroborated by written sources. Considered together and read against each other, the "Illustrations of Southern Tours," "Illustrations of the Mulan Hunt," and "Illustrations of Military Victories" form a

neat visual taxonomy (or a symbolic index) in which tent encampments and Mongolian *ger* (yurts) are exclusively associated with Inner Asian landscapes and a highly mobile and militarized political culture. Meanwhile, the southern tour paintings are intended as a tribute to southern landscapes and political sensibilities. It is against this highly idealized and stereotypical southern landscape that painterly portrayals of encampments and Mongolian *ger* (yurts) would have been wholly out of place.

But if we read the southern tour paintings as a tribute to more delicate southern Chinese sensibilities, this does not necessarily mean that the southern tours themselves were also mere exercises in Han cultural appeasement. The southern tour paintings were viewed by a very limited audience with ready access to the inner palace complex in Beijing, where experts believe they were kept.[13] However, the actual use of imperial encampments and Mongolian *ger* (yurts) during the southern tours actually played out on the ground in the Lower Yangtze delta to a much broader audience of spectators.

In the eyes of the emperor and the broader conquest elite, the use of imperial encampments during Qianlong's southern tours alluded to more nomadic and tribal modes of governance and political organization in which mobility was itself a form of security and a sign of martial prowess. According to a well-known Qing noble and historian of the Qianlong era, Aisin Gioro Jooliyan (Zhao-lian, 1780–1833),[14] the use of imperial encampments during imperial hunts as well as tours of inspection was undertaken not only "in reverence of simplicity and frugality" but also "for the purpose of remembering the origins" of the empire.[15] Qianlong himself equated the use of encampments during his first southern tour with free-ranging mobility on the open steppe. In early May 1751, he composed a poem entitled "Felt Quarters" (*zhanshi*), which is worth quoting in full:

> Lodging overnight on the overland route, We use "felt quarters" as usual.
> The shadows of strong steeds fall upon empty window openings.
> Moving about at will through both north and south,
> In warm and cold weather, according to the seasons.
> Immediately upon waking, We give orders to break camp,
> And make proper arrangements to dispatch the scouts.
> Whether on the move or in camp, the tents remain unaltered [constant].
> Thus are they nicknamed "boats of the steppe." [*pingyuan zhi zhou*][16]

Han Chinese elites hailing from Jiangnan also recognized the martial connotations that inhered in Qianlong's use of tent encampments. For example, Shen Deqian (1673–1769), a prominent poet and literary critic from Suzhou, described his imperial audiences with the Qianlong emperor in 1751 and 1757 as having occurred within the "military encampment" (*wuzhang*)

pitched at the confluence of the Yellow River and the Grand Canal in Qingjiang.[17]

Many other Han elites who witnessed the use of imperial encampments in the south may have either consciously or unconsciously avoided such references precisely because encampments symbolized the court's non-Chinese origins and ongoing preoccupations with Inner Asian diplomacy and military conquest. As noted earlier, the military encampments in the "Illustrations of Military Victories" were prominently painted on the walls of the ceremonial hall for military heroes—the *Ziguang ge*—in Beijing. This means that such images were seen by a public audience comprised of not only Inner Asian tributaries and courtiers, but also metropolitan officials, many of whom hailed from Jiangnan. Moreover, such scenes of Inner Asian conquest and diplomacy also circulated beyond official circles in the capital. In fact, prints of these very same conquest scenes (made from copper engravings etched in Paris[18]) were eventually installed at fourteen locations along the route of the southern tours in June of 1784 immediately after the completion of Qianlong's sixth and final southern tour.[19] The reception of local dignitaries and officials at encampments during the southern tours must have appeared quite similar or at least analogous to scenes from the "Illustrations of Military Victories" in which Inner Asian tribal leaders submitted to the Qing court's authority (Figure 2.11, website, and Figure 2.12).

THE SPECTACLE OF A "RULER ON HORSEBACK": THE IMPERIAL PROCESSION

In his well-known *Record of Pleasure-Boat Yangzhou* (*Yangzhou huafang lu*, c. 1795), Li Dou, an eighteenth-century denizen and local historian of Yangzhou, describes camps set up at docks approximately one mile (2–3 *li*) outside of city walls along the Grand Canal.[20] The main structure at each of these dock encampments was a medium-sized tent with a Mongolian-style domed roof. We may fairly assume that this description refers to the intermediate day camps discussed above. Archival documents also indicate that boats carrying imperial bodyguards, Tibetan lamas, high officials from the Board of War, and twenty-four of the emperor's steeds from the Palace Stud were the first to dock outside any urban center along the Grand Canal.[21] We also know that the Superintendency of the Imperial Encampment was in charge of setting up and securing these dock camps as well as of preparing the necessary number of horses for entering cities such as Yangzhou, Suzhou, and Hangzhou.[22] Given the weight of this evidence, we may reasonably conclude that the dock encampments described by Li Dou were part and parcel of the emperor's triumphal entries on horseback and served as staging areas for a

series of ritually militarized parades through Lower Yangtze cities.[23] This brings us to the visual impact of the imperial procession which centered upon the conspicuous display of a ruler on horseback.

The first two standard dynastic histories, Sima Qian's *Records of the Grand Historian* (*Shiji*) and Ban Gu's *History of the Former (Western) Han Dynasty* (*Hanshu*), both denigrated the act of "ruling from horseback" as an illegitimate mode of governance, based solely upon the use of military force. The *locus classicus* for this pejorative understanding of the trope "ruling from horseback" was the biography of Lu Jia, (re)written sometime between 200–400 CE.[24] Lu Jia, a native of Chu renowned for his eloquence, served the Han dynasty founder, Liu Bang (a.k.a. Han Gaozu, r. 206–195 BCE), during the overthrow of the Qin dynasty. According to his biography in both the *Shiji* and *Hanshu*, Lu Jia incessantly urged the Han founder to heed the political teachings found in the *Book of Poetry* and the *Book of Documents*. Liu Bang, for his part, grew impatient and lambasted Lu, saying, "Indeed, We *have* obtained [the realm] on horseback. So how can We follow the *Book of Poetry* and the *Book of Documents*?!" Lu Jia responded with his now-famous adage, "Do you mean that if you take the realm on horseback you can rule it on horseback? (*Ju mashang de zhi, ning keyi mashang zhizhi hu*; 居馬上得之, 寧可以馬上治之乎)"[25] In the final section of this essay, we will explore how, by reviving the practice of imperial touring, the Qianlong court attempted to transform the spectacle of "ruling from horseback" from a stigmatized sign of illegitimate military rule into a specific badge of ethno-dynastic (Manchu) discipline and diligence as well as benevolent civilian rule.

Recent scholarship has demonstrated that horseback riding became a marker of Manchu ethnic identity in the early- to mid-Qianlong period. The Qianlong emperor seized upon horseback riding as part of an essentialized "Manchu Way" that was supposed to simultaneously indicate and inculcate traits of martial prowess and vigor.[26] Throughout the 1750s, the emperor voiced his concerns over the growing tendency among high-ranking Manchu officials to ride in sedan chairs. Qianlong saw this trend as a sign of laziness and dissipation among the conquest elite and responded by trying to encourage horseback riding in a number of ways. First, he issued a number of proclamations that explicitly prohibited Manchu officials from riding in sedan chairs. The corollary to this prohibition was a mandate that all high-ranking Manchu officials, regardless of whether they were serving in civil or military posts, were to ride on horseback instead.

Second and more germane to present discussion, the Qianlong emperor attempted to set a more positive example by personally embarking upon numerous imperial tours of inspection starting in the late-1740s. These included his southern tours. While in Suzhou on his second southern tour of 1757, Qianlong proclaimed in an edict:

Generals and provincial commanders are responsible for commanding officers and soldiers. If they enjoy their high position by living in ease and seeking comfort for themselves [that is, by riding in sedan chairs and carriages] then how will they be capable of leading the troops and instilling bravery by personal example? . . . Commanders and vice commanders of the metropolitan banner forces are all to ride on horseback, and Manchu vice directors [of the six boards] are forbidden to ride in sedan chairs. . . .

Qianlong concluded his tirade by emphasizing, "In the areas through which We tour, We continue to ride on horseback each day."[27]

As this last statement clearly indicates, imperial tours of inspection were closely associated with horseback riding, which Qianlong, in turn, identified as an emblem of martial vigor and Manchu leadership. Imperial tours, then, were for Qianlong a means through which Manchu dominance might be secured, maintained, and displayed.[28] In other words, imperial tours, including the southern tours, were occasions for the performance, preservation, and promotion of ethno-dynastic identity and virtue.

Not surprisingly, the spectacle of Qianlong's ritual entries on horseback into urban centers appears in both the southern tour and the Mulan paintings—two genres of painting which are otherwise diametrically opposite in terms of their cultural references. In Figure 1.2 (see Introduction) we see an image of Qianlong's triumphal entry into Suzhou via Xumen taken from the Qianlong-era southern tour scrolls. A similar scene also appears in the Mulan scrolls (Figure 2.15, see website) where we see Qianlong entering the summer palace complex at Chengde, again on horseback and surrounded by his bodyguard. We might also compare these images to a third painting (Figure 2.16, website) entitled "Qianlong Engaging in the *Battue* Hunt" (*Qianlong congbo xingwei tuzhu*).

Qianlong's steeds in all three of these scenes appear to be tribute horses presented by Inner Asian tribes such as the Khalkas (in 1743) and Eastern Kazakhs (in 1757).[29] The three scenes are set in very different locales: the first (Figure 1.2) being Suzhou, a quintessential literati city in the prosperous and Chinese-dominated south; the second (Figure 2.15, website) being the summer palace complex at Chengde, north of the Great Wall; and the third (Figure 2.16, website) being a *battue* site in the Mulan hunting complex itself, a bit further north of Chengde. Some minor differences in details notwithstanding,[30] Qianlong's bodyguards in all three paintings are dressed identically, as is the emperor himself—in plain-colored riding jackets (*magua*) and frocks. More importantly, all three paintings reinforce Qianlong's image as an Inner Asian ruler on horseback surrounded by his most loyal Manchu and Mongolian troops—all of whom are, not surprisingly, on horseback as well.

As should be obvious by now, themes of martial prowess and ethnic difference also clearly mark the historical record of the southern tours but have rarely been noticed or commented upon by historians. In the final section of this paper we will explore how the Qianlong emperor also orchestrated spectacles of ruling from horseback in order to transvalue martial prowess and ethnic dominance into founts of benevolent civil rule as well.

EXTENDING ETHNIC PREROGATIVES BY "OBSERVING THE PEOPLE" WHILE "RULING FROM HORSEBACK"

The image of a ruler on horseback was not restricted to court paintings, but also permeated Qianlong's poetry. As mentioned above, Qianlong produced many poems while on tour, and they were meant for broad public consumption. In fact, the first chapters in gazetteers for prefectures—such as Yangzhou (1810), Suzhou (1824, 1877), and Hangzhou (1784)—consist entirely of reprinted imperial poems written during the southern tours.[31] Qianlong ordered the compilation of his poetry while he moved through these areas, and he clearly wanted them to serve as a narrative record for posterity.[32]

As one might expect, the many poems that the Qianlong emperor composed (or had someone else compose) during his southern tours are replete with refutations against possible claims that he might be visiting the Lower Yangtze on a mere pleasure junket. Upon arriving in Suzhou in 1751, Qianlong wrote, "The imperial procession alights in old Suzhou. / This is for the purpose of taking measure of popular sentiments. How could it be for Our Own pleasure?"[33] While riding his horse through Changzhou during his second southern tour, Qianlong wrote, "The purpose of coming to the South is to observe the people. / How could it be for the purpose of enjoying the wispy scenery?"[34]

Verses such as these can be found throughout the voluminous corpus of Qianlong's southern tour poems. Clearly, he strove to present himself as an emperor hard at work, not hard at play. In doing so, he seized upon a canonical discourse of "observing the people" (*guanmin*). While in Suzhou in 1757, Qianlong declared that "in visiting the south, two matters are of utmost importance: inspecting the Yellow River and observing the people."[35]

Qianlong was fully cognizant that "observing the people" was not only about seeing, but also about being seen. In early 1750, a full year before his inaugural southern tour began, Qianlong issued an edict "regarding preparation of the royal road" in which he insisted upon high visibility: "Although the view in some areas is interrupted or entirely blocked by straw and cloth bunting, the view from wide open spaces must be kept completely unobstructed."[36] On the day of his actual departure from Beijing,

the emperor eagerly anticipated the "throngs of people" who had already "crowded city boulevards in order to gaze upon the imperial procession" and was pleased to hear that "the gentry, local elders, and commoners all hoped to draw close to the radiant aura of the imperial presence." There was, however, one problem. Qianlong "truly feared that some local authorities were worried about overcrowding and might thus cordon off their jurisdictions ahead of time." Nevertheless, he was adamant about keeping the niggling of petty bureaucrats from putting a damper on the show. "If the roads are wide and spacious and securing the route is not expected to cause undue congestion," Qianlong wrote in a special edict, "then local officials are not to issue blanket prohibitions aimed at obstructing the sincere desire of ordinary subjects to draw near and gaze upon the emperor [*zhanjiu*]."[37] Having reached Suzhou six weeks later, Qianlong proudly proclaimed: "Since entering the province [of Jiangsu] a short time ago, both elderly and young have eagerly come forth, drawing near and gazing upon the imperial procession. Their genuine admiration and respect are quite pleasing."[38] Li Dou echoed the emperor's account: "Colorfully draped pavilions and waterborne stages were set up along the imperial route. All were a manifestation of deep sincerity. Every place through which [the imperial procession] passed was like this."[39] As Qianlong would have it, the act of gazing was mutual and suffused with specific meanings; it "both satisfied the [general populace's] sincere desire for an imperial visit and provided occasion for Us to observe the flourishing of local customs and popular sentiments."[40] In short, the southern tours were for Qianlong a means of conjuring popular acclamation.

These well-rehearsed rituals of manufacturing consent were ideologically unassailable because the phrase "observing the people" alluded to canonical precepts of benevolent civil governance found in the *Book of Changes* (*Yijing* or *Zhouyi*),[41] the *Book of Poetry* (*Shijing* or *Mao Shi*),[42] and the *Liji*[43] that were firmly supported by authoritative Han, Tang, and Song-era commentaries by well-known Confucian scholars: Zheng Xuan (127–200), Kong Yingda (574–648), and Zhu Xi (1130–1200). The Qianlong emperor's stated desire to "allow common folk to draw nearer" so that they might "more easily gaze upon [Us]" dovetailed nicely with standard interpretations of the hexagram for "contemplation" (*guan*) in the *Book of Changes*. Qianlong elucidated his own interpretation of "observing the people" in a poem he composed on April 25, 1780, as he set out for Jiangning on the return leg of his fifth southern tour.[44] The imperial interpretation derived from a canonical reading of the hexagram *guan* in which "a slight variation in the tonal stress gives the Chinese name for this hexagram [*guan*] a double meaning. It means both contemplating [that is—seeing, viewing, or observing] and being seen, in the sense of being an example. . . . The hexagram shows a ruler who contemplates

the law of heaven above him and the ways of the people below, and who, by means of good government, sets a lofty example to the masses."[45]

Some may be tempted to read imperial invocations of "observing the people" as a cultural concession whereby the Qianlong emperor presented himself as a "Confucian" defender of venerable political principles. After all, classically educated scholar-officials were surely familiar with the discourse of "observing the people" and probably found Qianlong's justification of his southern tours in this canonical idiom both politically palatable and culturally reassuring, not to mention ideologically unassailable. Although this interpretation of the southern tours as a form of cultural appeasement or propitiation is not entirely inaccurate, neither does it tell the whole story. An analysis centered solely upon the Qing court's acknowledgment of Han literati ideals may actually prevent us from fully appreciating the subtle workings of Qianlong's ideological statements and the complexities of the broader political culture in which he operated. More specifically, a close analysis of how the Qianlong emperor deftly intertwined classically sanctioned notions of "observing the people" with explicit references to horseback riding in his southern tour poetry provides important insight into the active process by which he continued to elaborate upon the concept of "ruling from horseback" as a legitimate and *ethnically imbued* mode of diligent and benevolent civil governance during his southern tours

Qianlong's southern tour poetry is filled with descriptions of himself "driving a horse" (*cema, ceji*), "sitting in the saddle" (*ju'an*), "mounting a steed" (*chengma*), and "drawing in the reigns" (*anpei*),[46] especially as he inspected the critical hydraulic infrastructure along the Yellow River[47] and the Zhejiang coastal seawalls.[48] Although such self-descriptions of an emperor on horseback are far too numerous to describe and analyze in individual detail here, one important point deserves our attention.

Whether traveling overland or via the Grand Canal, the Qianlong emperor *insisted* on riding on horseback when passing through administrative seats at the provincial, prefectural, and district levels[49] as well as when he visited scenic sites on the outskirts of major urban centers such as Yangzhou, Suzhou, Hangzhou, and Jiangning.[50] His reasoning was that "[traveling by] horse is more convenient than [traveling by] boat and also allows the common folk to draw nearer to [Our] radiance."[51] Indeed, it was an explicit policy that "each time [the imperial procession] arrives at a walled city, most disembark from the boats and ride horses [*cema*] past [the urban area]. [Our] desire is to observe the people [*guanmin*] and this [riding on horseback] is in accordance with the people's wishes."[52] This strictly enforced protocol explicitly identified the practice of horseback riding as a means of realizing a classically sanctioned tenet of "observing the people" (*guanmin*).

Qianlong's insistence on horseback riding during his southern tours, then, derived neither from administrative nor from logistical necessity, but rather from his ideological commitment to *ethno-dynastic* aggrandizement. During his travels through Jiangnan, Qianlong legitimized the ethno-dynastic spectacle of "ruling from horseback" as a means of inspecting hydraulic infrastructure and "observing the people"—that is, as a perfect vehicle for realizing diligent administration and benevolent civil rule in China proper.

CONCLUSION

Qianlong's southern tours, then, were political spectacles of the first order that necessarily entailed ideologically pregnant acts of seeing and being seen. Historical inquiry may also be thought of as entailing acts of imagination and visualization based upon the historian's critical *and* creative interpretation of available sources. As we have seen above, the Qianlong emperor imagined and presented himself as a ruler concerned with the tasks of benevolent civil governance. At the same time, he forsake neither his identity as a Manchu, nor his ideological commitment to ethno-dynastic aggrandizement. He presented himself as both a "Confucian monarch" *and* a "Manchu ethnarch," and he did this by transforming the ethno-dynastic spectacle of "ruling from horseback" into a means of "observing the people." Ruling from horseback in the Lower Yangtze delta, then, became an assertion of Manchu virtues and exceptionalism in both military *and* civil affairs. This was a new ideological horizon that extended Manchu prerogatives into the sphere of civil administration and statecraft. Qianlong's southern tours were not simple exercises in cultural concession in which his ethnic identity was hidden behind or subsumed under that of a literati tourist or even a "Confucian" monarch. Instead, Qianlong's southern tours should be viewed as ideological constructs, constituted through dynamics of cultural appropriation and redaction. It was through such acts of appropriation and redaction that Manchu ethno-dynastic rule was legitimated as the most appropriate means by which to realize venerable ideals of benevolent civil governance in China proper.

Abbreviations used in the notes:
DQHD (JQ): Tuojin et al. *Da Qing huidain (Jiaqing chao)* [*Collected statutes of the Great Qing, Jiaqing reign*] 1817. (Taibei: Wenhai chubanshe, 1991).
ECCP: Hummel, Arthur E. ed. *Eminent Chinese of the Ch'ing Period 1644–1912*. 2 vols. (Washington, D.C.: Government Printing Office, 1943 and 1944).

NXSD: G'ao Jin, comp. *Nanxun shengdian [Great canon of the southern tours]*. 1771. (Taibei: Xinxing shuju, 1989).

QDNXSD: Sa-zai et al. comps. *Qingding nanxun shengdian [Imperially commissioned great canon of the southern tours]* 1791. (Taibei: Taiwan Shangwu yinshuguan, 1983).

QLCSYD: China First Historical Archives ed., *Qianlong chao shangyu dang [Imperial Edicts of the Qianlong reign]* (Beijing: Dang'an chubanshe, 1991).

QSG: Zhao Erxun et al., *Qingshi Gao [Draft History of the Qing]* (Beijing, Zhonghua shuju, 1996).

NOTES

1. Qianlong's southern tours occurred in the spring of 1751, 1757, 1762, 1765, 1780, and 1784.

2. For a concise overview see Naquin and Rawski, *Chinese Society in the Eighteenth Century*, 147–158.

3. Joohoi served as a Commander-general of the Imperial Escort (*xiangdao tongling*) on Qianlong's first two southern tours in 1751 and 1757, while Nusan served in this capacity on all of Qianlong's first four southern tours (1751, 1757, 1762, and 1765).

4. For a more see Zhuang, *Qing Gaozong shiquan wugong yanjiu*, 9–107; Perdue, *China Marches West*, 270–292; and Millward, *Beyond the Pass*.

5. For more on the *Ziguang ge* see Qing-gui et al., *Guochao gongshi xubian, juan* 65 and QSG, *juan* 12, 454.

6. Wang, *Qingdai beixun yudao he saiwai xinggong*, 26–27.

7. Bi (Pirazzoli) and Hou, *Mulan tu yu Qianlong qiuji dalie zhi yanjiu*, 98.

8. ECCP, 74; and Qing-gui et al., *Guochao gongshi xubian, juan* 97, 960–966.

9. Many thanks to Cary Liu, a curator at Princeton University's Museum of Fine Art, who has alerted me to the presence of one temporary structure depicted in one of the scrolls of the Qianlong-era *Nanxun tu*. Although tent structures appear in the *Nanxun tu*, they are not a central element of the composition, and there is no representation of anything resembling an imperial encampment.

10. QLCSYD, v. 2, 886, doc. (4), QL 21/12.

11. Wang Zhenyu, *Yangji zhai conglu*, 47.

12. DQHD (JQ), *juan* 874, 31b–32a and 33b.

13. Hearn, "The 'Kangxi Southern Inspection Tour': A Narrative Program by Wang Hui," (Ph.D. dissertation, Princeton University, 1990), 63–64.

14. ECCP, 78–80.

15. Zhao-lian [Aisin Gioro Jooliyan], *Xiaoting zalu*, 372.

16. NXSD, *juan* 11, 26a.

17. Shen, *Shen Deqian ziding nianpu*, 44b and 55b.

18. ECCP, 74. Four Jesuit priests then living in Beijing—Giuseppe Castiglione, Ignatius Sichelbart, Jean-Denis Attiret, and Jean-Damascène Salusti—were ordered to make reproductions of these scenes for engraving. The copper engravings themselves were completed in Paris in 1774. A set of prints consisted of thirty-four sheets with sixteen paintings, sixteen poems, a preface, and a postscript. One hundred sets were sent to China of which only a few are extant. A complete set is preserved in the U.S. Library of Congress.

19. QDNXSD, *juan* 81, 5b. Locations included temples and other noted sites in Yangzhou, Wuxi, Suzhou, and Hangzhou.

20. Li, *Yangzhou huafang lu, juan* 1, 2–3.

21. QLCSYD, v. 2, 889.

22. *Lufu zouzhe, Junji dang [Grand Council reference collection]* (China First Historical Archives, Beijing), microfilm roll 033, frame no. 1153, Injišan, Qianlong 29/10/21.

23. The Qianlong emperor's movements through the city of Yangzhou during his first southern tour of 1751 buttress the undertone of martial vigor, with the procession passing through the parade grounds of the Green Standard military garrison in the middle of Yangzhou's new city, and the emperor encamping at to the east of the city wall. See Li, *Yangzhou huafang lu, juan* 9, 194.

24. Hulsewé, *"Shih chi,"* in ECT, 405.

25. Sima Qian, *Shiji, juan* 97, p. 2697–2706 (Zhonghua ed., p. 683.1–685.1); and Ban Gu, *Hanshu, juan* 43, p. 2111–2116 (Zhonghua ed., p. 540.2–541.2).

26. Elliott, *The Manchu Way*, 8 and 275–304.

27. QLCSYD, v. 3, 18, doc. 80 (edict QL22/2/28, 1757/4/16).

28. Chang, "A Court on Horseback," 255–292.

29. For paintings of tribute horses presented by the Khalkas (1743), Kazakhs (1757), and Afghans (1762) see Cécile and Michel Beurdeley, *Giuseppe Castiglione,* 103–105, 120–123, 165–166 (nos. 18–23), and 167–168 (no. 27).

30. In the Mulan scrolls (Figure 2.15, website), Qialong's bodyguard is armed with bows and arrows. Meanwhile in the Suzhou scene (Figure 1.2, see Introduction), they are armed with swords, sheathed in what appear to be jade scabbards. In the third painting (Figure 2.16, website), we see that Qianlong carries his own bow and arrows and is no longer protected by an imperial umbrella.

31. A-ke-dang-a, Yao Wentian et al., Yangzhou fuzhi (Gazetteer of Yangzhou prefecture) 1810 (Taibei: Chengwen chubanshe, 1974) *juan* 1 (edicts), *juan* 2–4 (poems); Li Mingwan, Feng Guifen et al. Suzhou fuzhi [*Gazetteer of Suzhou prefecture*] 1883. (Taibei: Chengwen chubanshe, 1970) *juan shou* 1–3.

32. Qianlong's southern tour poems were collected in a total of three volumes: the first chronicling his travels from Beijing through Zhili and Shandong provinces; the second his southward movements in Jiangnan and Zhejiang; and the third all poems written on his northward return to the capital. (QDNXSD, *juan* 17, 32b–33a.)

33. NXSD, *juan* 8, 4b–5a.

34. NXSD, *juan* 16, 1b.

35. NXSD, *juan* 16, 26a.

36. NXSD, *juan* 1, 3a.

37. NXSD, *juan* 1, 21a. The term *zhanjiu* is a classical allusion to the phrase "drawing near the sun and gazing upon the clouds" (*jiu ri zhan yun*) which refers to a description of the sage-king Yao's virtues found in Sima Qian's *Shiji*. See Nienhauser et. al., *The Grand Scribe's Records*, v.1 , 6.

38. NXSD, *juan* 1, 27a.

39. Li, *Yangzhou huafang lu*, p. 3, no. 3.

40. NXSD, *juan* 1, 21a.

41. For Kong Yingda's exegesis of the hexagram for *guan* as related to imperial touring (*xunshou*) as well as the concept of self-reflection (*guanwo*) and observing the people (*guanmin*) see *Zhouyi zhengyi* in Ruan Yuan, *Shisan jing zhushu*, 36.3.

42. For Zheng Xuan and Kong Yingda's commentary on the connection between "observing the people" (*guanmin*) and "imperial touring" (*xunshou*) in antiquity see *Mao Shi zhengyi* in Ruan Yuan, *Shisan jing zhushu*, 264 and 588.3.

43. For Zheng Xuan's annotation see *Liji zhengyi* in Ruan Yuan, *Shisan jing zhushu*, 1609.3.

44. The poem was entitled "Clear Weather" (*Qing*). (see QDNXSD, *juan* 18, 9a–b.) and was followed with an extended gloss on the interrelated principles of "contemplating/observing oneself" (*guanwo*) and "contemplating/observing the people" (*guanmin*) based upon Zhu Xi's commentary on the hexagram for "the ruler's contemplation" in *The Book of Changes*: "When ruler contemplates / observes himself, his actions are not simply limited to his own personal merits and mistakes. This should also include contemplating / observing the well-being of people as a means of self-reflection."

45. Wilhelm, trans., *The I Ching*, 82.

46. For "anpei" see Li Mingwan, Feng Guifen et al. *Suzhou fuzhi, juan shou* 2, 70b.

47. NXSD, *juan* 7, 10a [1751]; and *juan* 23, 4b–5a [1762].

48. NXSD, *juan* 17, 19b–20a.

49. For instance, in cities such as (from north to south): Huai'an (NXSD, *juan* 7, 10a [1751]; *juan* 15, 9a [1757]); Gaoyou (NXSD, *juan* 23, 12a [1762]); Yangzhou (NXSD, *juan* 7, 15a [1751]; QDNXSD, *juan* 16, 20a–b [1780]); Changzhou (NXSD, *juan* 8, 2a–b [1751]; *juan* 16, 1a [1757]; and *juan* 24, 1a [1762]), etc.

50. For example, Tiger Hill (*Huqiu*) (NXSD, *juan* 24, 16b–17a [1762]; and *juan* 32, 8b–9a [1765]); Mount Hua (*Huashan*) (NXSD, *juan* 16, 10b–11a [1757]); etc.

51. NXSD, *juan* 15, 17a, QL22, 1757 (Jiangnan).

52. NXSD, *juan* 23, 19b, QL27, 1762 (Jiangnan).

Chapter 3

In the Eyes of the Beholder

Rebellion as Visual Experience

Cecily McCaffrey

What does rebellion look like? The chaos and violence of popular uprisings are often presumed rather than articulated in scholarship on Chinese rebellions; yet it is obvious that the visual impact of rebellion, as well as contemporary experience of it, directly contributed to the influence of popular movements on Chinese history.[1] Rebellion appeared differently to select groups of historical actors: a posse of rebels might signify mob rule and chaos to an elite observer but simultaneously look like a band of brothers to an active member. This chapter will explore the different descriptions of rebels and rebellions in official documents, elite accounts, and rebel depositions. These alternative visions of rebellion overlapped and coincided in ways that highlight the relationship between the state and the people and demonstrate the impact of popular uprisings on the public order.

Visual sources relating to peasant rebellion in China in the eighteenth and nineteenth centuries are extremely limited. At best, scholars can look to a series of battle paintings commissioned by the Qing court in the late-nineteenth century or to sketched representations of rebellion that were published in the foreign press (Figure 3.1, see website).[2] However, these visual sources have limited utility if we are to address the question posed above in holistic terms. Court battle paintings celebrate the victory of Qing forces alone; foreign representations focus more or less exclusively on foreign concerns. In order to achieve a balanced accounting of rebellion, it is necessary to turn to the written record. In an era prior to the development of visual technology such as the camera, writers created pictures with their prose; these descriptions fuel the analysis in this chapter. Accordingly, the visual images presented in this chapter can only suggest what the events and phenomena described may have looked like: readers will have to employ their imaginative faculties in order to fully appreciate rebellion in visual terms.

Even when relying on the written record, it is difficult to describe peasant rebellion in abstract terms; all that can be gleaned from the sources are hints or clues for the historian to follow. Those caught in the fray of battle routinely describe groups of rebels hundreds or thousands of people strong. One presumes hyperbole in such accounts, but the overwhelming impression is of a mass of people, usually outsiders, descending on a village or a city. Descriptions of areas prior to rebel attack usually indicate an opposite phenomenon: streets are eerily empty as denizens abandon their daily routines for flight. In mountainous regions, military officials write of unfamiliar trails forking in unknown directions, their progress obscured by mist, the area seemingly devoid of human habitation until the next rebel ambush. Fire and smoke predominate in accounts of occupied cities under siege. Burnt buildings and looted storefronts signal rebel progress through an area; yet when the soldiers arrive, the consequences are not much different. Flaming projectiles are thrown over walls, and rebel "lairs" are routinely put to the torch. Finally, there is death and destruction. Layman observers are quite vivid in their descriptions of corpses piled in the streets and the stench of rot in the air. Even battle-weary veterans comment on the extent of the carnage at the end of a siege or on the brutal consequences of mountain warfare, where a missed step is a deadly plunge into a ravine far below.

This essay focuses specifically on religious rebellion during the Qing dynasty (1644–1911), with a particular emphasis on the White Lotus Rebellion (1796–1804) and the Taiping Rebellion (1851–1864). The sources for each perspective represented are almost purely textual. Rebel opinions are drawn from depositions taken either during or in the aftermath of an uprising. Elite observations come directly from first-hand accounts of revolt. The official view is culled from the correspondence sent from military and civil officials to the court. In citing and interpreting these materials, the emphasis rests on the depiction and representation of rebels and rebellion. Impression is favored over action. In other words, it matters less who won a battle than how it was presented. An emphasis on the visual aspects of unrest and uprising necessarily leads to a "re-visioning" of popular revolts, obliging the historian to focus on the contemporary experience of rebellion rather than its progress and conclusion. With this method, rebellion becomes a window into social and cultural history, illuminating the different perspectives and worldviews of the actors involved.

The concepts of heterodoxy versus orthodoxy and chaos versus order are repeating themes in the documentary record; these themes reflect elemental aspects of late imperial society and thus shape the narratives examined here. The Qing state espoused Confucian norms of behavior as a means of ordering the empire. Simply conceived, this secular philosophy constituted the measure of orthodox or correct practices, whether conducted in the imperial

chambers or in individual households.[3] To this end, there was a natural congruence between orthodoxy and social order. The label "heterodox" was applied to groups that engaged in antistate (hence antisocial) activity as a result of their religious beliefs. This label proved particularly potent. In addition to the very real consequences of the term—state regulations outlawed the existence of so-called heterodox sects, for example—it also carried a host of ascriptive characteristics. As detailed below, these descriptive attributes were common tropes in narrative accounts of rebel activity, to the extent that such confabulations were "seen" as well as believed.

The White Lotus and Taiping Rebellions were classic "heterodox" movements. The White Lotus uprising, which began as a localized revolt in Hubei province, spread across five provinces. Led by religious sectarians, the rebels put up a fierce show of resistance to state authority, making their final and longest stand in the mountainous regions of central China. The rebellion lasted nine years, 1796–1804, causing extensive damage to local agriculture and trade. The state was compelled to spend a vast portion of its treasury to pay for the suppression of the movement, leaving little surplus available to handle the military challenges of the nineteenth century. The Taiping movement began a scant fifty years later in the hinterlands of Guangxi province. Tens of thousands of believers followed the charismatic visionary Hong Xiuquan on a military march from the mountains of the southwest to the fertile rice fields of the Yangtze River delta, on a mission to establish a "Heavenly Kingdom" on earth. Their numbers growing to the millions, the Taiping rebels occupied a broad swath of China's heartland from 1853–1864, making their capital in the cosmopolitan city of Nanjing. The court was hard-pressed to mount a successful defense against the rebels, ultimately allowing private armies as well as foreign mercenaries to act in the name of the dynasty, a radical departure from precedent.

Yet it was not their violence alone that marked these movements as heterodox: the substance of their ideology was also suspect. The so-called White Lotus sects subscribed to popular Buddhist millenarianism and belief in the Eternal Mother, creator and sustainer of all humankind. Believers held that the end of the world was nigh and that a new age would soon arrive; the faithful would be delivered into the new age by the Eternal Mother. The sign for the apocalypse was the incarnation of the Maitreya Buddha, the Buddha of the Future, of whom there were many rumors (and supposed sightings) in central China in the 1790s. Sect teachers counseled their disciples to prepare to "rise up" by force of arms on the last day of the world, prophesied to be April 23, 1796 (as it turned out, the first uprising actually took place a few months ahead of schedule).

The religion of the Taiping Kingdom was problematic for other reasons. The Taiping King, Hong Xiuquan, proclaimed himself to be the second son

of the Christian God after this truth was revealed to him in a dream. Schooled in the basics of Christianity, Hong fashioned his own version of the religion wherein he and two disciples became direct conduits to Heaven. Charged by his Heavenly Father to rid the world of demons and bring the people back to the fold, Hong and his followers began a spiritual and military campaign, distinguished by the construction of a new social order that conformed to Hong's new faith. These radical beliefs and the profane practices that they engendered proved anathema to both Qing officials and Confucian elites, in no small part because the Taiping vision was explicitly opposed to the existing order.

REBEL EYES

Given the negative reactions of the ruling classes, it is particularly important to consider rebellion as seen through the eyes of the participants. Whereas official records focus on the unruly crowd and the chaos of battle, the view from the rebel perspective is that of ordered ranks and meaningful symbols. Symbol and ritual served to unite and rationalize rebel participation in the movement. Common garb and signal flags were not only practical tools of war but also shared icons of fellowship. These different elements were also components of a repertoire of protest in rural China; in following these practices, rebels were both aligning themselves with their historical predecessors and communicating their intentions to wider society.

There were inherently visual components to the expressed ideology and ritual of the White Lotus sectarians active at the end of the eighteenth century. When sect leaders began predicting the end of the world in the early 1790s, they claimed that the Maitreya Buddha had become incarnate in the person of one of the sect members. They also announced the arrival of a "True Master" who would protect the faithful in their religious quest. The description of this mystical creature is quite dramatic:

A True Master has emerged in Changchun'guan, Shanxi province. His name is Li Quan'er. The characters for "sun" and "moon" are on his right and left hands, he has the eyes of an emperor [phoenix eyes and dragon gaze], his appearance is extraordinary . . . There is a large stone in his hometown, which suddenly split open one day and produced a scripture that read: "A black wind will blow for a day and a night, it will blow countless corpses; white bones will form mountains, blood will flow like an ocean." The followers who memorize this scripture will avoid catastrophe. Li Quan'er will rise up on the *chen* day of the *chen* month of the *chen* year [April 17, 1796] Those who prepare weapons and ammunition to support him will be rewarded when the affair is completed.[4]

This short narrative was passed from teacher to disciple, likely memorized much as a sacred recitation might be. Accordingly, each detail is important. The imagery is particularly compelling: eyes of a phoenix, cracking stones, black winds, piles of bones. This evocative imagery gave substance to religious faith, presenting the supernatural as both ethereal and tangible at the same time.

Figures such as Li Quan'er materially and visually represented the religious sanction that the rebels believed they enjoyed. Li himself presented an imposing mien. The fate that awaited non-believers was equally impressive. Whether he was actually seen (and no one confessed to that event) matters less than the fact that his description circulated widely throughout central China on the eve of the rebellion.[5] Sect leaders who identified themselves with the True Master, either by proximity or otherwise, shared in his power and religious authority, a relationship that could be exemplified in iconic ways. One sect leader, Zhang Zhengmo, wore a sword which he claimed had been given him by Li Quan'er.[6] The sword made Zhang instantly identifiable and allowed him to claim the divine protection represented in the person of the True Master.

Public and private rituals reassured adherents of both divine sanction and the spiritual authority of rebel leaders. One leader of the White Lotus uprising in Hubei, Hu Zhengzhong, identified himself as a shaman and acknowledged his ritual role in the rebellion when questioned by Qing officials. Hu noted that he had conducted sacrifices on the eve of revolt. Later, when the rebels had established themselves in a fortress in the hills, a shrine was specially built for Hu, signifying the continued importance of ritual throughout the course of the movement.[7] Ritual performance also helped to bolster the courage of adherents in the thick of the fray. Military officials recorded the following encounter:

> We saw a rebel dressed in white, leading two thousand followers. . . He was carrying something in his hand and the rebels under his command fought without retreating. General Cheng De took up a gun and shot at the rebel from the hilltop, killing him, upon which the other rebels fled in consternation. . . . [We interviewed a captive and asked] who was the rebel in white? What was he holding in his hand? He answered that the man was leader Liu Shengming and that he was holding a copper snake in his hand. "[Liu] said that it was a talisman and that when he carried it into battle we [the rebels] would be safe from guns and cannon."[8]

In this case, the public demonstration of an invulnerability ritual and the physical symbol of magical powers (a copper snake) sustained thousands of followers until their divine protection was negated by a well-placed shot.

Whereas official observers used these anecdotes as proof of peasant superstition and heterodox behavior, for the rebel participant these rituals and the men and women who performed them were physical representations of the integrity of the rebel cause; their bold visibility was central to their power to rally their forces.

Another practice shared by sectarian rebels of all stripes was the use of colored sashes, flags and armbands to define association during an uprising (Figure 3.2). These markers served a very pragmatic purpose in clearly identifying friend from foe. The color of the sashes carried religious meaning as well. During the White Lotus uprising, sectarians uniformly wore white; Susan Naquin suggests that this color symbolized the "White Yang" era heralded in the millenarian prophesies.[9] The cloth sashes were standard equipment according to the testimony of one Hubei rebel:

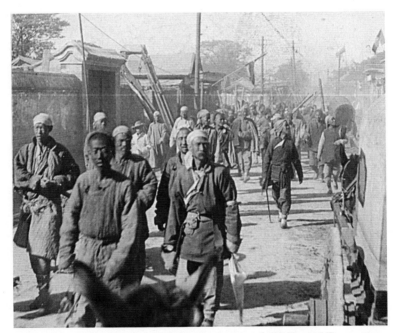

Figure 3.2 A company of "Boxers" in the streets of Tianjin. While contemporary observers may not have recognized the order in the rebel ranks, the use of simple accoutrements such as armbands (see figure in foreground) and colored sashes were an important means of distinguishing the rebel actors from the civilian populace, as well as a clear indicator of an individual's commitment to the rebel cause. Flags such as the one carried by the figure in the foreground of the photo were used to organize the rebels into military formations. From: Whiting View Company, c1901. Library of Congress Prints and Photographs, *Boxer Rebellion, 1900*. http://hdl.loc.gov/loc.pnp/cph.3g03917

This year, in the second month, [Teacher] Li heard of the uprising in [nearby] Jingzhou [and decided to act]. He called on me to join the rebel band. We agreed to meet at his house on the twenty-sixth of the month; we would wear white cloth sashes as markers and bring weapons from home.[10]

There were secular and spiritual reasons to don the required colors. When a high-ranking leader told his followers that "Only those wearing yellow amulets or carrying white banners will avoid harm," he implied that these markers would be visible to human and heavenly eyes alike.[11] Colored banners and signal flags also denoted hierarchy in the rebel ranks, providing direction in the tumult of battle. The simplicity of these implements belied the organization that they symbolized. A White Lotus sectarian described a hierarchy that ordered over fifteen thousand rebels in Hubei: thirty generals, fifty lieutenant colonels, two hundred colonels, and numerous lesser officials.[12] The organization of the Taiping forces was even more elaborate: one observer asserted that in each Taiping army, there were a total of 656 flags used to signal the ranks from sergeant to general.[13]

Flags, sashes and armbands acquired great significance following the outbreak of rebellion: possession of these pieces of cloth connoted membership in the fellowship of the faithful and conveyed the authority of organized violence; possession also indelibly marked the holder a criminal. An elite observer of the rebellion noted that mercenaries fighting for the state used this situation to their own advantage: "If they kill an ordinary person, they say they found a piece of white cloth [indicating rebel sympathies]."[14] Overzealous defenders needed to only mention the color white to justify wanton slaughter. Qing officials also sought to exploit the rebels' penchant for cloth banners. One commander equipped his troops with white flags and sought to draw the rebel forces out from their encampment, as rebel leader Zhang Zhengmo recounted:

[After months of siege], conditions [in the rebel camp] were desperate. I talked with [fellow leader] Liu and we decided to send messengers to [an affiliated rebel camp] seeking assistance. A couple of weeks later, I saw white flags in the distance, slowly approaching. I thought help had arrived and wanted to go meet them. Liu stopped me, saying, "We haven't heard back from the messengers—we cannot be rash." Later, when I saw the white flags coming closer, I again wanted to go down to meet them, and Liu stopped me again. So I sent some subordinates out and they were immediately captured. As for the messengers, they were also killed.[15]

The rebels identified themselves with the bearers of the white flags; it was only thanks to the suspicions of one prescient leader that the group was able to see beyond that association and avoid an ambush.

Awe-inspiring descriptions and iconic talismans explained and exemplified sectarian beliefs to thousands of followers; in times of upheaval, ritual performance and display of sacred objects served to reassure uncertain participants of the sanctity of their organized violence. One could allude to the prevalent illiteracy among the peasant class as one reason explaining the theatricality of popular movements, but most important was the visibility of the rituals and costumes which unified an insurgent group. Flashes of color served to guide movement; a clear manifestation of authority as demonstrated by clothing and equipment helped to focus people with little prior knowledge of battle. Successful manipulation of symbols ultimately transformed the hurly-burly of revolt and battle into a comprehensible spectacle for a rebel audience. Where others saw chaos, the rebels saw order; where others saw perversity and treason, the rebels saw the possibility of a new world.

ELITE OBSERVERS

Generally speaking, the upper classes in Qing society, a.k.a. the lettered elite, regarded the rebel population with hostility and suspicion. To these educated men, rebels personified heterodoxy and the irrational forces of popular superstition.[16] For example, Peng Yanqing, an observer of the White Lotus uprising in Hubei, characterized local sectarians thusly: "They reject their livelihood, disrespect their family, and distance themselves from all that they should uphold."[17] One can find a similar verdict in the following elite-authored anecdote from the Taiping Rebellion:

> In [January 1853] the [Taiping] rebels captured Wuchang city [in Hubei Province]. On January 18 they erected a platform in the square; the rebel leader ascended the platform and announced that he would "preach the way of truth."[18] His followers beat gongs throughout the city and ordered the inhabitants to come and listen. Among the latter was a scholar named Ma, who pushed his way through the crowd and approached the platform, saying that he had an important announcement. The rebel leader called him up and asked what he wanted to say. Ma said: "Everything that you have just said offends Heaven and goes against Nature. It is as meaningless as a dog barking. What is this 'truth' of which you speak? Let me tell you: where there is society, there are the Five Relationships.[19] You rebels [indiscriminately] call each other 'brother,' which goes against the relationship between ruler and ruled. Fathers and sons are called 'brother'; wives and daughters are called 'sister.' This goes against the relationship between father and son. Men and women are separated into different groups and not allowed to see each other; this goes against the relationship between husband and wife.[20] Friends and family are separated, which goes against the relationships between friends and brothers. Thus, the Five Relationships have

been completely abrogated. All this leaves is the 'brothers' relationship which you cite in your speech. So how is it that you don't recognize blood relationships and physically separate brothers while calling complete strangers 'brother?'[21] Given this perversity and deceit, it's obvious that you're nothing but a useless profligate." Ma cursed the rebel in this way without pause. The rebel became enraged and ordered that Ma be drawn and quartered. His minions attached each of Ma's limbs to a horse and tied his braid to a fifth. They used whips to urge the horses forward, but the animals would not budge. Meanwhile, Ma continued to curse the rebels as before. Ultimately the rebels pulled out their knives and hacked Ma to pieces.[22]

Ma's orthodox diatribe against the Taiping ideology clearly demonstrates the elite attitude toward the rebels' beliefs; in failing to conform to Confucian standards, the rebels were not only heretics but also sociopaths, a point demonstrated vividly in the conclusion of the story, where the horses prove themselves more humane than the rebels in refusing to punish Ma for speaking the *true* "way of truth."

It is impossible to know whether the event narrated above did in fact occur on January 18, 1853. Nevertheless, it is easy to appreciate the visual aspects of the story, as well as to acknowledge how this imagery would contribute to the impact of the anecdote as it was told, retold, and recorded. One can imagine how the rebels might have "seen" the event: the ability to corral people together and compel them to listen to a newly-defined orthodoxy, as well as to punish those who did not comply, signaled a new world order—at least temporarily. For elite observers, the reverse was true. Ma's lecture portrays the rebel ideology as nonsense, even farcical, while his fate portrays the rebels as brutish and ignorant.

Casting or "seeing" rebels as strange was not limited to the period of the Taiping rebellion. Peng Yanqing, cited above, narrated his impressions of the rebel masses on the eve of the siege of Dangyang city in 1796:

> I ascended the tower and looked out [beyond the city walls]; I could see people in the distance. [Actually], there were people who didn't seem like people and objects which didn't seem like objects. When [the person] grasping the white flag moved forward, the crowd would follow behind like a school of fish: when the flag moved, the crowd moved; when the flag stopped, the crowd stopped; when the flag turned, the crowd turned. To my bewildered eyes it looked as if the flag were the leader.[23]

As with the story above, this brief account is quite potent in its use of imagery; descriptions of disembodied flags and a school of fish serve to illustrate the distance between the elite observer and the rebel party. From the elite viewpoint, the activity of the rebels is almost incomprehensible.

The presence of women among the ranks of religious rebels was further occasion for elite comment. Although it was not uncommon for women to participate in religious sects nor for entire families to join a rebel movement, the manifold sightings of women during times of upheaval apparently disconcerted men whose wives rarely ventured beyond their own thresholds.[24] Given the attention this subject received in first-hand accounts, it seems that the spectacle of women assembling in public was equivalent to the appearance of rebel bands outside one's city: both were extraordinary and both were threatening. Furthermore, the one implicated the other. Emerging from a rebel-occupied city during the White Lotus uprising, Peng Yanqing noted that "there were women all over the hillside, white heads everywhere." As he fled the area, he came upon even stranger sights:

> I kept walking and came upon a house. There were women gathered in a nearby bamboo grove. I stopped for a rest and saw that the religionists had set up two tables and were calling people forward to register names. Everyone was given a scrip on which the phrase "Heaven and Earth conjoin and prosper" was stamped. A woman came out of the house, about 40 years old, her head wrapped in white cloth, and wearing a white jacket and trousers. When the women saw her they bowed deeply in reverence. After the registration was completed, they divided into groups, some fetching water, some gathering kindling, some cooking food, and some sewing flags.[25]

Peng's short narrative associates this gathering of women with rebel activity. The color white marks the women as belonging to a White Lotus-type sect. The quotidian activities they engage in contrast with the religious ceremonies of registering names and receiving charms, an opposition which serves to highlight the relationship between women and heterodox activity.

The participation of women in the Taiping rebellion was a well-documented phenomenon. Women fought in female companies, held positions of rank in the army, and served the Taiping King in his court. For the elite observer, the sight of these "brazen" women only reinforced a negative impression of the rebel forces. One account noted the ferocity of rebel women hailing from Guangxi province, where the Taiping movement began. Their demeanor distinguished them from the women of central China, the author continued, among whom even the most coarse could not compare.[26] This perceived difference was apparently highlighted by different cultural practices, as another description of Taiping women in Nanjing shows:

> The rebel hags plundered each household of its clothing and decorations . . . Wearing colorful, flower-embroidered clothes, whether it was a red blouse or a

sky-blue outer garment, they walked along barefooted with muddy feet. They hauled goods through the streets on carrying poles, drenching the clothes in sweat without knowing that this was uncouth and without knowing their own stupidity.[27]

As in the case of the White Lotus uprising, the sight of women acting outside of prescribed norms during the Taiping rebellion signified the disorder of the rebel occupation for elite observers. The derisive descriptions of the female rebels were sketched in the same spirit as the ideological arguments against their "heterodox" faith and likewise served as a marker of the distance between the "civilized" elites and their rebel oppressors.

Their bias notwithstanding, elite writers captured the corporeal experience of rebellion in ways that official reports and confessions did not. These men vividly described battle scenes as well as the destruction that accompanied them. When he fled rebel-occupied Dangyang city in 1796, Peng Yanqing recorded the casualties which lay in his path: one corpse by the side of the road, another burning in front of a temple, a third set upon by pigs and dogs.[28] When he reached the west gate, he wrote,

The only opening was a hole two feet wide, allowing one person to go through at a time. Those carrying money or wearing red clothing were killed.[29] There were piles of money and clothes in the streets and all of the crockery in the stores nearby was smashed. . . . Those coming and going were all vagabonds, wearing white cloths on their heads and carrying spears on their shoulders. If they happened on a crack, they poked it with their spear; if they passed a pig, dog, chicken, or duck, they invariably speared it as well.[30]

Peng's account clearly conveys the death, devastation, and chaos that characterized the civilian experience of rebellion (Figure 3.3). Descriptions of the carnage, which communicated the horrors of war in the most visceral terms, lacked the sanctimonious tone of the accounts which disparaged rebel beliefs and behaviors. Elite narratives of death bewailed insensate violence; it mattered little whether the perpetrators were religious rebels or imperial soldiers.

Against the proclivity of elites to portray the rebels in formulaic terms, literatus Zhang Dejian sought to persuade Qing military leaders to see past the stereotypes of rebel behavior in formulating defensive strategies. In his "Accounts of the [Taiping] Rebels," Zhang seeks to reveal the techniques by which the rebels are able to delude the imperial troops. Good intentions notwithstanding, these narratives present the Qing military as credulous and ill-prepared when compared to the cunning and shrewd rebels. Arrogance and ignorance are the primary faults of the soldiery; they either underestimate the

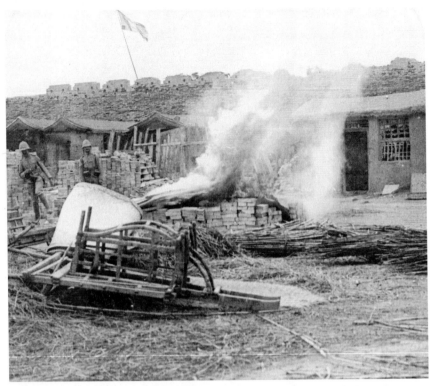

Figure 3.3 The caption that originally accompanied this photograph from the Boxer uprising read, "After the City's Capture—burning bodies of Chinese outside the Wall at South Gate, Tientsin, China." Elite observers of popular rebellion provided vivid descriptions of the death and destruction that accompanied revolt and its suppression. Far removed from the conflict, it is difficult for us to imagine the emotional toll of the carnage. This photo taken in the aftermath of the Boxer uprising shows a makeshift funeral pyre set against a backdrop of damaged homes. From: Underwood and Underwood, c1901. Library of Congress Prints and Photographs, *Boxer Rebellion, 1900.* http://hdl.loc.gov/loc.pnp/cph.3c12325

rebels' skills or they fall for obvious "smoke and mirrors" tricks, allowing the rebels the advantage in each case. The solution, as Zhang presents it, is for the military to "see clearly," whether that be seeing through their own prejudices or seeing through the rebels' Trojan Horse tactics.

Zhang begins his discussion of Taiping strategy with what he feels is a common misconception: "[People say,] the rebels are nothing but undisciplined bandits, how could they have a strategy?"[31] His description of rebel tactics includes sketches of military formations and encampments.[32] Figure 3.4 illustrates the "crab" battle formation, wherein a large company is flanked by smaller units, similar to the body of a crab with multiple

Figure 3.4 *Crab formation and "modified" crab formation*. Although many elite observers of rebellion emphasized the strange ways of the rebels, Zhang Dejian sought to convince his audience that the rebels were an effective fighting force. He provided detailed accounts of rebel tactics, highlighting the rational and strategic elements of rebel battle plans. He included illustrations of rebel battle formations in his account of the Taiping rebels; the crab formation presented here could be deployed in diverse ways depending on the conditions of battle. From: Zhang Dejian "Zeiqing huizuan" [Accounts of the (Taiping) rebels] in Zhongguo shixuehui eds., *Zhongguo jindaishi ziliao congkan, II: Taiping Tianguo* [Collection of Historical Materials of Modern China, II: The Taiping Heavenly Kingdom] vol. III (Shanghai: Shenzhou guoguang chubanshe, 1952), 128–129.

legs extending from the core. The smaller units are more mobile and can be moved in response to different offensive tactics: the variation depicted in the second image reflects the fluidity of the formation.[33] These images contrast sharply with the anecdotal accounts of rebel activities assessed thus far. In these pictures, the organization and foresight of the rebels is on display. The intent of the author is to convince the defenders to take the rebel threat seriously, if not to acknowledge the so-called ruffians as worthy opponents.

Zhang also cautions the Qing military to be on guard against rebel strategies of deception:

> When retreating from a city or a fort, the rebels leave the wounded behind to beat drums and make noise. They put up straw men on the walls, or put up spikes with hats on top. In the daytime, they plant flags; at night, they light lamps. The rebels can be gone several days before the locals take notice.[34]

Unfortunately for the imperial troops, sometimes the rebels adopted the reverse tactic, whereby they abandoned camp temporarily and then ambushed the soldiers who came to investigate.[35] More pernicious, however, were those ploys which preyed on popular beliefs and superstition.

An old rebel was captured and questioned: he said that when the rebels went into battle, they would fire off gunpowder charges in their rear ranks, creating a cloud of smoke. They would then take yellow and red jackets and throw them in the air. When the soldiers saw this (at a distance), they would mistakenly think that the rebels could fly, and would flee in terror.[36]

Zhang also described a similar strategy whereby the rebels would pick the most stalwart members of their group, dress them in costume, equip them with oversized pasteboard weapons, and conceal them in the ranks, sending them forward only in the heat of battle when they were most likely to frighten the soldiers.[37] The ascription of magical powers to religious rebels was not uncommon; indeed, even seasoned generals in the field might cite witchcraft to explain a swift rebel advance.[38] Yet Zhang exposes the credulity of the Qing military in unmasking the "magic" as optical illusion.

Elite accounts of religious rebellion invariably emphasized the visual, and therefore visceral, experience of revolt. The accounts cited above include the following imagery: rebels preaching from a stage, a man tied to five horses, white flags moving in procession, women gathering in groves, bodies lying scattered on the ground, armies marching in formation, red and yellow shirts flying through the air. The scenes alternate between the violent and the mysterious. The images convey the fear, trepidation, and suspicion that comprised the civilian understanding of rebellion. Combined, they represent the chaos of revolt and the impenetrability of the rebel movement for the elite observer. Most importantly, the elite emphasis on the visual elements of rebellion helps preserve these historical moments in living color, translating emotion into vivid prose for posterity.

THE OFFICIAL VIEW

There is no question that the sympathies of the Chinese elites lay with court and empire in times of rebellion, excepting of course the scant minority who voluntarily joined the rebel cause. Nevertheless, it is possible to differentiate between the elite perspective and the official view of religious rebellion in Qing China. As documented in correspondence between the emperor and his generals in the field, the official line on rebellion was colored by the political philosophy of the court as well as the exigencies of rule. Official documents reflected the formal position of the court with respect to religious uprisings: the real criminals were the rebel leaders, who were charlatans leading otherwise faithful subjects astray. Although "the people" could be brought back into the fold, the label of rebel tended to stick; thus "rebel" casualties numbered in the thousands. Official reports of rebellion spoke

of both people and warfare in logistical terms: numbers of killed, numbers to be fed, numbers on the offense, numbers of silver taels requested, etc. Impulses toward self-preservation and prevarication shaped both text and policy, resulting in a predictable pattern of representation. Rebels were always numerous, conditions were always difficult, and the military always fought with valor.

Names were important to imperial governance. Just as rank and title mattered in communication between the emperor and his officials, so too did the proper identification of whatever problem demanded the court's attention. Thus, what was seen and experienced in the field needed to first be phrased in proper language before it could be transmitted to the throne. There were complementary traits which were attributed to almost any rebel band which made an appearance in the eighteenth and nineteenth centuries. The first was disorder. In official correspondence, rebel bands were repeatedly referred to as "undisciplined mobs," in keeping with the belief that only a few of them actually knew what they were doing.[39] The second was numbers. Rebels were always described as undifferentiated bands ranging from several hundred to several thousand strong. The emphasis on the relative strength of the rebel bands presumably protected both those local officials who had been surprised by the uprising and those generals who were unable to quell the revolt in short order.

Descriptions of battle predominate in the missives sent from the field to the court. If the Qing defenders were bested by the rebels, the discussion would focus primarily on the rebels' superior numbers and the generals' judicious decision to retreat. If, on the other hand, the military was triumphant, the official accounts would laud the exploits of the soldiers and narrate the engagement in detail. Such is the case when Huguang Viceroy Bi Yuan reports the recovery of rebel-occupied Dangyang city in the summer of 1796:

> We set up large cannon to breach the city wall. We lobbed cannonballs and fireballs [into the city], setting fire to the residences within. Then we attached grappling hooks [to sections of the wall] and, using the force of many men, were able to break through, compelling the rebels to flee and conceal themselves. With the firestorms raging and the hot and muggy weather, we feared the soldiers would become exhausted. Viceroy Bi Yuan went in person to encourage them.[40]

This brief narrative successfully conveys the superiority of the Qing forces, the efforts of the soldiers, the dangers of battle, and the dedication of the ranking officials. Like the elite-authored accounts, this document uses vivid imagery to depict the heat of battle. However, where the elite observers emphasized the shock and pathos of violence, official reports adopted a more clinical tone, as documented in the conclusion of Bi Yuan's account:

> When the rebels saw the ferocity of our soldiers, all dressed in green, they took
> off their white clothing and mixed with the civilian population, hoping to avoid
> capture. We led the soldiers and militia forward and surrounded them. We killed
> them with guns and cut them with knives; we beheaded more than one thousand
> rebels.[41]

In this case the image of corpses conveys victory rather than fear; the exercise
of violence signifies control rather than chaos.

The presentation of violence as a corrective force was deliberate. The Qing
military represented the orthodoxy of the empire. The religious rebels were
heterodox not only by virtue of their beliefs but also by reason of their rebellion.
Indeed, the terms "religious rebel" and "heterodox rebel" are interchangeable in
the official record of popular movements. The persecution of rebels preserved
the sanctity of the state and reaffirmed the proper order in society.

While scenes of victory were presented in bold detail, military officers also
sent comprehensive descriptions of conditions in the field. These accounts
showed that the Qing soldiers were not only battling the rebels, but nature
as well. In the eighteenth century, there were numerous obstacles to the suc-
cessful pursuit of a military campaign. One of these, apparently, was rain.
Governor Hui Ling reported to the emperor that rain and fog not only impeded
the soldiers' progress, but also provided cover for marauding rebels.[42] The real
challenge lay in the mountainous regions that rebels of the White Lotus per-
suasion favored in the years 1796–1804. Figure 3.5 illustrates the dense forest
and rough terrain of an area frequented by rebels in the eighteenth century. The
rebels held the local advantage in these places; the imperial troops often trailed
well behind the active bands, light on information and heavy on equipment:

> We have reached Jinxiangping and suddenly encounter consecutive days of
> dense rain and swirling mist. You almost cannot see the person in front of you.
> The rebels lay a trap at every turn—and the mountain paths branch off in every
> direction. We fear that the rebels have quietly returned and are hiding in a gully
> or cave, ready to cut off any retreat. This area long ago suffered the depredations
> of war: now there is not even a chicken to be seen. The further we go, the deeper
> we get, the officers in front, the supplies following. The mountains are tall and
> the roads are narrow, it is difficult going . . .[43]

The mountains were terra incognita for the imperial armies. If the sol-
diers expressed trepidation in these circumstances, it reflected a fear of the
unknown rather than a fear of battle. These descriptions, like the elite narra-
tives discussed above, served to emphasize the cultural distance between the
rebels and the defenders (Figure 3.6, see website). Inasmuch as the rebel creed
distinguished the insurgents from proper society, their familiarity with a hos-
tile landscape bearing no markers of civilization likewise differentiated them

Figure 3.5 The hill country of central China: battleground of the White Lotus uprising. This photograph taken in 2002 of the mountainous terrain of Shennongjia in western Hubei, P.R.C. visually depicts the conditions described by officials in their reports narrating their pursuit of "White Lotus" rebels in the countryside. Officials emphasized the difficulties of negotiating narrow mountain paths and the ever-present dangers of rebel ambush. From: Personal collection, Sigrid Schmalzer.

from the majority of the emperor's subjects. The association of the rebels with the wilds of the Chinese hinterland identified the former as "wild" as well.

Such vivid field reports aside, a majority of official correspondence regarding rebellion was formulaic in tone and routine in its subject matter, focusing on the bureaucratic processes necessary to keep the war machine in motion and the polity in working order. These more mundane accounts convey another facet of the official view of rebellion, namely the ramifications of a local disturbance for the region at large. Military campaigns were one part of the official response to rebellion; equal effort was expended to ensure that the chaos of conflict did not disrupt local commerce and agriculture. Violent uprisings displaced hundreds of civilians, who fled to nearby cities and towns seeking assistance. The state reacted quickly to the growth of the refugee population, instructing local officials to set up temporary shelters and soup kitchens, and providing the refugees with financial assistance to return home and reestablish themselves when the danger had passed.[44] The primary concern was to move the refugees out of

the cities and to restore these families as independent, tax-paying households. Although the documents themselves do not dwell on physical descriptions of the refugee problem, the overall impression suggested by these reports is a very visible population of migrants crowding cities, setting up shanty towns on the outskirts of the county seats, and lining up for a daily portion of rice porridge.

Daily life was affected by rebellion as well. Communities played host to thousands of troops as they passed through town on their way to battle. Grain shipments multiplied to meet the increased demand occasioned by the military presence. Ships carrying wealthy merchants fled regions threatened by the rebels, compelling the state to commandeer other vessels to ensure the prompt delivery of men, grain, and materiel to convenient ports.[45] Even in those cities not immediately affected by rebellion, the effects of an uprising were palpable: soldiers and mercenaries crowded ports and teahouses, local trade and transport were disrupted, and prices for necessities like grain and salt rose steadily. In reporting these circumstances, local officials fleshed out a picture of rebellion in its quotidian aspects, illuminating the repercussions of distant violence on the social order.

The emperor was naturally pleased by official reports of victory in the field: tales of righteous violence exercised against a heterodox foe. Less welcome were those letters which explained setbacks and delays: stories of foggy days and impenetrable forests. Routine correspondence informing the court of relief measures for refugees, the arrival of military transports, and the rising price of grain were phrased in bureaucratic language but contained the most significant messages of them all. Although scant on detail, these reports represented the extent to which a local revolt could disrupt an empire, affecting commerce, agriculture, and everyday life. Rebel movements were referred to as "disorder" in court documents; taken *in toto*, the official view suggests that the rebels lived up to their moniker.

CONCLUSION

A focus on the visual experience of rebellion inevitably highlights that last observation. Rebels may have valued the community and belief structures undergirding their movement but they were not immune to violence. Elite observers bewailed the fate of civilians caught between rapacious rebels and murderous militia. Officials itemized casualties as they filed requisitions for more troops, more money, more grain. Viewed in human terms, rebellion engendered disorder and chaos, even if the rebels themselves did not fit that mold. When viewed from the human-eye perspective, it is the disruption of daily life and routine that is most significant. The fact that the rebels failed in their quest matters less than the fact that they began, setting off a chain

of events which, with the aid of select sources, we can begin to imagine in visual terms.

Abbreviations used in notes:

GZDJQ Gongzhongdang Jiaqing chao zouzhe [Palace memorials of the Jiaqing period], National Palace Museum, Taipei, Taiwan.

GZDGX Gongzhongdang Guangxu chao zouzhe Secret Palace Memorials of the Kuang-hsu period (Taipei: Guoli gugong bowuyuan, 1973–1975).

QDNM Zhongguo renmin daxue lishixi, Zhongguo diyi lishi dang'anguan, *Qingdai nongmin zhanzheng shi ziliao xuanbian* [Selected historical materials on peasant rebellion in the Qing dynasty] (Beijing: Zhongguo renmin daxue chubanshe, 1984).

QZQWS Zhongguo shehui kexueyuan Qingshi yanjiushi, Zhongguo shehui kexueyuan lishi yanjiusuo ziliaoshi, *Qing zhongqi wusheng bailianjiao qiyi ziliao* [Materials on the five-province White Lotus Uprising of the mid-Qing] (Nanjing: Jiangsu renmin chubanshe, 1981).

NOTES

1. Paul Cohen's treatment of the Boxer Uprising is a notable exception to this trend. Paul Cohen, *History in Three Keys: The Boxers as Event, Experience, and Myth* (New York: Columbia University Press, 1997).

2. See Hongxing Zhang, "Studies in Late Qing Dynasty Battle Paintings" *Artibus Asiae* 60.2 (2000): 265–296; *The Illustrated London News*, February 7, 1863.

3. See Kwang-ching Liu, ed., *Orthodoxy in Late Imperial China* (Berkeley: University of California Press, 1990); Kwang-ching Liu and Richard Shek, eds., *Heterodoxy in Late Imperial China* (Honolulu: University of Hawaii Press, 2004).

4. *QZQWS*, vol. 5, 35–36.

5. See, for example, *QZQWS*, vol. 5, 1–3; 35–36.

6. *QZQWS*, vol. 5, 35–36.

7. *QZQWS*, vol. 5, 32–33.

8. *QDNM*, vol. 5, 87–89.

9. Susan Naquin, *Millenarian Rebellion in China: The Eight Trigrams Uprising of 1813* (New Haven: Yale University Press, 1976), 113–114.

10. *QZQWS*, vol. 5, 9–12.

11. *QZQWS*, vol. 5, 1–3.

12. *QZQWS*, vol. 5, 59–60.

13. Zhang Dejian "Zeiqing huizuan" [Accounts of the (Taiping) rebels] in Zhongguo shixuehui eds., *Zhongguo jindaishi ziliao congkan, II: Taiping Tianguo* [Collection of Historical Materials of Modern China, II: The Taiping Heavenly Kingdom] vol. III (Shanghai: Shenzhou guoguang chubanshe, 1952), 143.

14. *QZQWS*, vol. 4, 269.

15. *QZQWS*, vol. 5, 36–41.

16. Cf. Donald Sutton, "Shamanism in the Eyes of Ming and Qing Elites" in Liu and Shek, 209–237.

17. *QZQWS*, vol. 4, 260.

18. The Taiping rebels sought to convert all of the residents to their faith, an amalgamation of Chinese beliefs and Christianity which centered on Hong Xiuquan, the self-proclaimed Heavenly King, son of God, and brother of Christ. The practice of "preaching" was common in the occupied areas and served to complement the institutional changes made in the Taiping "kingdom."

19. The Five Relationships are an integral part of Confucian teachings, delineating the fundamental distinctions in society. They are ruler and minister, father and son, husband and wife, elder brother and younger brother, and friend and friend. With the exception of the last, all of the relationships emphasize the respect of the latter for the former, and the protection of the former for the latter.

20. This charge refers to one of the most unpopular Taiping policies, mandating that men and women remain separate and celibate until the establishment of the "Heavenly Kingdom" on earth. The Taiping rulers ultimately allowed marriage among their followers following the occupation of Nanjing later that year (1853).

21. Ma refers here to the concept of "brotherhood" borrowed from the Christian tradition by the Taiping ideologues.

22. Zhang, 312.

23. *QZQWS*, vol. 4, 261–262.

24. During the late imperial period, the "ideal" female remained within the confines of the home. This arrangement signified the chastity of the woman concerned as well as the wealth of the family. As a gender ideal, the seclusion of women was practised predominately among the upper and middle classes; families of lesser means needed to rely on the labor of every member of the household, whether male or female. On the lives of elite women during the Qing, see Susan Mann, *Precious Records: Women in China's Long Eighteenth Century* (Stanford: Stanford University Press, 1997); on the presence of women and family in religious movements see Susan Naquin, *Millenarian Rebellion in China* and Cecily McCaffrey, "Living through Rebellion: A Local History of the White Lotus Uprising in Hubei, China," Doctoral dissertation, University of California, San Diego, 2003.

25. *QZQWS*, vol. 4, 264.

26. Zhang, 313.

27. Xie Jiehe, "Jinling guijia jishi lue" [Record of events in Jinling (Nanjing) in the guijia year] as quoted in John Withers, "The Heavenly Capital: Nanjing under the Taiping, 1853–1864" Doctoral dissertation, Yale University, 1983, 77. Translation by Withers.

28. *QZQWS*, vol. 4, 263–264.

29. Mercenaries in the service of the state often wore red to distinguish themselves; presumably this explains why those wearing red were killed by the rebels.

30. *QZQWS*, vol. 4, 264.

31. Zhang, 127.

32. Zhang, 127–137.

33. Other formations include "pulling thread," where the soldiers line up in single file; "one hundred birds," where the soldiers disperse in small groups; and "crouching tiger," where the soldiers crawl through the undergrowth. Zhang, 127–130.

34. Zhang, 156.

35. Ibid.

36. Zhang, 155.

37. Zhang, 156.

38. See, for example, *GZDGX*, 616.

39. See, for example, GZDJQ, document 276.

40. *QZQWS*, vol. 1, 173–175.

41. Ibid.

42. GZDJQ, document 228.

43. *QDNM*, vol. 5, 119–120.

44. See GZDJQ, document 778.

45. See McCaffrey, Ch. 4.

Chapter 4

Yangliuqing New Year's Picture

The Fortunes of a Folk Tradition

Madeleine Yue Dong

For more than three hundred years, from the sixteenth century to the early twentieth century, colorful woodblock-printed pictures decorated homes, tea houses, wine shops, and restaurants in towns as well as villages in China during the Spring Festival. These pictures bore different names throughout history, but by the nineteenth century, they were called *nianhua*, New Year's pictures. The images reached all levels of society, and they were so important to the families that the word *mai* (to buy) was often not used in discussing the pictures; instead, this crucial part of the annual celebration was called *ying nianhua* (welcoming or inviting a New Year's picture). In his mid-nineteenth-century description of "ten things to do for the New Year," Li Guangting described the custom: after a thorough cleaning of the house, people put up their New Year's prints on their walls. It was an occasion particularly exciting to children, and it was considered an important part of their education to look at depictions such as "Filial Piety" and "Busy Work in the Field." In Li's words, the pictures "cheered up children, and brightened up the house"[1] (Figure 4.1, see website). But the audience for these pictures was not limited to children; adults enjoyed talking about them just as much. Because the pictures would stay on the walls for the whole year (unless it was necessary to take them down), only to be covered by new ones at the next New Year, they were examined repeatedly and carefully throughout the year. The images were interpreted in detail; every possible reading was tried out; stories were told from the pictures; and knowledge and value were created, conveyed, and confirmed through this process.

Two types of images were used for New Year's decorations. One type was of gods and goddesses who were believed to protect people from disasters and bring them good fortune (Figure 1.4, see Introduction). These included the god of wealth with his wife and attendants, the stove god and his wife, the

earth god, silkworm goddess, granary god, the insect king, god of the well, the ox king, horse guardian, and the powerful door gods.[2] The other type covered a wide range of themes, such as harvest and seasonal celebrations, daily life activities, scenes from historical stories and dramas, and current events such as wars after the mid-nineteenth century. The term "New Year's pictures" usually referred to this second type.[3] The majority of these New Year's pictures differed from scholars' paintings in both motifs and colors. They depict narrative stories and figures in bright colors, in contrast to the primary focus on landscape in ink in scholars' paintings.

New Year's pictures were deeply rooted in popular cultural beliefs and practices. The artists adopted symbols and codes familiar to the audience to convey the meaning of the pictures, and many of the apparently simple objects in a picture impart special references understandable to the audience. Figure 4.2 from the Kangxi reign (1661–1722), for instance, appears on the surface to be a simple picture of one young woman playing with a girl and two little boys by a fish bowl. The picture carries the title of "A Hall Full of Gold and Jade"(金玉满堂). At first glance, the image seems to be lacking in copious amounts of either gold or jade, though the two children dancing around the fish bowl are wearing beautiful pendants. The reason for the title, however, lies elsewhere. In Northern mandarin dialect, the two characters for goldfish (金魚 *jin yu*) are homophonous with the characters meaning "gold"(金) and "jade"(玉). One layer of implied meaning of this picture, thus, is wealth: the house will be filled with gold and jade. But there is still another layer of meaning in the picture. "Jin" (gold) was usually used in combination with the word for boy to make the word "jin tong" (金童 golden boy), and "yu" (jade) with girls as in "yu nu" (玉女 jade girl). Therefore, the picture also expresses a wish for a house full of healthy and happy children. Each little boy, respectively, wears a pendant made of gold or jade on their neck, and the girl's hair ornament shows a Buddhist symbol for good fortune. New Year's pictures, in short, expressed people's wishes for what they considered good fortune and what was important in their lives. By the time of the Qianlong reign (1735–1795), drama scenes had also become popular in New Year's pictures, and this trend became more apparent and even dominant with the development of Peking Opera in the late nineteenth century (Figure 4.3).

The most important locations for the production of New Year's pictures were Taohuawu in Suzhou in the lower Yangtze region, Mianzhu in Sichuan, Weifang in Shandong, and Yangliuqing near Tianjin. I focus on Yangliuqing in this chapter because among these locations, it enjoyed the longest history in picture-making and represented the highest achievement of this folk art form.

The production of New Year's pictures in Yangliuqing started in the sixteenth century (Ming Dynasty), and reached its peak in the second half of the eighteenth century to the early nineteenth century, when thousands of

Figure 4.2 This Kangxi-era New Year's painting titled "A Hall Full of Gold and Jade" expresses aspirations for both wealth and a happy family full of sons and daughters. The Surroundings include fine furniture, embroidered robes, and a glimpse of an elegant garden through the window, depicting an idealized and comfortably wealthy setting. From: Pan Yuanshi and Wang Lixia, Yangliuqing ban hua [Yangliuqing Prints]. Taipei: Xiongshi tushu gufen youxian gongsi, 1975.

Figure 4.3 This Guangxu era (1871–1908) print captures the exciting climax of the popular Peking opera Chongxiao Lou. Note the play's name in the top right (the word "Chong" is missing due to damage, but "xiao" and "lou" are clearly visible) and that each character is also labeled by name to aid viewers in identifying the scene. This play and scene are highly martial in content, as were the majority of plays most popular with commoner audiences. In this scene, friends band together to victoriously revenge a sworn brother, thus the image conveys values of loyalty and brotherhood.

people were involved in year-round production in this small town and the villages surrounding it. The most productive shops turned out more than one million prints per year that reached a large market in north, northeast, and northwest China.[4] Yangliuqing's picture production, however, began to show clear signs of decline in the late nineteenth century, and it almost disappeared by the late 1930s. How did this form of folk art that had enjoyed such a long history nearly disappear within such a short time? Why did its decline and disappearance happen at this historical moment? In order to understand the development and decline of Yangliuqing New Year's pictures, we need to examine the context of major historical changes: wars, technological developments (railroads, lithography), and economic shifts. The content, quality, and eventually the very existence of these pictures cannot be properly interpreted without understanding the history of the materials used to make them, the labor processes, as well as the distribution and economic networks of the printing business. In this way, Yangliuqing New Year's pictures are an excellent example for understanding how ways of seeing and looking at images changed over the years, and how comprehending the larger history is crucial to understanding something as small and everyday as a picture on the wall.

THE TRADITION

A pattern emerges when we examine the geographical locations of the centers of New Year's picture production: except for Mianzhu in Sichuan, the other three major centers, including Yangliuqing, were located on the Grand Canal, the most important economic artery throughout most of the history of imperial China. This indicates that Yangliuqing's fortune was closely tied to the imperial economic system. The town was first recorded as Liukou in the Han Dynasty, and its name changed to Yangliuqing (Green poplars and willows) in the Qing Dynasty, following a reputation established by numerous poems praising the scenic view of lush trees along the waters.[5] Yangliuqing prospered when Beijing became the imperial capital in the Ming Dynasty in the mid-fifteenth century. When the Ming rulers first moved their capital to Beijing, the court used both land and canal transportation for grain shipment from the south, supplemented by shipment via the ocean, just as in the Yuan Dynasty. Later, the land and ocean transportation were both abolished, and the shipment of grain became exclusively dependent on the Grand Canal.[6] In the Ming, about 4,000,000 piculs of unhusked rice were being shipped up the canal every year under the supervision of 120,000 soldiers.[7] The Grand Canal kept regions along its route prosperous for four hundred years (for map of Grand Canal see Figure 2.1). Grain boats passed through Yangliuqing and brought to this town, in addition to other goods, news and stories from other parts of the country, paper and tinting from Suzhou, the center for New Year's picture production in south China. Except for the yellow, black, and golden pigments, which the Yangliuqing artists made themselves, all of the other colors came from the Yangzi region, especially Suzhou.[8] As a result of the wealth of the region, as well as the pressure of population density on land, Yangliuqing became a hub of mobility for goods and people, and its economic life centered on commerce. Thus, villagers around Yangliuqing made their living not only by growing and selling grain, vegetables, and flowers, but also by making wrapping paper for shops with recycled waste paper or engaging in the picture business. As most people in Yangliuqing were in some way involved in businesses, many of them consequently traveled all over the country, some as far as Xinjiang.[9]

It is difficult to locate documents that can tell us exactly how New Year's painting production in Yangliuqing started. But we do know that the earliest practice of posting pictures at New Year's was recorded in the Ming palace and included Yangliuqing pictures.[10] Yangliuqing's close connection to the outside world was shown in the artistic style of its pictures. Picture production certainly benefited from the development of woodblock book illustrations, which, since its development in the tenth century, had become considerably refined. In addition, the gathering of artists in Beijing, the arrival of Western

artists, and the promotion of landscape wood engravings and brass engraved wall maps by the 1700s all appear to have affected the Yangliuqing styles and contributed to the maturity of its pictures.[11] The recognition of Yangliuqing pictures was such that in 1867, Yangliuqing artist Gao Xuantong was invited into the palace to paint portraits for the Empress Dowager Cixi (Figure 4.4, see website).[12]

In its earlier period of production, Yangliuqing pictures were primarily sold in towns and cities, and rural residents had to go to the urban centers to purchase them. In *Dream of the Red Chamber*, for example, when the country woman Liu Laolao (Grandma Miu) visited the fabulous garden of the extremely wealthy Jia family, she comments:

> We country folks go to the cities to invite pictures when the New Year arrives. Sometimes when we are free from work [and looking at the pictures], we all say that it would be nice to go into the pictures for a visit. But we also think that the pictures are fabricated, how could there be real places like these? Who would expect that when I come to this garden today, I realize that this place is ten times better than the pictures. Someone has to make a picture according to this garden, and I can take it home to show them. They will be satisfied even if they die.[13]

Dream of the Red Chamber was written in the early 1750s, during the Qianlong reign. This was the heyday of Yangliuqing New Year's picture when the businesses focused on refined pictures at high production costs and targeted urban residents as their major customers. The nineteenth century witnessed a growth of the rural market for New Year's pictures, which, ironically, marked the starting point of the decline of both the town Yangliuqing and its refined art. Responding to the expanding and diversifying market, the pictures began to diverge into three categories: rough, fine, and extra fine. The more refined pictures served elite urban consumers, and the rougher ones went to the rural market. Usually, a new market was established by the refined pictures first, which were followed by the rougher kinds. Consequently, although some Yangliuqing pictures maintained their previous refinement, it was obvious that in order to make the pictures affordable to farmers, the producers had to lower labor and material costs by simplifying designs and using lower quality colors and papers. Drafting was no longer done by top level artists, but often by beginners.

This expansion of the rural market also led to reorganization of production in the Yangliuqing area. The earliest production was mainly concentrated in the town Yangliuqing itself. Each spring, the painting shops printed ink outlines onto paper, and distributed these to villagers—many were women—who filled in the colors and painted the faces. The pictures were then returned to the shops, where golden color was added to the most refined paintings,

and some were mounted.[14] The most prolific shop produced over one million paintings through year-round production, and hired about one hundred families to fill in colors.[15] With the growing popularity of the rougher pictures, which were much easier to make, some of the villages began to produce their own pictures, instead of simply accepting Yangliuqing's outsourcing. And the production of pictures became a year-round business in the whole area surrounding Yangliuqing. Pictures to the Northeast were shipped in June or July, while those going to Shaanxi and Gansu, because of the longer distance, were shipped in February or March. From October to mid-December, a picture market was run in Chaomidian, a town near Yangliuqing, at which time each picture shop rented hotel rooms in the area to display their products. Small peddlers went there to purchase the pictures wholesale and took them to towns and villages for retail sale. At the end of each year, temporary shops or booths were set up to sell New Year's pictures.[16] Although Yangliuqing still occupied the top position in terms of the quality of their pictures, it was losing its competitive edge over others in terms of quantity, and this tendency was exacerbated by changes in the region's geopolitical economy.[17]

A NEW GEOPOLITICAL ECONOMY

In the late Qing, impacted by some of the major events in modern Chinese history, Yangliuqing began to lose its geographical privileges. In 1842, the final battles of the Opium War were fought in Zhenjiang, where the Grand Canal and the Yangtze River met. The British cut off all grain shipment, which played a key role in forcing Emperor Daoguang to quickly sign the Treaty of Nanjing. From 1853, the Taiping army occupied Nanjing and Anhui for the next ten years and grain shipment was again interrupted. But it was the abolishment of grain shipment on the Grand Canal, the development of Tianjin as a treaty port, and the construction of railways that replaced the Grand Canal that permanently brought about the decline of Yangliuqing picture production.

Until the development of grain shipment on the ocean and by railroads, the amount moved on the Grand Canal amounted to 3/4 of that shipped throughout the entire country. In the Ming and the Qing dynasties, the majority of commercial centers concentrated along the Grand Canal. In North China, almost all the prosperous towns and cities were located along the Canal. In 1855, the Yellow River shifted its bed northward from Henan Province to Shandong Province. The Canal was destroyed, and shipment on it was interrupted. By then, ocean shipment had increased due to the introduction of improved ships. In 1872, China's first modern commercial shipping company was established in Shanghai, and part of the grain destined for the capital city of Beijing was

shipped on the sea. The Qing government also began a new policy that converted the grain shipped from the south to the north into silver, which was then used to purchase grain in the Beijing area. Consequently, only a small portion of tax grain was shipped on the Canal. By 1901, the Qing government converted all tax grain shipments into cash collection and stopped grain shipment on the Canal all together. The government-sponsored shipment of grain from the south to the north that had lasted for several hundred years was terminated, and the Grand Canal lost its primary function. In 1904, the office that had supervised the shipment was abolished. The local government was no longer interested in maintaining the Canal, and a portion of the Canal in Shandong Province was filled by mud and sand and was no longer useable.

To make the situation even worse for Yangliuqing, in areas that were Yangliuqing's most important markets, a new transportation system centered on the railroads replaced the existing one focused on waterways. The railroad system redrew the micro-geography of the Tianjin region and had major impacts on the production of New Year's pictures, to the disadvantage of Yangliuqing. Not being directly on the route of any of the railroads, the cost for paper and pigments, which were so crucial to the picture business, increased, and the marketing of the pictures was affected negatively. Before the mid-nineteenth century, Yangliuqing had relied on getting its paper and pigments from the south via the Grand Canal. With the demise of the Grand Canal, materials from the south were shipped first from Suzhou to Shanghai, then by sea to Tianjin, and then to Yangliuqing. Later, if they were to be transported by the train, they had to be sent to Nanjing first where they boarded the train to Tianjin. The other source for paper and pigments was imports from overseas, especially Germany. Whether originating in Suzhou or Germany, painting supplies now arrived in Tianjin first. With the cost for transportation added, they were more expensive for the picture producers in Yangliuqing than for the major printing factories in Tianjin. The unequal treaties of the late nineteenth century allowed imported goods to be transported and sold in inland China free of tax after a 2.5% customs, while Chinese goods still carried a significant rate of transportation and sales taxes. This made paper and pigments even cheaper in Tianjin than in Yangliuqing. In particular, paper and pigments from Suzhou, which Yangliuqing relied on to make the refined pictures that distinguished it from other producers, began to cost more than imported materials for the pictures as a result of the new transportation system and tax laws.

Yangliuqing's advantage over other places was the high quality of its pictures. In order to lower the cost of production, many picture shops switched to less costly paper and pigments imported from abroad. As Yu Fei'an explained, Yangliuqing's artists "had to apply careful calculations and strict budgeting to ensure that their product was good and that it would

be easy to distribute. For their colors, they carried out precise research and analysis on which kinds were easy to obtain, which kinds were inexpensive yet gave good results, which kinds were convenient to use, which would be relatively opaque, and whether they remained unchanged over time, and only after this was it decided which kinds of materials were to be used."[18] Chinese pigments were refined from plants and minerals and were soft and subtle in appearance, while imported colors were chemically manufactured, vibrant but harsh. Imported paper could not create the same effects as the paper from Suzhou. To maintain the quality of their pictures, Yangliuqing could not switch to imported paper and pigments for their refined pictures; if the pictures were to be produced at a compromised quality, Yangliuqing would not enjoy any advantage over other towns and villages, or Tianjin.

Among the winners in this new business climate were Chaomidian and Dongfengtai. Artisans in both villages had learned to make woodblock prints from Yangliuqing, and later surpassed Yangliuqing in the quantity of their picture production. A short distance south of Yangliuqing, Chaomidian was producing New Year's images by the late eighteenth century. Many residents of Chaomidian ran hotels, and made pictures as a sideline, focusing on rough quality prints.[19] Chaomidian was a key point on the route between Tianjin and Baoding, a gate to west and northwest China and Mongolia, and even images produced in Yangliuqing were assembled, packed, and shipped from this town to Henan, Shandong, and Baoding. As a result, the picture business developed faster in Chaomidian than in Yangliuqing, and Chaomidian's production reached about ten times that of Yangliuqing.[20]

Chaomidian, however, went through its own decline for reasons similar to those that led to Yangliuqing's demise. After the railroads were constructed, although Chaomidian still served as the assembling and marketing point for pictures shipped to Henan and Shandong, its connection to Baoding was no longer crucial; being on the Beijing-Hankou railroad, Baoding was now connected to different regions of China than before.[21] The pictures destined for west China were loaded on the Beijing-Suiyuan trains to Datong or Guihua, then sent on to Shanxi, Shaanxi, Gansu, and Xinjiang. By the mid-1920s, although Chaomidian was still producing more pictures than Yangliuqing, the number of picture shops there had declined to 30 from around 60 in 1910, and Dongfengtai had taken its position as the largest picture producer in the region.[22]

Dongfengtai was situated northeast of Tianjin, about 65 miles from Yangliuqing. It neighbored the Beijing-Fengtian (Shenyang) railroad (constructed between 1881 and 1912), which was less than 20 miles away, as well as the seaport Tanggu, connected by the Ji Yunhe (Hebei Canal). A Yangliuqing picture shop first established a printing business there in the mid-eighteenth century. In the early twentieth century, when Yangliuqing

had already declined, Dongfengtai entered its most prosperous days. All the pictures destined to the Northeast were put on boats in Dongfengtai and then loaded onto the Beijing-Fengtian trains. Dongfengtai dominated the Northeast image trade, and also served as a transfer point for shipment by ocean. There were not only a large number of picture shops there, but also many wholesale picture dealers. Although the town had no electricity, many picture shops tried to mechanize their production, using animals to pull the wood engraving and printing machines. Dongfengtai quickly surpassed both Yangliuqing and Chaomidian in the volume of its production.[23]

REFORMS

When China entered its tumultuous late nineteenth century, Yangliuqing pictures reflected current affairs and fundamental changes of the time. When violent conflicts between local Tianjin residents and the missionaries occurred in 1870, for example, Yangliuqing artists printed the picture "Burning the Wanghai Pavilion." This picture provoked Zeng Guofan (1811–1872), who, as the governor of Zhili was sent by the Qing court to deal with the problem, to comment: "Tianjin area people are as uncontrollable (*xiaozhang*) as usual. They engraved pictures of killing Westerners on woodblocks and printed them to show their pride."[24] When the Qing government began to advocate girls' education after 1898, Yangliuqing pictures depicted girls learning reading and writing. Several prints were made of the Boxers fighting Westerners in Tianjin. After the Eight Allied Forces invaded Beijing, one of the Yangliuqing pictures depicted Beijing residents robbing a pawnshop in the chaos, while Figure 4.5 depicts a fleeting moment of Qing victory against said Eight Allied Forces in Tianjin.

In spite of the presence of these new elements, Yangliuqing pictures through the early twentieth century continued to focus primarily on stable themes that were repeated year after year, and the images narrated long-lasting popular wishes in an agricultural society. When these beliefs and practices began to be considered backward at the turn of the twentieth century, however, the pictures that expressed them became targets of reform and government intervention, especially after the 1911 Revolution (Figure 4.6, see website). The Social Education Department of Tianjin established the Bureau of New Year's Picture Censorship, which examined all drafts at the picture shops before production. The depictions were divided into "improved" (those benefiting popular education) and "unimproved" (those derived from fictions and historical stories and were irrelevant to conveying modern or "new" knowledge). "Improved" pictures were granted permit for "permanent" production, while unimproved ones were allowed to be produced only temporarily (the argument

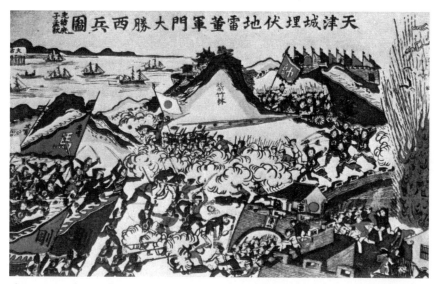

Figure 4.5 The caption at the top reads "Land mines in Tianjin, victory against the aggressor by Admiral Dong." This picture celebrates a moment of victory by Qing troops against invading Western and Japanese forces sent to put down the Boxer uprising in 1900. The Japanese forces (note the red sun flag) in the center of the image are attacked from both front and back by Qing troops. From: Yangliuqing nianhu, Tianjinshi yishu bowuguan ed. (Wenwu chubanshe, Tianjin, 1984), p. 15.

being long traditions were difficult to eliminate all at once) or, if deemed to undermine healthy customs, were to be banned immediately. The Bureau even dispatched officials to the picture shops and booths to investigate in an effort to ensure that the banned images would not be printed. In the spring of every year, the Bureau called for a meeting of picture merchants to discuss methods of controlling the production of New Year's pictures.[25]

Figure 4.7 shows a reformed New Year's picture depicting urban scenes of Tangshan, a town near Tianjin. In the 1870s, it had one of the first industrialized coal mines in China. The picture illustrates this new development, and shows Westerners, steam boats, a water fountain, Western-style buildings, trains, etc. The text on the picture explains that while Western novelties in Tangshan had attracted many people to visit the town, many were still unable to do so. The Jianlong shop thus printed this picture to allow people to tour Tangshan while staying in their own homes. Although the picture maintains some of the characteristic charms of earlier Yangliuqing pictures, it reveals the disadvantageous position of rural artists in their efforts to depict urban scenes: The wheels of the train do not appear to be at the right place; and it is impossible to comprehend from the picture how the pulleys and the water fountain would work.

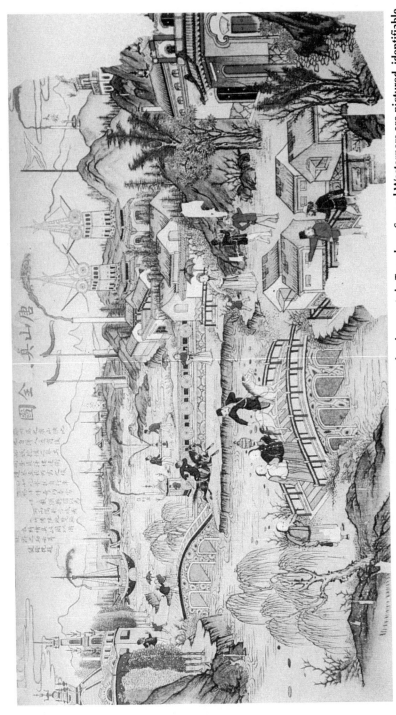

Figure 4.7 Reformed New Year's picture depicting the curious new developments in Tangshan. Several Westerners are pictured, identifiable through such details as their dress and facial hair. From: Pan Yuanshi and Wang Lixia, Yangliuqing ban hua [Yangliuqing Prints]. Taipei: Xiongshi tushu gufen youxian gongsi, 1975.

There is no evidence that these governmental interventions sparked a new vibrancy in the New Year's picture business. Indeed, the following comment from 1940 vividly depicts the depressed situation of New Year's pictures, including the "improved" ones, and is worth quoting at length:

Every year when it reaches the 11th and the 12th months, people from the countryside go to Beijing to buy New Year's pictures. Although they are only woodblock pictures filled in with colors, children love them. Although they are not elegant, the ordinary people need them. The contents of the paintings are activities of New Year's celebrations or scenes from dramas. They show either fat pigs opening the gate, or a god of wealth arriving at the door, or monkeys fighting for a straw hat, and mice getting married. When the newspaper *Jinghua ribao* was published,[26] Peng Yizhong advocated support for New Year's pictures by reforming them, arguing that they can contribute to education. But if we require the pictures to be reformed all the time, they become even worse and look absurd. All the female students in the pictures have bound feet and carry handkerchiefs but wear American-style hats. There are new-style decorative arches, but the figures wear old-style clothes. In scenes of New Year's celebration, it is the masters who do the cooking. One cannot help wonder, doesn't a family this wealthy have any servants? Since the Chinese are not good at reforming them, foreigners see opportunity for profit. Unfortunately the foreign paper changes color easily and turns yellow after the pictures stay on the wall for just a few days. In addition, the scenes and customs in these paintings don't fit the Chinese taste. Even so, a lot of people still buy them.[27] If the producers of woodblock New Year's pictures still hold on to their tradition, they are in fact giving up their right for profit. If they want to keep this business, they have to choose new drafters, and try to fit in the new times, but avoid overdoing it. If they can do this, the paintings can have a good market.[28]

Hopes for a "good market" proved to be wishful thinking. The mid-1920s were waning days for Yangliuqing, and by the mid-1930s production there had declined to near-extinction. A three-hundred-year-old tradition withered within thirty years. Some locally produced New Year's pictures emerged in villages and towns in other regions of the country, however on much smaller scales and of much lower quality. Only simple door gods continued to be produced to decorate the farmers' houses until the 1940s. Traditional woodblock-printed New Year's pictures encountered two challenges: lithographic printing, and later, the coming of calendar posters. Evidence points to a causal relationship between the decline of Yangliuqing New Year's pictures and the development of lithography and the popularity of calendar posters. This was an early indicator of what was to come: the severance of the continuum between the rural and the urban, and furthermore, the dominance of the urban over the rural, in cultural production.

LITHOGRAPHIC NEW YEAR'S PICTURES

Mechanized lithograph printing started in Europe in the mid nineteenth century and was first introduced into China in the 1870s, with most of the early establishments located in Shanghai. The technology was initially applied to re-printing existing materials, such as texts required for preparation for the civil service examination, dictionaries, and large projects such as the enormous, 800,000-page *Tushu jicheng* (Complete Collection of Illustrations and Writings from the Earliest to Current Times) for the imperial library. It was also adopted to print pictorial magazines such as *Dianshizhai* and *Feiyingge*, which became popular among urban residents and provided them access to news about current events (for an example of such pictorial prints see Figure 9.7 in book; also Figure 4.8, website). The heyday of lithography in Shanghai was from the 1870s to the end of the nineteenth century, when it was replaced by letterpress printing and offset printing. Lithography arrived in Tianjin, however, several decades later than in Shanghai. It was only after 1912, when the technology had already become out of date in Shanghai, that most of the modern printings factories, including Huazhong, Fuhua, Xiecheng, Yuanhe, and Yongxing, were established in Tianjin. All were initially very small establishments that started with the printing of business cards.[29]

Within a couple of decades of lithography developing in Tianjin, the wood-block pictures of Yangliuqing and its neighboring villages entered a serious decline. A Yangliuqing gazetteer written in 1938 observed that "Recently, lithograph printing has developed, and the production of Yangliuqing New Year's pictures declined. Only the printing of Stove Gods and door gods still survives. Chaomidian hires people to write couplets, paying one copper coin for each couplet, and the couplets then are sold in the Northwest."[30]

According to Zhang Fangtian, who owned one of the oldest wholesale shops of New Year's pictures in Tianjin, all the New Year's pictures in the Tianjin market were woodblock-printed when he first started his business in 1909. At this time the designs of the pictures, as well as the painters and engravers at picture shops in Tianjin all came from Yangliuqing and Chao-midian. In other words, urban production was drawing all its inspiration and artists from the countryside. Later, Japanese-produced lithographs featuring pictures of children began to be sold in the concessions. Zhang Fangtian bought some to test the market, and was encouraged by his success. By 1912 he was already selling about 500,000 of these prints made by Japanese studios every year. A printing company, Linji, recognized the market for the litho-graphs and decided to secretly print some of the Japanese pictures, using the names of printing factories in Shanghai. These practices started the lithograph printing of New Year's pictures in Tianjin. As companies saw the profitabil-ity in printing New Year's paintings, they adopted Linji's method, making

lithographic copies of Yangliuqing woodblock prints and printing them with machines. After 1917, these businesses thrived, the most prosperous of which was Fuhua.[31] Established in 1925, its manager, Zhang Jue, purchased modern machines from Japan, used imported paper, and copied many Yangliuqing designs. By increasing the variety of the prints, he was able to take advantage of the market established by Yangliuqing in the North, Northwest, Northeast, Shandong, and Henan. In the early 1930s, Fuhua's pictures occupied the markets in the whole of north China. In 1939 when Tianjin was flooded by an overflow of the Hai River, Fuhua's factories, machines, and papers were all submerged for a month. It never recovered from the loss, nor did lithograph New Year's pictures.

What this historical process tells us is that woodblock New Year's pictures were not losing ground to lithographic ones because of their traditional content or format. Lithograph factories in Tianjin were copying Yangliuqing pictures, and as a matter of fact, the Tianjin prints were obviously of much lower quality compared to those produced in Yangliuqing: the lines were not as clean, the colors less subtle, and the figures not as vivid. What was winning the war for the Tianjin printers was their higher efficiency, lower cost of production, and more convenient transportation.

The production of the pictures in Yangliuqing and its surrounding towns and villages was typically handicraft.[32] A picture was first drafted by a painter with incense sticks and then sent to the painting shop for evaluation and comments. After revision, it was painted in ink lines. Usually a painter had to make seven drafts for each painting: one black and white; five with the colors of black, yellow, red, blue, green; and one with all the colors to show the finished effects. Each painting needed six engravings, taking about 20 days to complete.[33]

The engraving was done manually. Lines within the painting had to be even between the top and the bottom layers so that they would remain consistent after many pressings. The lines were divided into three levels according to their difficulty. The most difficult were the lines for faces and hands which had to be extremely refined and could not tolerate fault. The second-rank lines were those for folds of clothes, and the third were for scenery and landscape.[34] When the engraving was done, it was placed on top of the printing table. The drafts with the ink lines were printed page by page, and then they were placed on the other engravings for the colors. By this point, when the five colors were all printed, the pictures were still considered half-finished. The faces of figures and other more refined areas had to be colored manually at various family shops in the Yangliuqing region. There was division of labor in the coloring process, with each person taking charge of one color.[35]

This production process clearly took a lot of time. Ink drafts were done in the spring, and in the summer they were given to villagers to paint in the

faces and fill in the colors. The investment would only return through sales at the end of the year. In addition, filling in the colors manually was very costly. According to interviews, the cost of color addition was about ten yuan for every thousand pages, or 20–30 percent higher than for the same number of pictures printed by lithograph, which cost about seven to eight yuan. Each lithograph machine, if run day and night, could print 16,000 prints. The Zengxing Picture Shop at Chaomidian had three electric machines, which could produce 48,000 pages daily. Some small shops, without electricity, used manual labor to pull their machines. But even so, a print machine could still be worked two shifts day and night, turning out 1,500 pages, several times that of the handicraft production. While a woodblock would be worn out after several thousand printings, a lithograph stone could print 100,000 copies. At first, print machines had been imported from Germany, then from Japan, but later they were made in Shanghai and Tianjin, making the purchasing of the equipment much easier and competition severe. As a result, the old-style production of woodblock print New Year's pictures, which was conducted by shops with much less capital, could not survive. The 1927 survey observed that only the shops that had been in business for a long time, had an excellent reputation, and were well-managed could barely sustain themselves, and that only a very small market was left for the old-style woodblock-printed, manually colored pictures.[36]

The challenge of lithography to woodblock New Year's pictures was, thus, primarily one of technology. The Tianjin picture production, however, suffered from "malnutrition." Tianjin lithograph New Year's pictures never surpassed Yangliuqing in quality or creativity, the new factories reprinting pictures that had already been produced as woodblock prints. In other words, Tianjin lithograph printers relied on Yangliuqing for creativity. But under this new competition, as under the one with Chaomidian and Dongfengtai, Yangliuqing again lost an important share of its market; it was unable to sustain its production by simply relying on the costly refined pictures and doing without the mass market. As the 1927 survey shows and Zhang Cixi's 1940 gazetteer confirmed, after production of the more refined New Year's pictures stopped in Yangliuqing, it was only the most primitive and rough kinds of door gods and other images of popular religion produced in Chaomidian and Dongfengtai that survived, until the war with Japan and the flood in the late 1930s further doomed production.

It appears that this new technology of lithography did not directly extinguish the genre of traditional New Year's pictures. The Tianjin production established its foothold in the web of synergy between the elite and commoner market: the Tianjin pictures were successful because they further fulfilled the needs of the rural market. The lower cost and higher efficiency of production of lithograph New Year's pictures fit the needs of the farmers,

who could not afford to be so picky about the quality of their pictures. In the long run, however, one might argue that because of its lowering the quality of New Year's pictures and lacking the creativity of rural production, eventually the technology, and the urban production system in which it was embedded, imperiled of the genre. The high efficiency of mechanized production also demanded that artists turn out drafts at higher speed, constraining the creativity that could go into each effort.

The oldest picture shop in Tianjin, Zhengxing zhai, closed its doors around the late 1930s. At the end of the 1940s, most of the lithograph New Year's picture shops in Tianjin were also out of business, including the largest factory with the longest history, Fuhua. In the 1950s, only one factory, Xiecheng, was left.[37] Although lithograph New Year's pictures in Tianjin did not last long, they nonetheless started a trend of urban cultural production replacing that of the countryside.

[See website (Figure 4.9) for images and discussion of the CCP state-led attempt to revive Yangliuqing New Year's paintings in the Mao era.]

NOTES

1. Li Guangting , "Xinnian shi shi" (Ten things to do for the New Year's celebration) in *Xiangyan jieyi* (1849) (Beijing: Zhonghua shuju, 1982). Also see Cai Xingwu, "Yanshi huosheng," in Zhang Jiangcai (ed.), *Jing Jin fengtu congshu* (Beijing: Zhonghua fengtu xuehui, 1938), 5.

2. Po Sung-Nien and David Johnson, *Domesticated Deities and Auspicious Emblems: The Iconography of Everyday Life in Village China* (Berkeley: Publications of the Chinese Popular Culture Project, 1992).

3. A Ying, *Zhongguo nianhua fazhan shilue* (Beijing: Zhaohua meishu chubanshe, 1954), 8–9.

4. Gongshang bu, Jingji taolun chu, *Jingji banyue kan* (Economics bimonthly), vol. 1, no. 3, December 1927, p. 30.

5. Zhang Jiangcai, "Tianjin Yangliuqing xiao zhi," in *Jing Jin fengtu congshu*, p. 1.

6. *Ming Shi* in *Er shi si shi*, vol. 19, p. 559.

7. As Endymion Wilkinson explains, "Under the Sui, hundreds of thousands of people were mobilized to repair old canals and to dig new ones. The resultant system linked the North to the South using the five river systems of the Haihe, Huanghe, Huaihe, Changjiang and Qiantangjiang. The canal was 40 paces wide, willow trees were planted on both sides, and granaries were built along the routes as well as 40 imperial rest houses. From the Song the entire system was called the Grand Canal (Da yunhe). In the Yuan, a 1,000-mile canal was cut from the existing canal at Xuzhou north across Shandong via Jizhou, Linqing and Haijin to Beijing." Endymion Wilkinson, *Chinese History: A Manual* (Cambridge: Harvard University Asian Center, 2000), 640–641.

8. *Yangliuqing xiaozhi*, pp. 2–3.

9. *Yangliuqing xiaozhi*, p. 9.

10. Bo Songnian, *Zhongguo nianhua shi*. Shenyang: Liaoning meishu chubanshe, 1986, p. 26.

11. Ah Ying, pp. 7–8.

12. Bo Songnian, 1986, p. 67.

13. Cao Xueqin, Gao E, *Hongloumeng*. Beijing: Renmin wenxue chuban she, 1998, p. 532.

14. Jin Ye, "Yangliuqing he Tianjin de nianhua diaocha" in *Wenwu Kaogu zhuankan: Zhongguo gedi nianhua yanjiu*. Xianggang: Shenzhou tushu gongsi, 1976, p. 52.

15. Bo Songnian, "Ji Yangliuqing nianhua de zhizuo ji qita" in *Wenwu Kaogu zhuankan: Zhongguo gedi nianhua yanjiu*. Xianggang: Shenzhou tushu gongsi, 1976, p. 2.

16. *Jingji banyue kan*, p. 30.

17. A Ying, pp. 24–25.

18. Yu Fei'an, *Zhongguo hua yanse de yanjiu*. Jiulong: Nantong tushu gongsi, [n.d], p. 43.

19. *Jingji banyue kan*, p. 30.

20. Jin Ye, p. 52.

21. Jin Ye, p. 54.

22. Jin Ye, p. 53. *Jingji banyue kan*, p. 32.

23. Jin Ye, p. 53.

24. Bo Songnian, 1986, p. 159.

25. *Jingji banyue kan*, p. 30.

26. *Jinghua ribao*, a vernacular, reformist newspaper, was established in 1904 by Peng Yizhong. It was closed down by the government in 1906, and Peng was exiled to Xinjiang. The publication was resumed when Peng returned to Beijing in 1913. It was shut down again soon, and was published again after Yuan Shikai died. The publication continued until 1922, although the paper in its later years became quite different from its early period.

27. These probably refer to the Japanese-printed pictures, which will be discussed in the following section.

28. Nilü guoke, *Dushi congtan* (1940). Taibei: Jinxue shuju, 1969 [reprint], pp. 58–59.

29. Jin Ye, p. 54.

30. *Yangliuqing xiaozhi*, p. 3.

31. Jin Ye, p. 54.

32. Bo Songnian, 1976, p. 2.

33. Bo Songnian, 1976, p. 2.

34. Bo Songnian, 1976, p. 3.

35. Bo Songnian, 1976, p. 3.

36. *Jingji banyue kan*, p. 32.

37. Jin Ye, pp. 54–55.

Chapter 5

Monumentality in Nationalist Nanjing
Purple Mountain's Changing Views

Charles D. Musgrove

An important element in the construction of a new visual modernity in early-twentieth-century China was the transformation of concrete representations of the state, embodied in architectural forms that were designed to define a seemingly new set of roles between that state and its subjects. During the decade from 1927 to 1937, when the Nationalist Party (Guomindang, or GMD) nominally ruled China, monumental architecture in the form of public buildings, statues, and tombs formed part of a concerted effort to construct a new symbolic template for unifying the Chinese people around the GMD state. This template was inherently visual, as monumental architecture was meant to be seen in order to convey larger messages. Some messages were explicit in the inscriptions of the monuments; others were implicit in the more subtle meanings to be gleaned from the constructions themselves—the orientation, the materials, and the forms of the buildings that spoke to older symbolic systems while tapping into new ones. While the state certainly wished to express particular meanings through monuments, those who were supposed to absorb the messages often applied their own interpretations to the structures in both subtle and spectacular ways—either through the mundane contemplations of personal experiences or through dramatic deviant behavior purposely designed to challenge the prescribed readings of the imagery.

This chapter focuses on the changing nature of monumentality reflected in the transformations effected on Purple Mountain, just outside the city walls of Nanjing. Purple Mountain was the location of the GMD's most important monument, the Sun Yat-sen Mausoleum (Figure 5.1). Sun Yat-sen (1866–1925) was a professional revolutionary who in his early career sought to overthrow the Qing dynasty, which was accomplished during the 1911 Revolution. In early 1912, Sun briefly served as provisional president of the newly established Republic of China only to resign in favor of General

Yuan Shikai in February 1912. When the republic collapsed into warlordism
shortly afterward, Sun spent the rest of his life advocating the establishment
of a "revolutionary" Nationalist government led by the party he had founded,
the GMD. Sun had famously proclaimed the necessity for transforming the
Chinese people from what he described as "loose sand" into a unified body
of citizens under the leadership of the GMD, and in some respects the monu-
ment in his honor was built with similar intentions. But Sun's was not the
only monumental tomb on Purple Mountain; one mountain slope already
served as the final resting place of the founder of the Ming dynasty, Zhu
Yuanzhang (1328–1398).

The term *monumentality* refers to the characteristics that cause an object to
be considered a monument. Monuments today are thought of as big, impres-
sive structures erected in public places designed to keep alive the memory
of important persons and events. But sometimes objects become monuments
even if they were not intentionally constructed to commemorate; for instance,
many ruins of what had been inconsequential buildings have become monu-
ments simply because they are remnants of something that is particularly old.[1]

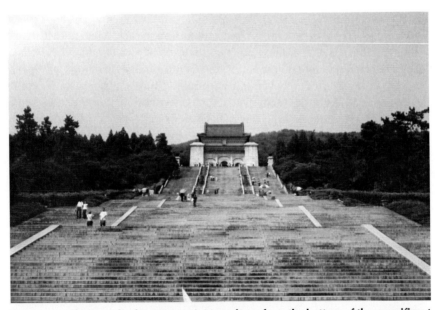

**Figure 5.1 Photograph of Sun Yat-sen's Mausoleum from the bottom of the magnificent
staircase that visitors must summit in order to enter.** This perspective highlights many
of the most distinctively modern attributes of monumentality that this complex symbol
conveyed, including it grand and visibility from a great distance, its domination of
the surrounding landscape, and its imposing feeling of permanence. From: Wikimedia
Commons (accessed December 20, 2013).

Thus, any object can become a monument if it serves a broader commemorative function—a document (such as the Declaration of Independence), a book (a Gutenberg Bible), or even a work of art (Michelangelo's *David*) might be considered a monument. Naturally, what is considered worthy of monumental status changes over time, as certain objects are erected to be important, then becomes significantly less important (such as Grant's Tomb), and maybe important once more.

Monumental conventions are not uniform, and vary considerably in different times and places. The paintings of Qianlong on his southern tours described by Michael Chang in Chapter 1 would indeed have been considered monuments at their conception, even though they were not created for widespread public consumption, since they clearly commemorated that event in a manner designed to impress select viewers with the importance of the man and the imperium he represented. But when those paintings are hung in a modern museum, the nature of their monumentality changes. Now these paintings mean something new to average viewers who are perhaps more interested in their artistic style than in their projection of imperial power.

This chapter describes how perceptions of monumentality changed as key sites on Purple Mountain developed. I argue that the Sun Yat-sen Mausoleum combined older, Chinese conventions of monumental form with new emphases on the visual representation of power and public access to those representations, two trends toward public visuality that typified modern nation-state forms of the era. As a result, monumentality itself in Nanjing became both more popularly accessible while, perhaps unintentionally, also more open to interpretations beyond state-prescribed meanings.

NANJING & PURPLE MOUNTAIN: CAPITALS & TOMBS, MONUMENTS & DECAY

In April 1927, during the GMD's Northern Expedition to unify China after two decades of warlord rule, General Chiang Kai-shek (1887–1975) declared Nanjing would be the capital of China in accordance with the desires of the late revolutionary hero and GMD founder, Sun Yat-sen. Shortly after entering Beijing in June 1928, the new one-party GMD government confirmed the decision to move the capital to Nanjing permanently. Municipal planning for the new capital's much-needed infrastructure, including roads, utilities, public buildings, banks, and residential neighborhoods began in earnest. A high priority for the fledgling Nationalist government was the completion of a tomb for Sun Yat-sen, construction of which had begun even before the Northern Expedition commenced. In fact, well before running water was

common or the various ministries had their own permanent homes, Sun's remains were safely interred in their final resting place.[2] With the many pressing needs facing a state that was constantly in debt, why was this structure considered so important?

It is not something we typically contemplate, but tombs are often essential features of capital cities. In the early-twentieth century when capitals all over the globe from Washington to Tokyo were being renovated and littered with monuments in order to express new nationalistic sentiments, many nation builders considered tombs to be important symbols of modern nationalism. From Napoleon's tomb in Paris to Lenin's tomb in Moscow, it seems that most capitals feature an important tomb or cemetery rife with national significance (Figure 5.2, see website).[3] Sun Yat-sen himself recognized the importance of such a symbol. On his deathbed in 1925 he instructed the party to place his remains on display (like Lenin's) in a tomb on Purple Mountain—just east of the city walls of Nanjing, where he had briefly served as the first president of the Republic in 1912—thereby immortalizing his role as a founding father of the modern Chinese nation.[4]

By making this command, Sun was forging a link between himself as self-proclaimed "founder of the Republic" and the heroic founder of the Ming dynasty, Zhu Yuanzhang, who was also buried on Purple Mountain. The parallels between their careers, certainly in Sun's eyes, were many. Zhu had led a patriotic drive to expel the Mongols from China. He then moved the capital from the "tainted" Mongol city, now called Beijing, to the more "Chinese" city of Nanjing in the south. After Zhu's death, however, his son moved the capital back to the north. Sun Yat-sen too had seen himself as leading the effort to expel what he considered a foreign dynasty, the Manchu Qing, from power, which was accomplished with the Revolution of 1911. In January 1912, Sun was inaugurated as provisional president of the Republic in Nanjing, which he argued should be made the permanent capital of China instead of what he considered the Manchu city of Beijing. After Sun resigned his post in favor of Yuan Shikai (1859–1916) in February 1912, however, Beijing remained the capital of the Republic.[5]

In calling for the construction of his tomb on Purple Mountain, Sun Yat-sen redefined the monumental nature of the already existing tomb of Zhu Yuanzhang. Even though the capital moved back north after his death, and the rest of the Ming rulers would be buried outside Beijing, Zhu's successors buried him in Nanjing according to his wishes. Throughout the Ming dynasty his tomb remained a revered site. Zhu's tomb was unquestionably monumental in nature, but it was built in a style quite different from Napoleon's or Lenin's. Instead of locating tombs inside capital centers, Chinese emperors had theirs constructed in mountainous locations outside their capitals, in places that were said to be auspicious and full of natural power, according to the rules

of *fengshui* (風 水). Moreover, Zhu's tomb was intentionally hidden from public view. Commoners were forbidden on penalty of death from treading on the sacred ground of the imperial tomb area, and the precise burial place was to be kept a strict secret to protect the emperor's remains. Even the imperial descendants generally did not see the actual tomb, which was buried in a large earth mound surrounded by a wall 350 meters in diameter. Instead they conducted imperial family rituals in an ancestral temple pavilion located at the end of a "spirit road," a path that laid out a sequence of ritual structures and images (Figure 5.3, website).[6]

There were certainly striking architectural and visual elements to this tomb complex, including the spectacular ancestral pavilion, or sacrificial hall, which originally covered an area of nearly 2,000 meters, making it probably the largest wooden structure in Ming China (Figure 5.4). This was the most important building for visitors, for it housed the spirit tablet of the emperor, and the sacrifices to the imperial ancestor were always performed here.[7] Other impressive structures included an arched gate that signaled that one was entering a particularly hallowed portion of the spirit road and a large

Figure 5.4 The Wooden Sacrificial Hall at the tomb of the founder of the Ming dynasty, Zhu Yuanzhang, in Nanjing. The original sacrificial hall completed in 1398 was much larger than the one pictured (notice how the set of staircases seems overly large for the small structure.) The original building was destroyed when the Qing dynasty put down the Taiping Rebellion in 1864. The Qing subsequently built this more modest structure afterward. From: Personal collection of Charles Musgrove.

rectangular stone gate tower that separated the ritual spaces of the complex from the burial mound itself.

It is important to note, however, that the audience privy to these sites was extremely limited, and that one did not see these monumental elements all at once. Instead, there was a gradual intensification of feeling as one traversed the spirit road through a series of architectural climaxes. The journey began at a special memorial arch that instructed visitors to dismount their horses. Then, one ascended respectfully along a winding path, passing through a stele pavilion housing a large, stone dragon turtle, and then a series of twenty-four larger-than-life stone statues of auspicious animals such as lions, camels, elephants, and mythical creatures that were considered guardians of justice. The path then meandered around a small hill and passed under the watchful eye of eight stone civilian and military officials, leading eventually to the gate of the ancestral pavilion, which was the final destination for most royal visitors.[8] Again, one generally was not allowed to gaze upon the grave itself, which was hidden. Overall, the tomb's monumentality was not expressed in an awe-inspiring view of any single dominating structure, but instead it was gradually revealed and felt in moving through the complex. Visual elements were important, but it seems that ritual practices and movements conveyed power more effectively in this form of monumentality.

By Sun Yat-sen's day, however, the Ming tomb offered only a shadow of its former grandeur. It had served as an intentional monument to the dynastic founder and was well maintained for as long as it was considered crucial for the maintenance of Ming power. But once the dynastic reins changed hands, its purpose changed considerably, and the attentiveness of its new caretakers gradually waned. It was customary for succeeding dynasties to maintain the imperial tombs of their predecessors as a sign of respect for the position that sitting rulers still occupied. Both the Kangxi and Qianlong emperors performed ritual sacrifices at the tomb during their southern tours.[9] However, there is little incentive to glorify too much the dynasty that one has overthrown, and Qing rulers also had to deal with persistent rebellious conspiracies whose rallying cries were "overthrow the Qing, restore the Ming." Thus, the Qing continued to forbid commoners from venturing near the Nanjing tomb, as much to prevent it from becoming a symbolic center of revolt as to protect the sanctity of the imperial site.[10] Overall, the monument's official significance had decreased significantly, and it had more subversive potential than anything else. Thus, the site became dilapidated from neglect, especially following the Taiping Rebellion (1850–1864). Nanjing had been the capital of the "Heavenly Kingdom," and the Qing almost completely destroyed the city in putting down the movement in 1864. The Ming tombs were badly damaged, and the spectacular ancestral hall burned down. The late-nineteenth-century Qing rulers chose not to invest scarce resources in

renovating this potentially dangerous Ming symbol, and a much smaller ancestral hall was built instead.[11]

When Sun Yat-sen held a ceremony at the Ming tombs on February 15, 1912, three days after resigning as provisional president, he helped bring the site back into the forefront of the public's imagination.[12] The ceremony itself was remarkable in that it burst through the taboos surrounding the site. In plain view of all, and captured by a number of photographers present to commemorate the event, Sun marched respectfully on foot with his entourage past the sacrificial hall all the way to the roof of the gate tower from which the typically unviewed burial mound could be seen. Here he paid obeisance to the Ming founder with a racially charged speech in which he proclaimed China's liberation from the Manchu "savages." Sun's offering ode concluded:

> I have heard that in the past many would-be [deliverers] of their country have ascended this lofty mound wherein is your sepulcher. It has served them as a holy inspiration. As they looked down upon the surrounding rivers and upwards to the hills, under an alien sway, they wept in the bitterness of their hearts, but today their sorrow is turned to joy. The spiritual influences of your grave at Nanjing have come once more into their own. The dragon crouches in majesty as of old, and the tiger surveys his domain and his ancient capital. Everywhere a beautiful repose doth reign. Your legions line the approaches to the sepulcher; a noble host stands expectant. Your people have come here today to inform your majesty of the final victory. May this lofty shrine wherein you rest [attain] fresh luster from today's event and may your example inspire your descendants in the times which are to come. Spirit! Accept this offering![13]

In his soliloquy, Sun Yat-sen dramatically redefined the Ming tomb as a site for rallying the forces of nationalism. The tomb immediately ceased to be a simply resting place for a former emperor or a symbol of secret resistance. Suddenly it was reconfigured as a place to glorify a resurrected hero of China's past in which the nativism he represented was his greatest attribute.

Sun Yat-sen also redefined the purpose of the ritual performed at the tomb. While he went through many motions that were similar to those performed in a sacrifice to imperial ancestors (respectfully walking the spirit road, performing the proper number of bows before the emperor's spirit tablet, etc.), the purpose of the performance was as much to state that this was a new beginning for China as it was to show respect to a former hero. This was not to be part of a series of regularly scheduled visits that would revere a particular dynastic ancestor and simultaneously legitimize a contemporary imperial ruler, as the rituals had done in the past.[14] Instead, Sun wanted to forge a link to a particular past that was essential for constituting a nation-state. Legitimizing imperial-era rulership had required sanctifying the role of emperor through obeisance to all who had previously held the office, even Manchus;

but in Sun's constituting a new nation-state, only those who met the criteria of being "Chinese" would necessitate respect.[15]

In visual terms, the tomb itself remained rundown from neglect and hence somewhat unimpressive, but through photographs of the ceremony, people all over the country could now see the various parts of this site that had recently been forbidden to commoners, thereby tearing down one element of its former monumentality—its mystery—but also opening up the possibility of new ways of experiencing its power. Meanwhile, Sun magnified the significance of Purple Mountain itself. The dragon and tiger in the speech referred to a common saying about Nanjing that the city commanded the power and strength of a "crouching tiger and coiling dragon." Now this power was to be felt from outside the walls, from the mountain perch where the tomb lay. This combination of ideas would lead the GMD later to envision the place as the ceremonial center of their new nation more than twenty years later.

THE SUN YAT-SEN MAUSOLEUM

With the construction of the Sun Yat-sen Mausoleum in the late-1920s and early 1930s, the focus on Purple Mountain clearly shifted away from the Ming tomb to the far more visually stimulating monument to the GMD founder. The mausoleum was to become the centerpiece of the GMD's own ritual reconstitution of the nation, and Purple Mountain was to encompass all the elements of a new worldview that would reposition China in what the GMD considered a new, modern context. More immediately, the GMD wished to impress upon the citizens of the Nationalist-led Republic of China that the party alone was the only legitimate leader capable of effecting this glorious transformation. To do so, party leaders would invoke both the image and "ideology" of Sun Yat-sen and attempt to embody that ideology in its greatest national monument, the Sun Yat-sen Mausoleum.[16]

In 1912, Sun Yat-sen envisioned a liberal democracy developing in the wake of Qing collapse, but by the early 1920s his optimism had been shattered as he accused the Chinese people of being "loose sand" with a "slave mentality" due to centuries of being conditioned to accept subservient roles under conservative authority figures. Inspired by the Bolshevik Revolution, Sun saw ideology as a means for educating people on how to live in the modern world. He quickly set out to develop his own "Three Principles of the People:" Nationalism, Democracy, and People's Livelihood. Sun claimed that these Three Principles would serve as a modern ideology for China, based on scientific principles, while also achieving "revolutionary" social progress. He proclaimed that the ultimate goal was liberal democracy, but by the 1920s he was also insistent that democracy could only be achieved after his

revolutionary party, the GMD, taught the people how to put the interests of the country before their own narrow ones. Thus, to Sun, an unspecified period of dictatorial "political tutelage" under the GMD would precede multiparty democracy.[17]

After years of warlord rule, which for many confirmed Sun's accusations about the inherent selfishness of China's leadership, Sun Yat-sen's popular image as a selfless patriot grew. Indeed, he was at the height of his popularity when he died in Beijing in 1925. Hence, the GMD had every reason to take seriously his instructions to bury him in Nanjing. This was a wonderful opportunity not only to fulfill their popular leader's dying wish by building a monument that would concretize his status as a "founding father" of modern China, but also to provide the GMD a chance to emphasize itself as the inheritors of his revolutionary vision, and thus worthy of the people's loyalty in the civil war that started less than a year after his death. After the completion of the Northern Expedition in 1928, the mausoleum would play crucial roles in simplifying Sun's contradictory legacies, particularly in singling out the GMD as the only leaders of China's modern revolution, as opposed to its main rival, the Chinese Communist Party.

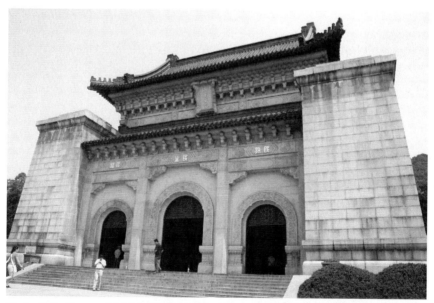

Figure 5.5 The sacrificial hall of the Sun Yat-sen Mausoleum in Nanjing which was completed in 1929. This structure was praised at the time for combining eastern and western elements into a bold new architectural form. Compare this stone and concrete structure to the sacrificial and spirit halls of the Ming tomb in Nanjing. From: Personal collection of Charles Musgrove.

Despite the numerous financial difficulties that the GMD faced, builders finished the first phase of construction just in time for interment ceremonies in late-May and early-June 1929.[18] In the architecture of the mausoleum (Figure 5.5), designed by architect Lu Yanzhi, one can see an attempt to strike a balance between old and new, democracy and party dictatorship. First, the form of the building roughly follows that of an imperial-era tomb, whose basic elements consisted of a wooden sacrificial hall in front of a round burial mound that enclosed the sarcophagus in stone. However, Sun's sacrificial hall differs from the imperial tomb in several important ways (compare Figures 5.4 and 5.5). For one, it is made of stone and reinforced concrete. While the traditional hall was made of wood to emphasize the constant filial duties of the descendants to maintain the structure, with Sun's tomb the permanence of the material was designed to show that Sun's ideals represented a permanent truth, as permanent as the nation itself. The tomb was also designed to put Sun's remains on display, as was considered appropriate for a modern, ideological founding father like Lenin. Featuring a metal door with a mechanical safe lock, the remains could be shut away for safekeeping, but, more importantly, it could also be opened at will for people to go in and respectfully gaze at his body, which would also last forever. Unfortunately, science failed to preserve his remains as Sun had hoped, and thus, in the end, the tomb contained a statue of his body as it appeared during the official lying in state instead (Figure 5.6, website).

The GMD hoped to inculcate its version of Sun Yat-sen's "ideology" at the site in a manner that would emphasize its own place of power in that vision. Inscriptions and carvings were a useful way to convey particular meanings. Thus, on the black marble walls of the sacrificial hall, the party carved the "Outline of National Construction" and the "Last Will and Testament," two of Sun's texts that called for the GMD to lead the nation in its drive for modernization.[19] These texts represented Sun at his most general and his least ideological; by leaving out the more specific texts on Sun's famous Three Principles of the People, the GMD designers avoided providing any details on the principle of "livelihood" and the confusing question of whether or not Sun had espoused a form of communism, which the right-leaning GMD vehemently denied.[20] The party sidestepped the issue of further interpreting these notions in stone, leaving that for the classrooms. Meanwhile, along the base of the seated statue the party carved scenes from Sun's life of revolution. These images were decidedly civilian in character: caring for the children, going abroad to propagandize, discussing with revolutionary colleagues, opening the national assembly in Nanjing, giving a speech that "awakens the deaf," and discussing how to protect the country. No scenes depict Sun leading a revolutionary battle or inciting angry masses. All the accompanying figures in these frescoes are reserved and respectful. In sum, the inscriptions

portray Sun as a great civilian leader, deserving of peaceful reverence, and with no hint of Marxist leanings.

In crafting these images of Sun Yat-sen, the GMD showed the kind of selectivity that goes into all forms of image-making, particularly when such images are meant to embody changing idealizations of political power. Just as images of Qianlong on his southern tours left out the yurts in order to project an idealized image of imperial majesty that was not a direct representation of the physical reality of those tours, so too did the GMD select images that only told part of the story of Sun's career in an effort to embody what the GMD hoped would be the new, postrevolutionary relationship between the state and the people: political tutelage under party guidance, not continued revolutionary violence as espoused by the rival Chinese Communist Party. As with the scrolls of Qianlong's southern tours, what is left out from the monument's narrative of Sun's life is as revealing as what is included.

Reinforcing the notion of Sun Yat-sen as the serene civilian leader is his seated statue, arguably the most remarkable image within the sacrificial hall (Figure 5.7). Sun is seated in a manner that strikes many as resembling the pose of Abraham Lincoln in the Lincoln Memorial, dedicated in 1922, which the architect Lu Yanzhi indicated was intentional.[21] Indeed, the GMD had made it clear when commissioning the tomb that it wanted the work to impress both foreign and domestic audiences. This statue would present a familiar appearance to foreigners. Statues of the deceased had not been a typical feature of Chinese tombs, where spirit tablets served as the focus of ritual attention instead. Notably, this statue of Sun is wearing the robes of a Confucian scholar instead of his famous "revolutionary outfit," the modern four-pocketed tunic suit that he designed himself (which instead appears on the sarcophagus).[22] Sun appears here serene and confident, with one hand lying calmly on his left knee and the other balled into a fist, also placed on his leg. Perhaps viewers noted the potential power behind the apparently placid demeanor, but with no explicit interpretation provided, viewers could arrive at their own meanings. Unmistakable, however, above it all, shining down on the scene inside the sacrificial hall was the GMD party emblem of the white sun and blue sky, a vivid reminder of the party's importance (Figure 5.8, website).

These messages were meant for a much broader audience than anything that appeared in an imperial-era tomb. The Sun Yat-sen Mausoleum was specifically designed to hold more than 50,000 people for state ceremonies that would be held there, for it was through public ceremonies that the GMD hoped to inculcate its desired meanings that would otherwise only be implicit in the images. Imperial ritual had been largely closed affairs, and the imperial family gained power from the fact that it alone could communicate with the imperial ancestors. The ceremonies at the Sun Yat-sen Mausoleum, on the other hand, were envisioned as huge public events meant to be seen.

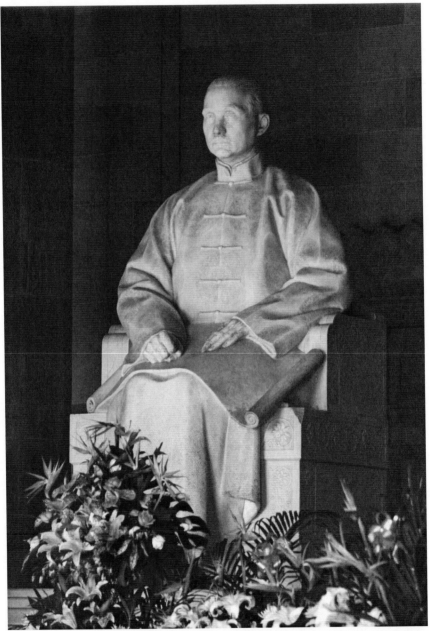

Figure 5.7 The statue of Sun Yat-sen that appears in the sacrificial hall. The designer of the mausoleum mentioned that the statue was designed to be similar to that of Abraham Lincoln at the Lincoln Memorial, which was dedicated in 1922. Note, however, that Sun is depicted wearing the robes of a Confucian scholar with a scroll in his lap. From: Personal collection of Charles Musgrove.

And while Qianlong's southern tours were clearly meant to be viewed as well, in this case state power was presented in a manner that differed subtly from the Qing effort to conjure "popular acclamation," as Michael Chang describes. With the public display of rituals to Sun Yat-sen's spirit, the GMD was essentially claiming that its power lay in the expansion of the scope of what was considered the new "national family." Space is insufficient here to provide a detailed description of imperial rituals of ancestor worship.[23] But over the course of the Nanjing decade (1927–37), the GMD developed a series of regular ceremonies honoring Sun Yat-sen that, generally speaking, modeled imperial rituals fairly closely. The party utilized ritual bowing instead of the kowtow, but otherwise the GMD members conducted regular "reports" to Sun's spirit; they read elegies on Sun's greatness, set up ritual offering tables, etc. The GMD emulated older rituals because these ancestral ceremonies already had a sacred air. More importantly, similar ceremonies were still being practised by private families honoring their own ancestors, which allowed the state to make a more concrete connection with the people who would recognize the validity of these forms of meaningful words and motion. Finally the GMD used them because they were identifiably Chinese, which allowed Chinese official ritual to be differentiated from other forms of official pomp and circumstance that were being re-invented in Europe and elsewhere.

The key differences between the GMD rituals and those of the "traditional" state (as the GMD called it) were in who performed the rituals and who the audience was. When the GMD performed the rituals to Sun, the audience was the nation. Everyone was supposed to see them and participate vicariously in them. Certainly, the GMD held a privileged position in the rituals for themselves. Party members held the honor of making the reports and oblations to the spirit of Sun Yat-sen, from which they could claim to be led by his guiding will. As such these rituals served a similar legitimizing function that the imperial rituals did for the emperor and his government. However, these rituals were made in plain public view, with cameras recording them for the benefit of the entire nation, which was supposed to learn lessons of proper citizenship and loyalty from the photos (see Introduction, Figure 1.3, as well as website). By opening up the central rituals to public view, the GMD was in fact extending the boundaries of sovereignty. Before, participation in the imperial rituals had defined who had legitimate authority. Only members of the royal household and their appointed officials could participate in the central rites of the state, though local officials and sanctioned organizations, such as lineages, replicated some of them at the local level.[24] From the exclusion of other families in the central imperial rituals, these participants gained the authority to rule "all under heaven." People in Nationalist China, on the other hand, not only could replicate GMD rituals, but could actually see them being performed at the highest levels, and members of the "masses" (organized

in officially sanctioned groups) even participated in them.[25] Everyone was included in the family of the nation, just as sovereignty ultimately now rested with the people.

Ultimately, the GMD would mobilize the whole mountain, including the Ming tomb, to glorify the party founder while placing him as the central figure in a reconfiguration of the nation. In July 1929, the national government set up the Sun Yat-sen Memorial Park Management Committee and directed that the highest priority be the "protection of the mausoleum." The committee would maintain the mausoleum grounds and construct further facilities to enhance them.[26] The committee oversaw the construction of lakes, gardens, forests, and numerous pavilions from which to view the "natural" beauty. While beautifying the landscape and providing places to rest as in a traditional garden, the goal here was not to while away an afternoon with poetry. Within the memorial park, people were supposed to "think of the Party Leader's grand and broad spirit and the difficulties of making revolution. Their thoughts are inspired and encouraged and are not simply entertaining their eyes and ears."[27] To assist in ideological contemplation, a commemoration hall housing Sun Yat-sen relics, a Library of Revolutionary History, and a Sun Yat-sen Culture Institute were added. This new "national park" would also house a special center for studying "real" Buddhism (not the "superstitious" kind that the GMD was concurrently attacking); an observatory with a new, modern telescope imported from Germany; a sports stadium and training complex; a martyrs cemetery and shrine; as well as special tombs for other important leaders. Nature, science, physical fitness, religion, loyalty, sacrifice, and many other key ideals were intentionally placed under the aegis of Sun Yat-sen's watchful spirit on Purple Mountain.

Not least of these ideals were Chinese history and culture, now seen to be embodied by the Ming tomb, which was to be renovated and preserved. Zhu Yuanzhang thus took his place in what amounted to a necropolis devoted to the ancestors of modern Chinese nationalism, particularly as represented by the GMD. Modest ceremonies were conducted at the tomb to commemorate this "national hero," but it was overwhelmingly clear which tomb dominated the landscape: it was Sun Yat-sen's mausoleum that was visible from miles away. The vast majority of visitors made Sun's tomb their primary destination, and only some detoured to the Ming tomb.

REVERENCE AND CONTESTATION

Monuments have a habit of taking on a life of their own after the designers and builders are (supposedly) finished with them. This is particularly true of monuments meant for widespread public consumption. Distinct and

unintended collective memories accrete to public spaces when actual uses defy prescriptions. For example, the Lincoln Memorial began as a monument to unity and the (mis)perception that the United States' racial problems had been resolved, but unintentionally turned into a locus for continuing social protest. Under conditions of censorship and martial law in Nanjing, the GMD hoped to preserve the Sun Yat-sen Memorial Park as a place for the reverent learning of the lessons of "political tutelage." It was not intended to become a place for questioning authority; but as it gained power as a national symbol, that is exactly what happened.

Throughout the Nanjing decade numerous people went to the mausoleum to pay their respects in the proper manner prescribed by the GMD. In fact, virtually all nationally significant gatherings that were held in either Nanjing or Shanghai, from party congresses and legislative sessions to product exhibitions and national sports meets, began with a ritual visit to the mausoleum, where officials made an offering and people paid their respects. The requisite visit usually culminated in a group photograph taken on the steps. Meanwhile, domestic and foreign tourists and visitors paid homage at the site and most sang its praises. For example, in 1929, a correspondent for the English-language *North China Herald* wrote that the mausoleum was impressive and that "all who have seen it agree on its beauty."[28]

From time to time, however, protestors managed to co-opt the site, most dramatically in an attempted suicide staged on December 27, 1935. Earlier in the year, Japanese forces, which already controlled Manchuria, extended their influence over north China by establishing a de facto government in eastern Hebei Province. On that day in December, General Xu Fanting, Chief of Staff for the First Army Corps in Xi'an, stood in front of the seated statue of Sun Yat-sen in the sacrificial hall and read aloud a text calling for the National Government to take a firm stand against Japanese aggression. He recited an ode, which read in part, "Visiting your mausoleum, my heart is sad. Crying in the mausoleum, I have no tears left. Worshipping at the Party Leader's mausoleum, every inch of liver and intestines is broken. To die without a general [who will lead the fight against the Japanese], this is most shameful." Then he moved out of the hall to the terrace in front of the steps, perhaps the most visible location in the entire city of Nanjing, where he drew a short sword and cut his stomach open. Guards immediately called for an emergency team to take him to a nearby hospital, where he eventually recovered. This act was a protest against the GMD leadership in general and its policy of appeasement in particular, but it also clearly illustrates how even those who were critical of the GMD came to respect the symbols of nationhood that it had constructed. It also served as a valuable reminder that symbols are more easily constructed than controlled, particularly when the central figure of the monument was one as contradictory as Sun Yat-sen.

CONCLUSION

After 1949, the Chinese Communist Party (CCP) continued to treat the mausoleum with great respect. It was well maintained, even through the Cultural Revolution, and dignitaries who visited Nanjing often paid their respects. The CCP consistently argued that it remained the true inheritors of Sun's legacy, as opposed to the GMD, which the CCP claimed had abandoned many of Sun's principles and fled with Chiang Kai-shek to Taiwan. Once again, though, the meaning of the site's monumentality changed. Sun's tomb almost took on the role that Zhu Yuanzhang's tomb had played for the GMD—it represented a site for the commemoration of an important national hero, but one who was considered far less important than the CCP's own founding icon, Mao Zedong. People who visited Sun's tomb did not usually perform the ritual bows, nor did they present reports or offerings. They respectfully took off their hats, but generally they came to just look upon the images of the man. Sometimes, important people would say a few measured words in praise of Sun, a reflection of the old rituals.[29] There was still a feeling of reverence at the site, but the more sacred spaces of the People's Republic were constructed in Beijing, not least of which was Mao's own mausoleum in Tiananmen Square, where his remains were displayed after his death in 1976.

We tend to think of monuments as grand structures where visual elements are dominant, and this certainly applies to most intentional monuments built in the nineteenth and twentieth centuries, which still dominate the landscapes of capitals around the world today. But when looking at how monumentality changed in Nationalist Nanjing during the 1920s and 1930s, the relationship between visual and ritual elements of monumentality is more readily apparent. In many ways, monumentality in China before the late nineteenth century was strikingly different from that of other parts of the world at the time. Imperial-era monuments could be grand structures, but the emphasis at architectural sites was more on moving through various structural elements, as large edifices often lay obscured behind gates and walls. Access to powerful spaces was strictly limited and through the limitations, elite status was defined. With the Sun Yat-sen Mausoleum, however, there was a clear emphasis on the visual aspects of the tomb. The mausoleum was built in a highly visible location, with what was for Chinese tomb architecture a new emphasis on the stone representations of the deceased. Previous conventions and taboos were dramatically discarded, while power was primarily conveyed through visual means.

Nevertheless, power was still conveyed through movement as well. Visitors, who now could be anyone, climbed the steps of Sun's mausoleum; they moved through the sacrificial hall and even walked around his sarcophagus. They also performed distinct rituals: from outright offerings to removing hats that also added to the sacred air of the place. The GMD intended such

movements to convey messages about the importance of revering the nation, as well as about their own political party. Yet, the movements and interactions that took place there also had the ability to change the meanings of the site, as protests and other nonprescribed uses created alternative sources of memory: in visiting, one did not just see what the GMD wanted to be seen, for on ascending to the summit of the stairs, one's mind might involuntarily be drawn to the story of the selfless general who cut his own torso to inspire resistance to GMD policies. And so inevitably, the nature of the monuments changed at Purple Mountain, just as they have at monuments everywhere, though we aren't always conscious of those changes.

In this chapter, we have also reflected on how images are selectively constructed to convey political ideals, regardless of whether the constructors are imperial-era monarchs or twentieth-century political parties. One question to consider is: Was there really a difference in the way that visual images conveyed power in these cases? For example, Michael Chang tells us that Qianlong's ritualized movement through the realm was a spectacle that was designed in part to make the emperor visible to his subjects. So was the GMD really engaging in something new when they built a monument to Sun Yat-sen that was "meant to be seen" by all? I would say that the main difference between the emperor's visual displays and those of the GMD lay in the nature of the invitation to view. Qianlong's highly visible parade of power on the southern tours invited subjects to view and be awed by imperial authority. The GMD invitation also hoped to awe its viewers with the power of the modern nation-state that it claimed to lead. However, to make the GMD conception of power palatable to a generation that believed the people should be sovereign, that invitation to view had to give people the sense that they would be empowered in that nation-state, even as the party insisted that the sovereign people needed to be educated first. Again, the notion of the "family-state" was a useful one. As a member of the national family, one did not just watch, but one also participated in the rituals that made the family unit sacred. And eventually the youthful members of the family would one day take the lead themselves. The question for the GMD, as to some extent it was for Qianlong, was whether or not the people would accept the invitation to view these power displays the way that the image-makers hoped they would. In this chapter we have seen that in some ways they did, and in other ways people applied their own meanings to the images in defiance of official expectations.

NOTES

A modified version of this chapter was published as "Monumentality in Nanjing's Sun-Yatsen Memorial Park," *Southeast Review of Asian Studies* 29 (2007): 1–19.

1. Alois Riegl, "The Modern Cult of Monuments: Its Character and Its Origin," Trans. Kurt W. Foster and Diane Ghirardo, *Oppositions* 25 (1982): 20–51. Wu Hung, *Monumentality in Early Chinese Art and Architecture* (Stanford: Stanford University Press, 1995).

2. Charles Musgrove, "The Nation's Concrete Heart: Architecture, Planning, and Ritual in Nanjing, 1927–1937" (Ph.D. dissertation, University of California, San Diego, 2002).

3. For relationships between tombs, monuments, and nation-building, see George L. Mosse, *The Nationalization of the Masses* (Ithaca: Cornell University Press, 1975) and Edwin Heathcote, *Monument Builders: Modern Architecture and Death* (West Sussex: Academy Editions, 1999).

4. "Sun Zhongshan yu Wang Jingwei tanhua" [Sun Yat-sen's conversation with Wang Jingwei], *Minguo ribao*, March 16, 1925. Also see Wang Liping, 26.

5. Sun resigned in an effort to complete a compromise arrangement that would preclude civil war between the southern revolutionaries and northerners who favored the leadership Yuan Shikai. For more on Zhu Yuanzhang's efforts to build Nanjing as the capital see F.W. Mote, "The Transformation of Nanking, 1350–1400," in G. William Skinner, ed., *The City in Late Imperial China* (Stanford: Stanford University Press, 1977).

6. For more on Chinese imperial tombs see Lawrence G. Liu, *Chinese Architecture* (New York: Rizzoli, 1989), chapter 7. For a description of the architectural features of Ming-era imperial tombs in Beijing (which were modeled on Zhu's tomb), see Ann Paludan, *The Ming Tombs* (Oxford: Oxford University Press, 1991).

7. Ceremonial vessels located outside the sacrificial hall and in the gate tower served as a symbolic reminder of ancient times when rituals were held out in the open air, but otherwise they were not used in the actual rites, Paludan, 10, 38.

8. *Zhu Yuanzhang yu Ming Xiaoling*, 59–64.

9. *Zhu Yuanzhang yu Ming Xiaoling*, 102–103. Till, 143–144.

10. Ye Zhaoyan, *Lao Nanjing*, 215.

11. *Zhu Yuanzhang yu Ming Xiaoling*, 147–148.

12. For a brief description of the ceremony, see Harrison, 41–42.

13. This translation is provided by Till, 144–145. Also see, *Sun Zhongshan quanji* [Collected works of Sun Yat-sen] (Beijing: Zhonghua shuju, 1982), vol. 2, 94–97.

14. See, Evelyn Rawski, "The Imperial Way of Death: Ming and Ch'ing Emperors and Death Ritual," in James Watson and Evelyn Rawski, eds., *Death Ritual in Late Imperial and Modern China* (Berkeley: University of California Press, 1988).

15. Though Sun clearly viewed the Manchus as foreigners and used such views to whip up pro-revolutionary sentiment, after the Qing were overthrown, he struggled to avoid so narrowly defining the Chinese nation, recognizing that to consider the Manchus foreigners would imply the loss of northeastern provinces which had served as the Manchu homeland. Ultimately, he arrived at a view of Chinese nationhood as the cooperation of the "five races": Han (ethnic Chinese), Mongol, Manchu, Hui, and Tibetan.

16. The term ideology in this paper refers to the concerted effort to integrate theories and goals into a sociological program. During the 1920s and 1930s, ideologists in China were mainly divided between those who favored an explicitly socialist ideology

(as with the Chinese Communist Party) and those (like the GMD) who favored the more vaguely defined ideology of Sun Yat-sen, which advocated social reform but not class antagonism. Within the GMD there was also great debate about how to define Sun Yat-sen's often contradictory statements about social reform.

17. Bergere, 378–381.

18. Sun Yat-sen died in 1925. His remains were temporarily interred in a temple at the Western Hills. After the GMD established its nominal authority of Beijing in 1928, preparations were begun to remove Sun's remains to their permanent resting place at Purple Mountain.

19. Ye Chucang and Liu Yizheng, eds., *Shoudu zhi* [Capital gazetteer] (Nanjing: Zhengzhong shuju, 1935), 261.

20. The concept of the "people's livelihood" shared similarities to ideals espoused by Chinese Communists at the time. For example, it called for the equalization of land rights. However, this was to be accomplished through progressive taxation, not through forced land redistribution. See Bergere, 167–172.

21. Lu Yanzhi, "Nanjing yu Guangzhou zhi Sun Zhongshan xiansheng jinian wu" [Sun Yatsen memorials in Nanjing and Guangzhou], *Mile pinglun bao: xin Zhongguo tekan*, October 10 1928, 21.

22. This revolutionary outfit was modified and then became known as the "Mao jacket," for it was common apparel during the Maoist era.

23. For more on imperial rituals see James L. Watson and Evelyn S. Rawski, eds. *Death Ritual in Late Imperial and Modern China* (Berkeley: University of California Press, 1988). For the "orthodox" version of the rituals performed in households, see *Chu Hsi's Family Rituals*, trans. Patricia Ebrey (Princeton: Princeton University Press, 1991).

24. For analyses of the interplay of imperial-era state ritual and local practices, see chapters by Joseph McDermott and David Faure in Joseph McDermott, ed., *State and Court Ritual in China* (Cambridge: Cambridge University Press, 1999). In particular, McDermott's chapter, "Emperor, elites, and commoners: the community pact," describes the expansion of ritual practices that had been the exclusive domain of officials to public ceremonies performed by local communities to honor the emperor during the Ming, but the material focus of the ritual was on a tablet of imperial instructions, not on an actual spirit tablet, as would be the case in ancestral rites.

25. These masses were organized into groups that participated in the parade that brought Sun's remains to the tomb. By contrast, imperialera rituals had been replicated by officials in the provinces in their capacity as representatives of imperial power. Commoners were not official participants in imperial state rituals.

26. "Zongli ling guanhui chengli tonggao" [Announcement on the establishment of the Party Leader memorial park management committee], July 3, 1929, *Zhongshan ling dang'an*, 403. See also Ye Chucang and Liu Yizheng, eds., *Shoudu zhi*, 258–9.

27. Ye Chucang and Liu Yizheng, eds., *Shoudu zhi*, 297.

28. "Rebuilding Nanking as a Capital II," *North China Herald*, May 25, 1929, 305.

29. In February 1953, Mao visited the mausoleum, where he bowed and sat silently for a few minutes. Shi Ping, "Mao Zedong ji du dao Jinling" [Mao Zedong's several trips to Nanjing], *Nanjing shi zhi* 30 (1988), 3.

Chapter 6

"The Me in the Mirror"

A Narrative of Voyeurism and Discipline in Chinese Women's Physical Culture, 1921–1937

Andrew D. Morris

In 1931, a Shanghai woman named Dai Mengqin wrote a short article for *The Life Weekly* on her recent conversion to a healthy exercise-filled life. Dai opened her piece by providing "historical background" that employed modern stereotypes of Chinese women's essential and unchanging weakness:

> Our nation's women have always sat around, just keeping an eye on the home, and not being accustomed to movement. Except for women working in the fields, they all were practically just Lin Daiyu [the female protagonist of *Dream of the Red Chamber*, famed for her weak feminine beauty], possessing beautiful features but lacking a healthy body.[1]

Dai described how she personally exacerbated this already sorry heritage by dismissing her husband's positive ideas about exercise. It was not until Dai examined in this same *Life Weekly* magazine some of its frequent "Healthy and Beautiful" pictorials, that she saw the light:

> I started to understand that a body's features and look are not unchangeable, that one can use one's own power to change oneself. My soul was extremely moved. That night I went to a bookstore and bought an American sports magazine, and after reading through it I realized that my interest was growing even stronger. I decided that I would learn how to exercise. The next day I bought a swimsuit and came back home to put it on before a mirror. I looked like a woman with a healthy body, but upon closer examination I noticed some major faults: (1) I had too much body fat, (2) my thighs were too thick, (3) my chest was too skinny, (4) my arms were a little bit too large.

Determined to correct these faults, Dai began practising sixteen types of exercise that her husband taught her. Enthusiastic about this modern technology of

the self,[2] Dai explained how she always took this exercise while "examining myself in the mirror. The me in the mirror is like my companion, and also like my strict teacher."[3]

Chinese women's physical culture during the Republican era (1912–1949), and especially during the prewar 1930s, presents a very complicated historical problem. Women, especially urban women like Dai, were objectified more and more by three main forces: a conservative and reactionary morality (purportedly "Confucian" but actually very modern), an invasive and exploitative media, and the crisis mentality of a government staring down the barrel of imminent war with the Japanese. The world of sport and physical culture (*tiyu*) can serve as a perfect microcosm of the pressures and demands placed on certain members of Chinese society during this era.[4] Others have written about the liberating aspects of athletic activity for women in China;[5] however, this is only one part of the story.

Dai's inspiring confessional above can serve as a very clear window on many aspects of women's physical culture of the time:[6] Women were blamed for their heritage of a "female weakness" which supposedly had also rendered China's children sick and weak for centuries. Female physical culture was dominated by the voices of men bent on creating a new healthy and strong Chinese Woman who could do her part to "strengthen the race and strengthen the nation." The popular media was saturated with images of buxom, healthy, and wealthy Western women with whom Chinese women were encouraged to compare their own physiques in the mirror. In many ways, we can read this as an unprecedented opportunity for Chinese women to explore and publicly express their sexuality. In others, we can see how women often were asked to internalize patriarchal and nationalistic imaginations of the worth and uses of their own bodies. This perfectly characterizes a modern pattern of power relations—expressed through visuality—that is known by many scholars as "the male gaze." An issue of the women's magazine *Linglong* published in April 1932 included a startlingly erotic photo of a nude Western woman reclining in ecstasy on the beach; its caption read: "A healthy figure that all would envy."[7] Such authoritative and normalizing statements made it clear how women should feel about the fitness of their own bodies as well as those of others.

Women's sports and physical culture were understood as part of a self-justifying narrative of women's liberation, where the freedom to exercise, even if under a male Nationalist command, could seem obviously superior to the "traditional confinement" of women to the inner sphere of the home. And physical culture was one more way in which modern citizens were to learn how to discipline themselves, to serve as one's own "strict teacher," and examine oneself in the mirror for any faults, all the while feeling grateful for this chance to become more healthy and physically fit in the service of

the nation. Dai's account bears close witness to the weight of the burden that the modern sporting culture could place on women during the 1930s.

WOMEN'S SPORTS AS NATIONAL GAMES, 1930s

China's Fourth National Games, held in Hangzhou in April 1930, were the first to include women's sports (track and field, basketball, volleyball, and tennis) as medal categories.[8] The 2,000-plus athletes participating in these Games included 448 women from 18 cities and provinces across China.[9] And it was here that China's first true female athletic star, a sprinter from Harbin named Sun Guiyun, emerged. (Figure 6.1, website). Sun set national records in the 50-meter and 100-meter contests, and all female track athletes would be measured for years to come against her speed and beauty.

By the early 1930s, the sporting world and Chinese media treated women's sports as truly worthy competition, not just the old colorful and lively distraction and novelty provided in the past. In the Fifth National Games held in Nanjing in October 1933, women's swimming, softball and martial arts (*guoshu*) were added to the schedule. There were now seven women's events, just one less (soccer—thought to be too "intense" for women[10]) than the eight events joined in by the male athletes, and more than 800 of the 2,000-plus athletes in attendance were women. It was not necessarily a coincidence that at the same moment women's sporting uniforms revealed more and more flesh, women's sports won a position of more authenticity and value vis-à-vis modern dreams of the fit body and the proud nation. The official National Games program, published by the *Shenbao* newspaper, seemed to frame women's sports totally within bourgeois fantasies of sexual trespass. *Shenbao* readers apparently understood very well the symbols involved in images like Figure 6.2 of women's athletic bodies and the apparent sexual availability conveyed.

Not only were imaginations of female bodies and sexuality easily appropriated as a national endowment, but they were commodified with ease as well; witness the advertisement for My Dear Cigarettes hovering over the National Games cover girl's bared thighs in Figure 6.2. Laurel Davis has analyzed the phenomenon of the *Sports Illustrated* "Swimsuit Issue" in late-twentieth-century America, describing it as a way for men to secure heterosexual status through forms of public consumption.[11] It is easy to extend this analysis to commodified and sexualized images of "sport" like that above. However, one difference would be that while *Sports Illustrated* in our time, according to Davis, "contain[s] only tokenistic coverage of women athletes,"[12] media coverage of the 1933 National Games paid much more attention to the competing women athletes. "Real" photos of women athletes from the Games also showed much flesh (for the time), although (as in Figure 6.3, below; and Figures 6.4 to 6.5,

Figure 6.2 **The flirtatious pose and expression of this figure from the cover of the *Shun Pao* magazine's All *China Olympic Special Edition* is typical of many cigarette advertisements and calendar posters from this era. What marks it as supposedly more appropriate to a sports issue is that the young woman is wearing a swimsuit.** From: *Shenbao quanguo yundonghui jinian tekan (The Shun Pao All-China Olympic Special Edition)* (Shanghai, 1933), front cover.

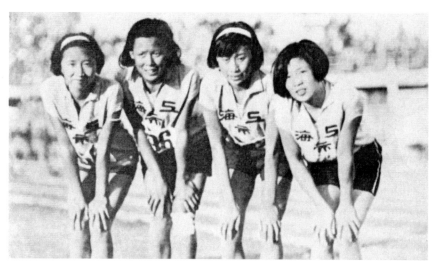

Figure 6.3 Shanghai women's 400-meter relay team, 1933 National Games.
From: *Ershier nian Quanguo yundong dahui zongbaogao shu* [1933 National Games
Official Report] (Shanghai: Zhonghua shuju, 1934), n.p.

website) this display was often and importantly mitigated by positioning it
within the context of virtuous teamwork, that loftiest of modern Nationalist
collective virtues.

This new focus on women's sports, however, fixed all the pressures of a
growing and exploitative urban media and the conservative demands of a
crisis-ridden national government on any women who entered the public ath-
letic realm. Again, Davis's analysis is relevant, as she describes *Sports Illus-
trated*'s swimsuit issue as a form of backlash against feminism and its threat
to hegemonic forms of American masculinity.[13] In the case of 1930s China,
it seems that owing to a similar fear that the emergence of strong and healthy
women athletes could undermine the macho claims that men's sports made
on the nation and national strength, the popular media was quick to categorize
any up-and-coming female athletes into some type or another. These could
include the sweet and loyal family girl, the fashionable makeup-wearing
"modern maiden," the timid and fragile girl whose sporting spirit was just not
enough to overcome her organic Chinese feminine weakness, or the woman
who married and left (that is, betrayed) the sports world, among other types.

Also disturbing was a voyeuristic convergence of prurience and national-
ism in a practice that might be called "ogling for the nation." Here men could
now, through the gaze of the modern print media, leer at the necks, arms,
and legs exposed by these women athletes' swimsuits and uniforms, and
get away with it. In this moment of national crisis, it seemed easy enough

to justify their gazing in terms of simple patriotism—after all, were not healthy women's bodies crucial to producing a strong Chinese citizenry of the future? (Figure 6.6, website.) Again, this question becomes more complicated when one considers women's own agency in this process. For example, we can witness a woman's new freedoms to publicly display one's body and sexuality. We also see the new means available for women (like Mrs. Dai in the introduction to this article) to consume and even fetishize (in the *OED* definition, "to pay undue respect to, to overvalue") these images. Once again though, Davis's suggestion that *Sports Illustrated* has worked to label a clearly heterosexual/masculine discourse as merely "sporting," and indeed this heterosexual masculinity as natural and normative, helps us to complicate this issue further.[14] Clearly, then, we must pay attention to these elements of the 1930s women's sporting story that are ignored or erased by narratives focusing solely on notions of "liberation" through athletic exertion.

NATIONAL CRISIS AND MEN'S ROLES IN WOMEN'S SPORTS

By the 1930s, the Guomindang's popular anti-imperialist line and the continuing Japanese encroachment over Chinese territory, economy, and sovereignty combined to create a tense atmosphere surrounding this once-fun realm of *tiyu*, or physical culture. In this time of national crisis, physical culture was not merely about sport, but also about national defense and strength—developing a physically fit citizenry, both male and female, that could fight the Japanese invaders. It was now a discourse that required and reinforced complete faith in the nation as the embodiment of the people's will, and as the sole subject and agent of progress.

The inclusion of women was on these terms as well: they were to be awarded measures of "liberation," repaid with the right to make sacrifices for the national project. This all would be on terms defined by these patriotic men, who of course took credit for the whole endeavor. As Wang Xiangrong, Vice Chairman of the Fifteenth North China Games in 1931, said in his closing ceremony address,

> These entire Games have been a great success. . . . There was an increase in the number of female athletes participating. Of course [this percentage] is still not up to the standards of the advanced sporting nations of the world, but seeing this progress in women's athletics truly gives everyone cause to congratulate themselves and rejoice.[15]

Men involved in the sporting world took pride in serving as appropriate and imposing figures of authority; their presence in many team photos

(Figures 6.7 and 6.8, website) seemed to infantilize the young women who ordinarily radiated much more confidence and presence.

Indeed, the power of modern "science" allowed authorities like physical education expert Wu Yunrui, impressed by what he learned on a fact-finding tour through Great Britain, France and Germany, to sidestep any truly liberating implications of women's physical culture:

> Women's sports are very important in terms of managing the household and the family. The woman's responsibilities in the household are cooking and cleaning. The former requires preparing three meals a day; if this presents too heavy of a burden, then there is no way that one can triumph in this work. In addition to the three meals, there is also the latter, cleaning and sweeping and tidying up, which can easily exhaust the spirit and fatigue the body. Again, if the body is weak, then there is no way to succeed in these tasks.[16]

Men like Wu were agile in avoiding any consideration of socioeconomic class—a variable that obviously was of much import in the Chinese world of modern sports. Words like his also helped to situate powerfully the notion that the use of fit women's bodies was not to guarantee equality for women, but instead to enable the men of China to make history in the public realm.

THE IDEOLOGY OF "HEALTHY BEAUTY" AND ITS DISCONTENTS

Not all women were expected to stay in the home, however; some women were projected as the physically fit models for the rest of China's 200 million females to follow. Soon national and local media began establishing successful or attractive women athletes as both role models and symbols of the new strong and loyal Chinese woman. Every large meet turned up new female sports figures for the masses to idolize and to whom modern urban women were supposed to compare themselves in the mirror. Indeed, then, for all the rhetoric about women's bodies and housework like that above, this moment of women's physical and sensual visibility still greatly complicates the historian's common notions of Chiang Kai-shek's anticommunist New Life Movement, and the conservatism that we have assumed to be so prevalent throughout 1930s urban China.

The photogenic "Four Harbin Sisters," led by Sun Guiyun and also known as the "Four Healthy Women Generals" (*nü jian jiang*) (Figure 6.9, website), won much attention with their sprinting performances at the 1930 Fourth National Games and the Fifteenth North China Games in 1931. Jiangsu sprinter Qian Xingsu, praised for her own "model quality," achieved fame

with her valiant performance against the "blue-eyed blondes" at Shanghai's 1931 International Meet.[17] At the 1933 Fifth National Games, articles about Ma Yi, the Liaoning athlete known as the "Iron Ox," sounded much like the melodramatic "human interest" pieces that have become a staple of contemporary American Olympic coverage. In Nanjing, Ma's inspirational gold medal performances in the discus and shot put allowed Chinese sports fans, as one writer put it, to "perceive the pain of the destruction of her native home [now occupied by the Japanese]."[18] Qingdao's amazing He sisters, Wenya, Wenjing and Wenjin (Figure 1.5, see Introduction), captured national attention with their clean sweep at the eighteenth North China Swim Meet in 1934.[19]

But the brightest of all female sport stars was "The Beautiful Mermaid" or "Miss China," Hong Kong swimmer Yang Xiuqiong (Figure 6.10, below; Figures 6.11–6.14, website). At age 15, Yang attained superstar status with her record-setting sweep of all four women's swim events at the 1933 National Games.

As always, however, this stardom was not without its price and qualifications. Fame for these women athletes was awarded in ready-made packages, each with its own formulated mixture of morality, poise, elegance, spirit, and commitment. Rey Chow has defined Chinese modernity in part as a process of "crushing . . . figures of femininity" at the same time that new kinds of voyeuristic interest are being constructed for the sake of the nation.[20] This is a particularly apt way of describing what happens to these successful female athletes who were typecast—in a perfect example of the asymmetrical heterosexual "male gaze"—by the Chinese media in their narrative of athletics and the nation.

Young swimmer Yang was the unanimous good girl of sport in the 1930s, the picture of sun-drenched bourgeois "healthy beauty" (*jianmei*). A writer for *Roll of Famous Chinese Women Athletes* wrote that "because of Miss Yang's healthy and beautiful figure and lovely face, she is known everywhere as the Mermaid. She is tender and quiet, proper and dignified, and has only nice things to say." A picture of Yang in a sun dress, ironing laundry was accompanied by the caption, "[b]esides sport, Yang Xiuqiong also especially enjoys doing work around the home."[21] And she proved her chastity and innocence by refusing a famous Shanghai film director's offer of CN¥2000 (US$600) to star in a motion picture.[22] Yang also soon became an unofficial government spokeswoman of sorts, putting on swimming demonstrations at New Life Movement-related events in Nanchang, Xiamen and Nanjing, as the Guomindang attempted to break down the boundaries between elite competitive sport and mass physical fitness programs.[23]

But her fame—young Yang was by far the best-known athlete in 1930s China—could seem stifling as well. When Chu Minyi, Secretary of the

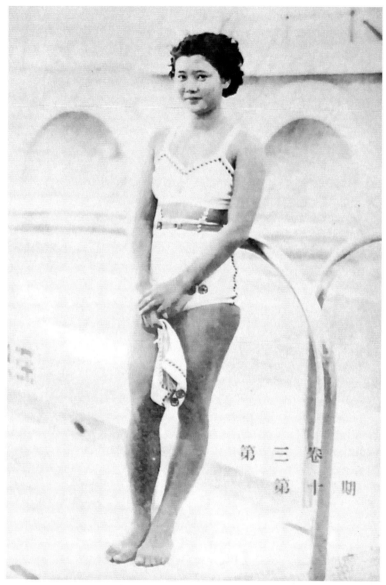

Figure 6.10 Hong Kong swimmer Yang Xiuqiong, "The Beautiful Mermaid." With the setting all but blurred out, the photo is designed to focus the viewer's attention on Yang's physical appearance. From: *Zhonghua yuebao (The Central China Monthly)* 3.10 (October 1935), back cover.

Executive Yuan, personally served the 15-year-old Yang as carriage driver on a scenic tour around the capital at the 1933 National Games, embarrassing rumors abounded about their relationship.[24] The youthful charm and beauty that put her on the covers of dozens of magazines also made her the subject of endless marriage rumors. Just days after her triumph at the Nanjing Games, the Hong Kong press was reporting that Yang would soon become the eighth wife of Chen Baiyuan, Chief Consultant of the Guangxi Bank.[25] It seems clear that the value her healthy and attractive physique had for popular Chinese fantasies and imaginations also took a personal toll on the teenage star.[26]

Other accomplished young women were typecast as they achieved fame. Qingdao martial arts expert Luan Xiuyun (Figure 6.15, website) was judged to be "the perfect female athletic figure" for her work teaching martial arts in two Qingdao elementary schools, as well as at her own First Women's Martial Arts Training Center.[27] Xu Zhongzuan, a Shanghai racewalker, was the wild girl of the sports set, dabbling in film acting as well as her hobby of riding motorbikes.[28] The nerd role was filled by Deng Yinjiao (Figure 6.16, website), an ethnic Chinese from Malaya who was near-sighted and often wore eyeglasses; one attentive author did have to admit, however, that "[a]lthough her face is not beautiful nor her skin silvery, her healthy [figure] still makes her attractive."[29]

The fall from fame of the "Four Harbin Sisters" was a tragic story that echoed for many Chinese the pain of the Japanese capture of that Northeastern city. Sun Guiyun's (Figure 6.1, website) decision to leave the track world she once dominated for basketball was seen as a great betrayal and negative example (as a "quitter") for sporting girls all over China. In 1933, she and four other women athletes were called out, and their integrity questioned, in the pages of *Diligent Struggle Sport Monthly*: "Is it that after winning one championship, they don't want to exercise anymore? Or is it that their performance has regressed and they are not willing to compete in a day of races? . . . Anyway, this allows us to see the vanity of women."[30] In 1935, the authors of *China's Girls Athletic Champions* wrote:

The Sun Guiyun of five years after [her 1930 National Games triumph] absolutely cannot match the Sun Guiyun of five years ago, and this is something one can tell right off. . . her magnificent and luxurious wardrobe, her makeup, looking for all the world like a debutante, without the slightest bit of the flavor of one out on the track. . . Her timidity, shyness and naivete of old are gone forever. I am not willing to go into great detail and describe here her private love life; this would bring such great sorrow to a Chinese sports world that is still in its developing stages. If every female athlete of the nation were like this, and just gave up like Miss Sun, our future would be filled with danger. What would we do? What would we do?[31]

Sun's teammate Wang Yuan was attacked in the media when she became the concubine of Bao Guancheng, the Chinese archtraitor who served as the puppet Manzhouguo government's "ambassador" to Japan. Wang later left this relationship, but then had to go into hiding to avoid the vicious slander that destroyed her reputation.[32] Teammates Wu Meixian and Liu Jingzhen were cast as tragic figures as well; Wu transferred to Fudan University in Shanghai and lost her athletic spirit, and Liu married and gave up sports for a home life.[33] In the cases of three of these Harbin Sisters (all except for Wu), we can see how choices they made about their own sexuality seemed to violate some imagined covenant, some moral condition to which the male-dominated media wanted to hold these women.

Michael Chang, a contributor to this volume, has previously written on a similar question relating to 1920s and 1930s movie actresses in Shanghai. Discussions about these women in popular magazines were often part of "a more general and widespread public discourse on dangerous women" whose social and sexual behavior (real or imagined) defied the vanishing patriarchal order of the day. Entry into this discursive world as a certain "type" of star, Chang suggests, often had very real and harmful costs, the "intimacy" that magazine readers imagining they were gaining with these women in the end resulting in "a deep sense of detachment and alienation."[34] As we see the media constructing similar identities for the women athletes described above at the same historical moment, we must imagine a similar set of costs that these women would have paid for their fame. In her study of the contemporaneous "Modern Girl" phenomenon in urban China, Madeleine Y. Dong (also a fellow contributor to this volume) has explained the societal anxieties about the Modern Girl look and lifestyle and its ability to lead its adherents "down a path toward disreputable actions or dangers. . . .blurred class and status lines and threatened the purity of the elite marriage market."[35] 1930s urban China's arbitrary definitions of which forms of sexuality would be made normative and acceptable, then, also reveal the asymmetrical power relations of women's involvement in the national sporting scene.

These media agents were not the only ones acting to categorize and classify the women's sports world and its stars, however; fans also were encouraged to do it themselves. In 1935, the Shanghai Athletic Publishing Society and the China Huamei Tobacco Company teamed to sponsor a "Chinese Sports Queen" contest, for the cause of "promoting women's sports and healthy, beautiful figures." Participating was fun and easy. Every ten-cent, ten-cigarette pack of Huamei's Guanghua (Radiant China) label contained a ballot that readers could use to vote for their favorite female athlete. A Huamei advertisement drew out quite clearly the commodifying function— again remember the analog of Davis's study of *Sports Illustrated*'s swimsuit issue in our own time—of such a selection process:

> How should the Sports Queen be selected? She must have a healthy and
> beautiful figure, superior athletic achievement, and a noble and lofty sporting
> morality. How could one describe Guanghua Standard Tobacco? It has fine and
> beautiful tobacco leaves, superior quality, and is packaged with noble and lofty
> technology![36]

Again, "sporting" was defined as male and heterosexual, the presence of
these fully commodified sporting women relevant only because of their erotic
youthfulness and femininity.[37]

The "Chinese Sports Queen" contest above and many of the images here
suggest the ways in which these images—not at all unlike images of today's
pop or sports stars—objectified their subjects in the eyes of readers and
consumers. Women athletes and their figures seemed here at least to be only
the equivalent of that most common commodity, the cigarette. The different
agents of the media constructed female athletes in every way as commodi-
ties who could be bought and sold, imbibed and enjoyed, public figures who
could be lionized and then besmirched. Many of these women likely had
entered the world of modern sports as a way to transcend their assigned roles
and succeed as individuals. Now, however, they found themselves as pub-
licly traded property which could be divided, categorized and defined into a
tableau of Chinese femininity that fit the needs of the male-defined nation.

In 1935 and 1936, two collections of pictures and short biographies
of Chinese female athletes were published in Shanghai: *China's Girls
Athletic Champions* (73 bios of women mostly from Shanghai) and *Roll
of Famous Chinese Women Athletes* (114 bios of women from all around
China). Two advertisements in *Champions* underlined the close relationship
between photography and the sporting world. The Wang Kai Photo Studios
claimed that "[i]n life there is only one way to be happy, and that is to
be healthy. And to maintain a healthy body and attitude, there is nothing like
photography." The Enlightenment Photography King studios agreed, "[w]e
all desire to maintain our healthy and beautiful body and look forever; for this
there is only photography."[38]

The modern technology of photography was a large part of the process by
which the sports and media establishments worked to impose their national
narratives and gazes on the world of female physical culture. Again, we know
that women were looking at these images too, measuring and comparing care-
fully to them their own physical features, and this fact makes it difficult to call
this a purely "male" enterprise. However, it is hard to deny that collections
like these mentioned above—composed of just the right mix of photos of
women wearing revealing uniforms or swimsuits, "traditional Chinese" *qipao*
robes, fashionable yet modest Western-styled outfits and prep school jackets
and ties—worked along masculine and heterosexual lines to portray Chinese

women athletes as a group with just the right balance of a healthy body, proper Chinese morality, and modern scientific thinking that the nation needed.

Photography's relation to women's sports also included the trend mentioned earlier of male heterosexual "ogling for the nation." Sporting and other popular magazines now were often adorned with pictures of Chinese women swimmers in their swimsuits, often wet (Figure 6.17, website). Women's sporting uniforms in the 1930s seemed to have been designed expressly for this voyeuristic purpose. Just a decade earlier, female athletes wore large-fitting tops, bloomers and beanies (Figure 6.18, website), and were nowhere to be found on Chinese magazine covers. However, by the 1930s the standard uniform was a V-necked white T-shirt with very high-cut sleeves, and short black shorts (Figure 6.19, website), shorter even than those worn by Western women athletes pictured in these same magazines.

New photographic strategies were adopted for shooting women's sports—one was the popular behind-the-starting-blocks angle, which could expose a treasured rear glimpse of these patriotic mothers-to-be. Team pictures almost always showed a front row of women sitting below their male teammates, their legs bared and extended toward the camera's gaze (Figures 6.20 and 6.21, website). Even individual post-event victory photos were different for men than women—while most winning men were photographed from the waist up, almost all women were pictured in full-body poses, in order to capture and sell the most winning flesh.

Indeed, a number of these photos depict women who look very uncomfortable being explored by the camera's male gaze. For the cover of *Diligent Struggle Sport Monthly*'s January 1935 issue, students at the Shanghai Patriotic Girls' School were posed straddling a set of parallel bars. (Figure 6.21, website). The media's scrutiny and attention seems to have been experienced as an imposition and intrusion by many of these women, most of whom likely would not have imagined all that could come with their participation in the seemingly liberating arena of sport. Figure 1.5 (see Introduction) is just one of several swimsuit shots of the three He sisters from Qingdao that regularly showed them looking annoyed and/or resentful at the eyeing they endured.[39] Many of these young women, enveloped though they were in a thoroughly modern regime of sport and commodification, did not see themselves as "capital-M" Modern Girls, who in other forms of media, as Madeleine Dong shows, were able to provocatively ignore, enjoy, or even return the imposition of the male gaze.[40] Even Superstar Yang Xiuqiong, the constant center of photographers' attention, at times betrayed a grudging discomfort with the lens trained upon her (Figure 6.22, website).

Even with all these pressures and intrusions that female athletes had to endure, the men in the sporting media could not fathom why some of these women would reject this objectification and degradation, and retire from

the public athletic scene. Women athletes who stopped competing and who did not go on to serve as physical education teachers were seen as quitters, women too tainted by the feudal Chinese values of weak femininity to be able to make a real contribution to the nation. Sun Guiyun, who suddenly left the track and field world, became public sporting enemy number one. In 1933, *The Sports Review* reported as a "humorous story" an incident where Sun, after suffering a head injury in a bicycle accident, snapped at an insensitive bystander who took this chance to ask her why she had left her boyfriend, the famous pole vaulter Fu Baolu![41] When an unnamed female basketball player from Shanghai quit after coming under harsh criticism in the media, *The Sports Review* had only this ho-hum, sarcastic comment: "News reporters can't please everybody."[42] This same Shanghai magazine reported in 1933 that Norwegian figure skater Sonja Henie was retiring at age 20 because male fans and reporters simply bothered her too much,[43] but few of these sports reporters seemed self-reflexive enough to see how this mirrored their coverage of China's women athletes.

CONCLUSION/RECONSIDERATION

This chapter attempts to draw out the main features of the world of Chinese women's physical culture, a world that was constructed in large part by the male-defined agendas of the government, the mass media, and the sporting community in prewar Republican China. It challenges narratives of one-dimensional "progress" and "liberation" with a different history of Chinese women's physical culture, a history that acknowledges and recognizes the power wielded by male agents of modern society who hoped to dictate their own narrative of national crisis and conservative "family" morality onto this stage of women's sports.

This complicated conclusion is captured most vividly by the words of Mrs. Dai Mengqin with which I began this paper. Dai was a woman with so many of the freedoms which a modern narrative of progress and liberation would reify so: she was literate, urbane, modern- and open-minded, participated in the "public sphere" of the modern media, had purchasing power, and sought to get in touch with and gain control over her body and sexuality.

However, efforts to critique this Chinese modernity can offer a different perspective. Dai's idea that "the me in the mirror is. . . like my strict teacher" rings so clearly of the ways in which modern disciplining power works. This new measure of discipline that Dai imposed on herself (being her own strict teacher, examining herself for any faults) jibes perfectly with the goals of the modern state, which, as Takashi Fujitani writes, aims to discipline the individual subject-citizen via the "positive deployment of power into the

soul of the individual."[44] The joy and subjectivity which Dai now felt as she regulated and conditioned her own body, an act surely taken of her own free will after all, speaks to the relevance of Fujitani's formulation. The popular media's and the modern state's many layers of hegemonic influence in modern physical culture, the doctrine of "science," and the wisdom of Dai's husband provided Dai with the new self-understanding and the desire to analyze, classify and rectify her own faults, to normalize herself.[45] And Dai's knowledge of the West, gained via photos of healthy, buxom, modern Western women so often featured in Chinese periodicals, bespeaks the media's use of these images to construct conceptions of what the New Chinese Woman was supposed to be and look like.

However, at the same time, we would be wise to remember American photographer Diane Arbus's evocative observation that "A photograph is a secret about a secret. The more it tells you the less you know."[46] As historians, we must ask ourselves if it is right to concentrate only on these more pernicious aspects of Chinese women's physical culture—especially when one can identify so many similar patterns in our own media and culture today. One recent example can be seen in a photo shoot of women athletes at the University of Massachusetts in 2007. The "Sisters in Sports" photo essay in the university magazine—of pairs of sisters who excelled in UMass swimming, track and field, and lacrosse—was so popular that it merited its own "Behind the Scenes" feature online.[47] The photos, which show the women smiling, showing their "game faces," and striking sporting poses, also highlight the young women's athletic physiques. Although there is nothing that strikes the modern viewer as prurient about these photos, this explicit fascination with the act of photographing the athletic female body is still compelling. It reminds us of all of the ways in which women in our own society today are taught to see and discipline the fitness and beauty of their own bodies. At the same time, it is also a simple illustration of all of the freedoms that these women enjoy to display and exert publicly their bodies in ways unimaginable in many parts of the world.

Therefore, when we engage in our keen critiques of this past moment in Republican China, what kind of historical injustice might we commit against the Chinese women of the 1930s who happily made the choice to involve themselves in modern sporting culture? In Arbus's words above, what "secrets" about these women may we be missing when we come to our conclusions some eight decades on? Indeed, as Kracauer explained in 1927, "[i]n a photograph, a person's history is buried as if under a layer of snow."[48]

By looking at the ways in which the state, media and popular morality worked to constrain, classify, define, and name these women, are we just restating an ahistorical "Chinese tradition" of the oppression of women where there perhaps is not one?[49] And, indeed, do postmodern philosophy and social theory, with their notions of the "male gaze," also ironically work to exclude

Figure 6.23 Students of the Southeastern Women's Physical Education Normal School, Shanghai. From: *Qinfen tiyu yuebao* [Diligent Struggle Sport Monthly] 2.2 (November 1934), front cover.

consideration of how women contemplate and identify with active images of other women?

These photos (especially ones like Figure 6.23) and other sources ask us to see the ways in which these women sought to mitigate these obstructions and avoid becoming mere "victims" by finding their own meanings, expression, and exploration in the bodily culture they pursued.

NOTES

1. Dai Mengqin, "Jianshen jianguo de tujing" [The Way to Build a Healthy Body and a Healthy Nation], *Shenghuo zhoukan [The Life Weekly]* 6.26 (20 June 1931), p. 535.

2. Foucault uses this phrase to discuss regimes of self-examination, obedience, and sacrifice of the self. Michel Foucault, *et al.*, *Technologies of the Self: A Seminar With Michel Foucault* (Amherst: University of Massachusetts Press, 1988), p. 45.

3. Dai Mengqin, pp. 535–536.

4. On this topic, see two important recent books: Yunxiang Gao, *Sporting Gender: Women Athletes and Celebrity-Making During China's National Crisis, 1931–45* (Vancouver, B.C.: University of British Columbia Press, 2013); Yu Chien-ming, *Yundongchang neiwai: Jindai Huadong diqu de nüzi tiyu (1895–1937) (On and Off the Playing Fields: A Modern History of Physical Education for Girls in Eastern China [1895–1937])* (Taipei: Institute of Modern History, Academia Sinica, 2009).

5. For example, see Fan Hong, *Footbinding, Feminism and Freedom: The Liberation of Women's Bodies in Modern China* (Ilford, Essex: Frank Cass Publishers, 1997).

6. For comparison to questions of women's body images in our own era, see, for example, Susan Bordo, *Unbearable Weight: Feminism, Western Culture, and the Body*, Tenth Anniversary Edition (Berkeley: University of California Press, 2003); Virginia L. Blum, *Flesh Wounds: The Culture of Cosmetic Surgery* (Berkeley: University of California Press, 2003).

7. *Linglong* 48 (27 April 1932), p. 1964.

8. At the Third National Games, held at Wuchang in 1924, female teams competed in basketball, volleyball, and softball, but only as demonstrations and not medal events. The Far Eastern Championship Games, a (mostly) biennial sports festival that rotated between China, Japan, and the Philippines from 1913 to 1934, also featured women's tennis and volleyball as demonstration events beginning with the Sixth Games held in Osaka in 1923. Andrew D. Morris, *Marrow of the Nation: A History of Sport and Physical Culture in Republican China* (Berkeley: University of California Press, 2004), pp. 87–91.

9. *Quanguo nü yundongyuan mingjiang lu* [Roll of Famous Chinese Women Athletes] (Shanghai: Qinfen shuju, 1936), pp. 33–35.

10. For example, famed educator Wang Huaiqi had written in 1928, "Soccer has a very intense quality to it; young men naturally are quite interested in this type of competition. But children or weak women surely cannot bear this kind of excitement. . . . Men's and women's bodies are naturally different, so their exercises and sports have to correspond to these different levels [of endurance]." Wang Huaiqi, *Xingqiu guize* [Starball Regulations] (Shanghai: Zhongguo jianxue she, 1928), pp. 2–3.

11. Laurel R. Davis, *The Swimsuit Issue and Sport: Hegemonic Masculinity in Sports Illustrated* (Albany: State University of New York Press, 1997), pp. 51–54.

12. Davis, p. 59.

13. Davis, pp. 55–56.

14. Davis, pp. 30–31.

15. *Di shiwu jie Huabei yundonghui* [The 15th North China Games] (n.p., 1931), p. 121.

16. Wu Yunrui, "Wuguo minzu fuxing zhong nüzi tiyu zhi zhongyao" [The Importance of Women's Physical Education in the Revival of Our Nation's People], *Tiyu zazhi* [Physical Education Magazine] 1.1 (4 April 1935), p. 1.

17. *Quanguo nü yundongyuan mingjiang lu*, pp. 4–5.

18. Pei Shunyuan and Shen Zhenchao, *Nü yundongyuan (China's Girls Athletic Champions)* (Shanghai: Tiyu shubaoshe, 1935), n.p.

19. *Liang zhounian gongzuo zongbaogao* [Two Year Anniversary Official Work Report] (Qingdao: Qingdao Tiyu xiejinhui chuban weiyuanhui, 1935), p. 41.

20. Rey Chow, *Woman and Chinese Modernity: The Politics of Reading Between West and East* (Minneapolis: University of Minnesota Press, 1991), p. 86.

21. *Quanguo nü yundongyuan mingjiang lu*, p. 1.

22. Pei and Shen, n.p.

23. In 1936, Yang would be the star attraction at a Shanghai Aviation Association Swim Meet held to raise money to buy warplanes in honor of Chiang Kai-shek's birthday. Yiru, "Jiangxi shuishang yundonghui" [The aquatic meet in Jiangxi], *Qinfen tiyu yuebao* [Diligent Struggle Sport Monthly] 1.11 (August 1934), pp. 26–29; Fujian sheng difangzhi bianzuan weiyuanhui, ed., *Fujian shengzhi: Tiyu zhi* [Fujian provincial gazetteer: Chronicle of physical culture] (Fuzhou: Fujian renmin chubanshe, 1993), p.134; Wu Ningxing and Gu Qingfang, "'Meirenyu' quanjia Jinling yongtan xianji ji" [A record of the performances presented on the Nanjing swimming stage by "The Mermaid" and her entire family], *Jiangsu tiyu wenshi* [Materials from the history of Jiangsu physical culture] 6 (January 1988): 49–50; "Yi yue lai zhi yundong bisai" [Competitive sports this past month], *Qinfen tiyu yuebao* [Diligent Struggle Sport Monthly] 3.10 (July 1936), p. 949; Feng Shaoer, "'Meirenyu' Yang Xiuqiong zai Shanghai" ["The Mermaid" Yang Xiuqiong in Shanghai], *Shanghai tiyu shihua* [Items from the history of Shanghai physical culture] 24 (September 1989), p. 48.

24. Wang Zhenya, *Jiu Zhongguo tiyu jianwen* [Glimpses of physical culture in the old China] (Beijing: Renmin tiyu chubanshe, 1987), pp. 159–160.

25. "Yang Xiuqiong zuo pingqi de yaochuan" [Rumors that Yang Xiuqiong will be wed], *Qinfen tiyu yuebao* [Diligent Struggle Sport Monthly] 1.3 (10 December 1933), p. 75.

26. For more on Yang, see Gao, *Sporting Gender*, pp. 166–207.

27. *Quanguo nü yundongyuan mingjiang lu*, p. 32.

28. Pei and Shen, n.p.

29. *Quanguo nü yundongyuan mingjiang lu*, p. 3.

30. Sun Hebin, "Ping Di wu jie Quanguo yundonghui nüzi tianjingsai" [On the Fifth National Games women's track and field competition], *Qinfen tiyu yuebao* [Diligent Struggle Sport Monthly] 1.2 (November 1933), p. 6.

31. Pei and Shen, n.p.

32. Jiangjun, "Wang Yuan nüshi xiajia panni ji" [The Story of Wang Yuan's Being Married to a Traitor], *Tiyu pinglun (The Sports Review)* 16 (21 January 1933), p. 10; Pei and Shen, n.p.

33. Pei and Shen, n.p.

34. Michael G. Chang, "The Good, the Bad, and the Beautiful: Movie Actresses and Public Discourse in Shanghai, 1920s–1930s," in Yingjin Zhang, ed., *Cinema and Urban Culture in Shanghai, 1922–1943* (Stanford University Press, 1999), pp. 129, 131, 150.

35. Madeleine Y. Dong, "Who Is Afraid of the Modern Girl?" in The Modern Girl Around the World Research Group, eds., *The Modern Girl Around the World: Consumption, Modernity, and Globalization* (Durham: Duke University Press, 2008), p. 201.

36. Pei and Shen, advertisements on inside front cover and back cover.

37. Davis, pp. 26–29.

38. Pei and Shen, advertisements on inside back cover.

39. *Liang zhounian gongzuo zongbaogao*, photo before p. 1; *Quanguo nü yundongyuan mingjiang lu*, p. 24.

40. Dong, "Who Is Afraid of the Modern Girl?" p. 208.

41. "Xiao Hua" [Humorous Story], *Tiyu pinglun (The Sports Review)* 56 (4 November 1933), p. 169.

42. Sheng, "Wanguo lanqiu" [International Basketball Competition], *Tiyu pinglun (The Sports Review)* 22 (11 March 1933), p. 34.

43. Mei, "Nü yundongjia tuiyin" [Female athlete retreats into hiding], *Tiyu pinglun (The Sports Review)* 25 (1 April 1933), p. 47.

44. Takashi Fujitani, "Technologies of Power in Modern Japan: The Military, The 'Local', the Body," *Shisô* 845 (November 1994), p. 14.

45. Michel Foucault, "The Means of Correct Training," in Paul Rabinow, ed., *The Foucault Reader* (New York: Pantheon Books, 1984), pp. 200–203.

46. Patricia Bosworth, "Illusions of Arbus," *Vanity Fair* 552 (August 2006), p. 155.

47. "Behind The Scenes Of A UMass Magazine Photo Shoot," from site "University of Massachusetts - Official Athletic Site—Women's Lacrosse," 17 May 2007 (accessed 21 May 2007), http://umassathletics.cstv.com/sports/w-lacros/spec-rel/051707aac.html.

48. Siegfried Kracauer, "Photography" (1927), in Thomas Y. Levin, trans. & ed., *The Mass Ornament: Weimar Essays* (Cambridge, Mass.: Harvard University Press, 1995), p. 51.

49. Dorothy Ko, *Teachers of the Inner Chambers: Women and Culture in Seventeenth-Century China* (Stanford: Stanford University Press, 1994), pp. 1–4.

Chapter 7

Rethinking "China"

Overseas Chinese and China's Modernity

James A. Cook

At a 1922 meeting of the Manila Chinese Chamber of Commerce, the "Cotton King" of the Philippines, the overseas Chinese entrepreneur Lin Zhuguang, gave a speech to his fellow Chamber members to announce a large gift he was making to build a primary school in his ancestral village located in the southeastern province of Fujian. Still only 21 years of age, Lin's gift had taken the Chinese émigré community in Manila by storm. Philanthropy of this sort was supposed to be conducted by community elders; his father, Lin Xuedi, had given US$5,000 to disaster relief just before his death in 1918. For a young man like Lin Zhuguang to give a gift of such size caused quite a stir in the large, but close-knit Chinese business community of Manila.[1]

Part of the motivation behind Lin Zhuguang's gift was to honor his father's death, but other factors were also in play. "While honoring my father was certainly part of my intentions," noted Lin, "I also want to use the gift as an opportunity to increase the influence of the overseas Chinese community back at home. We have a duty to our motherland to transform her as we have transformed Southeast Asia. What we have learned here must also be applied in our villages and schools back at home."[2] These patriotic motives continued to grow in the younger Lin. In later years, although he would continue to reside in Manila, he would contribute US$5,000 annually for the school's upkeep and was a member of its board of directors. Why would Lin Zhuguang contribute so lavishly to a school located over 800 miles from his residence in Manila?

The answer to this question illustrates many of the ways in which living abroad affected the lives of China's large overseas community. Life outside China not only made a great number of émigrés extremely wealthy, but also forced them to face virulent anti-Chinese racism, thereby creating within overseas Chinese communities a strong nationalism and a deep loyalty to

Chinese culture. By the 1930s, these feelings had developed into a powerful desire to help rebuild and modernize their mother country. As one poet from Fujian Province who was living abroad noted:

> Fujian is our ancestral village,
> It feels like our blood and bones,
> We are like its parents,
> Protecting its shore and nurturing its growth.[3]

The process by which these feeling grew was both global and transnational in nature. Motivated by events both in China and abroad, many Chinese overseas like Lin Zhuguang played a critical role in communities on both sides of the ocean. Indeed, the economic and cultural contributions of Chinese abroad became so important that beginning in early twentieth century the Chinese government coined a new term, *Huaqiao* or "Chinese sojourner," to emphasize the permanence of Chinese citizenship. This new identity of the *Huaqiao* would transform the way in which many overseas Chinese imagined the Chinese nation, extending the country's influence far beyond the geographical confines of China proper to include all residents in Chinese communities abroad.

The experiences of China's *Huaqiao* in the twentieth century force us to rethink some of our most commonly held notions about the relationship between a nation, its territory, and its people. It has become second-nature for us to assume that the borders of a nation are conterminous with the geographical confines of its territory, and that only those who were born within or live within a nation's borders are its citizens. The familiar map of China—the rooster-shaped outline whose head is Manchuria, chest is the southeast coast, and tail is the western provinces—certainly serves as an important visual representation of the nation. However, the rapid movement of Chinese sojourners back and forth across the Pacific to both North America and Southeast Asia, the development of Chinese communities abroad that have identified with the Chinese mainland rather than their host countries, and the rise of Chinese nationalism within those communities all attest to the fact that national boundaries may not be as fixed as we generally assume. What does it mean to live abroad but to still consider yourself to be Chinese? Can a nation be defined solely by territorial boarders, or can it be imagined socially, ethnically, or culturally?

The idea of remaining "Chinese" while abroad was reinforced by both cultural and geopolitical considerations emanating from both sides of the sea. Overseas Chinese continued to feel the magnetic pull of the homeland. They wove together an embracement of Chinese language, dress, diet, and customs with residence outside China into an identity that stressed the connection

between Chinese culture and nationalism: they saw themselves as *Huaqiao*. If we emphasize a cultural identity rather than a national, as many Chinese living abroad did in the first half of the twentieth century, then our map of "China" may need to be redrawn.

This chapter analyzes the key visual images and markers that connected *Huaqiao* with China in the late-nineteenth and early twentieth centuries. Like Charles Musgrove's work on the structure of the Sun Yat-sen memorial located in the hills of Nanjing, it considers the meaning infused into important cultural and religious buildings, but moves to explore places—like Singapore, Batavia (Jakarta), and Saigon—outside the Chinese nation itself. These structures housed powerful reminders of the connection between Chinese immigrants and their hometowns. Temples, native-place associations, and even homes were more than just buildings; they were concrete representations of the cultural and social forces around which émigré life was organized. Image, identity, and place were powerful forces connecting émigré Chinese and their hometowns in China, and they were steeped into the very structures that sheltered the overseas Chinese community. Eventually, these currents of culture and identity would also return to China and have a powerful impact on its own development.

THE CHINESE DIASPORA

By the start of the twentieth century, there existed both in Southeast Asia and North America large immigrant Chinese populations. In the United States and Canada, the discovery of gold had jumpstarted Chinese immigration. For example, California's Chinese population grew from approximately 50 in the 1840s to 25,000 by 1852. In 1880 more than 100,000 Chinese resided in the United States, and that number remained relatively constant until the end of World War II.[4] When opportunities in the United States ended due to the enactment of anti-Chinese immigration laws in 1882, Canada saw its Chinese population explode from 4,383 in 1881 to 46,519 in 1931.[5] Most of the Chinese immigrants coming to North America came from China's province of Guangdong (Canton).

The number of *Huaqiao* in North America, however, paled in comparison to their cousins in Southeast Asia, who were scattered across what were then the American Philippines, British Malaya and Burma, French Indochina (Vietnam, Cambodia, Laos), the Dutch East Indies (Indonesia), and the independent Kingdom of Siam (Thailand). Large numbers of Chinese had migrated to these areas since the early fourteenth century. A 1947 census estimated that there were over 8.5 million Chinese in Southeast Asia, with the largest populations in Thailand (2.5 million), British Malaya (2.6 million), and the Dutch East Indies (1.9 million).[6]

While immigrants departed from across all of China, it was the three south-eastern provinces of Guangdong, Fujian, and Zhejiang that provided the vast majority of the *Huaqiao*. In particular, it was the people from southern Fujian (*Minnan*) who were the earliest and most enthusiastic émigrés to Southeast Asia. Small numbers of Chinese had pushed across the border into Vietnam as early as the first-century BCE, but it was not until the development of reliable maritime transportation in the tenth-century CE that we begin to see sizeable numbers journeying abroad. The first overseas Chinese were merchants, and by the fourteenth-century CE Chinese trading centers had been established across Southeast Asia. The famous Chinese explorer Zheng He (1371–1433), who sailed from China to Africa, was certainly aided by these early Chinese settlers. For example, the great trading center of Surabaya, located on the island of Java, housed a robust Chinese community of "more than a thousand families of foreigners; and among these, too, there are people from China" when he visited in 1405.[7] Wherever he traveled in Southeast Asia, Zheng utilized overseas Chinese intermediaries to conduct trade and secure spices.

Figure 7.1 allows us to gauge just how deeply early Chinese migration was interwoven with the comings and goings of Chinese traders. Chinese merchant communities, as detailed in Figure 7.1, dotted the coasts of much of Southeast Asia. Sailing south from the ports of Xiamen (Amoy) and Guang-zhou (Canton), China's traders followed the monsoon winds and ventured throughout much of peninsular and island Southeast Asia in search of goods to feed a growing Chinese economy. There, they were joined by Indian and Arab traders who were hoping to exchange their wares for local goods, as well as Chinese silks and porcelains. In the fifteenth and sixteenth centuries, the Chinese government occasionally banned ocean trade (1550–1567) but most often tolerated and occasionally even entered the trade to Southeast Asia; both long-established and new port cities grew in response to the bur-geoning commerce.[8] Manila, Hoi An, Phnom Penh, and Batavia (Jakarta) were just a few of the more prominent examples that owed their existence and continued viability to the Chinese junk trade. Indeed, when European traders arrived in the sixteenth century, overseas Chinese merchants were already in command of the intra-Asian trade.

The arrival of European colonialism in Southeast Asia in the eighteenth and nineteenth centuries only accelerated Chinese immigration. As colonial control spread across the region and the European demand for raw materials from Southeast Asia (rubber, tin, etc.) grew, there was greater demand for both the Chinese commercial agent and the Chinese laborer. Venturing out into the countryside, which European merchants were loath to do, Chinese entrepreneurs harvested vast amounts of rubber, tin, and other raw materials to be shipped back to European factories. For example, in the Philippines, overseas Chinese traders were responsible for the opening of the countryside

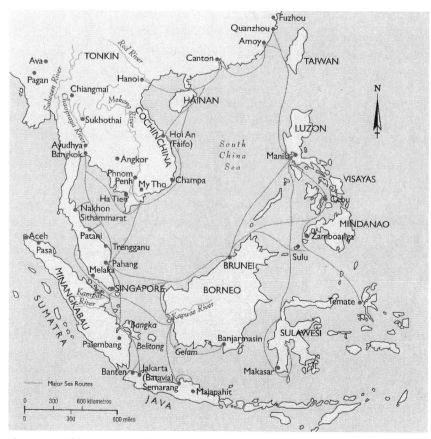

Figure 7.1 **This map shows the trade routes of overseas Chinese merchants throughout Southeast Asia. Maritime trade connected the ports of Amoy, Quanzhou, and Guangzhou to the majors cities of Southeast Asia and these eventually became major population centers for Chinese abroad.** *Source*: Anthony Reid, "Flows and Seepages in the Long-term Chinese Interaction with Southeast Asia," in *Sojourners and Settlers: Histories of Southeast Asia and the Chinese*, eds. Anthony Reid and Kristine Ailunas-Rodgers (Honolulu: University of Hawaii Press, 1996), 16. Used with permission.

for Western merchants, leading to a tenfold increase in Philippine exports between 1855 and 1902.[9]

As the European demand for Southeast Asia's raw materials continued to grow during the nineteenth century, it became clear that the indigenous peoples of the region would be unable to meet the demand for labor. European rulers and Chinese merchants, therefore, turned to China for large numbers of cheap, indentured laborers. The cities of Xiamen and Guangzhou quickly became centers for the infamous "coolie trade," which shipped large numbers

of locals to Southeast Asia to work in mines and on plantations. Just how many people left China as coolies for Southeast Asia is difficult to gauge. In Xiamen, for example, official records note over 1.3 million people departing the port between 1876 and 1899, though these numbers do not include the many people who left without being registered by local officials. By 1900, this number averaged more than 100,000 per year.[10] At the receiving end, more than 5 million Chinese arrived in British Malaya alone during the nineteenth century, with another 12 million in the first four decades of the twentieth century. In fact, by the end of the 1930s, Chinese outnumbered Malays in British Malaya.[11]

As a result of the coolie trade, enormous numbers of Chinese now lived outside of China. Figure 7.2 illustrates the size of the Chinese diaspora as it stood in 1930. As you can see, China's total population of over 500 million people was joined by an additional 15 million Chinese abroad. In some cases (Taiwan, Hong Kong, and British Malaya) overseas Chinese were the majority, but in others they represented only a fraction of the total population. We need to keep in mind, however, that even in places like Canada and the United States, where overseas Chinese represented less than 1% of the total population, *Huaqiao* continued to live in concentrated "Chinatowns" where they remained the dominant cultural and social influence.

Most overseas Chinese, however, did not consider themselves to be permanent immigrants, but rather sojourners or temporary residents in their host countries. This sojourning attitude sprang from a number of factors. The strong pull of the Chinese motherland was important: many Chinese saw themselves journeying abroad solely for economic reasons and hoped to return to China once they had made their fortune. Additionally the institutionalized racism that many Chinese encountered abroad made assimilation into those societies nearly impossible and strengthened their identity with the Chinese motherland. Whether in North America or in Southeast Asia, most *Huaqiao* were denied citizenship, ghettoized into Chinatowns that separated them from indigenous and Western residents, subjected to unfair and extraneous taxes, and often forced to carry identity cards that labeled them as "Foreign Orientals." Finally, the rise of a strong Chinese nationalism in the early twentieth century that demanded that all ethnic Chinese, no matter where they resided, contribute to the welfare of the Chinese motherland, ensured that *Huaqiao* communities abroad continued to be defined as being part of the Chinese nation.

SEEING "CHINA" IN SINGAPORE'S CHINATOWN

In April 1840 a large crowd of overseas Chinese gathered in Singapore's harbor district to welcome the arrival of a new local celebrity. Gongs and colorful

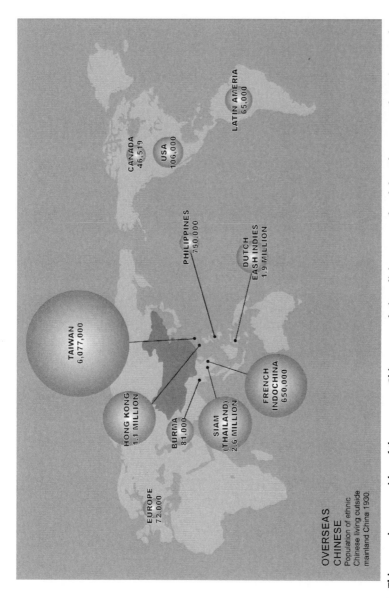

Figure 7.2 This map gives us an idea of the overseas Chinese populations living across the globe. Please note that Taiwan and Hong Kong are separated from China as a result of colonialism. What caused large numbers of Chinese to journey abroad and relocate in these countries? How do these significant numbers of Chinese living abroad force us to rethink what are the borders of China proper? Do we need to redefine the idea of "China"? *Source:* Map by Michael Lien. Used with permission.

costumes peppered the large crowd, and a group of small children enthusiastically greeted the new arrival. Conveyed in a large canopied chair decorated with yellow silk and crepe, the luminary was surrounded by a bodyguard of celestial warriors who escorted her and the tens of thousands in attendance to the newly built Thian Hock Keng (Tian Hou Gong) temple, which would be her residence in Singapore. So many Chinese residents gathered that the procession stretched for over one-third of a mile. Who was this new star in Singapore? Was it an important Chinese official or, perhaps, a famous writer or singer? No, the celebrity was not a person, but a wooden statute of the Goddess of the Sea, or Mazu as she was known among the local Fujianese immigrants.[12] Why would this figurine (Figure 7.3) deserve such a royal welcome?

In Singapore's large overseas Chinese community, which lacked the presence of the formal Chinese state, religion and culture played a much stronger role in the organization of the local community. The Thian Hock Keng Temple, pictured in Figure 7.4, was a place of worship, but its influence in Singapore's Chinese district went far beyond celestial concerns. Local disputes, judicial matters, and legal questions were also adjudicated under its roof. In order to increase the temple's importance within the eyes of the local community, every aspect of its planning and construction was infused with visual representations of the cultural links between Chinese communities overseas and the mainland.

The temple was originally a small joss house, or building dedicated to burning incense, for Mazu—the Goddess of the Sea and the patron saint of Fujian's sailors. As the number of Chinese junks or ships visiting the city's harbor increased, more and more sailors and wealthy merchants desired to display their gratitude for Mazu's protection during the long and perilous voyage from China. Eventually the small joss house became the Thian Hock Keng Temple. Sponsored by Tan Tock-seng, a wealthy Hokkien merchant, all of the building materials—the pine wood, the granite pillars, the carvings, even the craftsmen—were imported from China.

The structure of the Thian Hock Keng Temple reveals much about the vicissitudes of life in Singapore. Architecturally based upon a traditional Chinese house or palace, the temple's layout consists of a series of pavilions constructed around open courtyards that allowed for the movement of people, air, and light through its various bays. What separates Thian Hock Keng from a common house is its rich decoration. Red, black, and gold lacquered wood and brilliant tiling cover the roof and floor. Inside, several areas are specially designated for displays of gratitude toward Mazu and other deities. Perhaps the temple's most visible symbol, evident in Figure 7.4, is the collection of dragons perched on its roof. Although viewed in Western art as an embodiment of evil, the dragons of Thian Hock Keng are instead synonymous with

Figure 7.3 This is a photograph of the current Mazu statue sitting in the Thian Hock Keng Temple. Although the statue is new, the hopes and aspirations found within the statuary are not. It is located in Singapore, but the statue is distinctly Chinese. What are the markers that tell us that this is a statue created for Chinese worshippers? *Source*: Used with permission.

Figure 7.4 The Thian Hock Keng Temple. This is a picture of the Thian Hock Keng temple from the late nineteenth century shows the distinctively Chinese architecture of the temple. How do the numerous dragons and the architecture set it off as a distinctively Chinese space that is separated from the rest of the surrounding city? *Source*: Courtesy of National Museum of Singapore, National Heritage Board. Used with permission.

strength and justice. Surrounding a central flaming pearl of immortality, the dragons, which lived in water, are another representation of the dreams and risks of the Chinese immigrants who traveled to Singapore by sea. They are also an imperial emblem, the self-authorized use of which reinforced the temple's quasi-governmental status. Finally, color plays a key role in the temple's powerful imagery. The vigor and festivity of red, a common color in Chinese temples owing to its connection to marriage and family, is combined with the royal presence of yellow on the outside, while inside the temple, green tiling is a symbol of earth. These colors were another important cultural link to the homeland.

The temple's celestial residents were powerful cultural connectors to China. Its most important occupant was, of course, Mazu. Believed to be a reincarnation of Guanyin, the Goddess of Mercy, Mazu was, according to legend, born in 960 CE on Meizhou Island in Fujian. The seventh daughter of a local fisherman, Mazu was able to save her father and several of her brothers from a typhoon by praying for their safety. Near this legendary savior stood

a plaque proclaiming *Boqing nanmo* or "Tranquility in the South Seas," a direct reference to the importance of maritime trade in Singapore. Owing to the size of the Fujianese émigré population in Singapore, it should come as little surprise that Mazu played an important role in the city's religious life.

Mazu, however, was not the only inhabitant of the temple. Seated behind her is Guanyin. Another dweller is Confucius, the venerated scholar, and sitting directly opposite him is a statue of the Gambler Brother (Figure 7.5, see website). The presence of Confucius established a scholarly connection to the mainland. Fearful of losing their Chinese identity, the study of Confucian classics was an important cultural identifier for many immigrants. A similarly important cultural icon, the Gambler Brother was not the decider of games of chance, but rather of fate. The instability of life in Singapore elevated the importance of luck in seeking one's fortune among Singapore's *Huaqiao*.

Thian Hock Keng's role within the community was not limited to religious functions. It was also an administrative and welfare center. The temple was the de facto headquarters of the Chinese Kapitan—the local leader appointed by the British colonial officials to oversee tax collection, minor police matters, and judicial issues. Since the Kapitan was entrusted to maintain law and order in the Chinese community, but was not provided with funds to do so, the moral and religious presence of the temple eased his burden. Additionally, in times of need, Thian Hock Keng distributed food and medicine for the sick and needy.

Equally ubiquitous throughout Southeast Asia was another structure that symbolized the transnational flows of culture and commerce that defined Chinese communities abroad. Originally found in southeastern China, the shophouse had migrated to Southeast Asia with the Chinese diaspora. The structure had caught the eye of Singapore's governor, Sir Stamford Raffles, when he had resided in Java from 1811 to 1815.[13] Ever a devotee of commerce, Raffles admired the combination of work and residence that the building represented and mandated its appearance throughout Singapore shortly after he founded the colony in 1819.[14]

A two- or three-storied structure, the bottom level contained the occupant's business while the top acted as a residence. Owing to the area's subtropical climate, the top story extended out over the bottom floor, acting as an overhang to protect pedestrians and customers from the sun and frequent rainstorms. Moreover, shophouses were commonly built next to one another in order to provide a continuous overhang for pedestrians. Figure 1.6 (see Introduction) captures one of the buildings' most significant features. Each building adjoined the next, and each was built exactly in line with its neighbor in relation to the sidewalk, creating an uninterrupted string of commercial facades along the street. No front yards or courtyards of any kind separated their facades from the public. Rather, their aligned facades were built flush

with the sidewalk, and their doorways give out immediately onto the public street. Thus, the public space of the street was contained by a solid front of commercial space.

A number of architectural elements mediated the closeness of public and private space that traditionally had been separated by a courtyard or front yard. These elements, such as doors, windows, the overhang, and, particularly, business signs, became much more significant to the pedestrian once the facades of the buildings were made flush to the sidewalk. Nonetheless, the shophouse openings provided a means of direct communication—visual, vocal, and even tactile—between the customer and the shopkeeper, engendering exchanges of conversation, food, service, merchandise, and gestures. This was a radical change from the privacy of the courtyard design that had dominated traditional Chinese architecture. Combined with the construction of modern thoroughfares, the shophouse and the boulevard marked a radical re-conceptualization of the separation between interior and exterior, public and private, house and street; one where commercial exchange rather than privacy now dominated community life (Figure 7.6, see website).[15]

The primacy of commerce and culture were obviously ingrained into Singapore's built environment. Overseas Chinese in Singapore journeyed to the city for no other reason than to seek their fortunes. Often the very homes and streets which provided shelter were themselves commercial vessels. Living in a foreign country and isolated from the rest of the population by colonial officials, Singapore's overseas Chinese population turned to temples, schools, Chinese Chambers of Commerce, and native-place associations for important government services. Colonial governments wanted to keep the cost of running their colonies low, and so they declined to pay for the welfare and educational services of Chinese sojourners. Relying upon the traditional Chinese practice of employing elite leadership in these functions, temples and other social organizations became powerful quasi-government organizations in Chinatowns across the world. Located far beyond the confines of the borders of China, temples like the Thian Hock Keng reinforced what it meant to be Chinese, but in traditional cultural and religious terms rather than nationalistic. The ways in which the buildings of Singapore's Chinatown were constructed, painted, and decorated held particularly strong symbolic values, and they dominated the life of Chinese across the globe.

BRINGING IT ALL BACK HOME: OVERSEAS CHINESE AND CHINA

Chinese communities abroad initially maintained close cultural ties with their homes via institutions such as the Thian Hock Keng, but by the start of the

twentieth century these connections began to undergo important changes. Stung by Western criticism of China's Confucian culture as being outmoded and feudal, embarrassed by the inability of the Qing dynasty to protect China from Western imperialism, and influenced by their exposure to European nationalism while abroad, overseas Chinese sought to become a more important force for reform and change back home. Since commerce and culture dominated overseas Chinese society abroad, the return of *Huaqiao* influence naturally flowed along these lines.

While overseas Chinese in North America were limited by exclusion acts and racism in their choice of economic pursuits, some *Huaqiao* merchants in Southeast Asia had become extremely wealthy supplying European and Japanese demand for raw materials such as tin and rubber over the first two decades of the twentieth century. Remittances of foreign currency now began to flow back to China with regularity. While the majority of these funds were generally used for day-to-day expenses by relatives back in China, capital was also channeled into more productive investment like housing, business, and transportation. One overseas Chinese resident described his desire to invest in his hometown of Xiamen as follows:

> As a resident of the Philippine Islands and as a native of southern Fujian province where Xiamen is located, I am deeply interested in the fate of the city The overseas Chinese, particularly those coming from that part of the country, are closely knit with the fortune of their city and should be given a say in its administration, for they are somehow concerned with its affairs. From both far away and when we return to the city, we have always held Xiamen dear and given our wholehearted cooperation and material support when such was needed.[16]

By the 1920s, overseas Chinese investment in mainland China, particularly up and down the southeast coast from Guangzhou to Shanghai, had become a critical source of capital. Funds from North America and Southeast Asia sparked new economic opportunities, helped alleviate China's precarious balance of payments problems, and increased the economic integration of overseas Chinese communities with ancestral villages.

While it is impossible to arrive at a precise figure for total remittances from Chinese abroad back to the mainland, researchers have estimated that during the 1920s approximately CN¥425 million, or over US$210 million, was sent.[17] Again, while the majority of these funds were used by mainland relatives for living expenses, investment in housing and industry also flourished. For example, in the province with the largest overseas Chinese population, Fujian, overseas Chinese invested 125 million yuan into public utilities, real estate development, urban infrastructure projects, commerce, and banking in prewar Republican China.[18] Additionally, these investments introduced new technologies and forms of business organization from abroad. Railroads, bus

companies, and mining operations were all opened in southeast China with overseas Chinese capital.

Huaqiao were also important conduits for cultural and societal change. We have already noted the important role of overseas Chinese in educational philanthropy, particularly in their native provinces of Fujian and Guangdong. Overseas Chinese influence, however, stretched into the curriculum and pedagogy of teaching as well. The competitiveness of the Southeast Asian and North American economies required very different skills than those taught in traditional Chinese schools. English, economics, and mathematics were required subjects, and the high demand for both skilled and unskilled Chinese labor led to the creation of new schools in China that prepared young Chinese for life abroad. Perhaps the most famous example of these new currents of educational reform could be found in Xiamen University, a college completely funded and administered by overseas Chinese but located in China.[19] Additionally new tastes in clothing, theater, literature, and other forms of cultural publishing began to move back across the South China Sea.

The impact of these new commercial and cultural currents upon the villages and cities with the largest overseas Chinese populations was significant. In cities such as Guangzhou, Shantou, and Xiamen, overseas Chinese capital funded the complete reconstruction of these cities. In Xiamen, for example, local planners, builders, and business leaders decided to rebuild the city so that it catered to overseas Chinese tastes. This meant the recreation of an urban landscape that closely conformed to the colonial milieu of Southeast Asia's port cities, i.e., an environment dominated by modern transportation facilities, an orderly urban environment where business transactions could be conducted in an efficient and timely manner, and, of course, a certain style of housing (Figure 7.7, see website).[20]

As they reordered the city's urban landscape through massive land reclamation projects, urban planners produced a "Xiamen renaissance based not on European architecture, but rather a building that embodied the mercantile success of Xiamen's transnational business community—the shophouse."[21] Within the city center, in area after area, Xiamen's older homes were purchased by developers, demolished, and then replaced by rows of shophouses. This, in turn, altered the entire city milieu. No longer was Xiamen characterized by a hodgepodge of different buildings, winding roads, and a vibrant temple culture dedicated to Mazu; in its stead appeared a regularized network of modern boulevards lined with row after row of highly standardized shophouses. Fed by increasing overseas Chinese remittances and a booming real estate market, housing construction in Xiamen moved ahead at an astonishing pace. Between 1928 and 1932, more than 5,300 new homes were built within the city, with over 90% of the units funded either fully or in part by overseas Chinese capital.[22]

REIMAGINING CHINESE NATIONAL IDENTITY

The Chinese character *Huaqiao* (华侨) combines the meanings of Chinese identity (*hua*, 华) with the ideal of movement abroad (*qiao*, 侨).[23] Yet with a few different strokes of the brush or pen, the word *qiao* can be rewritten to mean bridge (桥). It is perhaps this rendition of *qiao* that best describes the role of China's overseas Chinese. While they were certainly migrants, they were also China's bridge to the outside world.

Initially, the movement of culture and people was essentially one-sided. Just as the statue of Mazu was transported from Fujian to the Thian Hock Keng temple in 1840, so too did large numbers of Fujianese and Cantonese immigrants make the perilous journey across the sea to Southeast Asia and North America. In these new and often hostile social climates, Chinese immigrants constructed powerful symbols of their home identity in the form of temples, arches, and residences. Throughout the twentieth century, in both the Republican era, and later in the post-Mao reform era as well, overseas Chinese communities worked to bring their powerful and heartfelt influences back to their ancestral hometowns and homeland; the entrepreneurial spirit as well as the characteristic versions of "traditional culture" that they forged overseas came back with them.

Even as *Huaqiao* strove to reshape their new environments in the image of their homeland, their journeys eventually changed what it meant to be Chinese. On the one hand, many overseas Chinese were deeply committed to traditional Chinese culture. The May Fourth Movement of 1919, led by radicals such as Chen Duxiu, exposed Confucian culture to withering criticism and played a critical role in the foundation of the Chinese Communist Party. Abroad, however, May Fourth intellectuals were never very popular or very powerful. To many *Huaqiao* their ideas smacked of defeatism and played into the hands of notions of Western cultural superiority. On the other hand, having spent time abroad within the modernizing confines of North America and Southeast Asia, many overseas Chinese felt that they truly understood the process of modernization and how to create a modern Chinese identity. Their vision of a modern nation was radically different from that found in the United States or Europe, in the national capital of China, or among Chinese Communist revolutionaries. Wedding the commercial wealth of overseas Chinese merchant life with a revamped Confucianism and a deeply rooted cosmopolitanism, China's overseas residents hoped to create a new vision of China that reflected these values.

Returning to the example that opened this chapter, the experiences of Lin Zhuguang help us further rethink our assumptions about the stability of national borders. The Chinese diaspora was fundamentally transnational in character; through the movement of goods, people, and ideas, it continuously

linked Chinese communities on both sides of the Pacific. In other words, what do we consider to be "local" when we live in a place whose residents are constantly moving back and forth across national boundaries? Diasporic communities, like the *Huaqiao* communities we have been discussing, undermine our traditional conceptions of national identity by their very fluidity. Figure 7.1 reminds us that this process is not new. Indeed, it has been developing for several hundred years. Yet today, amid constant reminders of the patriotic obligation to defend national borders, the experience of China's *Huaqiao* reminds us that there are many ways to define a nation. The way overseas Chinese communities in the 1920s and 1930s defined what it meant to be Chinese cautions us to rethink our assumptions of the sanctity of geographic borders in history.

NOTES

1. Xiamen huaqiao zhi bianzuan weiyuan hui, *Xiamen huaqiao zhi* (Xiamen: Lujiang chuban she, 1991), 354.

2. Zhonghua shanghui chuban weiyuanhui, *Feilubin Minlila Zhonghua shanghui sanshi zhou nian jinian li, 1904–1933* (Manila: Chinese Chamber of Commerce, 1936), ji yi.

3. Zhu Ming, "Fujian shi women de jiaxiang," *Fujian yu huaqiao*1.1 (April 1938), 17.

4. Lynn Pan (ed.), *The Encyclopedia of the Chinese Overseas* (Cambridge: Harvard University Press, 1999), 261.

5. Ibid., 235.

6. Victor Purcell, *The Chinese in Southeast Asia* (London: Oxford University Press, 1965), 3.

7. Ibid.

8. Geoff Wade, "Ming China and Southeast Asia in the 15th Century: A Reappraisal," *Asia Research Institute Working Paper Series, No.28* (Asia Research Institute, National University of Singapore, July 2004), http://www.ari.nus.edu.sg/docs/wps/wps04_028.pdf (accessed December 17, 2013).

9. Robert E. Elson, "International Commerce, the State and Society: Economic and Social Change," in *The Cambridge History of Southeast Asia, Volume 2: The Nineteenth and Twentieth Centuries*, ed. Nicholas Tarling (Cambridge: Cambridge University Press, 1992), 142.

10. Fujian sheng dangan guan, *Fujian zhi: huaqiao zhi* (Beijing: Dangan chuban she, 1990), 17–18.

11. Ibid., 37.

12. Song Ong Siang, *One Hundred Years' History of the Chinese in Singapore* (Singapore: University of Malaysia Press, 1957), 50–51.

13. Ellen C. Cangi, "Civilizing the people of Southeast Asia: Sir Stamford Raffles' Town Plan for Singapore, 1819–1823," *Planning Perspectives* 8 (1993), 167.

14. Ibid., 178.

15. I have made this argument referring to the nature of shophouse architecture before in James Cook, "Re-Imagining China: Xiamen, Overseas Chinese, and a Transnational Modernity," in *Materializing Modernity: Changes in Everyday Life in Twentieth Century China*, eds. Madeleine Yue Dong and Joshua Goldstein, 156–194. Seattle: University of Washington Press, 2006.

16. Ralph C.D. Ko, "The First Mayor of Amoy, an Overseas," *The China Critic*, VI (April 6, 1933), 358.

17. C.F. Remer, *Foreign Investments in China* (New York: Howard Fertig, 1968), 187.

18. Lin Jinzhi, "Jindai huaqiao zai Xiamen de touzi ji qi zuoyong," *Zhongguo jingjishi yanjiu*, 1987.4, 111.

19. James Cook, "Currents of Education and Identity: Overseas Chinese and Minnan Schools, 1912–1937," *Twentieth Century China* 25.2 (April 2000), 1–31.

20. Virgil Ho has argued that perhaps I overstate the sociocultural importance of the shophouse in Xiamen. In his own work, Ho focuses primarily on the city of Canton and notes that, while the shophouse was an important new architectural feature of twentieth-century construction, it was not the dominant defining element. I would agree that this might be the case in Canton, but in Xiamen and Singapore the shophouse was certainly a dominant architectural feature in their commercial centers and I would argue took on a much greater degree of primacy in the cities. For more, see Virgil Ho, "Images of Houses, Houses of Images: Some Preliminary Thoughts on the Socio-Cultural History of Urban Dwellings in Pre-1940s Canton," in *Visualizing China, 1845–1965: Moving and Still Images in Historical Narratives*, eds. Christian Henriot and Wen-hsin Yeh (Leiden: Brill, 2013), 208.

21. *Nanyang shangbao*, October 30, 1929.

22. Xiamen shi fangdi chan zhi bianzuan weiyuan hui, *Xiamen shi fangdi chan zhi* (Xiamen: Xiamen daxue chuban she, 1988), 16–17.

23. The character *qiao* first arose during the early fourth century to refer to those individuals who had moved south to escape the violence of the Eastern Jin dynasty. See *Ciyuan*, 0140.4.

Chapter 8

The Myth about Chinese Leftist Cinema

Zhiwei Xiao

A film's meaning is often defined less by its supposed "intrinsic" qualities than by the circumstance under which it is viewed. To take an example from American film: from the 1910s through the 1960s many Asian characters were played by white actors in "yellow face." While certainly viewed as offensive by most Asians and minority audiences at the time, the majority of white film viewers were generally unperturbed by these highly stereotypical and degrading portrayals of Asians; today we are immediately struck by the obvious racial prejudice of such images (Figure 8.1 below and 8.2 website). The issues in Chinese film history are, as we will see in this essay, quite different; but the central point, that the *context* in which a film is viewed is often even more important than its intrinsic *content*—that audience *reception* is often as important as image *production*—lies at the crux of this chapter. A distinction must be made between what films meant to their audiences at the time of initial release and what their future viewers read into them in later years, for these interpretations are often divorced from the experience of the moviegoers of the past.

I argue in this chapter that the labeling of a large number of 1930s Chinese films as "leftist" in current Chinese film historiography distorts historical reality. By projecting an unambiguous political reading onto these films, the label ignores the complexity of the relationship between the Chinese film industry and the Nationalist (GMD) government, disregards the political context in which these films were made, and excludes other interpretative possibilities. As I will show: 1) the so-called leftist films were often consistent with the Nationalist government's policies; 2) indeed, if there was an oppositional thrust in these films, that thrust had more to do with shifting political circumstances than with any conscious "leftist" positioning of the filmmakers and 3) the myth about leftist cinema was manufactured in post-1949 China by

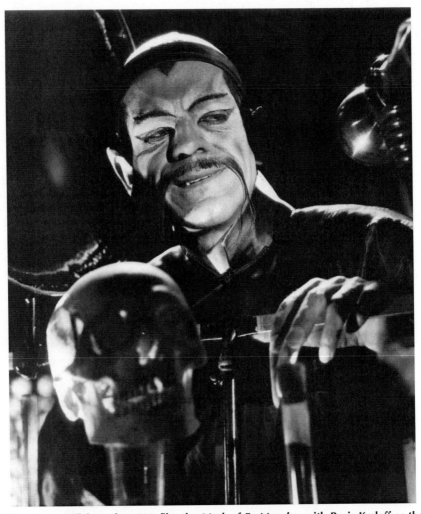

Figure 8.1 Still from the 1932 film the *Mask of Fu Manchu*, with Boris Karloff as the
evil Dr. Fu Manchu and Myrna Loy as his beautiful daughter. Both actors performed in
"yellow face" which was common in most Hollywood films at the time that included
Asian roles. The offensive stereotyped images were well-suited to the equally racist
"yellow peril" plot—Fu Manchu seeks to unearth the sword and mask of Ghengis Khan
in an attempt to rally Asia to wipe out the "white race."

a group of people to serve their own political agenda rather than for histori-
cal accuracy. All three of these points highlight that the changing context of
reception, not the intrinsic content of the celluloid images themselves, has
played a primary role in shaping how many Republican-era Chinese films
have been understood.

Indeed, the Nanjing decade (1928–1937), while a relatively stable period in comparison to the preceding all-out civil war or the warlord era (1916–1928) and the impending Japanese invasion (1937–1945), was a decade of uncertainty and change. Though the Nationalist government consolidated its rule over much of China from 1928–1937, its control over the country was still very weak. The GMD military was apparently incapable either of destroying the Communist insurgency (first in Jiangxi and later in Shaanxi Province) or of resisting the Japanese invasion of Manchuria in 1931. Even within the GMD government there was much factional wrestling, both over personal power networks and policy issues. And in Shanghai and Nanjing, modernizing cities in the heart of GMD-controlled China, there was a lively leftist cultural movement that sought to use the new mass media of popular publications and film to reach sympathetic audiences. Where did the new and extremely influential medium of film fit in the volatile world of GMD-ruled China in the 1930s? How did the GMD government attempt to turn film to its own purposes, or at least contain its potential for disruption? We will begin with these questions, and then try to understand how and why the complex answers to them have been distorted to create the overly simplistic myth of Chinese leftist cinema heroically resisting the GMD's merciless repression. Finally, we will consider what this tells us as about the power of historical context in shaping how visual images are understood.

THE YIHUA INCIDENT: A REINTERPRETATION

Early in the morning of November 12, 1933, Yihua Film Studio was vandalized by a group of young men who identified themselves as members of an anticommunist league in Shanghai. Armed with sticks and bricks and wearing masks, they broke glass, knocked over furniture, and smashed any expensive film equipment in sight. Before the studio employees had recovered from shock, the thugs had boarded a truck and sped off. As the studio staff began to assess the damage, they noticed scattered flyers that stated "Eradicate Communists" and "Down with the Treacherous Communists." The vandals also left a letter posted on the wall accusing the studio of making leftist films. The letter identified several films by their titles, including some produced by other film studios, and denounced them as propaganda for the Communist Party. The letter was signed by "The Anti-Communist Squad of the Film Industry in Shanghai" and threatened further actions if Yihua did not change its ways. The next day, other film studios in Shanghai received identical letters warning against the menace of communism and demanding that filmmakers stop making films depicting class struggle or advocating aggressive nationalism.[1]

Film historians refer to this episode as the Yihua Incident and it is typically seen as one of the key moments in what I am calling the myth of leftist film. In China's official film historiography, this incident is presented as epitomizing the repressive nature of the Nationalist regime and as evidence of the hostile environment under which leftist filmmakers operated. But this interpretation begs more questions than it answers. If the Nationalist government was unhappy with Yihua Film Studio, why didn't the authorities shut it down or send the police to arrest the filmmakers responsible for making subversive films? If the films identified by the vandals were indeed "leftist" in nature, why did the government censors approve them for general release in the first place? And if the government was behind the vandalism, why did the perpetrators of the incident have to wear masks and flee the scene?

Part of the answer lies in the factionalism and institutional rivalry within the Nationalist government centered in Nanjing. Between 1928 and 1930 the Nanjing regime developed policies to assert its authority over film production and exhibition, culminating in the establishment of the National Film Censorship Committee (NFCC) in early 1931. However, different government agencies competed for control over film censorship. The personnel makeup of the NFCC reflected this contestation: four of the censors came from the Ministry of Education, three from the Ministry of Interior and one was a GMD Party representative from the Bureau of Propaganda. This structure was inefficient because the censors answered to three different government departments. The ministries paid, promoted, and disciplined their own representatives on the NFCC, so the censors felt pressure to be loyal to their home ministries and had little motivation to work together. As a result, censors from the Ministries of Education and Interior often defied requests and directives from the GMD's Ministry of Propaganda.[2]

The GMD's lack of control over the NFCC was typical of the early years of the Nanjing decade; the GMD Party's control over the government apparatus was incomplete. Many people working for the government did not necessarily embrace the GMD doctrine or political agenda. As far as the NFCC was concerned, while the GMD representative was ferreting out political heresy, the representatives from the two ministries were more interested in sniffing out films in violation of codes of moral decency and foreign films portraying China in an offensive manner. On several occasions, the censors from the two ministries overruled the GMD representatives' objection to issuing exhibition permits to films of suspect political orientation. GMD loyalists were furious with the NFCC and frustrated with their inability to control the agency.

In early 1933, a GMD report alerted the central authorities to the infil-
tration of the film industry by Communist/leftist intellectuals. The report
identified a dozen films by title as examples of Communist influence and
blamed the NFCC for failing to take the necessary measures to suppress
them. Interestingly, the list includes several films *not* on the Yihua vandals'
list while at the same time omitting several titles mentioned in that list; in
other words, even within the right wing, there was a great deal of uncertainty
and disagreement over which films were leftist.[3] Nevertheless, both wanted
to place film censorship firmly under GMD control. As political pressure to
crack down on leftism mounted, the NFCC responded with a memo to major
film studios in Shanghai, which read, in part:

> Because film has a tremendous impact on the minds of people, it is crucial to
> choose the right subject matter. Our country is plagued by problems within and
> without and social mores are declining. It is up to film to play the role of moral
> pillar. . . . Our film industry is quite aware of its responsibility and most recent
> productions have fulfilled their social obligations. But occasionally, there are a
> few films that go too far (*jiaowangguozheng*). They either exaggerate reality, or
> advocate class struggle—both errors have grave consequences. We want to call
> your attention to this problem. Please be careful in the future.[4]

The memo's mild, nonthreatening tone suggests that the NFCC censors
believed that politically subversive films were few and that the nature of their
offense was an issue of excess, not deliberate political opposition. It was in
this context that right-wing GMD elements decided to take the matter into
their own hands, resulting in the Yihua Incident.

Hence, I would argue that the Yihua Incident sheds light on the divisions
within the Nationalist government, divisions that actually gave filmmakers
greater maneuvering space, if not legal protection. The vandalism against
Yihua Film Studio was the work of extremists and was not endorsed by the
official establishment, which is why the perpetrators had to hide their identi-
ties and flee the scene. The ransacking happened in the context of a power
struggle within the Nationalist government over who should control film
censorship. Indeed, in many ways the real target of the vandalism was not
Yihua Film Studio but the NFCC, for the calculated result of the incident
was to put enormous pressure on the NFCC, thereby justifying its takeover
by the GMD. Within a few months of the incident, the NFCC was dissolved
and reorganized. The new Central Film Censorship Committee (CFCC) was
under the direct and complete control of the GMD. Yet, as we will see, even
full GMD control over censorship did not make the lines of what constituted
political heresy any more clear-cut than before.

THE AMBIGUITIES OF MEANINGS

The battle for control of film censorship between ministry bureaucrats and GMD loyalists ended in the latter's victory. The GMD Ministry of Propaganda appointed all the CFCC censors and the new administrative structure guaranteed that they would toe the Party's line. But ironically, while the new CFCC paid more lip service to cracking down on leftist filmmaking, no substantial changes resulted from the organizational shake-up. In fact, if we look at what the government censors actually attacked in the 1930s, we find that they were far more concerned with censoring sexually suggestive content or superstitious elements from films and that political content was far less often their focus (Figure 8.3).

High-ranking party officials repeatedly condemned the commercial orientation in the film industry and urged filmmakers to be socially responsible. The campaign against martial arts and ghost films is an example of the

Figure 8.3 A still from the 27 hour long film series *The Burning of Red Lotus Temple* (*Huo shao Hongliansi*, dir. Zhang Shichang). The 19 silent films of this series were released by the Mingxing film company between 1928 and 1931 and no copies survive, but this image captures magical special affects where several warriors battle with flying swords. Films with such special effects and magical spectacle were extremely popular in Chinese cities in the 1920s and 1930s but often criticized by elites and the target of censorship.

official cultural policy. At the All China Film Producers' Conference, the GMD ideologue Chen Lifu advised that a film should be "seventy percent educational and thirty percent entertaining" (*san fen jiaoyu, qi fen yule*). Shao Yuanchong, the Minister of Propaganda, reminded conference participants that "the film enterprise is really an educational venture. . . film should not aim at catering to the [low] tastes of urbanites."[5]

Indeed, in the vast majority of cases the cuts and revisions that the censors made were not related to the films' political orientation but rather to their perceived indecency (Figure 8.4). For instance, censors required the director of *Goddess* (*Shennu*, dir. Wu Yonggang, 1934) to delete a scene where a prostitute and a man walk toward a hotel together because it was "too suggestive." (Figure 8.5, see website) The director of *Fallen-flower Village* (*Feihuacun*, dir. Cai Chusheng, 1934) had to delete a scene that showed a pair of pants falling off a bed and another that showed a girl undressing.[6] Three scenes from *The Reunion* (*Haitang hong*, dir. Zhang Shichuan, 1936), were ordered cut: two depicted gambling and a third showed a character coughing blood, an act the censors deemed distasteful.[7] For the purposes of writing a visual history it would be wonderful if frames from these deleted scenes could be featured here for analysis, but of course this footage was removed and destroyed—every historical approach is limited by it source materials.

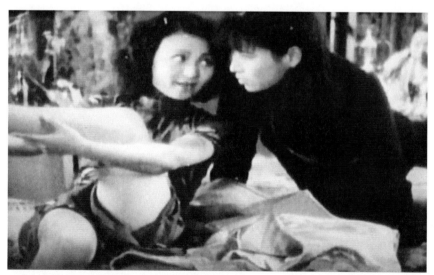

Figure 8.4 The images removed from films due to state or self-censorship in the Republican era are lost to history, but this still from *The Empress of Sport* (*Tiyu Huanghou*, dir. Sun Yu, 1934), with actress Li Lili showing off her shapely and extremely healthy legs (she plays a track star in the film) is typical of the limits of risqué displays of the female body of the time period.

These examples show that political subversion was not the main focus of
film censorship; ninety percent of the films denied exhibition permits by the
government in 1932 were for reasons having to do with sex and violence, not
political heresy.[8]

Here was the irony: the director of the newly formed CFCC, Luo Gang,
observed that the very government policies that discouraged cheap entertain-
ment flicks and encouraged films to be socially relevant and educational
directly contributed to the leftist tendency of many films. This was because,
as Luo himself noted, it was nearly impossible to realistically depict social
issues without touching on the class dimension of modern Chinese society.[9]
Luo realized that the majority of filmmakers were not underground commu-
nists, but simply filmmakers who wanted to make socially responsible films.

No wonder then that GMD censors had great difficulty in defining what
constituted a leftist film. Many examples illustrate how confused the issue
was. A 1933 issue of the Communist publication *International Literature*,
published in Moscow, praised *Spring Silkworms* (*Chuncan*, dir. Cheng Bugao,
1933) and *Dawn in the Metropolis* (*Duhui de zaochen*, dir. Cai Chusheng,
1933) as leftist films,[10] but the GMD censors did not consider these films polit-
ically problematic and never mentioned them as leftist.[11] In fact, government
censors selected several films that are now labeled as "leftist" by Communist
film historians as fine examples of Chinese filmmaking and sent them to inter-
national film festivals. For example, the Nationalist government submitted
six films for a 1933 Italian international film festival: *Three Modern Women*
(*San ge modeng nuxing*, dir. Bu Wancang, 1933), *The Dawn of Metropolis*
(*Duhui de zaochen*, dir. Cai Chusheng, 1933), *Night Life* (*Chengshi zhi ye*,
dir. Fei Mu, 1933), *Wild Rose* (*Wo de ye meigui*, dir. Sun Yu, 1932), *Freedom
Flower* (*Ziyou zhi hua*) and a documentary entitled *The Spectacles of Beijing*
(*Beiping daguan*).[12] With the exception of the documentary, all five feature
films have been labeled "leftist" by post-1949 Chinese film historians.[13] Simi-
larly, for a 1935 film festival in the USSR the CFCC censors submitted two
feature films, one of which, *The Song of Fishermen* (*Yu guang qu*, dir. Cai
Chusheng, 1935) is now lauded as a classic example of leftist filmmaking.
In 1937 the League of Nations' Education Film Commission invited China to
submit materials for inclusion in the Encyclopedia of World Cinema project;
two of the four films selected, *Song of the Fishermen* and *Big Road* (*Dalu*,
dir. Sun Yu, 1934) are now considered classic leftist films.[14] (Figure 8.6,
see website) Moreover, many supposedly leftist films received government
awards and endorsements: in 1936, the Nationalist Central Propaganda Com-
mittee honored seven films, two of which are now dubbed leftist;[15] in 1937, in
another government-sponsored film award, the winners of Gold, Silver, and
Bronze for Best Domestic Film were all written or directed by people now
considered leftists by Communist film historians.[16] High-ranking Nationalist

government officials not only endorsed "leftist films," but also supported the studios that produced them. The GMD's cultural tsar, Chen Lifu, even helped director Bu Wancang, who was responsible for several alleged leftist films, to raise CN¥ 30,000 to start his own film studio![17]

How do we explain the GMD's endorsement of supposedly leftist films? One might argue that perhaps the censors missed or misinterpreted leftist content and let it pass; but if the official censors could not detect subversive messages in these films, what was the likelihood that ordinary moviegoers at the time interpreted these films as politically oppositional? Many surviving filmmakers from the 1930s have portrayed themselves as antagonistic toward the former GMD government and have tried to explain the GMD authorities' approval of their films as their having outsmarted the censors and cleverly manipulated the system, but the consistent high visibility of so many supposedly leftist films under the GMD regime undermines the claim that these films were politically oppositional. Perhaps a closer look at historical context will help us grasp more clearly why GMD rhetoric and policies regarding film censorship were so inconsistent.

WALKING THE DIPLOMATIC TIGHTROPE: WHEN PATRIOTISM IS UNPATRIOTIC

The GMD central government viewed film as a crucial tool for mobilizing public support for China's resistance to imperialism and it often encouraged filmmakers to inject patriotic spirit in their films, but for the GMD such patriotism could be a double-edged sword. In September 1931 the Japanese Army attacked and invaded Manchuria; the NFCC quickly issued a memo encouraging major film studios to make inspirational films to rouse patriotism in their audiences.[18] Patriotism did indeed sweep the Chinese public in the wake of the Japanese attack, but as street demonstrations, boycotts of Japanese goods, and, in some cases, mob attacks on Japanese nationals escalated, the Japanese responded with further saber-rattling. On January 28, 1932, the Japanese attacked Shanghai, causing enormous loss of life and property. One of the incidents that triggered this attack involved a Chinese newspaper editorial. The editorial used the word "unfortunately" to express disappointment that an assassination attempt against Emperor Hirohito had failed. The Japanese considered this editorial an affront and demanded that the Chinese authorities shut down the newspaper office.[19] If an editorial article could be used by the Japanese as an excuse to bully China, the potential for films with anti-Japanese messages to cause an international incident was even greater.

What was the GMD to do? The GMD soon found itself trying to dampen the very patriotism it had fanned. Chiang Kai-shek repeatedly argued that

until China was ready to confront Japan militarily, China had to appease the Japanese and avoid providing them any excuses for further attacks. But Chiang's appeasement policy was roundly criticized by both the Communists and by his political rivals within the GMD. They accused him of submitting to Japanese aggression and failing to defend China. In this context, patriotic films purported to fan anti-Japanese sentiments suddenly went from being lauded by GMD officials to being deemed inconsistent with, or even oppositional to and subversive of, Chiang's appeasement policy. In 1934, the CFCC told major film studios to tone down the nationalistic rhetoric in their films.[20]

Moreover, the censors also felt depictions of Chinese life that focused on social ills might inadvertently strengthen Japanese claims that China's backwardness—its ineffective government, suffering peasantry, and lack of political unity—justified their invasion. Rather abruptly, precisely the kind of socially-conscious depictions encouraged by earlier NFCC and CFCC policies were now discouraged; representing China's darker side could help the Japanese to present themselves as potential liberators of a "backwards" China. Such films went from being seen as important tools of reform to being deemed potentially subversive of GMD efforts to protect China's national sovereignty and gain international respect (Figure 8.7, see website).

The film *Humanity* (*Rendao*, dir. Bu Wancang, 1932) is a case in point. The film initially received enthusiastic endorsement from government officials because it dealt with problems in the countryside. In an annual review of the Chinese film industry, a member of the NFCC stated that *Humanity* represented the best in Chinese filmmaking and regarded it as a "classic."[21] In 1934 *Humanity* was nominated to represent China at the Milan International Film Festival. However, as Japanese criticism of the GMD government's failure to address China's rural bankruptcy intensified, the film's depiction of rural life—with its reference to disease, famine and starvation—seemed to give credence to Japanese claims. As a result, government censors retracted their earlier praise and removed the film from the list of candidates bound for Milan.[22]

The GMD government's cultural policy constantly shifted to accommodate the changing political situation. It became nearly impossible for either filmmakers or government officials to determine whether a film was politically correct with any sense of certainty because what was advocated at one moment could be deemed inappropriate soon thereafter. In this situation, no one could be on the right side of the political spectrum all the time. The constant vacillation in government policy may have increased the risks of censorship for some films, but at the same time, government censors also understood that the problems they had with many films were due to political circumstances rather than to the intrinsic qualities of the films in question. Hence, as we have seen, the government rarely rigorously went after filmmakers for making politically inappropriate films. If the GMD censors rarely

found the films produced in 1930s Shanghai to be politically offensive, then how is it that historians in the twenty-first century have come to believe these dusty celluloid reels to be rife with leftist anti-GMD images?

THE ORIGINS OF THE LEFTIST CINEMA MYTH

Although the term "leftist cinema" did appear in official GMD documents in the 1930s and was occasionally used in fan magazines,[23] written accounts of Chinese film history published before 1949 hardly mention leftist cinema. In one of the earliest accounts of Chinese film history, Gu Jianchen in the 1934 China Film Year Book makes a passing mention of the infiltration of the film industry by Communist writer Tian Han and a couple of films scripted by leftist writers, but has no further discussion of a leftist cinema movement. In the 1940s, a film industry insider, Jiang Shangou characterized 1930s film as focused on social activism and reform, but never used the term "leftist" in his discussion.[24] The manufacturing of the leftist cinema myth did not begin until the late-1950s and picked up momentum in the 1960s. The circumstances under which this myth was created and subsequently evolved were intimately connected to factionalism and power struggles in Communist China.

In the early years of the PRC, Chinese filmmakers were generally split between those with career roots in the Shanghai film world (Shanghai was essentially China's Hollywood in the 1910s to 1940s; all of the films discussed in this paper were made in Shanghai) and those with strong ties to Yan'an, the Communist base area in the rural hinterland of Northwest China. Needless to say, those from Shanghai were mostly veteran filmmakers; the Yan'an filmmakers acquired their rudimentary film training in the Communist-controlled countryside and had almost no experience making studio films. Those from Shanghai tended to pride themselves on their technical expertise; those from Yan'an bragged about their revolutionary credentials and unquestionable loyalty to the party and Mao.[25]

In the early 1950s the Shanghai group enjoyed the upper hand. The central film bureau in Beijing was headed by Yuan Muzhi and Chen Boer, both of whom had worked in Shanghai. Not surprisingly, the bureau in Shanghai was entirely dominated by the Shanghai group, with the city's Cultural Commission under the charge of Yu Ling and Xia Yan, both longtime figures in the Shanghai film world. Indeed, Xia Yan and his friends were in powerful positions in post-1949 China and had little reason to feel threatened by the Yan'an group.

However, by the late 1950s and early 1960s the power struggle increasingly shifted in favor of the Maoist leftists from Yan'an. Xia Yan and his friends came under vicious attack, with Xia under internal investigation for his alleged antiparty activities. The charges leveled against him focused on

his using his power and influence to shelter and promote people with questionable political backgrounds and his endorsement of a number of films whose political orientations were deemed problematic.[26]

In an effort to defend themselves and prove their revolutionary credentials, Xia Yan and his group began to stress the leftist thrust of 1930s cinema and their involvement in it. In 1959, in one of the earliest articles that spearheaded the notion of leftist cinema, Yu Ling emphasized the revolutionary nature of the 1930s films, Xia's leadership role in the film industry's leftist turn, and the Party's endorsement of Xia's activities. The implication of Yu's account was obvious: the revolutionary credentials of Xia and his friends were unquestionable; their contribution to the Communist cause was immense; and, in case anyone wanted to fault them for having collaborated with capitalist film producers in 1930s Shanghai, that collaboration had been approved by top party officials.[27] At the same time, under Xia's direct backing, the film historian Cheng Jihua was composing an authoritative two-volume *History of Chinese Cinema* (*Zhongguo dianying fazhan shi*, first published in 1963). From the start, the guiding principle of this work was to foreground the Communist Party's leadership in 1930s cinema. The assessment of the pre-1949 Chinese filmmaking legacy was to be based exclusively on each and every film's political orientation. By placing "leftist cinema" at the center of his narrative, Cheng's *A History of Chinese Cinema* became the basis for many other historian's accounts of 1930s Chinese cinema, both inside and outside China.[28]

Cheng's narrative of 1930s Chinese cinema is both teleological and doctrinal. His decision on which filmmakers and films to include in his discussion, how much space to be allocated to them, and what should be the appropriate amount of praise or criticism for them was dictated not by an understanding of the 1930s reality, but by individual filmmakers' political standing in late-1950s China. Hence, the most laudatory words are reserved for Xia Yan and his friends, who still held high offices at the time the book was written and were trying to defend their status. In contrast, the films of famous 1930s directors like Bu Wancang and Sun Yu were given very little credit because both directors had already fallen from grace with the CCP leadership: Bu had followed the Nationalists to Taiwan in 1949, and Sun had been condemned as a rightist in 1957, putting all of his earlier films under a cloud of suspicion.

A surge or articles and memoirs about 1930s cinema appeared in film magazines and newspapers in the late-1950s as the Xia camp desperately tried to fight against their declining power and influence. In a last ditch attempt to save themselves from an imminent purge, Xia and his friends used whatever influence they still had to orchestrate a campaign to manufacture the leftist cinema myth and cast themselves as revolutionary heroes, dedicated to the party and loyal to the Communist cause. The truth about the 1930s Chinese

reality was never the dominant concern in this leftist cinema myth; the main impetus behind its creation was the desire of Chinese filmmakers to win, or at least survive, the power struggles of the 1950s–1970s.

Unfortunately for Xia and his "clique," their efforts did not save them. One by one, each of them was purged and subject to political persecution. Indeed, during the Cultural Revolution, Maoist leftists and Red Guards simply denounced all 1930s films in their entirety—no Republican-era film was leftist enough. Yet on a certain level the Red Guards actually accepted and recapitulated the myth of leftist cinema that Xia Yan's group had created, for they too upheld leftist politics as the only criteria on which to base film criticism and the only meaningful lens through which to view film history.[29] Even after the Cultural Revolution the leftist myth was retained in tact. The new regime under Deng Xiaoping corrected the "Maoist excesses" of the Cultural Revolution, and Xia Yan and members from his group who survived the Cultural Revolution took back the offices they had previously occupied. Of no small significance, the official debut of their return to power was occasioned by a national conference purporting to commemorate the fiftieth anniversary of the Leftist League. Xia Yan and other major figures from their camp all made speeches.[30] In the wake of this conference, there was once again an outpouring of articles, memoirs, and books about leftist cinema. With Xia Yan and his group back in power, no dissenting voice about the subject could be heard and the leftist cinema myth was firmly cemented in public discourse.

Indeed, with the political benefits associated with "leftist cinema," many have tried to jump on the bandwagon. As a result, the official list of supposedly leftist films has been expanding continuously. In 1959, Yu Ling identified thirty-five films as leftist.[31] Three years later, Cheng Jihua labeled some fifty films as leftist.[32] By the early 1990s, the chief editor of *The Chinese Leftist Cinema Movement* (*Zhongguo zuoyi dianying yundong*) included seventy-four titles as leftist.[33] Yet few scholars have questioned the inconsistency or validity of the term "leftist cinema" as a viable paradigm through which to understand films made in the past.[34]

THE CASE OF THE TWIN SISTERS

The film, *The Twin Sisters* (dir. Zheng Zhengqiu, 1934), nicely illustrates how the meaning of a given film is subject to interpretation and political manipulation. In the story, a pair of twins is separated at a young age (Figure 8.8). Years later (the film is set in 1924, during the warlord era) one of the sisters, Dabao, lives in poverty; the other, Erbao, is married to a powerful general. As fate would have it, in her attempt to find employment so that

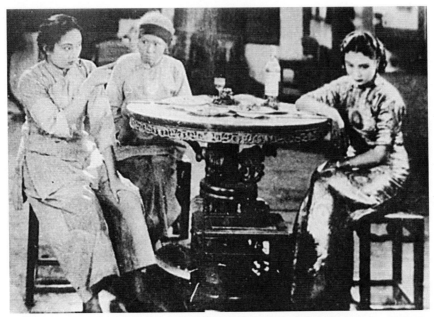

Figure 8.8 Still from the climax of the film *Twin Sisters* (*Zai sheng hua*) in which the two sisters played by Hu Die share the screen. The film touches on many of China's social problems in the 1930s, including the disparities between rich and poor and the high-handed treatment of the poor by the rich. The above image is a good example of representations that raises these class tensions but is certainly far from a clear promotion of class revolution or an unequivocal "leftist" message.

she can support her sick mother, disabled husband, and two children, Dabao, winds up working as a wet nurse for her sister Erbao's child. Of course, neither sister is aware of their blood kinship. In fact, Erbao treats her sister as she would anyone beneath her class standing—with condescension, and undisguised cruelty. Desperate for money to pay her husband's hospital bill, Dabao begs Erbao for an advance on her salary, but Erbao rejects the request, roughly slapping Dabao when she asks a second time. Driven by desperation and prompted by Erbao's abuse, Dabao attempts to steal a gold necklace from Erbao's child. It so happens that a houseguest walks in and catches Dabao in the act of stealing. As she tries to break away, Dabao pushes the guest against a wall, accidentally dislodging a vase from its stand, which falls on the head of the guest who is accidentally killed. Dabao is arrested. By another amazing coincidence, the man in charge of Dabao's alleged theft/murder case is her own father, but he does not realize that Dabao is his daughter. But when Dabao's mom comes to visit her in jail, she recognizes her husband. The heroic mother threatens to reveal her husband's sordid past (he was once an

arms smuggler dealing with foreign imperialists) if he doesn't do something to help Dabao. At the climax of the film, with the entire family reunited, Dabao denounces the rich and powerful as a cold-hearted bunch and condemns the phony nature of the class gap between her and her sister; Erbao then apologizes for the way she has treated her sister and invites her mom and her twin sister to sit in her car. With that, Dabao is rescued from certain harsh sentencing and the family patches things up.

Upon its release, the film immediately became a hit. Indeed, *The Twin Sisters* has been ranked as one of the six most popular films in the entire history of Chinese filmmaking.[35] Many critics also lauded the film. Some praised its realistic portrayals of the hardships suffered by the ordinary people and its exposure of the ugly side of the rich and powerful; others appreciated the film's craftsmanship and technical sophistication—the Chinese film industry was undergoing the transition from silent to sound, and *The Twin Sisters* demonstrated Chinese filmmakers' mastery of the new technology. The female lead, Hu Die, who played both of the twin sisters in the film, also received plaudits. Letters from fans poured in demanding the studio make a sequel.[36]

The GMD government praised the film as well. It won best sound film in 1934.[37] A year later, the Nationalist government included the actress Hu Die in a delegation to represent China's film industry at Moscow's International Film Festival and the film was submitted as an entry. Indeed, it is not hard to understand why "right-wing" members of the official establishment often liked *The Twin Sisters*. First, the film is explicitly set in 1924, the warlord era, thus relegating its depiction of human suffering to the historical past. It thus avoids directly implicating 1930s Chinese reality or the GMD. Indeed, the original version of the film includes a scene where Dabao's husband helps to distribute GMD newspapers and pamphlets espousing Sun Yat-sen's Three People's Principles (the central credo of the GMD) thereby portraying the GMD as liberators of the oppressed masses.[38] China's misery is placed at the doorstep of warlords and foreign imperialists; many of the misfortunes integral to the plot (the original abandonment of the twin sisters and their separation, the death of Dabao's father-in-law) are blamed on the violence of foreign arms smuggling. For such reasons, the "right-wing" establishment could comfortably shower the film with honors.

By the same token, many leftist intellectuals disapproved of the film precisely because in their view it failed to address the domestic roots of China's problems. Despite the focus on class issues, the solution the film proposes to resolve class conflict is, in the words of one critic, "to be reconciliatory" (*tiaohe zhuyi de taidu*) rather than resist exploitation.[39] In particular, when Dabao fumes against the exploitation of the poor by the rich, her mother (in many ways the film's ultimate heroine) repeatedly admonishes her: "We poor people are born poor. Please learn to be patient and accept your fate."

Lu Xun, China's leading leftist cultural critic, faulted *The Twin Sisters* on account of this "poor man's philosophy" and lamented that if people are taught to accept their fate, the future of China will be hopeless.[40]

Despite the left's dismissal of the film in the 1930s, in post-1949 China, *The Twin Sisters* gradually metamorphosed into a model leftist film. At first, in the 1950s, Communist film historians continued to view the film as politically problematic and ideologically dubious. One author denounced it as an example of the wrong kind of mass appeal.[41] While a few 1950s critics did think the film noteworthy,[42] it was generally excluded from the honor roll of progressive leftist films.[43] It was not until after the Cultural Revolution, in the 1980s, that *The Twin Sisters* became consistently labeled "leftist." First, in an article to commemorate Zheng Zhengqiu, Xia Yan, suggested that *The Twin Sisters* was a "transitional work" marking Zheng's shift to progressive filmmaking; as such it necessarily contained both backward and revolutionary elements.[44] Xia's remarks signaled a more lenient assessment of Zheng and his films on the part of the official establishment. A study of Zheng's entire film repertoire was soon published crediting Zheng for his contribution to Chinese film history.[45] Today *The Twin Sisters* is most often described as a successful model of revolutionary filmmaking that exhibits both the correct ideological orientation (i.e., promulgating class consciousness) and an ability to appeal to mass audiences.[46] We see here the myth of leftist film in action: *The Twin Sisters*, a film rejected by the Chinese left when it was made, is now described as a model of Republican-era leftist art.

CONCLUSION

In discussing myth making as an approach to history, Paul Cohen has observed that typically, mythologization achieves its effect "not through out-and-out falsification but through distortion, oversimplification, and omission of material that doesn't serve its purpose or runs counter to it."[47] Cohen's insight is a useful reminder when dismantling the myth about leftist cinema.

It is an undeniable fact that there was a flourishing leftist culture during the Republican period. It is also beyond dispute that a number of underground Communist writers, already active in the left-wing cultural movement, became involved in filmmaking in the early 1930s. No serious historian should be blind to the influence of the leftist movement on the filmmaking of the time. But to what extent that influence constituted a "leftist cinema movement" and in what sense the films that involved underground Communist writers were subversive and antagonistic to the GMD government are questions open for debate and far from settled.

As I have demonstrated in this chapter, while right-wing Nationalists in the 1930s may have made a ruckus about leftist films as a strategy to justify taking control of film censorship from more liberal elements in the government, overall the Nationalist government was quite receptive to the very films that are now labeled leftist. I have also stressed the fluidity of the historical context which renders the meanings of the films from this period extremely ambiguous. Any attempt to interpret these films from a single angle will fail to bring out their complexities and multiplicity in meanings. While Xia and his friends may deserve our sympathy and though it is understandable that they would want to repackage 1930s cinema to save themselves from a political purge in the Mao era, the myth they have created and perpetuated is a too simplistic and one-dimensional representation of Chinese filmmaking during the Republican era. This narrowly defined political interpretive framework hampers our fuller and more complex appreciation of 1930s Chinese films.

NOTES

1. The incident is reported in *Damei wanbao* (*Evening News*), November 13, 1933. See *Guowen zhoubao*, 11:6 (February 1934) for the full text of this letter.

2. For more details about the NFCC operations, see Zhiwei Xiao, *Film Censorship in China, 1927–1937*, a Ph.D. dissertation, Department of History, University of California, San Diego, 1994.

3. No. 2 Historical Archives, Nanjing, 2 (2)-271/16J1505, dated April 5, 1933.

4. *Dianying jiancha weiyuanhui gongzuo baogao* (The work report of the national film censorship committee), Nanjing, 1934, p. 64.

5. *Quanguo dianying gongsi fuzeren tanhua hui jiniance* (The symposium of all China film studio executives, conference proceedings), 1934, p. 30.

6. *Zhongyang dianying jiancha weiyuanhui gongbao* (The central film censorship committee news bulletin, hereafter ZYGB), 1:9 (1934), p. 37.

7. Ibid, 3:8 (1936), p. 48.

8. *ZYGB*, 1:2 (1932).

9. Luo Gang, "Zhongyang dianjian gongzuo gaikuang" (An overview of film censorship under the CFCC), in *Zhongguo dianying nianjian* 1934 (China film year book, 1934), Nanjing: 1935, pp. 1–3.

10. For details of the article, see *International Literature*, no. 4 (1933), p. 153. This journal was published in Moscow and distributed throughout the world, including China. Presumably, the Nationalists had access to this publication.

11. No. 2 Historical Archives (2)—271/16J1505, dated April 5, 1933.

12. See *The Work Report of the National Film Censorship Committee* (Dianying jiancha weiyuanhui gongzuo baogao), Nanjing: 1934, pp. 42–43. *Freedom Flower* is not mentioned in any sources currently available, which raises the possibility that it may be *Freedom Soul* (*Ziyou hun*, dir. Wang Cilong, 1931).

13. Although the Chinese sources mention Milan as the site of this event, no research in Italian has confirmed the reference. My thanks go to Ms. Pollacchi Elena for bringing my attention to this issue.

14. *Yingxi nianjian* (Film year book), p. 45. The date of this publication is unknown, but its contents suggest that it was published between 1936 and 1937.

15. "Zhongyang xuanchuanbu juban guochan yingpian pingxuan" (The CPC set up best film award for domestic productions), in *Zhongyang ribao* (Central daily), June 1, 1936.

16. "Benjie guochan yingpian pingxuan jiexiao" (This year's film award has been announced), *DS*, 6:25 (1937), p. 1076.

17. You Li, "Bu Wancang juran kai dujiao gongsi, Chen Lifu dai choubei ziben sanwanyuan" (Bu starts a company of his own, Chen raises 30,000 for him), in *Yule Zhoubao* (*Variety*), 1:5 (1935), p. 166.

18. *ZYBG*, 1:1 (1931), p. 28.

19. Donald Jordan, *China's Trial by Fire: The Shanghai War of 1932*, Ann Arbor: University of Michigan Press, 2001, p. 11.

20. See *ZYBG*, 1:5 (1934).

21. Guo Youshou, "Er shi er nian zhi guochan dianying" (Chinese film in 1933), in *China film year book 1934*. Guo later defected to mainland China while serving as a diplomat to Europe for the Nationalist government. See Qian Wen, "Yi pian danxin bao chunhui – Guo Youshou qiyi qianhou" (A loyal heart to motherland—the defection of Guo Youshou), in *Minguo chunqiu* (Republican forum), no. 5 (1992), pp. 59–64.

22. *ZYGB*, 1:6 (1934), p. 3 and *The Work Report of the National Film Censorship Committee*, Nanjing: 1934, p. 43.

23. For instance, in Jia Mo's critique of the ideological orientation in Chinese filmmaking. See Jia Mo, "Yingxing yingpian yu ruanxing yingpian" (Hard films versus soft films), in *Xiandai dianying* (Modern cinema), 1:6 (1933).

24. Jiang Shangou, *Yinguo neimu* (Inside the film world), Shanghai: Tiandi chubanshe, 1946.

25. Paul Clark, *Chinese Cinema: Culture and Politics since 1949,* New York: Cambridge University Press, 1987.

26. "Shanghai shi dianying ju guanyu san shi niandai wenxue yanjiu suo de renyuan peibei chuangzuo qingkuang" (The film bureau of the Shanghai municipal government: details concerning the Institute of Literary Studies in the 1930s—its personnel and output), SMA, B177-1-297. The document is dated 1964.

27. Yu Ling, "Dang zai jiefangqian dui Zhongguo dianying de lingdao yu douzheng" (The Communist party's leadership in the film industry before liberation), in *Zhongguo dianying* (China screen), 5 (1959), pp. 29–33 and 6 (1959), pp. 42–46. Yu himself was actively involved in writing film criticism in the 1930s and was a close ally of Xia. After 1949, while Xia served as the director of the Cultural Bureau of the Shanghai Municipal government, Yu was Xia's deputy director.

28. Among the more influential derivative accounts, Jay Leyda's *Dianying: An Account of Films and the Film Audience in China* (Cabridge, Mass., MIT Press, 1972) has in turn become the source of many English writings about 1930s Chinese film.

29. For examples of Red Guard publications, see "Yi Jianghua wei wuqi, chedi zalan dianying jie fan geming xiuzheng zhuyi wenyi heixian" (Using Mao's talk as weapon, smash the counter-revolutionary black line in the film industry), May 3 1967.

30. Hu Qiaomu, "Zai jinian 'Zuolian' chengli wu shi zhounian dahui shang de jianghua" (Speech at the conference commemorating the fiftieth anniversary of the Left League), originally published in *Renmin ribao* (*People's daily*), April 7, 1980, reprinted in *Zhongguo dianying nianjian 1981* (*China film year book, 1981*), Beijing: Zhongguo dianying chubanshe, 1982, pp. 187–88.

31. Yu Ling, "Dang zai jiefangqian dui Zhongguo dianying de lingdao yu dou-zheng" (The Communist party's leadership in the film industry before liberation), in *China Screen*, 5 (1959), pp. 29–33 and 6 (1959), pp. 42–46.

32. For Cheng's discussion of leftist cinema, see his *Zhongguo dianying fazhan shi* (*A History of Chinese Cinema*), Beijing: 1981, pp. 171–493.

33. Chen Bo, ed., *Zhongguo zuoyi dianying yundong* (*The Leftist Cinema Movement in China*), Beijing: China Film Press, 1993.

34. One rare exception is Lu Hongshi, who questions the notion of leftist cinema in a footnote. See his *Zhongguo dianying shi, 1905–1949* (*A History of Chinese Cinema, 1905–1949*), Beijing: Wenhua yishu chubanshe, 2005, p. 61, footnote 1.

35. Li Yizhong, "Zhongguo dianying jiushi nian liu da maizuo pian tanxi" (An analysis of six box office hits in the 90 years of Chinese film history), in *Dangdai dianying* (*Contemporary Cinema*) 6 (1993), 8–16.

36. Xuan Jinglin, "Wo de yinmu shenghuo" (My Life as a Movie Actress), in *China Screen,* 3 (1956), 72–75.

37. "Guochan pian bisai jiexiao" (The results of domestic film competition), *Diany-ing shibao* (*Movie Times*), July 16 (1934), 2.

38. The surviving print of the film being circulated today no longer has these details, and, interestingly, in the reprint of the director's own reflective article on this film in the early 1990s, his comments about these specific details are also deleted. One wonders if the disappearance of such details from the current film print and in docu-mentary references to them is merely coincidental. For Zheng Zhengqiu's article, see his "Zimei hua de ziwo pipan" (Self criticism on The Twin Sisters), in *Shehui yuebao* (*Society Monthly*) 1 (June 15, 1934), 39–41; for reprint of his article, see "Zhongguo zaoqi yingren zishu" (Early Chinese filmmakers: in their own words), in *Shang ying huabao* (*Shanghai Film Studio Pictorial*) 10 (1991), 22.

39. Ya Fu, "Zimei hua ping yi" (Comments on The Twin Sisters, I), in Yi Ming ed., *San shi niandai Zhongguo dianying pinglun wenxuan* (*An anthology of reviews of the 1930s Chinese films*), pp. 34–5.

40. Lu Xun, "Yunming" (Fate), in *Lu Xun, Lu Xun quanji* (*The Complete Works of Lu Xun*), vol. 5, pp. 442–3.

41. Yuan Wenshu, "Jianchi dianying wei gongnongbing fuwu de fangzhen" (Upholding the principle of film serving the workers, peasants and soldiers), in *China Screen*, 1 (1957), 20.

42. Yang Deli, "Zunzhong lishi he qianren" (Respect history and forerunners), in *China Screen*, 5 (1957), 1–3.

43. Yu Ling, "Dang zai jiefang qian dui Zhongguo dianying de lingdao yu dou-zheng" (The Communist party's leadership and struggle in the Chinese film industry before liberation), *China Screen*, 5–6 (1959), 29–33; 42–46.

44. Xia Yan, "Jinian Zheng Zhengqiu xiansheng" (Remember Mr. Zheng Zhengqiu), Shangying xinxi (Shanghai film studio news bulletin) (February 20, 1989), reprinted in *Zhongguo dianying nianjian* (*China Film Yearbook*) 1989, 311–12.

45. Li Jinsheng, "Lun Zheng Zhengqiu" (A study of Zheng Zhengqiu), in *Dianying yishu* (*Film Art*), 1–2 (1989).

46. Tan Chunfa, "Shunhu shidai he guanzhong de yishujia – jinian Zheng Zhengqiu danchen yi bai zhounian" (Conforming to his time and serving his audience—commemorating Zheng's 100 anniversary), in *Dangdai dianying* (*Contemporary Cinema*) 1 (1989), 86–95.

47. Paul Cohen, *History in Three Keys: the Boxers as Event, Experience, and Myth*, New York: Columbia University Press, 1997, pp. 213–4.

Chapter 9

Imagining the Refugee

The Emergence of a State Welfare System in the War of Resistance

Lu Liu

In late-August 2005, Hurricane Katrina pounded the Gulf Coast of the United States, leaving a trail of devastation and human suffering. For the millions of television viewers worldwide who had been following the news, initial curiosity quickly turned into fear, concern, and profound sorrow at the catastrophe that destroyed neighborhoods, killed 1,300 people, and displaced 1.1 million residents. Soon this sorrow turned to frustration and outrage at the patent failure of the government—local, state, and federal—to respond effectively to the crisis.[1] The disaster exposed gaping flaws in the government's emergency management. The 600-page National Response Plan to coordinate federal agencies and integrate them with state, local, and private sector partners was put to the test and came up tragically short. Waves of criticism across the political spectrum assailed the relief response by national and local governments to the disaster.

Now imagine if Hurricane Katrina had broken out on a much larger scale. Not limited to the Gulf Coast, its devastation covers an area ranging from Massachusetts to Florida; not confined to just the one historic city of New Orleans, it batters multiple political, cultural, and financial centers such as New York, Washington D.C., Boston, and Miami—all would have to be abandoned. Imagine tens of millions of refugees as well as thousands of businesses, factories, universities and other institutions had to be evacuated. How would the government react to meet the challenges of such a catastrophe?

That was precisely what happened in China toward the end of the 1930s. The Nationalist Guomindang (GMD) government was facing exactly such a challenge as China was plunged into a total war that would soon develop into World War II. Beginning in July 1937, Japan initiated a series of invasions first along the eastern coast and in central China, then in 1938 pushed its

military advance farther westward. After a series of military frustrations, the GMD government was forced to relocate the national capital from Nanjing, located near China's southeast coast, to Chongqing, a mountainous city deep within the western interior.

This chapter describes the massive human tragedy and exodus instigated by the Japanese invasion—but that is merely the setting of our story, not its primary focus. The comparison with Hurricane Katrina not only helps us understand the enormous scale of the wartime catastrophe, but also its important political and historical consequences. Catastrophic events like Katrina and the Japanese invasion are certainly real occurrences that directly affect the lives of millions of people, but they are also events that become media spectacles for even larger national and global audiences. The representations of such catastrophes can have a tremendous impact on how they are interpreted—particularly on how they are interpreted politically—and therefore also on how they are handled when governments respond to them.

Let's look at Hurricane Katrina first as an example (Figure 9.1, see website). To the hundreds of thousands of the victims and the viewing public, the floods were initially experienced as horrible acts of nature. But within hours of the dikes collapsing in New Orleans the news media began representing the tragedy as quite probably involving political incompetence. Criticism was largely prompted by televised images of residents who remained in New Orleans without water, food, or shelter, as well as images of the deaths of citizens by thirst, exhaustion, and violence days after the storm itself passed. For television audiences, the city's descent into disorder was epitomized by the scene at the convention center. Starting August 31, images from the New Orleans Convention Center dominated the television news. Television networks started to run a montage of graphic scenes from the center, including pictures of dead bodies. As CNN correspondent Chris Lawrence reported, "[T]here are thousands of people just lying in the street. They have nowhere to go. . . . Some of these babies, 3, 4, 5 months old, living in these horrible conditions. Putrid food on the ground, sewage, their feet sitting in sewage. We saw feces on the ground. It is—these people are being forced to live like animals."[2]

More than representing suffering, the images of the refugees exposed the ignorance of relief officials. While television stations were broadcasting images of victims stranded and starving, Federal Emergency Management Agency (FEMA) director Michael D. Brown was shown expressing his satisfaction with the city's preparation for the hurricane, and city officials were telling people that the convention center had food and evacuation facilities. With the official rhetoric in such sharp contrast to the refugees' actual plight, the public could not help directing their anger toward

officialdom: "We have been abandoned by our own country," Jefferson Parish President Aaron Broussard sobbed on NBC's Meet the Press, "Bureaucracy has committed murder here in the greater New Orleans area, and bureaucracy has to stand trial before Congress now."[3] Neither was the President of United States spared public critique. The image of President George W. Bush staring out the window thousands of feet above the devastation as Air Force One traversed the Gulf Coast epitomized the impression that he was aloof and out of touch, discrediting his ability to lead. His popularity plummeted: 63 percent of Americans disapproved of Bush's handling of Katrina.[4]

As this sketch of the coverage of Hurricane Katrina makes clear, images can be presented to pursue specific political goals. Televised images of neglected hurricane refugees contributed greatly to framing the public's interpretation of the tragedy as a direct result of political incompetence. A natural storm led to a political storm for the Bush administration.

The refugee crisis wrought by the Japanese invasion in 1937 followed a somewhat similar trajectory: news media focused on the plight of millions of war refugees, while social and cultural elites elaborated on a variety of responses to the refugee crisis, including criticizing the GMD government's indifference to their dire needs. This chapter examines visual representations of the Chinese refugee crisis of the late-1930s, and the official and unofficial interpretations and reactions to that crisis. The primary point is to highlight how the Japanese invasion and the consequent refugee crisis became a source for transforming people's ideas on the management of disaster relief, and how the media discussions and images of the refugee plight led to national supervision and involvement of the GMD state in a sphere that had historically been dominated by local elites and charities. The first section focuses on visual representations of Chinese refugees created by the news media in the first months of the invasion in late 1937 and early 1938. Images of war refugees stirred up public anxieties about chaos and public health and contributed to the constructed knowledge of "the refugee problem." The next two sections examine political responses to the media representation. First, we look at how the U.S. media used images of Chinese refugees to help collect aid for wartime China and boost the war effort. We then turn to Chinese interpretations of the crisis, where perceptions of the refugee crisis led to a consensus on the insufficiency of the existing relief measures, and where intensive news coverage of war refugees finally impelled the full engagement of the central government. The last section surveys the services and facilities that the GMD extended to mass evacuees en route to the interior. By the end of the war, the GMD government had displaced the private sector of voluntarism—native-place associations in particular—as the primary provider of welfare.

VISUALIZING REFUGEES

On July 7, 1937, Japan initiated an attack on Beijing, then known as Beiping. China reacted with the War of Resistance (1937–1945), which developed into the China theater of World War II. The invasion generated masses of refugees in unprecedented numbers. When the Japanese army reached the suburbs of Shanghai in early August, acute anxieties arose among urban residents. For some, fear of the unpredictable behavior of the Japanese troops was sufficient to induce an immediate abandonment of their homes. Rumor soon spread that the coming battle would be extremely violent and that civilians would not be spared. Figure 9.2 depicts Shanghai residents pouring into the French concession for refuge. The crowds were "like the waves of the Qiantang River. All kinds of sound—babies crying, elders yelling for help when pushed to the ground, parents screaming for lost children—pierced into

Figure 9.2 Thousands of residents of Shanghai's Native City press for admission to the French Concession on November 15, 1937. Many waited at the gates for days, but the French authorities did not grant entry due to sanitary and other concerns. This photograph (originally run in the 1937 *North China Daily News*) like many others recording these events, depict a "sea" of humanity, swamping cars and other vehicles, in such a dense crush that no ground can be seen. Taken at the end of the Porte du Nord, at B. des Deux Republiques. Much thanks to Christian Henriot for permission to use. From: Virtual Shanghai: Shanghai Urban Space in Time, at www.virtualshanghai.net.

everyone's heart."[5] The local population started to desert their communities, loading their meager belongings onto their backs, carts or rickshaws. Day and night, roads and bridges leading to the foreign concessions were jammed with crowds.

The refugees' plight was covered by news media, both through visual documentation and graphic description. While the foreign concessions provided a safe destination for the displaced, many found it extremely difficult to get in. Facing the torrent of refugees and an impending struggle over limited resources of food, water, and lodging, the concession authorities reacted with strict measures. Foreign patrolmen armed with guns set up bamboo fences and steel gates at the intersections to the concessions. Though a thin line of fence, as shown in Figure 9.2, it composed the demarcation line between "heaven" and "hell." Every day thousands of refugees stood in front of the gates waiting for any opportunity to cross over.

Refugees endured shortages of food, living space, and money. Everywhere outside the fence was misery (Figure 9.3, see website). Refugees sat on sidewalks, leaned against walls, beside doorsteps and shop doors "like big piles of trash." Frequent rains visited them too. Lying on the ground, they were soaked by muddy water. "Too tired to care about rain or dirt, they remain asleep. One can easily read the exhaustion on their faces."[6] Food supplies hardly met demand, and the cries of children were inescapable. In a sea of refugees, social workers resorted to throwing buns and dough sticks directly into the crowds. Fights ensued: "The hungry cared least about social decency. Young adults jumped high for a quick catch in the air, with the weak, the old, and women crying for mercy."[7] Refugees were plagued with diarrhea and beriberi due to a lack of nutrition. According to news reports, nearly 200 refugees died each day of hunger or malaria.[8]

The relocation of refugees—first to their ancestral hometowns and then to "Free China" in the western interior—was deemed essential. Like many treaty port cities, Shanghai had a huge sojourning population. In September 1937, the northern part of the Jiangsu province received 250,000 returnees, among them many industrial workers and rickshaw pullers.[9] But many refugees came from much farther away and had no means of transport home. Rail cars either faced bombing or were subject to military requisition. Shipping companies refused to lend their sampans and tugs for long distance use or asked impossibly high fees. Toward the end of 1937, when Shanghai and Nanjing were lost to the Japanese troops, millions of refugees voted with their feet and thus initiated one of the great migrations in human history.

The literature and media of the time carried graphic reports on the desperate plight of the refugees in relocation. When added to movements of armies and equipment, the relocation of civilians placed an intolerable burden on logistics. Photographs, artist renderings (Figure 9.4, see website), and written

accounts of these scenes convey that the most striking impression for observers was the sheer mass of refugees: "[T]heir number! . . . They overran everything; they were everywhere."[10] Railway networks nationwide faced severe challenges. There were never enough trains available to use for relocation. Lines were frequently subject to traffic jams. The management of the railway system was anything but systematic. To miss a train was often nothing short of a tragedy. Trains arrived hours or days late and departed without warning, leaving crowds of passengers behind, pursuing cars along the track, shouting and waving.[11] Thousands of families were separated. In response to the crises, by the end of 1937, the public was demanding sweeping social welfare reforms.

FOREIGN REACTIONS TO AND USES OF IMAGES OF SINO-JAPANESE WAR REFUGEES

Soon, accounts of Japanese atrocities reached foreign audiences, and China's resistance became a major international news story. In the October 4, 1937 issue of *Life* magazine, an estimated 136 million readers saw the famous picture (Figure 9.5) of a crying Chinese babysitting helplessly amid the ruins of the South Railway Station in Shanghai after a Japanese air raid.[12] The pitiable sight of the lone baby had a profound impact on Americans. As Christopher Jespersen points out in his research on the changing American images of China during the 1930s and 1940s, the impression that helpless China was being tormented by evil Japan soon became entrenched in the United States and helped generate an anti-Japanese atmosphere. In a 1937 Gallup poll that asked Americans what events interested them the most during that year, the Ohio floods topped the list, but just below them came the Sino-Japanese War. Americans' sympathy clearly lay with the Chinese, rising from 43 percent in August 1937 to 74 percent by May 1939. In 1938, more Americans were concerned with the China war than with the German movement into Austria.[13]

It was out of such concern that Americans translated their sympathy into tangible assistance. A variety of civic organizations became channels supporting relief efforts for Chinese refugees. The American Committee for Chinese War Orphans directed its efforts toward providing shelter, food, and care for the rising population of refugee children; the American Bureau for Medical Aid to China raised money to provide medical treatment to civilian victims and wounded soldiers, and in1941 it was consolidated with the United China Relief (UCR). The UCR released numerous publications for fundraising purposes, and the powerful and moving image of the crying Chinese baby was reprinted in newspapers and magazines and used in newsreel footage across

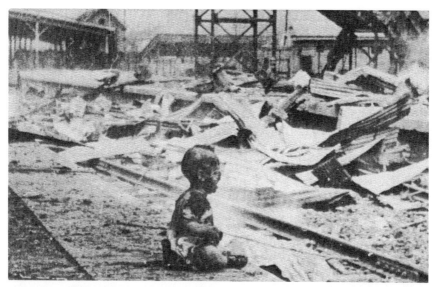

Figure 9.5 Baby crying at Shanghai railway station, after Japanese bombing; aka the "Bloody Saturday" photograph. On August 28, 1937, the Japanese launched an air attack on the Shanghai south railway station, killing hundreds. This photo, taken by H. S. Wong, a Chinese-American employee of the Hearst Metrotone News, became an iconic image of Japanese wartime atrocities in China. But it has also been the subject of controversy: there is some evidence that the child was posed by Wong, and some argue that the photo incites anger by presenting an exaggerated image of Japanese cruelty. See website for more on this debate. From: National Archives, ID 535557.

the nation. One of the UCR postcards featured this photo, and the reverse side bore a note of explanation: "This is Ping Mei—a child of China. . . . He is one of 50 million refugees who desperately need food, clothing, shelter, medical aid." Another anecdote tells well the power of the crying baby image: When Madame Chiang Kai-shek, the First Lady of China, visited the United States five years after the Shanghai bombing in November 1942, waiting for her at the White House was a letter from Cathleen Quinn of East Orange, New Jersey. Enclosed along with the letter was three dollars from Mrs. Quinn and her daughters—with instructions explaining that it was to help "the little guy on the railroad tracks somewhere in China."[14]

Images of the "50 million" Chinese refugees were circulated more widely in the United States after the bombing of Pearl Harbor, this time for domestic mobilization of the war effort. Shortly after the United States entered World War II, Frank Capra, the Hollywood director, accepted the task of preparing a series of orientation films for American troops. The seven core films subsequently produced under the collective title *Why We Fight* highlighted

the theme that two worlds were locked in mortal combat, the free world and the slave, "civilization against barbarism," "good against evil," the Allied "way of life" as opposed to the Axis "way of death." One film in the series was devoted exclusively to the war in Asia. Titled *The Battle of China*, this was an epic paean to the resistance of the Chinese people against Japan's aggression, made in part with cooperation and footage supplied by the GMD (see Introduction, Figure 1.7). Building upon American sympathy for the Chinese and anti-Japanese sentiments, the Capra touch was displayed in striking scenes of Chinese dignity and heroism amid an orgy of Japanese destruction and atrocity. Such a contrast was heightened by the film's commentary, in which Japan's rhetoric of "co-existence and co-prosperity" was recited while the screen showed the devastation of China's cities and the mutilated corpses of its men, women, and children.[15]

The Battle of China devoted nearly five minutes of newsreel footage to the heroic march of Chinese refugees from the coast to the interior (Figure 9.6, see website). American audiences witnessed the dismantling of modern industries, the pulling of junks and boats on which parts of machinery were loaded and then guided by human hands along the narrow passes of the Yangtze River's Three Gorges, the retreat of modern educational institutions, and the evacuation of millions of refugees either packed on top of trains or fleeing by foot. It was, as the film's narrator declared, "the greatest mass migration ever recorded."[16] Indeed, among Capra's explicit attempts to win sympathy by building parallels between Chinese and U.S. history, he frames this westward migration in terms deeply resonant with U.S. narratives of Manifest Destiny: "moving westward on a trek that stretched through 2,000 miles of roadless wilderness. . . Westward to freedom."[17] Just like their American counterparts, the Chinese of *The Battle of China* were carrying the torch of freedom for a better postwar world. During the course of WWII, the *Why We Fight* films were shown as required viewing for millions of American soldiers in addition to public theaters across America and overseas, where they were distributed with soundtracks in French, Spanish, Russian, and Chinese.

DEBATING SOCIAL WELFARE

In China, images of the refugees were being used as well, at times to bolster Nationalist mobilization, but also for quite different ends. Historically, disaster relief in China had been handled primarily by the private sector. Local elites were expected to contribute resources for the public good at private expense. Historian Timothy Brook documented a famine relief incident in a small county along the southeast coast of China in 1751 as follows:

The magistrate deputed gentry to go to the wealthy people and encourage them to make donations. Li Changyu and his friend Tu Ketang rushed about encouraging people to forward grain and were successful in amassing the required amount. The magistrate suggested setting up a central soup kitchen, but Li Changyu pointed out the dangers of doing so. . . . [He argued that] the better method would be to draw up ward registers and distribute grain directly to the people [in their home areas]. . . . The magistrate agreed to his plan and thousands of lives were saved.[18]

This event highlights certain fundamental patterns of social relief at the local level in late imperial Chinese society. First, local elites were the primary benefactors. The types of aid provided by elites included collecting and distributing gruel to the hungry; caring for the weak, aged, widows, and orphans; providing medical care; housing the homeless; and, if the displaced were immigrants, dispersing refugees to hometowns. Second, in terms of the relationship between the state and local society, the magistrate as the representative of state authority was constrained by limited resources and understaffing. He had to ask for help from local elites and rely heavily upon their cooperation. Thus, elites such as Li and Tu played a leadership role throughout the relief effort. Finally, note that central government intervention barely existed in this case of famine relief. While Beijing did from time to time allocate resources for the management of big disasters, such aid was assigned mainly in the form of special relief funds and delivered in an *ad hoc* manner without an established role for the central government or coordinated relief plans.

The Taiping Rebellion of the mid-nineteenth century, the largest peasant rebellion in Chinese history, brought more opportunities for local elites to expand their activism. After a decade-long endeavor to suppress the revolt, the government had exhausted its resources and had to depend upon local elites for reconstruction projects. The consequence of this was a trend toward even greater elite ascendancy and a further decline of state control over local society. Urban areas in particular witnessed the rising power of civic society. Migrant merchants and workers founded a variety of guilds and native-place associations, organizing celebrations in addition to providing the forms of relief described above. If a family could not afford a coffin, the guilds would provide burial expenses for the deceased. Figure 9.7 is an illustration from the *Dianshizhai Pictorial*, a popular magazine published in Shanghai in the 1880s and 1890s. The sketch depicts an obviously destitute household with few belongings. Three men stand by a plank bed, on which a recently deceased man is covered with a padded quilt. According to the commentary at the top of the sketch, the elderly man standing closest to the bed is a representative from a Shanghai trade guild who provided the family with 17,000 copper cash for funeral expenses.[19] Pictorials like this reminded the

Figure 9.7 Image from *Dianshizhai Pictorial*, an illustrated supplement to Shanghai's leading newspaper, *Shenbao*. *Dianshizhai* used methods of lithographic printing that coupled rapid reproduction with great sharpness of detail, qualities that imparted a sense of immediacy and clarity and lending the paper's representations an aura of realism. From: *Dianshizhai Pictorial*, series 4, vol. 4. Shanghai: Shenbao guan, 1895.

magazine's elite and educated readers that such activities for the public good were central to maintaining their place in society.

The tradition of voluntarism under the nominal supervision of the government continued into the Republican era (1911–1949). As soon as the Japanese attacked Shanghai, Pan Gongzhan, head of the Social Bureau of the Shanghai Municipal government, called on leaders of Shanghai society for cooperation. They combined their forces roughly into two agencies, the International Relief Committee and the Union of All Shanghai Voluntary Agencies (the Union). The latter became the largest relief entity in Shanghai at the time, incorporating charities, professional unions, and native-place associations. Students, housewives, and the many newly unemployed workers volunteered to offer their services. The Union organized them into eleven divisions for such functions as fundraising, sheltering, rescue militias, education, food supply, medical care, shipping refugees home, and burial services, to name but a few.[20]

The Japanese invasion and the refugee crisis changed the private nature of social welfare in China. Social elites realized that wartime relief was more than a cause of charity. First of all, philanthropy alone could not suffice to pay the bills of relief. In Shanghai for example, at the start of the war residents donated their time, labor, and money to run makeshift hospitals, rescue militias, orphanages, and numerous war-related operations, but local charitable resources soon began to run dry under the sheer enormity of the relief demands. One month into the war, the Union had spent CN¥160,000 out of its CN¥170,000 reserve fund.[21] Facing a shortage of money, some social activists suggested introducing new taxes—for example, increasing the tax on private property. Yet such measures would of course demand further state involvement in the realm of social services.[22] The depleting of civic resources continued into the1940s, with no return in sight. And here is where the war's impact was most enduring: the war finally destroyed the myth of voluntarism. Zhao Puchu, a top Buddhist leader who served on the executive board of the Union, acknowledged that at the beginning of the Union's activities, the funds came mainly from social and private donations. After half a year, however, it started to depend upon remittances from the Chongqing government.[23] The role of the state emerged as indispensable and visible to all.

The refugee crisis generated by the Japanese invasion pushed the relief system beyond its traditional practices. For example, the strategy of repatriating refugees to their ancestral hometowns was now deemed a poor solution, for though the pressure on cities might be relieved, those dispatched home could hardly make a living. "What can they do after returning home?" asked the newspaper *Shenbao*. "[Becoming] beggars, bandits, or traitors, these are likely their only alternatives. At present, for national survival, a simple strategy of repatriation is absolutely wrong."[24] Critics argued that it would

be far better to evacuate refugees to the interior so that they could partici-
pate in the war effort. But accomplishing this agenda would demand a level
of central planning and a unified organization for nationwide relief that did
not yet exist.[25] Zhang Zhongshi, a writer and general editor for Shanghai's
famous Life Bookstore, elaborated the need for the state to take on the role
of overall management. He proposed that the state guarantee refugee access
to transport by forming a system of unified control: military requisition of
vehicles, trains, and ships would be limited in order to save some for use
to evacuate civilians.[26] Zhang also pointed out that those traveling by foot
suffered severe monetary losses since many hotels and shipping companies
engaged in price gouging in order to earn higher profits. He proposed that
the state assert regulations to curb such wartime inflation and to set up rest
hostels at key transit points to accommodate refugees.[27]

In short, the relocation of the refugees required much deeper state
involvement, for only the state could have broad enough powers to fulfill
these plans.[28] In newspapers and magazines, a visible and vocal critique
of the absence of state investment in relief efforts attributed the failure of
relief to the failure of the GMD government. Without an efficient state pro-
viding direction and coordination, the relief work organized by civic orga-
nizations was little more than perfunctory. The GMD needed to establish a
national system of relief.[29] The refugee crisis thus redefined the boundary
between state and civil society by entrusting greater responsibilities for
social welfare to the wartime state. The relief of mass refugees demanded
the further involvement of the wartime state and centralization in the over-
all management of natural and human resources. It was under such public
expectation that the GMD government set up a national infrastructure for
refugee relief.

BUILDING A NATIONAL RELIEF NETWORK

On April 23, 1938, the GMD government formed the Development and
Relief Commission (DRC), and from spring 1938 to the start of the 1940s, the
DRC gradually grew into in a gigantic welfare complex. It not only absorbed
old voluntary organizations but also replaced them as the primary benefactor
of refugees, with the former playing a still indispensable but reduced sup-
porting role.

Though the governing board of the DRC presented little difference from
earlier relief agencies (a combination of politicians and social elites from all
walks of life), changes in actual administration and staffing were major. The
staff was no longer made up of volunteers but was a corps of full-time, sala-
ried social policy bureaucrats. Many of these professionals came from other

government departments that, due to wartime relocation, were dispersing and disbanding, creating a phalanx of seasoned administrators who were themselves desperate for aid. Xie Qi, for example, was a member of the Department of Civil Affairs in the Nanjing government who, along with seventeen other colleagues, was stranded without transport after the department disbanded in November 1937. Running out of personal savings, the petition of Xie and his colleagues for monetary assistance was initially rejected.[30] As more and more similar petitions reached wartime capital Chongqing in December, the GMD government realized it faced a serious challenge in figuring out new arrangements for its former functionaries.[31] On December 15, 1937, the Executive Yuan drafted a plan to form a wartime service corps for the purpose of relief and relocation. According to the plan, the DRC would take charge of civilian evacuation, coordinate their transportation, and mobilize the masses. All the former government functionaries currently unemployed were eligible to apply for positions administering the new services.[32] On April 23, 1938, along with the DRC, the Wartime Services Corps came into existence.[33] The motion stirred up an immediate response from the former government staff. In five months, the corps had recruited 1,218 operatives (to fill out a designated quota of 1,500 openings) and dispatched 445 of them to new assignments.[34] Later, the Executive Yuan authorized the Services Corps and its relief stations to recruit any additional assistants they needed directly from local relief societies.[35]

The DRC divided war-affected regions into eight relief zones and mapped out a transit network through these zones, linking coastal China section by section to free China. Masses of refugees counted upon the network for directions, daily necessities, and monetary subsidies. Thirty-four general stations were set up in provincial capitals or commercial and communications centers,[36] between which were a series of relief stations linked every 30 kilometers by sub-stations. Between sub-stations, rest hostels were scattered in small towns or villages along usual travel routes, roughly every 15 kilometers.[37] Even during the peak of retreat in 1938 and 1939, the DRC maintained control of twenty-six of the thirty-four general stations. Over the next two years, as the Japanese extended their incursion deep into central China, the DRC withdrew and limited its work mostly to the western part of China, losing many stations in the east, but adding another eighty-two stations and hostels to the network for the resettlement of evacuees.[38] By the time of Pearl Harbor, the DRC managed thirty-eight general stations, and 1,059 sub-stations and rest hostels.[39]

Tong Wangzhi was a merchant from Changshu County in Jiangsu Province who, along with about twenty friends, left his hometown for the western interior in late 1937. In spring 1938, in a small county named Wuwei on the bank of the Yangzi River, they encountered the DRC and its agents for the

first time. In Tong's recollection, when they reached the gate of the Wuwei
County, they found a DRC agent waiting behind a table at the entrance. He
directed Tong and his company to take lodging in a local hotel. Tong and his
friends filled out a form with a list of their names. The owner of the hotel
sealed his signature on the list and reported to the local DRC station. The
travelers enjoyed two meals and a night of sleep for free. The next morning,
the DRC agent came to the hotel to check on Tong, dispensing half a yuan
to each as a travel stipend. Of this amount, thirty cents came from the state
budget and thus required their signature on a DRC receipt; with regard to
the remainder, the agent told them that since it derived from the contribution
of local notables, the DRC needed no receipt. While Tong and his friends
received travel stipends, an old woman who stayed in the same hotel asked
this DRC agent for a relief subsidy. The lady sadly told the DRC agent that
she had lost track of her husband in the exodus. Hearing of her difficulties,
the agent offered her a substantial stipend to pay for two days of meals, travel,
and housing. Tong felt surprised: "It is really amazing that the DRC could be
so generous."[40]

Tong's experience illustrates the services the DRC offered to the refugees
on move: the provision of lodging, meals, and transport help. DRC opera-
tives usually set up their registration tables near bus stops, wharfs, and train
stations so that refugees could spot them easily.[41] Moreover, the DRC pre-
pared free shelters for the refugees by making full use of public spaces like
temples, schools, and theaters.[42] And the DRC was not the only national level
apparatus providing refugee relief; Figure 9.8 is part of a two-page spread
from *Young Companion* magazine publicizing the activities of the Wartime
Orphanage Committee, a GMD-led group (with strong ties to the GMD's
New Life Advisory Committee) that provided shelter, schools, and medical
care to war orphans on a coordinated national scale.

The dire conditions of refugee life led easily to illnesses like sunstroke,
malaria, and cholera. According to one eyewitness's account, "the first thing
that happens when the refugees arrive at a [refugee] camp is that they are de-
loused. There are de-lousing stations in all the big Chinese towns."[43] Transit
stations also distributed medicine when available,[44] and in 1939 the DRC
started to organize its own medical facilities. By the end of that year, it had
set up twenty-nine refugee hospitals, thirty-three mobile medical teams serv-
ing along the routes connecting DRC stations, and was issuing medical cards
that enabled sick refugees to access free care at local hospitals.[45] According
to DRC records, more than 1,200,000 evacuees benefited from DRC medical
services by late 1939.[46] Overall, the rising importance of the state was best
illustrated in the following statistic: from late 1937 to the end of 1940, an
estimated 26 million refugees received help from various institutions; among
them, nearly 70 percent received support from the DRC transit system.[47]

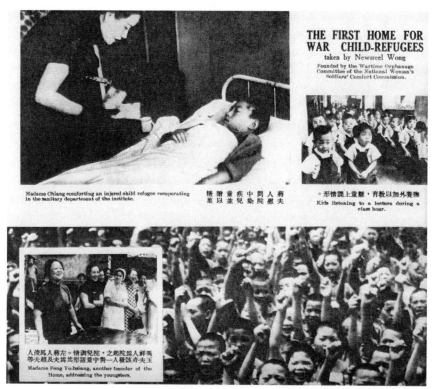

Figure 9.8 By the 1930s pictorials had moved from single-image hand-drawn lithographs (see Figure 9.7) to photographic montages. The *Young Companion* (*Liangyou*) was the most famous Chinese news pictorial of the era (China's *Life Magazine*) These images from the May 1938 issue (showing Madame Chiang Kai-shek giving comfort to an injured orphan, and Madame Feng Yu-xiang speaking above a cheering mass of children) comprise half of a 2-page photo spread that also shows orphans in school and getting medical check-ups. *Young Companion's* national and international readership included overseas Chinese communities whose donations were being solicited by the Wartime Orphanage Committee. *Source*: *Young Companion*, May 1938, Shanghai.

CONCLUSION

Prior to the outbreak of total war, the welfare provided to refugees hardly went beyond the traditional philosophy that treated the refugee problem as a humanitarian cause to be handled by the charitable work of local elites and volunteers. The Nationalist state was content with its status as supervisor. Toward the end of the 1930s, the plight of mass refugees exposed the weakness of traditional relief practices. Recognizing the constraints of voluntary associations, social activists demanded the state to take more responsibility

for social welfare. In reaction to popular criticism, the GMD government established the Development and Relief Commission and its nationwide aid and transit network to coordinate relief efforts, expanding the role of the GMD state in the lives of the Chinese people.

In his chapter "Monumentality in Nationalist China," Charles Musgrove analyzes what may seem to be a similar process of expanding GMD power taking place in the hills of Nanjing's Purple Mountain. The GMD saw construction of the Sun Yat-sen memorial in the late 1920s as a way to bind the loyalty of the Chinese people to its new leadership. But it is not always the state that decides how it will present itself to the people in order to reinforce its authority. In the modern context of mass media images (newspapers, magazines, and newsreels in the 1930s; television news and blogs today), how a government will fare under and react to a crisis is powerfully shaped by how images of that crisis are produced and interpreted. This chapter has looked at two different but related uses of refugee crisis images in relation to the GMD government. On the one hand, the GMD's ally the United States and the GMD government itself used images of the Chinese refugee crisis to demonstrate the suffering, fortitude, and emerging unity of the Chinese people in the face of catastrophe and thereby helped mobilize domestic and international support for the war effort. On the other hand, similar to the case of Hurricane Katrina, the GMD also faced interpretations of images of the crisis that were highly critical of its management. The refugee crisis forced the GMD to expand its role into areas of social welfare.

The war reshaped the relationship between the Chinese state and society, with images of the refugee crisis playing an important role in reshaping public perceptions and expectations of the state. Responding to these images, voluntary civic associations and concerned Chinese demanded the centralization of social services. The DRC quickly developed into an enormous, proactive institution that was capable of implementing new agendas, centralizing the existing relief agencies, monopolizing the implementation of welfare policies, and initiating new welfare practices. As a result, the wartime GMD state became a main benefactor for social welfare, increasingly taking on responsibility over citizens in crisis, and increasingly expected to do so—a role that would become a double-edged sword for the GMD over the coming decade.

NOTES

1. U.S. Department of Homeland Security, *The Federal Response to Hurricane Katrina: Lessons Learned*, by Frances Townsend, Open-file report, Office of the President, February 2006, 5–11.

2. "Katrina: A Timeline," http://www.huffingtonpost.com/greg-saunders/katrina-a-timeline_b_28133.html.

3. "Meet the Press Transcript: Aaron Broussard, President of Jefferson Parish, Louisiana," http://www.democraticunderground.com/discuss/duboard.php?az=view_all&address=105x3958504.

4. Jonathan Weisman and Michael Abramowitz, "Katrina's Damage Lingers for Bush," *Washington Post*, 26 August 2006, A01.

5. Xiaojuan, "Cong zhanqu dailai de xiaoxi" (News from the war zone), in Mei Yi and Zhu Zuotong, eds., *Shanghai yiri* (One day in Shanghai) (Shanghai: Shanghai shuju, 1991), 2.15–2.16.

6. "Lusu jietou de renmen" (People sleeping on the street), *Shanghai yiri*, 2.110–2.111. The image of refugees as "ants" is scattered everywhere in the contemporary accounts included in *Shanghai yiri*. For example, Ye Hao, "Tao chu Nanshi" (Escaping Nanshi), 2.30; and Liu Weisheng, "Banjia de fenrao" (Troubles of moving), 2.37.

7. Wang Jingzhuang, "Muqin hai zai Nanshi" (Mother still stays at Nanshi), *Shanghai yiri*, 2.34–2.35.

8. "Ji'er xian shang de nanmin" (Refugees in hunger), *Ba-yi-san kangzhan shiliao xuanbian* (Selected documents on the Shanghai Campaign of 1937) (Shanghai: Shanghai shehui kexueyuan lishi yanjiusuo, 1986), 92.

9. "Yizhi nanmin kenhuang jianyi shu" (Proposal on moving refugees to cultivate wastelands), *Ba-yi-san kangzhan shiliao xuanbian*, 402.

10. Han Suyin, *Destination Chungking* (Penguin Books: 1959), 128.

11. Ibid., 126–127.

12. A controversy later developed over this iconic picture. Some insisted that the photo was staged. The photographer, H.S. Wong, a Chinese-American employee of the Hearst Metrotone News, was seen to move the baby onto the tracks, possibly under the agreement of the father. Nevertheless, the photo still shows clearly the damage of the Japanese air attack that killed an estimated 1,500 civilians, with only 300 surviving.

13. T. Christopher Jespersen, *American Images of China 1931–1949* (Stanford: Stanford University Press, 1996), 46.

14. Ibid., 55.

15. John W. Dower, *War without Mercy: Race and Power in the Pacific War* (New York: Pantheon Books, 1987), 16–18.

16. *Why We Fight: The Battle for China*, directed by Frank Capra, U.S. Army Signal Corps., 1944.

17. Ibid.

18. Timothy Brook, "Family Continuity and Cultural Hegemony: The Gentry of Ningbo, 1368–1911," in Joseph W. Esherick and Mary Backus Rankin, eds., *Chinese Local Elites and Patterns of Dominance* (Berkeley: University of California Press, 1990), 45.

19. Ye Xiaoqing, *The* Dianshizhai Pictorial: *Shanghai Urban Life, 1884–1898* (Ann Arbor: Center for Chinese Studies, University of Michigan, 2003), 147.

20. "Shanghaishi jiuji weiyuanhui zhangcheng" (Regulations on the Shanghai Relief Commission), *Ba-yi-san kangzhan shiliao xuanbian*, 446–447.

21. *Jiuwang ribao* (Salvation daily), 22 September 1937, *Ba-yi-san kangzhan shiliao xuanbian*, 436.

22. Han Shu, "Qiansong shi juedui bugou de" (Repatriation of refugees is far from enough), *Ba-yi-san kangzhan shiliao xuanbian*, 401.

23. Zhao Puchu, "Kangzhan chuqi de Shanghai nanmin gongzuo" (Shanghai's relief work at the beginning of war), *Ba-yi-san kangzhan shiliao xuanbian*, 473.

24. Han Shu, 400–401. For similar news reports, for example, "Nanmin panghuang wulu" (Refugees had no other means), *Shenbao* (Shanghai daily), 25 April 1938, 2.

25. Li Gongpu, "Jiuji nanmin gongzuo jihua dagang" (Outline of relief plans), *Kangzhan sanrikan* (Resistance semi-weekly) 2 (23 August 1937), 11.

26. Zhang Zhongshi, "Congsu gaishan houfang de jiaotong"(Expedite improvement of communications to the interior), *Kangzhan sanrikan* 35 (9 January 1938), 6.

27. Ibid.

28. Han Shu, 400.

29. Li Gongpu, 11.

30. "Zhongyang jiguan renyuan shusan" (Disperse the staff of the central government), 2 September 1938, National Historical Archive (Taipei), *Guomin zhengfu dang*, 361 *juan*, 2162–2164.

31. Take the Department of Civil Affairs as an example: other former staff like Liu Yapeng, Lin Zhipan, Liu Manqing, and Chen Si made similar petitions. They asked either for a recall to work or for financial assistance. "Zhongyang jiguan renyuan shusan," National Historical Archive, *Guomin zhengfu dang*, 361 *juan*, 1231–1232, 1456–1457, 1465–1468, 2198–2199, respectively.

32. "Xingzhengyuan feichang shiqi fuwutuan banfa" (Methods on the formation of the Wartime Services Corps of the Executive Yuan), 15 December 1937, National Historical Archive, *Guomin zhengfu dang*, 326 *juan*, 428–431.

33. "Xingzhengyuan feichang shiqi fuwutuan banfa," revised on 23 April 1938, National Historical Archive, *Guomin zhengfu dang*, 326 *juan*, 441–443.

34. "Feichang shiqi fuwutuan faling" (Decrees on the Services Corps), 5 September 1938, National Historical Archive, *Guomin zhengfu dang*, 326 *juan*, 564–565.

35. "Ge zongzhan bianzu jiuji gongzuo fuyidui zanxing banfa" (Draft on the recruitment of relief teams by all general stations), Second Historical Archive (Nanjing), 117 *quanzong*, 12 *juan* (May 1939).

36. Second Historical Archive, 117 *quanzong*, 4 *juan* (August 1938).

37. *Geming wenxian* (Documents on the Nationalist Revolution), vol. 96, 455–456.

38. Adjustment of the DRC transit system, 1 May 1939, Second Historical Archive, 118 *quanzong*, 5 *juan*.

39. The numbers for sub-stations and hostels are estimates due to the frequent adjustment and conflicting records during the war. Relevant documents are, for example, "Nanmin shusongwang jihua dagang," November 1938, Second Historical Archive, 117 *quanzong*, 4 *juan*; and, *Geming wenxian*, vol. 96, 77; vol. 97, 389, 401, 411, 432.

40. Tong Wangzhi, "Yige nanmin de liangzhong zaoyu" (One refugee, two experiences), *Kangzhan sanrikan* 36 (13 May 1938), 11.

41. Methods on refugee relief, 14 December 1937, Second Historical Archive, 118 *quanzong*, 71 *juan*, vol. 1.

42. Violet Cressy-Marcks, *Journey into China* (New York: E.P. Dutton & Co., 1942), 243.

43. Ibid.

44. DRC , for example, documents on medical care in May, October, November 1938–1939, Second Historical Archive, 117 *quanzong*, 19 *juan*.

45. *Geming wenxian*, vol. 96, 60–73.

46. Sun Yankui, *Kunan de renliu: kangzhan shiqi de nanmin* (People in misery: refugees in the Anti-Japanese War) (Guilin: Guangxi shifan daxue chubanshe, 1994), 167–168.

47. Statistics on wartime refugees, July 1938–December 1940, Second Historical Archive, 11 *quanzong*, 696 *juan*.

Chapter 10

Revolutionary Real Estate

Envisioning Space in Communist Dalian

Christian Hess

Throughout the summer of 1946, long before Mao's final victory in 1949, thousands of poor Chinese families living in the overcrowded streets of the northeastern city of Dalian moved out of their dilapidated houses and into the spacious residences of the city's former Japanese colonial masters. During the 1930s, Dalian had been one of the most important strongholds of Japanese power in northeastern China, or Manchuria. These families were the benefactors of one of the largest transfers of urban real estate ever carried out in a Chinese city. In less than one year, from July 1946 through May 1947, over 27,000 families moved from the city's poorest neighborhoods into Japanese houses located in areas of the city that had once been off limits to the majority Chinese population.[1] Tales of entire neighborhoods moving into colonial homes filled the pages of local newspapers; they read like a socialist drama—the urban poor and working class, the masters of the new socialist society, rewarded with the homes of the former masters of colonial society. Even the local radio station covered the moves on a daily basis. One paper carried news of an overjoyed neighborhood that vowed to send pictures of themselves in front of their new homes to Mao himself.[2] It appeared as if an urban version of the Chinese Communist Party's (CCP) socialist land reform was in full swing.

A few years later, in 1949, newspapers and journal articles throughout China praised the socialist transformation of what had been for forty years a major Japanese colonial port city, labeling Dalian "new China's model metropolis." At the core of this new definition of Dalian was an image of the city as a center of production modeled on cutting edge, Soviet-style industrial polices. This vision of the city as production center would be the hallmark of the urban modernization programs carried out by the CCP across China in the early to-mid 1950s.[3] When taken to its extreme, the image of Dalian as a center

of industry also took on a utopian dimension when the city's experience was presented to the rest of China. Dalian had become, in one author's opinion, not just a production base, but "in the last four years it has transformed itself into a worker's paradise."[4] Indeed, with families from poor neighborhoods receiving the spacious former residences of the Japanese colonialists, it certainly seemed like a socialist paradise. Yet, was this image of an unfettered transition to socialism really so easy and rapid? Had Dalian, in just a few short years, made the transition from a city of Japanese colonial development to a new socialist metropolis? Or, as is often the case, was there more going on than meets the eye? Additionally, what was this urban "vision" of Chinese socialism, how did it differ from its much more well-known rural counterpart, and how did the new Communist regime view its relationship with city residents?

This chapter focuses on the transition from a colonial to a socialist political system in the port city of Dalian, located in China's Liaoning Province. Like pieces authored by Charles Musgrove and James Cook, it analyzes the visual symbols contained within specific structure. More specifically, it seeks to shed light on the critical issue of how a new regime handles the issue of how to manage social relations created by an earlier government. In cities, where populations are large, dense, and heterogeneous, this management issue can become particularly acute. Physical infrastructure and architecture represent their own set of dilemmas for the new polity. What, for example, would a dictatorial power who took over the United States do with the monuments in Washington D.C.? To take Iraq as an example, in present-day Bagdad much of what had served as the physical and architectural spaces of the Hussein regime's power—Saddam's palaces and prisons—function in much the same way as they had before. Many of Saddam's palaces function today as the center of coalition military power. In the case of Dalian, after 1945, the Soviet military and the CCP took control of a city whose physical features—from buildings to transportation systems, shopping districts to parks—bore the stamp of Japanese colonial development. A key issue for the new socialist regime, then, was how to use this space, and re-frame it as part of the new "look" for a socialist city.

Dalian's experience from 1945 through 1950 also provides a window through which we can view several interrelated issues in the understudied history of the immediate postwar years in China. First, Dalian was one of the few major cities prior to 1949 where the CCP could experiment with their own urban agenda. Furthermore, CCP administration, it was assumed, would be made easier by the fact the city was still occupied by Soviet Union forces who had "liberated" Dalian with Japan's surrender in August 1945. Yet, no sooner had Chinese Communist forces entered, than clashes flared between these two socialist brothers. At the core of these conflicts were different visions of how best to mobilize people and resources in order to jumpstart the

city's industrial base, further exposing differences in what types of promises could and should be made to urban workers and the urban poor in the name of socialism. In short, exactly what urban socialism was supposed to look like differed according to the visions of CCP officials, Soviet military authorities, and city residents.

A major compromise between the two political powers involved an attempt to bring socialist transformation to the masses by redistributing Japanese housing in what amounted to a carefully orchestrated, urban version of rural land reform. This effort included both visual propaganda—parades and press coverage—as well as an important but under-examined performative and experiential aspect of CCP propaganda found in the public struggle sessions against colonial-era grievances and exploitation. In the rural arena, this performative aspect of CCP administration involved the public trials of landlords and other "class enemies." How would this component of the CCP's revolutionary strategy play itself out in the urban arena?

Thus, the key challenge the new powers faced was how to recast both urban society and the colonial urban environment into a socialist mold. In other words, what steps did they have to take to make a city that was once the very embodiment of Japanese colonial development, capitalism, and militarism look like a new socialist space? What would a socialist city look like? Was this to include the physical dismantling of the highly visible parts of the colonial built environment in an attempt to erase the colonial past? If not, how would they be incorporated into the "new" definition of the city?

Each of these three interrelated themes touches on an aspect of "the visual" in Dalian's history; how the new CCP government depicted socialism in material terms, how that vision was brought to the masses through a unique version of urban land reform, and, ultimately, how memories of the colonial past persisted in the socialist future. The overarching theme of this chapter is that urban socialism was presented by various historical actors in Dalian during the late 1940s in very material terms. By using images drawn the built environment of the city itself, we can begin to understand how those terms were represented, how changing material standards may have been experience, and what socialist urbanity meant in China even prior to the founding of the People's Republic in 1949.

THE SPECTACLE OF "MOVING DAY": COLONIAL MANSIONS FOR CHINESE WORKERS

Colonial-Era Housing Conditions

Initially, Japanese urban planners had envisioned colonial Dalian as a segregated city. The city's spatial grid, as it developed in the early twentieth

century, called for separate residential zones for Japanese and Chinese, buff-
ered by parks and wide boulevards.[5] Wealthy Japanese lived in large homes
south of downtown, near the sea, while bureaucrats, managers, engineers,
researchers and their families lived in Western-style row houses throughout
the city. Due to Dalian's rapid increase in population in the 1920s and 1930s,
housing became scarce. As a result, areas of the city like Xigang (Western
Ridge) became increasingly mixed, and some Japanese merchants and their
families moved into the neighborhood. Although Chinese and Japanese lived
side by side in Xigang, there existed a drastic spatial inequality between
Chinese and Japanese in terms of domestic space. Taking Dalian as whole,
Japanese residents comprised one quarter of the city's population yet con-
trolled and occupied over 65% of its real estate. In Xigang, Chinese com-
prised 89% of the district, yet occupied only 58% of the housing space.[6]

There were also drastic differences in the quality of housing between
Chinese and Japanese residents. The Xing family represents a typical case.
Xing Guihua, a 15-year-old in 1946, arrived in Dalian with her family from
Shandong in search of work in 1940.[7] The Xings lived for a time in the brick
workers' dormitory complex, nicknamed "the Red House" (*hongfangzi*) by
Chinese residents, built near the docks. This was an extremely crowded,
walled enclosure, complete with its own opera stage, brothels, and opium
dens. It was essentially a city within a city, with walls designed to keep the
exploitative side of Japanese imperialism contained and hidden away from
the city core. Located on the outskirts of town, it even featured its own
orange-colored tramcars, set up by colonial authorities, to shuttle laborers to
and from the docks, where the majority worked loading and unloading trains
and ships. Other Chinese families who arrived in Dalian, particularly those
without formal employment, lived in sprawling slums built on or against
sewage canals and garbage dumps. They built homes from whatever materi-
als they could (Figure 10.1). The poorest lived in covered holes dug into the
soft ground, or in makeshift tent communities. Rain often made conditions
miserable as streets turned to mud and became clogged with raw sewage.

The Xing family eventually moved out of the worker dormitories and into
a flat in Xigang, a densely populated area of cramped brick homes. Their
apartment was very small. Seven family members shared a six-square-meter
room.[8] Xigang, pictured in Figure 10.2, was the center of colonial Dalian's
Chinese business community—its "Chinatown." The streets were narrow and
packed with small shops and residences. Street-side restaurants and a bustling
outdoor market, where crowds often gathered to watch street performers and
acrobats, were key features of daily life in Xigang.

The contrast with Japanese neighborhoods was striking. There, Japanese
planners built brick houses in Western styles, following the cutting edge
of housing design popular in Japan.[9] Homes in these neighborhoods were

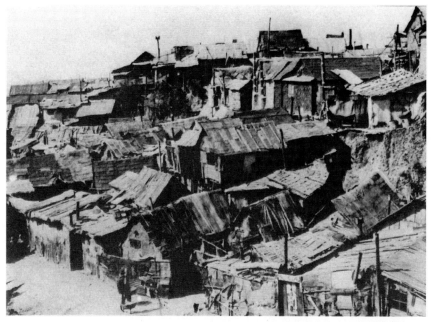

Figure 10.1 Siergou, a shantytown at the edge of Dalian. This was an area populated by migrant workers and their families, many of whom came to the city from Shandong in search of work on the docks, or in construction trades. This type of image might be used by colonial authorities to justify their own projects to build dormitories for Chinese workers, which offered cleaner living conditions along with more control. The CCP used such images as examples of colonial exploitation in which Chinese people are denied access to the city in which they work. Siergou was thus a focal point in the housing campaigns. From: Li Zhenrong, ed., *Dalian mengzhong lai* [Dalian comes from a dream]. People's Fine Art Publishing House, 1996.

spacious, and contained all the amenities of modern housing, including gas for cooking and heating. Small, walled yards and gardens separated individual residences (Figure 10.3). Occasionally, the calls of a tofu peddler could be heard from the windows, but most shopping was done in central markets or department stores. The streets were broad and quiet, starkly devoid of the many activities of the streets of Xigang.

Just as the political order in Dalian shifted upon the arrival of Soviet military and CCP officials in August 1945, the spatial hierarchy of the colonial era also broke down. Large numbers of, but not all, Japanese civilians, one-quarter of the city's population, were shipped back to Japan in a massive repatriation movement following the war's end. This situation presented the CCP with a unique opportunity to end one of the most glaring vestiges of Dalian's colonial history. By transferring ownership of vacant Japanese

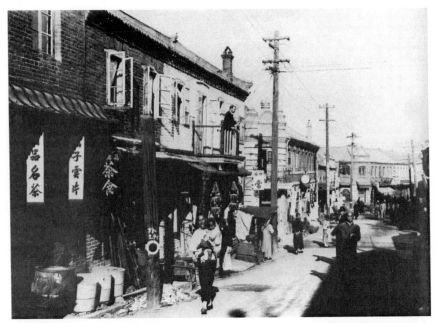

Figure 10.2 Dalian's Xigang district. This area represents a developed, densely populated district of the colonial city populated by long-term Chinese residents. The photo, likely taken in the 1920s, captures a typical street scene. Such photos serve to reinforce an image of the city comprised of strictly segregated districts, in which the narrower streets of this largely Chinese district are contrasted with the wider boulevards of "Japanese" Dalian. From: Li Zhenrong, ed., *Dalian mengzhong lai* [Dalian comes from a dream]. People's Fine Art Publishing House, 1996.

homes to Chinese workers and the urban poor, CCP cadres would not only begin the process of reinventing the city as a socialist paradise, but also target a key group for support within their urban political strategy. It was a revolutionary attempt to transfer the ownership of urban property on a vast scale. Yet how was this done, and what were the consequences?

Urban Land Reform: Mobilizing the Urban Poor

One of the most comprehensive efforts by CCP cadres to work closely with urban residents in Dalian was through the housing redistribution campaign. Ironically, although a major goal of the campaign was to legitimize CCP authority, it was only with the prolonged presence of yet another foreign military force that allowed it to exist. The Soviet military presence made Dalian a stable environment, particularly when compared to other cities in the region, like Shenyang and Harbin, which were highly contested throughout

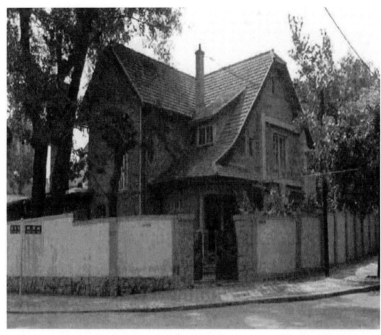

Figure 10.3 A typical Japanese colonial residence with a walled garden. Houses like these often featured gas appliances and telephones. These are the type of properties that were left abandoned as the Japanese civilian population returned to Japan after 1945. This is a contemporary image. These homes are now under threat from developers, but continue to represent part of the city's architectural heritage. From: Nishizawa Yasuhiko, *Zusetsu Dairen toshi monogatari.* Kawade shobo shinsha, 1999.

the civil war. This stability made it an ideal place for CCP cadres to forge an agenda for urban governance, of which housing reforms were an integral part. However, military stability aside, the Soviet presence also severely limited CCP operations in terms of grassroots work among urban residents— including some of the key tactics for making revolution. Soviet gendarmes, for example, routinely curbed violent "settling of accounts" (*qingsuan*) movements in the city, a popular tactic used by the CCP in rural areas to take back Japanese property by force.[10]

Working under these limitations, and with Soviet oversight, CCP officials designed the housing redistribution campaign to be a carefully controlled experiment. It was not to include violent seizures of property. Such a decision was made in response to the earlier actions of CCP cadres, some of whom in early 1946 stormed Japanese homes at random, forcibly removing Japanese families by gunpoint.[11] Several months later, at the outset of the housing redistribution campaign, CCP officials took great care in clarifying which

properties could be touched, and which could not. The houses of Japanese militarists, industrialists, diplomats, and high-level functionaries were fair game to recover and redistribute. Importantly, however, those of skilled Japanese workers, technicians, and poorer Japanese laborers and their families, by far the majority of the Japanese population after 1945, were strictly off-limits. Why was this the case? Essentially, their expertise was needed in keeping factories running. Without their knowledge and skills, the Japanese-manufactured machinery that powered these factories would quickly break down and production would cease. Throughout the late 1940s, Japanese technicians and skilled laborers enjoyed a privileged status in the new society, reflected by the fact that their houses were not confiscated, but rather protected.[12]

Although not violent, housing redistribution was "radical" in the sense that, like the more radical phase of land reform carried out by the CCP in Manchuria in 1946–1947, it aimed to redistribute property in an egalitarian way. Indeed, the campaign involved processes similar to that of land reform in rural areas.[13] From the perspective of the Soviet military officials, however, the policy must have seemed extremely radical. In fact, compared to the dire conditions of urban housing throughout the Soviet Union, Dalian must have seemed like a housing paradise.[14] The idea to redistribute colonial-era housing to workers and the urban poor is alleged to have come from Luo Ronghuan (1902–1963), a leading CCP military official. Like other top ranking CCP officials, Luo came to Dalian to recuperate from the stresses of war and revolution in a seaside villa, once the exclusive domain of Japanese and wealthy foreigners. After describing the benefits of land reform for mobilizing the masses in rural base areas, Luo urged local CCP leaders to follow a similar path and redistribute housing to urban residents. Several months later, in July 1946, the CCP issued the first official declaration on urban housing redistribution. The stated goal was to "provide the masses with real material benefits in the form of houses."[15]

On July 15, 1946, leading CCP cadres called a citywide meeting with representatives from the Soviet military, and Japanese and Korean labor groups in order to launch the movement, and establish the agenda for the campaign. The campaign's main purpose was to take advantage of Dalian's massive housing surplus by moving urban laborers and their families into fine, Western-style homes to give them a sense that "they are now masters of society."[16] There was also a very real fear that, if left to stand empty, these houses might either be occupied by the Soviet military, which controlled 28% of building and housing space in the city after 1945, or might be slowly stripped apart and looted.[17] Looting was a great concern. Official sources note that, in the absence of a stable economy, women and children often spent their days stripping vacant homes in Japanese neighborhoods of valuables.[18] In fact, in the year immediately following Soviet takeover, the sale of

Japanese goods on the resurgent free markets throughout Dalian was often the sole economic activity for tens of thousands of jobless workers. Prohibitions on the export of such household items as stoves, furnaces, and metal piping, all of which were stripped from homes throughout the city, point to the CCP's concern regarding the high volume of trade in these items.[19] Regulations to protect these homes called for the construction of metal fencing around vacant neighborhoods. The main concern was that large numbers of jobless people were stripping apart homes, and if such behavior continued, those properties would be of little future use.

After the initial citywide meeting, CCP cadres from the district and ward level formed "housing readjustment work teams" (*zhuzhai tiaozheng gongzuodui*). These teams were the backbone of the campaign. They fanned out into poor neighborhoods, selecting activists among residents while carrying out detailed investigations of housing and living conditions. Like land reform in the countryside, investigations determined which neighborhoods were the poorest, and what the housing conditions and family sizes were like in such neighborhoods. For local neighborhood leaders, particularly the ward heads, their first task was to present their claim as a poor neighborhood.[20] For example, the head of the number fourteen ward, a predominantly Chinese neighborhood, lobbied cadres that his ward was quite poor, with many families living on hillside shacks. Moreover, most residents there earned their living as rickshaw pullers, and had little money and food.[21] Cadres spent up to several months in neighborhoods like this, carrying out investigations of social and economic conditions there, right down to the household level.[22]

From the CCP's perspective, this was the most crucial activity of the campaign. It was largely through the housing redistribution campaign that the CCP had the most intimate contact with the local population, particularly those not participating in organized labor activities. Moreover, one of the main ways in which the CCP chose to "view" people it wanted to govern was through the lens of housing. The investigations resulted in the formulation and application of a system of ranks for families based on occupation, income, family size, and housing conditions in order to determine moving priority. Those whose existing homes had few problems, but were found to be too small and crowded were classified as "grade one." Those families with damaged houses that could be rebuilt were "grade two," while "grade three" included families and individuals with completely dilapidated homes or no homes at all.[23] Priority for new housing was given to those families ranked grades three and one.

These rankings also established the terms of ownership for a family's new home, a system that proved to be a source of confusion for both officials and city residents. Many of the poorest families, those from grade three,

were granted full proprietary rights over their new dwellings, and could buy, sell, or even rent them accordingly.[24] In Xigang, of the over 2,500 families relocated by the end of the campaign, 2,000 received full proprietary rights, another 350 families received five years of free rent, and 80 families were granted three years of free rent. However, in the early phases of the movement, some merchant families and small businesses also received free rents and proprietary rights. In May 1947, CCP cadres had to re-investigate the situation, eventually adjusting titles and rental agreements, ensuring that those with the means to pay for their new property would do so.[25] By the early 1950s however, the state regained control of property, taking away full ownership rights.

Once street-level investigations were completed, mass meetings to explain to local residents the housing redistribution process followed. Poorer families were encouraged to vocalize their plight and speak their minds against those who had made them suffer in years past. An internal report on the movement from July 7, 1946, placed great emphasis on building support among the masses. Cadres should lead the way in organizing the city's poor to carry out much of the movement themselves; in this way, the report says, "the poor can be made to feel that they are the masters."[26] This feeling, it was thought, would bind the urban poor to the new regime. The heavily publicized drama of moving day was thus the final stage of a series of events that drew a large segment of a given neighborhood to participate in the process. Neighborhood members were elected by ward leaders to be in charge of moving teams and for organizing local security teams (*banjia jiuchadui*) that were responsible for overseeing up to 10 families.[27]

The actual moves were carried out in three waves from July 1946 through 1947. In the first two phases, from July through February 1947, cadres paid little attention to long-term urban planning, focusing instead on providing for the immediate needs of Dalian's poorest families. The egalitarian qualities of the campaign were evident at this time, as houses were distributed to poor people with little concern for the size of the homes in relation to number of family members. As we shall see below, this created numerous complaints, as large families often received smaller homes than smaller families. Moreover, in the first phase, some unemployed workers were given land to till in the rural suburbs rather than houses within the city.[28] Once factories came back online, officials realized it was far more efficient to find housing nearer to industrial enterprises. Thus in the second phase of housing reform, carried out from December 1946 through February 1947, such mistakes were avoided.

Moving day throughout various Chinese neighborhoods, captured in Figure 1.8 (see Introduction), was a heavily publicized visual spectacle, featuring music, dancing, songs, and, most importantly, a moving convoy that was more a parade than a column of trucks. With their possessions securely

latched to moving trucks, families marched alongside union volunteers, who led them in songs and lofted banners that read: "The People's Democratic Government has taken us from hell and delivered us to heaven!"[29] As the parade wound its way through the city, thousands of curious onlookers stopped to watch the procession. The trucks finally pulled over on a spacious, tree-lined avenue featuring rows of large, Western-style homes with fenced yards. Xing Guihua, whom we met earlier, remembers that once the trucks stopped in what used to be a Japanese neighborhood, CCP officials told her family that they were free to select their new home from any on the street before them. The overjoyed Xing family sprinted from the truck to claim the nearest home.[30] It featured three large rooms, separated by sturdy walls, and a spacious kitchen featuring gas appliances. Like many such houses, it was equipped with a stove, a fireplace, and a bathroom.

By mobilizing the city's sizable print and broadcast media, themselves inheritances from the Japanese regime, the CCP announced that there would be material gains in the new order for loyal urban residents. Once neighborhoods had successfully moved, CCP officials organized massive assemblies to hand out deeds to their new homes. Xing Guihua recalls that over 1,000 families, including her own, attended such an assembly, where they received a deed along with a portrait of Mao Zedong to hang in their homes.[31]

News of the moves made the front pages of local newspapers, which carried the details of the campaign, including speeches from neighborhood activist meetings right through the events of moving day. From the start of the movement, the local, CCP-controlled press used strong patriotic and racial overtones to characterize the campaign, creating a sense that the comfortable life once denied Chinese was finally at hand. Efforts to generate class consciousness were no doubt part of the housing campaign, but its most powerful propaganda involved images of poor Chinese. Newspaper articles carefully and clearly explained the inequalities of the colonial-era housing situation. One article wrote, "Under Japanese imperialism, Chinese children wouldn't dare play in Japanese neighborhoods; if they did they'd be beaten and cursed. Chinese couldn't just freely build a house, rather they lived in wooden shacks built on sewage canals, and even then had to bribe Japanese police."[32] In an effort to contrast the situation in Dalian with cities in Nationalist-held areas, articles described how the Nationalists were demolishing poor neighborhoods throughout Nanjing without relocating or providing for the residents. "The democratic government cares about city people and their housing situation. Now poor live in good homes. In Nationalist-held areas there are lots of good houses, but they don't give them out to the poor."[33] This was a particularly effective way of driving home the point that the Soviet-backed government would take better care of them than the Nationalist government.

The final wave of the housing campaign, carried out in the spring of 1947, was the most controlled, and reflected the CCP's growing emphasis on industrial recovery and other policies aimed at jumpstarting Dalian's economy. Officials established clearer guidelines for decisions about rents and property rights, and paid more attention to integrating economic development with the movement of people. For example, the newly established Finance Bureau (*Caizheng ju*) coordinated the distribution of shops and retail properties to merchant families.[34] By the summer of 1947, as the movement wound down, newspaper articles lauded the achievements of the housing campaigns, boasting that over 20 percent Dalian's residents received new homes.[35]

THE CONCRETE COLONIAL FOUNDATIONS
OF SOCIALIST DALIAN

We have seen one attempt by the new regime to redistribute the spoils of the Dalian's colonial-era built environment. The redistribution of property in Dalian was impressive; it compared favorably with similar attempts undertaken by the CCP in the country's rural areas. Of course, the departure of the majority of China's former "colonial oppressors" made the task of identifying land and property to redistribute much easier for local cadres. Nonetheless the fact that a fifth of city residents suddenly found themselves in new homes was trumpeted by the CCP as emblematic of the city's new socialist economy. The new leaders of Dalian envisioned a city owned, populated, and administered by Chinese workers. Yet, just how socialist was postcolonial Dalian? What had happened to city's seductive, rich colonial past?

As a total colonial space under Japanese control from 1905 through 1945, Dalian's physical environment was designed to showcase Japanese development of the region. The striking port facilities, the headquarters of the Southern Manchurian Railway (SMR), and the European architecture of the downtown district (see Figure 10.4) were captured on postcards representing the physical face of the city. The main roundabout in the downtown core featured a large plaza, and a circular ring road on which one would find monumental architecture featuring banks, hotels, a post office and government buildings. An elaborate tramcar system crisscrossed the city, stretching from the industrial district on the west side of Dalian, including the large SMR railroad factory complex, through the downtown core and the massive port facilities, which, along with the SMR corporate headquarters, served as the lifeblood of the colonial city.

The new Sino-Soviet regime did little to alter the built environment of the city. There was little need or desire to dismantle its key features. Soviet

Figure 10.4 Downtown Dalian at the peak of Japanese rule. Streetcars arrive from every direction under the watchful eyes of an elevated police box. Here, the celebrated colonial infrastructure of the city is clearly on display, as is the reality of colonial power here. Note there are a number of military and police personnel visible in the photograph. From: Li Zhenrong, ed., *Dalian mengzhong lai* [Dalian comes from a dream]. People's Fine Art Publishing House, 1996.

military authorities and CCP cadres used these buildings as their headquarters: what is now the headquarters of the Dalian municipal government was once the seat of the administrative apparatus under the Japanese in the late-1930s. Other physical structures of the colonial past—its housing, public spaces, transportation, parks, and streets—remained, and thus so too did the potential to remember that past at a time when new authorities were attempting to redefine Dalian as a model production city in a socialist mold.

In 1949, following several years of redevelopment in the hands of Soviet and CCP officials, Dalian hosted a major industrial exhibition. This event served to highlight Dalian's industrial recovery under the Soviets and the CCP, cementing the city's new definition as a vanguard model production metropolis of new China. Newspaper reporters, travel writers, and thousands of other visitors, including overseas Chinese industrialists, flocked to Dalian to see the exhibition, which was carefully organized following months of researching similar events held in New York, San Francisco, and even those

held by the Japanese regime in Manchuria in the 1930s. In the three months
that it lasted, the exhibition attracted over 300,000 visitors.[36]

Walking through the display halls, visitors saw industrial products made in
Dalian's recently recovered industries, including items ranging from machine
tools and chemical products, to buses and tramcars. One observer noted that
Dalian was capable of producing things that Shanghai and Beijing had never
been able to produce, and people visiting from Beijing felt that many products
were the same quality as those found in the United States.[37] The final hall of
the exhibition was a heavily propagandized homage to Sino-Soviet relations,
featuring pictures and displays driving home the point that Soviet aid, and
Dalian's full embrace of the Soviet model, made the futuristic world of pro-
duction they were witnessing possible.

Products and exhibits, however, were not the only things to see. The city
itself was on display. Numerous journalists and writers who came to report
on the exhibition also took in the sights of Dalian and reported what they
saw. "Dalian," one visitor wrote, "has been made into a true production
metropolis. City people's productivity and labor, this is the new character of
Dalian."[38] Another visitor wrote, "Riding the streetcars, it is easy for us to feel
that we are already living in a society led by workers. Everyone on the trams
is a worker, wearing dark uniforms in blue and gray. Even the women wear
these; we saw no gaudy clothing."[39]

According to these observers, the city's culture, not its built environment,
seemed transformed by the new regime. Yet, despite the effort to publicize
these new features of the city, many of the journalists who visited Dalian
in 1949 wrote glowingly of the city's past. Walking out of the train station,
one writer was moved by the vista of "such a modern city" (*jindaihua de
chengshi*). "The Japanese, as far as city planning is concerned, had great
skill—the streets are very wide and lined with trees." Praise for aspects
of Dalian's colonial modernity did not stop there. The author continued,
"The Japanese have very hygienic practices, and as a result the buildings
here are quite spacious and ordered." In direct comparisons with Shanghai
and Beijing, Dalian was favored for its highly developed public transporta-
tion, particularly the colonial-era streetcar system, which "reaches nearly
every corner of the city." Likewise, the author noted that Beijing "has too
many bicycles," and, like many cities of the interior, "not enough public
transportation," while Dalian, he judged, "among all of China's cities, has
the best public transportation; the price is cheap, you don't have to wait, and
you can get anywhere."[40] Spacious apartment buildings, once the residences
of Japanese, were now home to workers and their families, who "abandoned
their old huts and now live in these Western-style buildings."[41] In these brief
examples, one can see the ways in which the colonial-era built environment,
although little changed, remained an essential feature of what made Dalian.

Try as they might to shift the emphasis onto what was "new" about the city, visitors in 1949 were awed as much by features of the city's colonial past as they the more mundane displays of its socialist present.

CONCLUSION

Regime change, the replacement of one form of political control with another, is a major theme in the study of history. History textbooks are filled with pages devoted to the demise of older forms of empire and the rise of new nations, including the revolutionary movements that led to the foundation of socialist states in Russia and China. Even today, the idea that founding a new political regime will bring major change to people's lives is embraced by countries like the United States and the United Kingdom The current state of affairs in Iraq, for example, was premised on the idea that toppling the Saddam Hussein regime would somehow lead the Iraqi people in an entirely new direction, down the road to democracy.

Statues might be toppled, but physical, concrete legacies of the past remain: Saddam's palaces are still used as fortresses for a military regime, and his prisons still hold Iraqi people captive. Dalian during the years from 1945 to 1950 provides us another historical window through which to view how a new regime grappled with the question of what to do with an urban built environment that had been bequeathed by an entirely different admin- istration. The CCP hoped to transform the city from a colonial stronghold into a socialist paradise by transferring ownership of property and land into the hands of the urban poor. Under Japan's colonial order, all of the factories and fine residences were owned by Japanese residents. Now, the owners of all property and, of course, the means of production would be the people of Dalian. The CCP's vision of Dalian's future was one predicated on socialist construction led, of course, by the party.

The parades of 1946 were essentially a visualization of the movement of ownership and capital from one regime to another. The CCP had transferred the property and former assets of Japan's colonial regime, and, in the case of housing, literally into the hands of the people of Dalian. The crowds of people moving from Xigang with their belongings accompanied by posters of Mao Zedong and banners proclaiming the virtue of the CCP were, in many ways, a staged spectacle designed to perform on the street what was taking place in the city's economic and political circles.

In the end, however, both regimes were predicated on production. In the case of Japan's colonialist regime, management of the city's resources was organized around profiting the Japanese imperial state and there was little concern for Dalian's Chinese residents. The new regime's publically stated

principals of socialism meant that, in theory, industry within the city was now controlled for the benefit of the Chinese people. Yet both sets of leadership, organized around seemingly diametrically opposed principals, were primarily concerned with maximizing industrial production. While the new CCP leadership may have wanted to banish the city's colonial past, the city's main function as a transportation, manufacturing, and distribution center remained unchanged. Much of Dalian's colonial past was part of the socialist future.

NOTES

1. These statistics are available at the Dalian Municipal Archive website: http://www.da.dl.gov.cn/xhsb/messageinfo.asp?id=343

2. *Xin sheng shibao*, September 1, 1946.

3. Chen Qiying, "Dalian—xin Zhongguo de mofan dushi" (Dalian—new China's model metropolis), *Luxing zazhi* vol.23 no.11 (November 1949).

4. Li Zongying, Liu Shiwei, and Liao Bingxion ed., *Dongbei xing* (Travels through the Northeast) (Hongkong: Da gong bao chubanshe, 1950), 50.

5. Koshizawa Akira, *Shokumin chi Manshū no toshi keikaku* (Urban planning in Manchuria) (Tokyo: Ajia keizai kenkyu jo, 1978), 49–50.

6. Xigang qu weidangshi bangongshi, ed., "Xigang qu 'Qiongren da banjia'" (Poor people's big move in Xigang district) in *Xigang wenshiziliao* 4 (July 1997): 71–72.

7. Lao Xigang huigu dangnian "pinmin banjia yundong" qiaoluo dagu zhu jin Riben fang (Looking back at the poor peoples moving campaign in old Xigang, ringing in moving into Japanese homes with gongs and drums) in *Dalian wanbao,* March 19, 2006.

8. Ibid.

9. Jordan Sand, *House and Home in Modern Japan: Architecture, Domestic Space, and Bourgeois Culture, 1880–1930.* Harvard University Press, 2003, p.263–287.

10. Tan Songping, "Jieguan Daguanchang jingchashu yu jianli zhongshanqu wei" (Recovering the colonial Daguangchang district police office and establishing the Zhongshan district police) in Zhonggong Dalian shi Zhongshan qu wei dangshi bangongshi, ed. *Zhongshan chunxiao* (Zhongshan's dawn of spring) (Dalian: Dalian haiyun xueyuan chubanshe, 1992), 1–6.

11. Dalian difang dangshi bian, ed. *Zhonggong Dalian difang dangshi ziliaohuiji* (Compilation of historical materials of the Chinese Communist Party, Dalian branch) (Dalian: (no publication data), 1983), 377.

12. "Zhonggong Lüda diwei guanyu kaizhan Dalian zhuzhai tiaozheng yundong de jueding" (The CCP Lüda committee's decisions regarding the spread of the housing redistribution movement), July 7, 1946, in CJSG, 515–520.

13. Pepper, Suzanne. *Civil War in China: the Political Struggle, 1945–1949.* Lanham: Rowman and Littlefield, 1999 [1978], 277–289.

14. Sheila Fitzpatrick, *Everyday Stalinism, Ordinary Life in Extraordinary Times: Soviet Russia in the 1930s.* Oxford: Oxford University Press, 1999, 46–54.

15. Cong Xuanyou, "San qu zhuzhai tiaozheng yundong" (The housing redistribution movement in three districts) in Zhonggong Dalian shi Zhongshan qu wei dangshi bangongshi, ed., *Zhongshan chunxiao* (Zhongshan's dawn of spring) (Dalian: Dalian haiyun xueyuan chubanshe, 1992), 42.

16. Dalian shi fangdichan guanliju bianzhi bangong shi, ed. *Dalian chengshi fangdichan da shiji* (A chronology of real estate in the city of Dalian). (neibu, no publication data: 1989), 3–4.

17. Ibid.,19.

18. Ibid., 7–8.

19. Ibid., 11.

20. In February 1946, the city was broken down administratively into five districts (*qu*). Each district was composed of between 20–40 wards (*fang*), with each ward containing twenty-five neighborhoods (*lu*). Many of the ward heads and even neighborhood heads were essentially the same people that had been in charge during the Japanese regime. See Lüda gaishu bianji weiyuan hui, ed. *Lüda gaishu* (A brief account of Lüda), Lüda: Lüda gaishu bianji weiyuan hui yinxing, 1949.

21. *Xin sheng shibao*, September 7, 1946.

22. *Xin sheng shibao*, August 28, 1946.

23. Cong Xuanyou, "San qu zhuzhai tiaozheng yundong" (The housing redistribution movement in three districts) in Zhonggong Dalian shi Zhongshan qu wei dangshi bangongshi, ed., *Zhongshan chunxiao* (Zhongshan's dawn of spring) (Dalian: Dalian haiyun xueyuan chubanshe, 1992), 43–44.

24. Cong Xuanyou, "San qu zhuzhai tiaozheng yundong" (The housing redistribution movement in three districts) in Zhonggong Dalian shi Zhongshan qu wei dangshi bangongshi, ed., *Zhongshan chunxiao* (Zhongshan's dawn of spring) (Dalian: Dalian haiyun xueyuan chubanshe, 1992), 47–48.

25. Ibid., 48.

26. "Zhonggong Lüda diwei guanyu kaizhan Dalian zhuzhai tiaozheng yundong de jueding" (The CCP Lüda committee's decisions regarding the spread of the housing redistribution movement), July 7, 1946, in CJSG, 515–520.

27. Cong Xuanyou, "San qu zhuzhai tiaozheng yundong" (The housing redistribution movement in three districts) in Zhonggong Dalian shi Zhongshan qu wei dangshi bangongshi, ed., *Zhongshan chunxiao* (Zhongshan's dawn of spring) (Dalian: Dalian haiyun xueyuan chubanshe, 1992), 44.

28. Relocating the urban poor and those deemed "unproductive" into rural areas was a tactic carried out in other cities throughout Northeast China (Manchuria). See Steven I. Levine, *Anvil of Victory: The Communist Revolution in Manchuria 194–1948*. (New York: Columbia University Press, 1987), 188–190. For such resettlement in Lüda, see Zhang Pei, *Dalian fangwen jiyao* (Summary of a visit to Dalian) (Herafter DFW) (Shenyang: Dongbei Xinhua shudian, 1949), 2–3.

29. *Xin sheng shibao*, August 27, 1946.

30. *Dalian wanbao,* March 19, 2006.

31. Lao Xigang huigu dangnian "pinmin banjia yundong" qiaoluo dagu zhu jin Riben fang (Looking back at the poor peoples moving campaign in old Xigang, ringing in moving into Japanese homes with gongs and drums) in *Dalian wanbao,* March 19, 2006.

32. *Dalian ribao,* August 27, 1946.

33. Ibid.

34. LDGS, 275.

35. *Guandong ribao,* June 5, 1947.

36. See Dalian gongye zhanlanhui, ed., *Gongye Zhongguo de chuxing* (The embryonic state of industrial China) (Guangzhou: Xinhua shudian, 1950), and Gong zhan hua bao (Industrial exhibit pictorial), no.1 and no.2 (July and September 1949).

37. Dalian gongye zhanlanhui, ed., *Gongye Zhongguo de chuxing* (The embryonic state of industrial China) (Guangzhou: Xinhua shudian, 1950), 9.

38. *DFW,* 12.

39. Yan Jing, ed., *Dongbei fangwenlu* (Records of a journey to the Northeast) (Beijing: Shenghe, dushu and xinzhi sanlian shudian, 1950), 120.

40. Yang Jing, ed. *Dongbei fangwen lu* (Records of a visit to the Northeast) (Beijing: Shenghuo shudian, 1950), 117–120.

41. Li Zongying, Liu Shiwei, and Liao Bingxion (ed.), *Dongbei xing* (Travels through the Northeast), 46.

Chapter 11

Spatial Profiling

Seeing Rural and Urban in Mao's China

Jeremy Brown

People in all societies judge, categorize, and differentiate. During China's socialist period (1949–1978), one of the main sites of differentiation and discrimination was place-based: urban versus rural. Like racial, ethnic, and gender difference in North America today, rural-urban difference in Mao Zedong's China was socially constructed and historically contingent. But it was also very real. The way people saw and experienced rural-urban difference had real consequences. Under Mao, people who lived in villages ate different food, spoke a different language, wore different clothes, and had a different skin color from people who lived in cities. A peasant's typical day was different from that of an urban worker. The economic gap was also huge: urban people earned guaranteed salaries and had money to spend while village incomes were miniscule and tenuous.

When we consider that the Communist revolution was based on peasant support and aimed to bridge the economic and cultural chasm separating city from village, it seems puzzling that difference between urban and rural people remained so persistent during the Mao era. According to orthodox Marxism, the countryside was backward and stagnant, and only the urban working class could effect revolutionary change. China under Mao, however, appeared to point toward a new path, with peasants as the main revolutionary force offering the utopian promise of equality between city and countryside. But reality was more complex. After the Communists established the People's Republic in 1949, China entered a period of "learning from the Soviet Union" and Soviet-style heavy industrial development became priority number one.[1] In order to finance urban industrialization, peasants were forced to sell grain to the state at artificially low prices and were restricted from leaving their villages. At times, Mao expressed dismay at the anti-rural implications of this policy orientation. As historian

Maurice Meisner writes, Mao responded by promoting the "resurgence of an ideology that spoke on the peasants' behalf and the pursuit of policies that tended to benefit the countryside rather than the cities and their 'urban overlords.'"[2] This ideology was most evident during the Great Leap Forward (1958–1960), which called for irrigation projects, rural electrification, and small-scale village industry, and again during the Cultural Revolution (1966–1976), when more rural youths attended school than at any other point in Chinese history.

Yet while the Great Leap Forward and the Cultural Revolution were ambitious and ultimately cataclysmic experiments, neither event significantly changed how rural and urban people saw each other. Why not? One significant factor was the two-tiered household registration, or *hukou*, system, which classified every individual in China according to rural or urban residence.[3] Household registration was institutionalized after the starvations and massive population dislocations of the Great Leap famine (when tens of millions perished), and it guaranteed food rations, housing, health care, and education to urban residents. Rural people were expected to be self-reliant and were officially restricted from moving to cities, although many peasants still migrated illicitly.[4] Mao may have periodically questioned the anti-rural nature of China's Stalinist development model, but because he never wavered from its institutional underpinnings (the *hukou* system and grain rationing), rural and urban people remained unequal.

While scholars have documented the details and consequences of the *hukou* system, the visual dimension of rural-urban difference is less well understood. Rural-urban difference endured under Mao because of an ingrained culture of seeing that predated the Communist takeover of the mainland. I call this culture of seeing "spatial profiling," which means determining someone's background as rural or urban at first glance and treating him or her differently based on appearance. When we analyze place-based identity in China in terms of how people saw one another, everyday exchanges and local practices seem more powerful and lasting than Maoist ideology or shifting national policy.

How old was spatial profiling in China? Historians differ on the extent of the rural-urban divide in Ming (1368–1644) and Qing dynasty (1644–1911) China. Some scholars hold that there were no significant cultural differences between the two realms, while others argue that a distinct urban identity emerged.[5] Most agree that by the Republican era (1912–1949), the gap between town and country had sharpened significantly as the rural economy stagnated and as urban centers—particularly coastal treaty ports like Shanghai and Tianjin—witnessed an upsurge of modern industry and print culture.[6]

As modernization fueled the growth of cosmopolitan cities, urban dwellers increasingly came to view villagers and rural life as inferior. Historian Xiaorong Han has shown how during the first half of the twentieth century, urban intellectuals, even those who had been born and raised in villages themselves, saw peasants in contradictory and contemptuous ways: for example, ignorant yet sweetly innocent, or poor yet disturbingly rebellious. As Han writes, this engendered a process of mutual alienation: "No matter how strongly the intellectuals sympathized with the peasants, in the eyes of the peasants they were often strangers with strange ideas as well as members of the ruling class."[7] By the time the Communists assumed national leadership in 1949, rural and urban people spoke different languages, wore different clothes, and had distinct conceptions of work and labor. Migrants brought customs and rituals from their native places to the metropolis. And throughout the Mao era urban people were sent to live in the countryside for "reeducation" by the peasants and to provide expertise needed for building the socialist countryside—including millions of "sent-down youth" during the Cultural Revolution (see Zheng's chapter in this volume). Nonetheless, cities and villages continued to diverge in architecture, infrastructure, and social geography.[8]

Communist policymakers and propagandists were well aware that villagers and city dwellers held potentially troublesome preconceived notions about each other. But official efforts to reshape urbanites' views about peasants, both in the immediate post-takeover period and throughout the 1960s and 1970s, ended up reinforcing difference rather than eliminating it. Spatial profiling—seeing others as rural or urban in everyday interactions—proved to be remarkably durable.

In 2004–2005, over the course of a year of research in and around Tianjin, I asked almost everyone I met about rural-urban difference, logging ninety interviews. When I was in Tianjin, north China's largest port city and home to more than ten million residents, I asked if people had ever been to a village during the Mao years, and what they thought of peasants and villages. When I went to the countryside, mostly to Baodi County, a rural area about forty-five miles north of Tianjin, I asked the opposite.[9] Whether in the city or in villages, I asked how people could determine the rural or urban identity of someone they were meeting for the first time.

The people I interviewed assumed that, as a foreigner, I knew little about China and the Mao period. My perceived ignorance was an advantage because respondents were forced to explain in detail things that they usually took for granted. Differences in clothing, food, and language might be too obvious and natural to mention to an insider. But these everyday distinctions get us closer to understanding how people have seen and experienced rural-urban difference.

SEEING PEOPLE

As economic networks between city and countryside were reestablished in
the early 1950s after years of war and strife, propaganda images clarified that
cities would remain China's locus of civilization and economic development.
In Figure 11.1, a cartoon celebrating renewed rural-urban ties, shopping in
the city is presented as a happy event for peasants, but in order to mark the
shoppers as rural, they are drawn as yokels, with wrinkled faces, big hats, and
baggy, rumpled clothes. One is clutching a long pipe, the other toting a gunny
sack. They have plenty of time on their hands as they happily pose while
indifferent townspeople go about their regular business in the background.

**Figure 11.1 This cartoon comes from a travel montage featuring the Communists'
efforts to rebuild the city of Yantai in Shandong province in 1950. The cartoonist's
message was that peasant shoppers belonged in a healthy socialist city, but they were
nonetheless clearly identified as wide-eyed, bumpkin-like outsiders.** From: Shang Yi,
"Nongminmen xiao mimi de jincheng lai mai dongxi" [Peasants smilingly enter the city
to buy things], *Manhua yuekan* 6 (November 1, 1950): 20.

The cartoonist was playing up to readers' imagined notions of what rural people should look like. Worn clothing and wrinkled faces remained surefire markers of rural people well after 1950.

Figure 11.1 suggests that peasants would still be easily identifiable as hicks in Mao's new China. Almost all of my respondents claimed that they were able to tell whether someone was rural or urban during the Mao period without hearing them speak a word. Even in a first encounter on the street or at the market, clothing, bearing, and skin color were clear indications of place-based identity and helped people mentally categorize others. One Tianjin man visited his ancestral village for the first time as a young boy in the 1970s. He said that the main difference he noticed between city people and peasants was that peasants "looked old" because they worked outside all day long.[10]

Other city people said that they could tell a person was rural because of his or her darker skin. City people who spent a lot of time outside felt stigmatized as rural by their urban peers. A Tianjin-born teenager who was sent to work at a state-run farm on the outskirts of the city in 1963 was annoyed by the constant comments of his family during his weekend visits home: "you're tanned black," they kept saying.[11] In Figure 11.2, a photograph taken in 1968, compare the face of model sent-down youth Xing Yanzi (right) with the face of her conversation partner (left). The elderly woman's dark, wrinkled face identifies her as a peasant. Even in images meant to celebrate rural-urban togetherness, the city was represented by youthful vigor and light, while the countryside appeared dark and old by comparison.

Clothing was another important marker of rural difference. Respondents described urban clothing in the 1950s, 60s, and 70s as fashionable, new, and made from tailored fabrics. Village attire was dirty, tattered, and made of homespun cotton. Even in images meant to publicize the interconnectedness of cities and villages in 1950s China, dress and adornment identified people as urban or rural. Figure 11.3 accompanies a written passage about how cotton and food from villages enter the city and help factory production to flourish. On the left, a woman with short hair, a floral-print top, and a work apron attends to a machine in a textile factory. On the right, a woman with braids and a plain, striped top picks cotton by hand. The factory worker's modern hairstyle and showy clothes mark her as urban.

City and village people looked different before the Communists assumed power, and this would continue in the new society, as Figure 11.3 suggests. Tianjin residents noticed differences in clothing as soon as the mostly rural soldiers of the People's Liberation Army occupied the city in January 1949. A Communist official who followed the soldiers into Tianjin remembered that city people were surprised by the conquerors' rustic attire and asked, "How can you wear such tattered clothing?" The new rulers

Figure 11.2 Li Changjie, "Jiaoliu xuexi xinde" [Study notes on an exchange], Renmin huabao she. July 1968. In this photograph by a photographer working for *China Pictorial* (Renmin huabao), a model sent-down youth, Xing Yanzi, speaks with an unidentified woman, whose red ribbon reads "*daibiao*" (representative). Available from: ChinaFotoBank, photo 301644, http://photos.cipg.org.cn/.

of Tianjin explained, "We wear these clothes all day long to march and fight battles, so of course they are tattered. We aren't particular about such things."[12]

Tianjin residents also worried that the new regime might prohibit urban fashions. Indeed, as Christian Hess's contribution to this volume shows, transforming urban environments to render them more visibly revolutionary was a key priority for Communist leaders. People in Tianjin spread rumors that the Communists had prohibited urban-style gowns and leather shoes, and some clerks stopped wearing glasses to the office because spectacles were a clear marker of an urban intellectual identity.[13] This particular symbol persisted throughout the Mao era, as shown in Figure 11.4, a photograph taken in 1975 of city youth collaborating with peasants on scientific soil management. Even without reading a caption, viewers would be able to immediately identify glasses-wearing Hou Jun, front left, as a woman from the city sharing her specialized knowledge with rural people.

Figure 11.3 This visual depiction of urban-rural difference appears in a book of verse celebrating China's "worker-peasant alliance" (*gongnong lianmeng*). From: Xiu Mengqian, *Gongnong lianmeng xiang qian jin* [The worker-peasant alliance advances forward] (Shanghai: Laodong chubanshe, 1953), 18.

Shortly after the Communists occupied Tianjin, female workers asked the Party cadres taking over their factories if they were still allowed to perm their hair or wear lipstick and high heels.[14] The officials replied that people were free to wear whatever they wanted, but the regime was much stricter toward its own officials than toward urban factory workers. In 1949, a woman cadre at the newly founded *Tianjin Daily* newspaper found an old pair of high heels on a windowsill at the office. In the rural areas under Communist control before 1949, she had loved to dance and always wanted to wear heels, so she was elated to find a free pair. She began wearing the shoes, which had probably been discarded by a more cautious coworker, but her colleagues criticized her for violating the image of frugality that the Communists wanted to present. She had to get rid of the shoes and do a self-criticism.[15] In policing what the woman newspaper cadre could wear, the new regime was acknowledging urban-rural difference. High heels were an extreme symbol of urban leisure and frivolity, and because the party was striving to uphold its hardworking image in the immediate takeover period, it was a serious ideological lapse for the dance-loving woman to wear them.

The concern over ideological correctness gained renewed emphasis in the mid-1960s, when in the wake of the Great Leap disaster, Mao became concerned that the revolution was dying. In the years leading up to the Cultural

Figure 11.4 Gao Mingyi, "Hou Jun he qunzhong tantao tianjian guanli" [Hou Jun explores field management with the masses], Renmin huabao she. 1975. In this photograph by a photographer working for *China Pictorial*, model sent-down youth Hou Jun (front left), works in the fields with the nameless "masses" of Doujia village. Available from: ChinaFotoBank, photo 284385, http://photos.cipg.org.cn/.

Revolution, the Party launched the Socialist Education Movement and Four Cleanups Movement to root out corruption and reinstill commitment to socialist revolution. And so, more than fifteen years after the high heels flap, official documents again criticized urban clothing styles as unacceptably decadent, and in so doing, implicitly recognized the continued salience of difference between city and village styles.

A 1966 article, "The Revolutionary Crucible Gives Birth to a New Person," chronicled the multiple transformations of a girl named Jinxia, who left her village in Hebei Province to attend a university in Tianjin. When she first got to Tianjin, Jinxia wore rural clothes and her classmates derided her as a hick.

She decided that it was a loss of face for her to wear her coarse cloth gown in the city, so she borrowed money and had a fashionable skirt and blouse made. She also traded her old cloth bookbag for a faux leather handbag. During summer break, Jinxia visited her home village. Jinxia's mother had died shortly after childbirth, and a fellow villager had nursed her. As soon as she got off the bus, Jinxia ran into her old wet nurse, who cried out a happy greeting, but Jinxia pretended not to hear her. A friend with Jinxia said, "Somebody is calling you." Jinxia looked back, saw the old woman's dirty tattered clothing, and coldly replied, "I don't know her." Later when she was sent to another Hebei village on a work assignment, Jinxia realized her errors and apologized for "forgetting her roots." Her story confirms that clothing was still a crucial marker of rural-urban difference in 1966.[16]

According to my interviewees, even new city clothes were not enough to cover up someone's rural identity. Four people, all village-born, said that rural people carried themselves differently, no matter what they wore. A Baodi woman who first went to the city in the late 1950s said that "even if a village person has good clothes," he or she "cannot wear it well, it will not look clean."[17] Another Baodi man who spent many years in and around Tianjin agreed, saying, "Even if a peasant puts on city clothes and goes to the city, you can tell that he's a peasant from his bearing."[18] A rural bearing (*fengdu*) was hesitant and dazed, he explained, not confident and spirited like that of urban people. As this man's comments and Jinxia's experience as a new college student attest, when villagers went to the city or came in contact with urban people, they became acutely aware of their inferior status. For the first time, their clothes seemed dirty and threadbare. One villager who first went to Tianjin in 1949 seeking work remembered: "I felt I was an idiot and that I knew nothing."[19]

In addition to outward markers of urbanity or rusticity, most of the people I interviewed were convinced that villagers and city people had distinct personalities. City residents often called villagers *laoshi* or *pushi*, terms that mean "honest" or "down-to-earth" but also imply "naive and simple-minded." Communist propaganda actually encouraged such descriptions of rural personality shortly after the takeover of Tianjin. For example, a 1949 report about an industrial exhibition in Tianjin remarked that the presence of peasants at the meeting had transformed city residents' "incorrect viewpoint of treating peasants as unimportant." By meeting villagers, city people learned about "the peasants' hard work, plain living, and sincere and frank feelings."[20] The report emphasized post-1949 changes, but still assumed difference and hierarchy.

Rural people I talked to readily agreed that they were *laoshi*,[21] and had an even broader vocabulary to describe themselves as honest or straightforward: *shizai*, *tanbai* (real, honest, dependable), *chengshi* (honest and trustworthy),

and *hanhou* (simple and honest). But villagers also had negative impressions of urban personalities. If rural people were honest and straightforward, then urbanites were the opposite: *jian* (treacherous), *jianhua* (crafty), or *hua* (slippery).

These place-based descriptions were not limited to everyday conversations. They also appeared in official documents throughout the Mao era. A 1951 report on a trade exhibition in Tianjin noted that peasants, afraid of city thieves and cheats, held on tight to their wallets after getting off the train in Tianjin. Before the 1951 meeting, some Tianjin people still thought that "peasants were tattered, casual, and impolite." But after meeting rural people at the trade exhibition, Tianjin residents supposedly realized that peasants were actually "honest and considerate, plain and simple, well-behaved and courteous."[22] Yet these apparent ideological transformations were fleeting. In advance of a peasant representative meeting in Tianjin in 1965, urban shopkeepers admitted that they judged rural people solely by their appearance (*yi yimao qu ren*) and tried to pawn off their dull, low-quality items on gullible rural shoppers. After hearing propaganda about the peasant representative meeting, the shopkeepers pledged to change their ways and treat peasants better.[23]

Why were such stereotypes so persistent throughout the Mao era? Ideas about rural-urban difference predated the founding of the People's Republic in 1949. Afterward they were either impervious to propaganda or buttressed by official messages that implicitly reinforced difference even as they outwardly criticized discrimination and ostentation. Alongside new institutional barriers like the *hukou* system that separated city and countryside, a long-standing culture of seeing differentiated between rural and urban people, both in everyday interactions and in official propaganda.

SEEING PLACE

Ideas about difference went beyond appearances and purportedly innate characteristics. People linked distinct notions of food, labor, and cleanliness to the urban sphere or the rural sphere. All of these issues arose from economic differences between privileged cities and struggling villages.

How food was obtained and prepared—and, not insignificantly, how it tasted—loomed large in respondents' ideas about rural-urban difference in the 1950s, 1960s, and 1970s. For many in the Tianjin region, the difference between village and city came down to coarse grain (*culiang*) versus fine grain (*xiliang*), meaning cheap cornmeal versus expensive processed wheat flour. Villagers wanted to make sure I understood that although noodles and dumplings made out of wheat flour are relatively common in northern Chinese villages nowadays, they were rare luxuries forty years ago. My hosts

in villages made a point of feeding me fried cornmeal cakes or steamed corn buns so that I could get a taste of what rural life was like during the Mao period.

One elderly Baodi woman gave me a plate of watermelon slices and told me that she had never been to a city in her life. Tianjin was just over an hour away by bus, and Beijing was only two hours to the west, but she had never had the chance to visit. She had heard that the city was great, especially compared to her village, with its bumpy dirt roads. In 2005, the uneven potholed lanes remained, but as she understood it, the rural-urban gap had closed in terms of food. "We used to eat corn buns here," she said, and that was all she needed to say about rural-urban difference in the Mao era.[24] To her, eating coarse grain was the main thing that distinguished her village from Tianjin— before and after 1949.

Rural women who had the chance to visit Tianjin in the late 1960s and early 1970s remembered the wheat noodles and dumplings more than anything else. One Baodi teenager made friends with a Tianjin girl who had been sent to live in her village in the late-1960s. The sent-down youth's parents heard about their daughter's new friend and invited her to visit Tianjin. "When we got to Tianjin, I thought that everything was new and fresh," the country girl said. "Her family treated me very well, they boiled noodles and made dumplings for me. Where could you find wheat flour in the village back then?"[25] She went on to praise the beauty of Tianjin's colonial buildings, relics of the city's days as a treaty port, but the architecture was secondary to her memories of special food.

The corn/wheat gap was one of the most glaring manifestations of rural inferiority. Rural people knew that urbanites ate wheat regularly, and city residents were aware of the difference too. I spoke with an eighty-year-old Tianjin-born man who asserted, "The food that peasants make tastes bad." Switching into English, he added: "No taste, no odor; tasteless, odorless." He remembered that in the 1940s and 1950s, food-based distinctions were used to curse people. "You cannot afford to eat wheat flour" and "corn brain" were two of the most stinging insults of the era, he said. In everyday interactions, such anti-rural slurs were as prevalent after 1949 as they were before.

While rural people acknowledged the high quality of city food, they disparaged the quantity. Rural visitors to Tianjin in the 1950s complained that portions were too small. They felt that this stinginess reflected poorly on city people. Offering small portions was not *laoshi*. One old man I met in the Baodi town square said that whenever he went to the city for family visits or for work meetings, he did not like to eat out or in city people's homes because the dishes were too small and everything seemed too formal. At restaurants, he paid what seemed like a lot of money but never got enough to eat. He preferred going to a relative's house in the city for home-style meals.

Rural men complained about tiny platters of food in Tianjin, but women envied the conveniences of city cooking. When a village teenager visited her sister's city home in the late 1970s, she immediately noticed that meals were prepared on a gas stove. It seemed so easy and fast. In villages outside of Tianjin, families heated their food over fires fed by dried corn stalks and other kindling, a practice that has continued in the twenty-first century today, as seen in Figure 11.5 (see website). While the concrete base shown in the photograph is a relatively recent innovation, the use of organic fuel is not.

For rural people in the 1960s and 1970s, cooking on a gas stove was an unattainable luxury. That city people cooked with gas instead of burning dried corn stalks also exemplified how divorced they had become from agricultural production. Both villagers and city people agreed that urbanites did not understand where their food came from. One running joke that three people independently mentioned to me was the inability of urban youth to distinguish between chives and young wheat stalks. When one Tianjin youngster first arrived in a Baodi village as a sent-down youth in April 1964, he assumed that the surrounding fields of green sprouts swaying in the breeze were full of the tasty chives that he enjoyed in his dumplings back at home. He wondered aloud why there were so many chives growing there. A villager on the welcoming committee cleared up the confusion. "After [the sprouts] grow up, we harvest and process them into the wheat that you eat in the city," the villager explained.[26]

Another Tianjin boy assigned to a village even closer to the city made the same mistake in 1977. "You sure have a lot of chives," he told the villagers who greeted him. Probably tired of correcting confused city kids, the peasants stayed quiet. A few days later, the group of newly arrived sent-down youth used wheat sprouts as filling for a batch of what were supposed to be chive dumplings. They tasted terrible.[27]

The issue of where food came from was connected to another major place-based distinction: city work versus rural labor. Villagers toiled in the fields from dusk until dawn and made hardly any money, while salaried urban employees had set work hours and a day off on the weekend. There are two different words for "work" in Chinese: one refers to employment with regular hours (*gongzuo*), the other to farm work and other non-salaried physical labor (*ganhuor*). Peasants doing farm work do not *gongzuo*, they *ganhuor*. The main difference was that city workers had guaranteed salaries, while village incomes depended on the harvest and how much grain the state requisitioned in a given year.

Not only was farm work virtually unpaid, but it involved incredibly tough physical labor. City people who tried their hands at farm work invariably described the experience as arduous, while rural dwellers derided the inability of urbanites to work hard. One Baodi villager had the opportunity

to compare rural and urban people after he joined the army in 1968. His unit was stationed in coastal Fujian Province and included recruits from cities and villages throughout China. He noticed immediately that the city soldiers had trouble with physical labor. The city people lacked toughness, he said. The Baodi soldier explained that indoor and outdoor plants grow differently, meaning that the city soldiers were like delicate house plants.[28]

Sent-down youth or visiting urban officials openly admitted that they were not as good at farm work as the locals. This seemed natural to them, but they found it troubling that villagers judged visitors based on their ability to toil in the fields. A Tianjin teen sent to Baodi in 1964 said that he was unhappy during his first two years in the village because he was so much slower and weaker than his rural peers. Nobody appreciated his middle school education. All they saw was how poorly he did farm work. He earned less than half of the upper limit of daily work points, less than an average local woman made. The teenager was adept at repairing machines, better than local villagers but even when he did repairs, he still made fewer work points. The standard for assigning work points was field labor, not repair work, he was told.[29]

Officials stationed in villages made a point of trying to work hard in the fields. One Tianjin cadre was sent to a Baodi village in 1975 to mediate a dispute. In order to gain the trust of people in the village, his first task was to do farm work. "When a peasant is checking out what an official is really like," he said, "he checks how you labor, if you shirk work or if you are lazy. Whoever works with him and leads the way on a job gets along best." The official worked hard and reached the level of the strongest female farm worker. This was enough to earn the respect of the locals, he said.[30]

While some urbanites at least attempted to work in the fields, others openly scorned agricultural labor as dirty, unpaid grunt work. City children adopted this attitude at a young age. One man born in a Hebei village in 1962 moved to Tianjin as a small child along with his parents and three siblings. His father had a factory job, but his mother and the children lived in Tianjin illegally, without urban *hukou*. (In the Mao era, children inherited *hukou* status from their mother. This rule limited urban population growth in an era when many families lived apart, with migrant men working city jobs while their wives and children remained rural residents.) The Hebei man said that as a child, he was teased because he was from a village. One day, in a fight with an older neighborhood bully, the village boy managed to beat up his tormentor. The humiliated loser told his rural-born nemesis, "When we grow up you will have to hoe the dirt in a village and I will become a factory worker."[31] Even children knew that village labor was inferior to city work.

This association between dirt, filth, and villages remained strong throughout the Mao period. One man from a mountain village was convinced that

city people looked down on peasants because "villagers have bad hygiene, they smell bad." For this reason, he said, it was "natural" that outsiders would scorn peasants. Rural people who went to the city felt self-conscious about their dirtiness. They associated hygiene with urbanity, and saw dirtiness as a sign of inadequacy. Two Baodi women who visited Tianjin remarked that the city seemed exceptionally clean and that everyone emphasized hygiene there. They felt that constant remarks about hygiene might be targeted at them. One woman who was in Tianjin in the early 1960s told people in the city, "Don't dislike us because we are dirty. If it were not for us, what would you eat?" She explained in an interview, "Actually they did not look down on me. Because I was young at the time, my clothes were clean and quite nice. They all said that I did not seem like a village person."[32] She was cleaner than the city residents had expected, she said.

SPATIAL PROFILING

Spatial profiling in Mao's China marked individuals as rural or urban. People saw others' clothing and skin color, and coded them as belonging to the countryside or the city. The same place-based encoding applied to everyday practices, from cooking and eating to labor and hygiene. This everyday culture of seeing was so ingrained that policy and propaganda during the 1950s, 1960s, and 1970s, far from eliminating rural-urban difference, actually reinforced it.

Spatial profiling in Mao's China occurred in both official settings and in nonofficial interactions at the grassroots. Everyday place-based profiling stigmatized rural people and led villagers to internalize a sense of inferiority vis-à-vis city people. This sense of inferiority was bolstered by backhanded praise in official propaganda (peasants as "honest and simple") and also by the socialist planned economy, which offered a package of exclusive rights and benefits to urban residents and attempted to lock villagers to rural communes. Yet while the *hukou* system was an important part of the rural-urban divide, it did not make all of the difference. An entrenched way of seeing that stemmed from genuine economic and cultural differences greeted the mostly rural Communist soldiers and cadres who took over Chinese cities in 1949. As long as the economic and cultural gap between cities and villages remained, so would spatial profiling.

NOTES

1. Research for this chapter was assisted by a Fulbright-Hays Doctoral Dissertation Research Award and a Social Science Research Council International

Dissertation Field Research Fellowship with funds provided by the Andrew W. Mellon Foundation. For a concise overview of the planned economy under Mao, see Barry Naughton, *The Chinese Economy: Transitions and Growth* (Cambridge, Mass.: MIT Press, 2007), 55–84.

2. Maurice J. Meisner, *Marxism, Maoism, and Utopianism: Eight Essays* (Madison: University of Wisconsin Press, 1982), 71.

3. Tiejun Cheng and Mark Selden, "The Origins and Consequences of China's Hukou System," *China Quarterly* 139 (September 1994): 644–668.

4. On the substantial unsanctioned migration of the Mao period, see Diana Lary, "Hidden Migrations: Movements of Shandong People, 1949–1978," *Chinese Environment and Development* 7, no. 1–2 (1996): 56–72.

5. On the idea of a rural-urban continuum during the Ming, see F. W. Mote, "The Transformation of Nanking, 1350–1400," in G. William Skinner, ed., *The City in Late Imperial China* (Stanford: Stanford University Press, 1977), 101–154; on the formation of a distinct urban identity in the Qing dynasty, see William T. Rowe, *Hankow: Commerce and Society in a Chinese City, 1796–1889* (Stanford: Stanford University Press, 1984).

6. See, for example, David Faure and Tao Tao Liu, "Introduction," in David Faure and Tao Tao Liu, eds., *Town and Country in China: Identity and Perception* (New York: Palgrave, 2002), 1–16.

7. Xiaorong Han, *Chinese Discourses on the Peasant, 1900–1949* (Albany: State University of New York Press, 2005), 139.

8. See Hanchao Lu, *Beyond the Neon Lights: Everyday Shanghai in the Early Twentieth Century* (Berkeley: University of California Press, 1999).

9. Baodi County became a sub-municipal administrative district (*qu*) administered by Tianjin in 2001.

10. Interviewee 33 (author's numbering system).

11. Interviewee 57.

12. Zhonggong Tianjin shiwei dangshi ziliao zhengji weiyuanhui and Tianjin shi dang'anguan, eds., *Tianjin jieguan shi lu* [History of the takeover of Tianjin, hereafter cited as TJJG], vol. 2 (Beijing: Zhonggong dangshi chubanshe, 1994), 259.

13. TJJG, vol. 1 (Beijing: Zhonggong dangshi chubanshe, 1991), 136; TJJG, vol. 2, 153, 183.

14. TJJG, vol. 2, 183.

15. TJJG, vol. 2, 352.

16. *Hebei siqing tongxun* [Hebei four cleanups bulletin], *zengkan* 61 (May 23, 1966): 29–31.

17. Interviewee 86.

18. Interviewee 18.

19. Interviewee 43.

20. Tianjin shi dang'anguan, ed., *Jiefang chuqi Tianjin chengshi jingji hongguan guanli* [Tianjin urban macroeconomic management in the initial stage following liberation] (Tianjin: Tianjin shi dang'an chubanshe, 1995), 326.

21. When journalist Peter Hessler befriended a rural family in the early 2000s, *laoshi* was the only word the parents used to praise their young son. Peter Hessler, "Kindergarten," *New Yorker* 80, no. 7 (April 5, 2004): 58–67.

22. Wang Kangzhi jinian wenji bianjizu, ed., *Wang Kangzhi jinian wenji* [Collected writings commemorating Wang Kangzhi] (Tianjin: Tianjin renmin chubanshe, 2001), 434.

23. Hexi District Archives (Tianjin), 1-6-26C, 9.

24. Interviewee 65.

25. Interviewee 88.

26. Interviewee 26.

27. Interviewee 64.

28. Interviewee 22.

29. Interviewee 6.

30. Interviewee 5.

31. Interviewee 31.

32. Interviewee 86.

Chapter 12

Cinema and Propaganda during the Great Leap Forward

Matthew D. Johnson

What is propaganda? While the term connotes a pejorative meaning today, during the early twentieth century it served mainly to denote a type of persuasion—images and words which imparted a political message. The rise of modern propaganda is closely associated with the rise of new technologies such as radio, film, and television which were viewed not only as sources of entertainment but also as potential tools of social education and control. Over the decades however, the term "propaganda" has become mainly associated in the U.S. with "totalitarian regimes and war efforts, [which were] perceived as threats to liberal democracies."[1] Our negative usage of the word "propaganda," in other words, has a history. In China as well, terms like propaganda and political education may today raise a certain degree of skepticism among the general populace. Yet it is undeniable that throughout much of the twentieth century the production of mass media for specific state purposes constituted a highly public and officially acknowledged function of government. By asking a few simple questions: This chapter will dispel some of the mystery or unfamiliarity associated with cultural life in the People's Republic of China (PRC) during the "Mao years." What was propaganda from the perspective of those who produced it? What messages did it contain? How was it disseminated to audiences? How was it viewed and received? Finally, how did it become a part of its recipients' everyday lives? The medium and era upon which we will focus is film during the Great Leap Forward (1958–1961)—not only because propaganda images from this period were so vivid, as we shall see, but also because this was a key era when film's influence, particularly its spread into the countryside, grew enormously. The Leap thus provides scholars of visual culture with pivotal moment for examining how state claims which now strike us as exaggerated, even hollow, were made "real" for audiences, and how they might have been received.

219

PROPAGANDA, THE COMMUNIST PARTY,
AND STATE-LED DEVELOPMENT

Xuanchuan, a Chinese term many translate as "propaganda," has the broader meaning of "disseminating" or "announcing" messages endorsed by the dominant political regime. Some scholars of Maoist politics believe that such messages were intended to transform members of society by making them take on the Communist Party's goals "as their own values."[2] The party's reasons for pursuing such a transformation are suggested by Julian Chang, who writes that in 1950s China, "a high level of mass political consciousness was [interpreted as] an explicit prerequisite for national development and propaganda was seen as a crucial tool for increasing those levels of political knowledge."[3] Taken together, these two observations indicate that *xuanchuan* was seen as a means of creating social consensus based on party norms and as an indispensable tool for the promotion of national development. In both cases, *xuanchuan* implies a hierarchical relationship between political elites on the one hand and audiences—the "masses"—on the other. In the context of the PRC, *xuanchuan* ("propaganda" hereafter) can thus be generally understood as indicating a media-based program intended to "encourage and guide the masses toward the party-state's policy goals."[4]

One of the most important means of communicating Communist Party-approved values was cinema. Although mainly confined to China's coastal cities throughout much of the pre-1949 period, motion pictures spread rapidly throughout China after the founding of the PRC, most notably during the Leap period, when the party, led by Mao Zedong, called for a dramatic modernization of rural society and an end to gradualist developmental policies. The Great Leap Forward put "politics in command," and film was no exception. Indeed, film technology itself was seen as an important improvement over existing forms of cultural production and consumption, one whose technology manifested the modernizing agenda of the PRC state (see Figure 12.1, website). As the "exhibition network" (*fangying wang*) extended into villages, slogans and images supporting the Leap saturated China's public space via movie screens. One of the main arguments of this chapter is that films produced during the Leap often tended to blur the line between past, present, and future in a way specifically intended to mobilize audiences by instilling in them the belief that "the future was now," and that conditions of material want and poverty were soon to be consigned to the dustbin of history. From the perspective of Communist Party leaders, visions of imminent prosperity were meant to motivate citizens to unleash their mental and physical energies in the pursuit of improved well-being and international prestige. While in hindsight these methods may appear deeply manipulative and misguided, they nonetheless represented these leaders' attempt to place the PRC among the ranks of

developed nations, or even at the top of the hierarchy. As the philosopher Ci Jiwei argued:

> Material superabundance was the goal; on this were superimposed. . . the soaring spirit of altruism and the ethos of complete communal sharing to give that materialist goal the semblance of an idealistic totality called communism. For a utopian project like this one, where material abundance outweighed all other considerations, poverty was naturally the principal psychological lever . . . From this enlightened poverty, it was believed, there would burst forth the utopian energy that would "change heaven and earth" (*gaitian huandi*).[5]

Film was a form of visual propaganda that reinforced this goal of "superabundance" by hinting at what a changed heaven and earth might look like, and by providing a map of how to get there.

A GENRE IS BORN: *SONG OF THE RESERVOIR* AND THE "DOCUMENTARY-STYLE FEATURE FILM"

The international context of the Great Leap Forward was the Cold War. In simplest terms, the Cold War was a contest beginning in the 1940s between two systems of power, one capitalist and one socialist. One of this war's defining features was that the principal powers involved—the United States, the Soviet Union and, increasingly, the PRC—did not often engage direct in military conflict. Rather, technological and economic development played a vital role in proving to rivals and potential allies alike that each country's system was a success. Propaganda was thus pivotal to Cold War geopolitics, convincing citizens to take part in supporting their nation while demonstrating to other nations that evidence existed to back up claims for supremacy in such areas as nuclear capability, agricultural production, per capita wealth, and the space race.

When the Leap was announced in January 1958, Communist Party leaders were in essence claiming that their own nation was poised on the brink of an unprecedented stage of rapid economic growth and material prosperity rather than simply championing the model of socialist development promoted by the Soviet Union, Party ideologues and planners pointed to signs of rapid collectivization in the cities and countryside to show that communism might be achieved with previously unimaginable rapidity. Indeed, many high-ranking members of the Communist Party, including Mao Zedong and Liu Shaoqi, believed that the nation's transition from capitalism to socialism was virtually complete.

Propaganda, including the motion picture, was used widely to support this accelerated transition into socialism, and a whole new film genre emerged to

capture and manifest the Leap's breakthrough. Known as "new features" (*xin yishupian*), "feature-style documentaries" (*yishu xing jilupian*), "documentary-style features" (*jilu xing yishupian*), or "Leap Forward films" (*yuejin pian*), what distinguished this genre was its attempt to combine two very different cinematic modes—the documentary and the fictional-feature film—in order to meld reality with utopia. From a psychological perspective, the key was to convince people that the Leap was in essence *already happening* in select parts of China, and that by joining in, ordinary citizens would be hastening and spreading a new post-Leap reality of national wealth, prosperity, and power.

The acknowledged harbinger of this new filmmaking trend, *Song on the Reservoir* (*Shuiku shang de gesheng*, Changchun Film Studio, 1958) tells the story of a young female commune member, Gao Lanxiang, whose self-less attitude nearly becomes an obstacle to her marriage plans. Gao's fiancé, Gu Zhiqiang, works on the Ming Tombs reservoir construction project near Beijing (see Figure 12.2, website). Gao also wants to participate in the effort to modernize China's infrastructure, and joins up with a well digging crew in her home village, which is far from Beijing. The couple, now physically separated, must put off their wedding. Yet Gao is then miraculously transferred to Beijing for a new work assignment, and ultimately to the very same reservoir construction site where Gu is working. The two are reunited, and married (see Figure 12.3, website). Their commitment to the reservoir project, however, leads Gao to rhapsodize that, of all things, labor is "the most beautiful (*mei*) and meaningful (*you yiyi de*)."

The movie, released in July 1958, was fictional, but the Ming Tombs reservoir construction project was quite real. Begun at the launching of the Great Leap Forward in January 1958, the reservoir was one of the highest-profile development projects of the 1950s.[6] Intended to promote rapid economic growth by bringing irrigation to the countryside, the site was visited by national leaders, foreign diplomats, and thousands of PRC citizens who, like the fictional Gao and Gu, volunteered their labor to help complete this monumental task. Mao Zedong and state premier Zhou Enlai were depicted in carefully posed photographs lifting shovels in support of the project. *Song on the Reservoir* contained numerous scenes capturing this ongoing labor, presenting it not as fiction, but as contemporary fact accompanied by a fictionalized love story and lively music (see Figure 12.4, website). For far-flung viewers throughout China, such documentary scenes served as evidence that public works projects like that at the Ming Tombs site—enormous projects mobilizing thousands of volunteer laborers working night and day with tremendous enthusiasm and speed—were indeed very real, and that rapid transformation of China's countryside was truly possible and already underway. The fictional aspects of the film, detailing not only Gao and Gu's love story but also their commitment to work, implied that anyone could take part in

these endeavors; both characters were rural people, with little to distinguish them from others in the film apart from their enthusiasm and youth. In short *Song on the Reservoir* suggested that a new period of national transformation was dawning, and that Chinese citizens throughout the country could—and *should*—take part with the same self-sacrificing spirit exemplified by Gao and Gu (see Figure 12.5).

The film was instantly labeled a new cinematic genre. "[*Song on the Reservoir*] reflects new things and new people," trumpeted the *People's Daily*, referring to the film's positive depiction of selflessness in support of national development, "while it might lack a preponderance of artistry, regardless, it shows exactly the inherent nature (*bense*) of our socialist era and is a concrete manifestation of the upsurge in Communist consciousness."[7] The reviewer was right—*Song on the Reservoir* had been completed hastily, and the composition of its mise-en-scène made little use of varied backdrops, costumes, and special effects typically associated with feature film during the late 1950s. However, the review was quick to draw readers' attention to the film's numerous virtues: its characters' personalities were easy to understand; they put national goals, like water conservancy, before personal

Figure 12.5 Human and mechanical labor achieve the incredible in *Song of the Reservoir*. The signs read, "Study the Enthusiasm of the Ming Tombs Reservoir."
From: *Shuiku shang de gesheng* [Song of the Reservoir]. Changchun Film Studio, 1958.

goals; working people and authority figures (the solution to Gao's problem is suggested by her commune chairperson) were prominently and positively depicted; romantic love coexisted with personal sacrifice and restraint; the filmmakers were attuned to the "pulse" (*maibo*), or "spirit" (*jingshen*), of the era; the scenery was composed of existing state projects, incorporated real events, and incurred little or no significant expense. In short, both directors and actors had, according to the official press, entered the "torrent" (*hongliu*) of contemporary social transformation. In other words, the film modeled and endorsed Great Leap Forward goals of mass mobilization, while at the same time referring to real events—in this case, China's ongoing material and ideological transformation as promised by Communist Party leaders.

"OUR NATION IS LIKE AN ATOM": THE GREAT LEAP FORWARD AS DEVELOPMENTAL IDEOLOGY

What made *Song on the Reservoir* and the dozens of documentary-style features that followed in its wake so distinctive was not just that these films contained images of model individuals, but that they made the extraordinary seem both possible and real. This latter effect, conveyed by the "documentary style," was achieved by employing visual evidence which referred to real places—the actual Ming Tombs reservoir, for example—and real outcomes, such as the reservoir's completion. The message was that ordinary people, working together, could achieve immense results in building a newer, better, and more prosperous society for all. While *Song on the Reservoir* did depict mechanized equipment, its overwhelming visual focus was on human labor such as digging, carrying heavy loads of dirt on shoulder poles, and other, more "traditional" construction methods.

The key to this line of reasoning was Mao Zedong's belief that the PRC had already completed the transition to socialism by January 1958, thus implying that communism and material prosperity—"each according to their wants"—beckoned. What made Mao's views unlike those of more orthodox Marxist–Leninists was that he apparently did not believe that urbanization and industrialization were necessary prerequisites of communism. The main premise of the Great Leap Forward, as described to China's people, was that China could "leap" *over* this developed-world stage of social development ahead of schedule and transition directly to communism, just so long as the state owned the means of production and people were willing to throw themselves into the task. China's "poor and blank" condition, in which 90 percent of the population consisted of peasant farmers, whose literacy rates were low, was not an obstacle to material growth because, as Mao explained to members of the Supreme State Conference:

Our enthusiasm has been aroused. Ours is an ardent nation, now swept by a burning tide. There is a good metaphor for this: our nation is like an atom . . . When this atom's nucleus is smashed the thermal energy released will have really tremendous power. We will be able to do things which we could not do before. When our nation has this great energy we will catch up with Britain in fifteen years.[8]

According to Mao, what people *believed* they could do was more important than the restrictions placed on their behavior by environmental, technological, or other factors.

This "voluntarist" strain in Mao's understanding of social change has received considerable attention from his interpreters. For the intellectual historian Maurice Meisner, one of Maoism's chief characteristics was that it functioned as "an ideology of development. . . as well as one promising a future Communist utopia."[9] Maoism was thus partly a theory of economic modernization, which emphasized hard work, self-denial and sacrifice, and unwavering commitment to collective or national goals as the prerequisites of Communist utopia (see Figure 12.6, website). For that utopia to arrive, each member of society was required to throw themselves into the process of making China richer and stronger. In a political system based on these norms, propaganda represented one of the chief means through which people were taught Mao's vision and how, accordingly, they should behave. At the time of the Great Leap Forward, the release of collective energies depicted in films like *Song on the Reservoir* were thus meant to reinforce Mao's assertion that anything was possible with the right spirit by providing visual evidence that what Mao said was true (see Figure 12.7, website).

CELLULOID SPUTNIKS: FROM RESERVOIRS TO COMMUNES IN FILM AND PROPAGANDA

Mao's voluntarist vision was by necessity also supported by the many propagandists within the Communist Party, who in turn employed a variety of media to support Mao's claims that a new Communist society was not only possible, but actually being created. Mao particularly favored rural people's communes—enormous, mega-farms the size of entire counties formed at his tacit urging during the run-up to the Leap—as the symbols of this ongoing transformation. Commune leaders and propagandists then worked together to create visual evidence that the communes did indeed represent communism in practice. Collective meals at which people ate everything they wanted (see Figure 12.8, website), and smiling, well-fed children (see Figure 12.9, website), were depicted as signs that a more abundant society was possible,

desirable, and *actually being created* in the year of 1958. In the context of a country where food shortages, rationing, and inadequate nutrition were still realities in some places, this message was powerful.

Following films like *Song on the Reservoir*, which depicted a project that had already become a national icon by mid-1958, subsequent Leap-era features and shorter films became even more exuberant in their claims for present-day material superabundance. This trend reflected the fact that political leaders at all levels were themselves were being heavily pressured by Mao and his closest supporters to launch "sputniks" (a reference to the new Soviet satellite, whose successful orbit of the Earth had shocked the world) in production, pressure which led to fabrications and wild experiments, ultimately resulting in widespread starvation and death.

Peasants were, in theory, the most essential targets of pro-Leap propaganda, because food production was essential to keeping a national labor force fed. Film industry planners addressed this issue directly by coming up with a list of themes they believed would motivate peasants to work harder and grow more. These included: celebration of the past year's agricultural harvest; victories in production that could be attributed to the party's general line of socialist construction; summaries of "experience" (*jingyan*) gained during the past year of large-scale collectivization; "leaps forward" in the cultural and educational realms; and plans to guarantee plentiful food and clothing to every citizen, along with other evidence of the "promising and blissful" prospects offered by socialism and communism.[10] By viewing "countless examples of increased production" and extolling the "advantages of the socialist system," peasants would become resolute and faithful (*xinxin*) in following the socialist road toward collectivized agriculture.[11]

In practice, however, one of the most common characteristics of later Great Leap Forward films was that they depicted amazing—and, it was later discovered, almost completely fabricated—accounts of stupendous crop yields and mechanical achievements in far-away places. "Feature-style documentaries" joined documentary-style features (indeed the two terms were sometimes used interchangeably) as films which further blurred the distinction between what was real, and what was futuristic or simply faked. Industrial and urban workers were also featured in Leap-era filmmaking. For example, *A Factory Grows and Thrives* (*Bai shou qijia*, Changchun Film Studio, 1958) recreated the story of a Liaoning industrial unit which, primarily through its workers' own efforts, became a national leader in production of nonferrous alloys. Rural images of the Leap further extolled the virtues of agricultural communization (*renmin gongshehua*) by depicting vast, productive fields, enormous crop and yields and, above all, healthy and smiling peasants.

In a sense, such images had always been a staple of Communist Party propaganda. What made them different in the context of the Leap was that

the claims for productivity and the all-conquering power of human will were so exaggerated. This was also the case for depictions of everyday prosperity, which were either unsustainable (as in the case of commune canteens where commune members ate as much as they wanted at no cost), or staged. Professional actors were enlisted to star in "true" stories.[12] Hastily produced documentaries, like *Hubei's Ten-Thousand Catty Field* (*Hubei wan jin tian*, Science Education Film Studio, 1958) or *King of Early Rice* (*Zao dao wang*, Central News Film Studio, 1958), depicted grossly exaggerated harvests as genuine local accomplishments (see Figure 12.10).[13] The reality of such claims, though dubious, was uniformly confirmed in the rest of the state media, which likewise led the way in portraying and circulating new exaggerations, fictions, and half-truths.

CELEBRITY WORKERS: HUANG BAOMEI, FROM LABOR MODEL TO MOVIE STAR

Creating images of prosperous communes and incredible feats of production was one way in which propagandists attempted to persuade people to throw themselves into frenzied production. Another way, foreshadowed in *Song of the Reservoir*, was to create charismatic model individuals for audiences to emulate. In keeping with the logic of Leap-era filmmaking, the more realistic the models, the better; the stories needed to sell as plausible reality rather than mere fantasy.

One well-publicized film that not only based its story on the embellished exploits of a real-life worker, but also starred that person as themselves in the title role, was *Huang Baomei* (Tianma Film Studio, 1958). Huang was an actual employee of Shanghai's Number 17 National Textile Mill, who earned a reputation for outperforming other workers in her unit even when using old, out-of-date equipment, and for sharing her ultra-efficient production techniques freely rather than guarding them for the sake of personal glory. In the filmed version of her story, Huang and her coworkers are pitted against several rival teams in a friendly contest to see who can produce the most. Huang surprises everyone by sharing her techniques with her competitors. Her teammates, though initially taken aback, are so inspired by her sense of fairness and selflessness that they work hard enough to win the contest. The Number 17 National Textile Mill workers win the prize, after which Huang and her comrades are presented on the screen transformed into the fairy maidens (*xiannü*) of folktales—a plot twist supposedly suggested by the mill's manager (see Figure 2.11, website).

Like the Ming Tombs reservoir project, the Shanghai Number 17 National Textile Mill provided a concrete setting and sense of reality that audiences

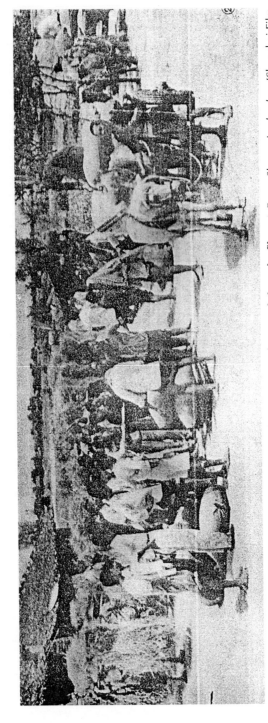

Figure 12.10 Staging and displaying Hubei's ten thousand catties—a photograph from the film set. From: *Shang ying huabao* [Shanghai Film Studio Pictorial], no. 10, 1958.

could grasp. Parts of Huang Baomei's story were also plausible. She was, in fact, a national labor hero whose achievements had been first recognized in 1954. It also helped Huang's stardom that she was young, healthy-looking, and graceful—in this respect she was not unlike other entertainment celebrities in socialist China, a point made more apparent when Huang's face appeared on the cover of *Shanghai Film Studio Pictorial* when her film was first being promoted (see Figure 12.12). Huang's charisma, though, was further embellished by the way in which the state media machine swung into action to bring her story to audiences. The film *Huang Baomei* was directed by the well-regarded filmmaker Xie Jin, who surrounded her with a cast of professional actors while adding entertaining subplots and special effects.

Like the fictional Gao Lanxiang of *Song of the Reservoir*, Huang was depicted as a selfless, humble person with unswerving devotion to the cause of meeting national production goals (and, in Huang's case, superhuman production abilities). This use of charismatic, real-life figures to inspire audiences was not new. "Model" (*mofan*) workers had long been a staple of PRC popular and visual culture, and indeed represented a distinctive component of socialist culture around the world. These heroic personalities fulfilled important propaganda functions by embodying values and behaviors that state leaders expected of their citizens. To be a model worker indicated that one possessed personal qualities that could be explicitly linked to goals of national development. In addition, model workers were invariably depicted as utterly normal people who achieved exceptional things almost entirely due to their extraordinary commitment to the PRC and Communist Party, thereby serving to communicate the message that anyone was capable of contributing to these causes. Films like *Huang Baomei*, however, carried the rewards of model worker-dom to a new level. In being encouraged to compare their own lives with those depicted on the screen, audiences were not only goaded to activism, but also encouraged to dream that maybe they too could become a "star" during the Leap.

FILM AS INDUSTRY: PRODUCTION, DISTRIBUTION, AND EXHIBITION

Having looked at the form and messages of Leap-era cinema, we now turn to another key feature of the propaganda apparatus—the film industry itself. As with other media, such as radio, the press, visual arts, literature, and performance, cinema was a form of cultural production which was managed by the Communist Party's internal propaganda institutions. During the 1950s, propagandists used their political power to make state culture an inevitable feature of individual leisure time; when people weren't working, state-created

Figure 12.12 Real-life model laborer and cinematic star Huang Baomei on the cover of *Shanghai Film Studio Pictorial*. From: *Shang ying huabao* [Shanghai Film Studio Pictorial], no. 8, 1958.

news and entertainment was often the only form of media available. While not all culture produced by the state was dry and boring, the messages could become monotonous, in the sense that every cultural product was required to be "about" some aspect of Communist Party policy. Such was the case during the Great Leap Forward. By 1958, Party leaders demanded that all culture

should be "adapted to the needs of technical transformation, and [should also] serve economic construction. The fundamental goal is accelerating the development of society's productive forces . . . cultural work cannot depart from the party's general line."[14] Cinema was no exception.

As we have seen, from mid-1958 onward studios were increasingly engaged in the propagation of pro-Leap optimism. Significant numbers of studio employees, including directors and screenwriters, were "sent down" to the countryside in order to study conditions there and participate in rural cultural work as observers and entertainers (see Figure 12.13, website). Conversely, central cultural organs like the Beijing Film Studio were suddenly inundated with local officials transferred there in order to learn how to produce films in their own provinces.[15] In both cases, the idea was to maximize the appeal and distribution of motion pictures beyond China's cities and wealthier regions.

Filmmaking during the Leap was not only supposed to be far-reaching, but also quick and efficient. For many studio workers, and particularly those involved in the more physically demanding aspects of production, the sheer pace of shooting became a source of resentment and fatigue.[16] Approximately one hundred low-budget, rapidly shot "satellite films" (*weisheng pian*, yet another reference to the Soviet Union's *Sputnik* satellite) were filmed during the early years of the Leap.[17] Budgets were small, and crews might be given only two to three days to prepare for shooting an entire feature film.[18] Studios competed against one another for bragging rights over who was faster or more prolific; Changchun Film Studio, which could already claim the first true Great Leap Forward film in *Song on the Reservoir*, was known for being the most enthusiastic in this regard. As one prominent film critic remembered, "it was a movement . . . it wasn't acceptable if you weren't producing satellites (*fei fang bu xing*), because producing satellites was the goal."[19] Filmmakers who did not pick up the pace risked their careers. The conspicuously highbrow and deliberate director Shui Hua (1916–1995) fell from favor, at least in part, as a result of his inability, or unwillingness, to adapt to the Leap's new demands.[20] Getting the message out trumped concerns over cinematic quality.

Promoting the Leap depended on distribution as well as on production. In March 1958 a national meeting of distributors and projectionists was convened by the national Ministry of Culture, and attendees were briefed on their responsibilities to advance the Great Leap Forward by "broadening the propagandistic and educational uses [of film]," and "playing a close supporting role in the high tide of agricultural production."[21] A subsequent conference for film industry leaders was convened in May, during which participants drew up plans for each province, municipality, and autonomous region (excluding Tibet) to establish a studio capable of producing newsreels

and documentaries.[22] In each case, the goal was the same: dramatic increases in screenings and audiences nationwide.

Much of the pressure for effective distribution was placed on projection units—film projector operators and on-site propagandists employed by specific theaters, cadres' and workers' leisure clubs (*julebu*), schools, and mobile film teams (*liudong dianying dui*) operating in rural and sparsely populated areas. Employees were expected to ensure that films reached the widest audiences possible, and that films were properly understood by those who watched them.[23] In northwestern Xi'an, for example, theater staff organized recreational "film criticism groups" to encourage filmgoers to reflect on what they had seen, and identify the main political messages. Theaters also handed out leaflets that introduced the main character and highlighted key plot points, while monitoring public opinion concerning specific films. All of this was part of a larger process by which propagandists attempted to gauge whether or not state culture had been effective (*youxiao*) in transmitting meanings intended by filmmakers and higher-level Ministry of Culture officials.[24]

It is important to point out that messages were not always transmitted successfully. In other words, propaganda did not always work to achieve the goals to which it was applied. Two of the main obstacles were projection teams who shirked propaganda work and the attitudes of audience members themselves.[25] Making culture serve politics was difficult, in the sense that not all propagandists or filmgoers necessarily shared preconceived notions of what a film should mean, or how ambiguous scenes should be interpreted. Even in Leap-era China cultural consumers, particularly in cities, had some choice over what they wanted to consume, and not all state-sanctioned films (theaters also screened a considerable number of foreign imports) were equally popular, or distributed on a national basis.[26] Some cultural officials suspected, perhaps rightly, that audiences might be drawn to films for reasons which had little to do with "correct" politics at all. Finally, theater owners were also expected to generate profitable box office returns, creating pressures which favored exhibiting films with popular appeal rather than those which were, like the films we have discussed thus far, explicitly tied to contemporary policies.[27]

AUDIENCES AND FILMGOING PRACTICES

While audiences did not necessarily like all of the pro-Leap films they encountered, film as a medium was made more available for public consumption in 1958 than at any other previous point in the history of the PRC. Both urban and rural areas were targeted for cinematic expansion. At a March 1958 "great leap" meeting for workers' union projectionists, for example, those

attending were explicitly instructed to establish better working relationships with work units underserved by the cultural system, and to seek the largest possible audiences.[28] While attendances did indeed increase over the course of the year—Beijing projectionists noted a 124 percent increase over 1957 attendance numbers—these film workers found themselves working around the clock to keep pace with the frenetic rhythms of Great Leap Forward social mobilization.

During the earliest days of the Leap there were very few films like *Song on the Reservoir*. The new emphasis on voluntarism was primarily promoted not through film, but by exhibiting cheaply and rapidly produced slides such as those urging workers to "chase England and catch up to America" in steel output. By June 1958 the situation had changed, and over fifty news-reel theaters (*xinwen yingyuan*) had been opened in the cities of Beijing, Shanghai, Tianjin, Wuhan, Shenyang, Changchun, Xi'an, Jilin, Tangshan, and Shijiazhuang, for the purpose of employing newsreels, documentaries, and scientific films in propagating the party's Leap-era "general line" concerning national development.[29]

In the countryside, efforts to "expand the exhibition network"—to deliver more filmic images to more people—were even more dramatic. Film was still a rarity throughout much of rural China and reaching these areas was one of the overriding goals of the Great Leap Forward. Implementing such plans was, of course, far more difficult than simply drawing them up. In Shaanxi Province, personnel in many projection units possessed "great enthusiasm" but lacked concrete solutions.[30] Obstacles to their exhibition work included lack of equipment, lack of reliable transport and, often, lack of electricity. In some areas, local film institutions hoping to fulfill their new assignments, resorted to all-night screenings (*tong xiao chang*) or daybreak screenings (*ji jiao chang*), which kept projectors running around the clock (see Figure 12.14, website).[31] In many cases county-level film equipment providers were unable to keep pace with rural demand. Other challenges came from within the propaganda system. Urban projection units, upon receiving their rural assignments, typically greeted the news with disdain. Indeed, many simply "squatted" in larger towns and cities, hardly ever venturing into the countryside, while others disregarded the new orders entirely.[32]

Despite these limitations, it is difficult to underestimate the degree to which the spread of film into rural society represented a substantial, qualitative shift in cultural life for those targeted by the state's efforts to create a truly national cinematic apparatus. According to one experienced projectionist, films shown at the outskirts of urban centers (cities, county seats) during the early 1950s would almost always draw a sizable crowd of rural onlookers who would often travel considerable distances for the spectacle.[33] For rural audiences, film became perhaps the *most* important channel for receiving

national news, given that illiteracy and a scarcity of printed media remained common conditions throughout the countryside (see Figure 12.15).

Nonetheless, several important limits to film's power over rural imaginations and cultural life remained. First, while rural attendance increased dramatically from the late-1950s onward, considerable differences between urban and rural conditions remained. In addition to being fewer in number, countryside screenings almost invariably took place outdoors to huge audiences. For a single film to draw 3,000 to 4,000 attendees was not uncommon, and people sat on both sides of the screen. In such contexts, it was not only the films but also the spectacle of the associated environment—vendors of food and other goods, large crowds of strangers, and so on—which constituted a vital part of the experience. While it might be too much to say that film literally competed for attention alongside these other attractions, it is clear that watching the film was only one of several activities that together made up "filmgoing" (*kan dianying*). Talking, eating, meeting potential romantic partners, getting together with one's friends and family, or just watching the general excitement (*kan renao*) were also important draws for audience members.

Figure 12.15 Reconstruction of a rural screening ground, Shaanxi Province.
From: Christian Hess, Sophia University, 2005. Used with permission.

In short, while anecdotes concerning film projection reveal the intensity with which propagandists attempted to transform people's ordinary leisure into a forum for state-sanctioned messages, they also belie the persistence with which financial and human limits constrained this official cultural project. Preexisting distributions of infrastructure and economic resources favored urban areas with respect to cultural resources such as film equipment and screenings. Audiences attended films but did not always take away the intended messages or even pay attention during the show. Nonetheless, the earliest months of the Leap were awash in new sights and sounds. Documentary-style features blurred the line between fiction and reality, while the saturation of theaters and rural threshing grounds with utopian imagery infused everyday life with increasingly outrageous calls for, and claims regarding, the participation of ordinary people in this sublime moment of social change.

CONCLUSION: PROPAGANDA AS STATE-SANCTIONED REALITY

Great Leap Forward production targets remained in effect for approximately three years (1958–1960); then, from 1960–1962, the country was plunged into a catastrophic famine and economic failure induced by those very policies. As the famine receded, economic recovery became the guiding principle. Over these years, from around 1962–1966, the visionary economics of the Leap were replaced by the carefully calculated, step-by-step process of balanced central planning. Rather suddenly, many early Leap policies and creations were out of step with the party's vision and corrective measures were deemed necessary. One of these measures included removing from active circulation many of the feature-style documentaries and similar films produced between 1958 and 1961. An internal report published on May 23, 1962 by the Shanghai-based Tianma Film Studio shows that beginning in that year, both central and local cultural institutions had ordered a review of films produced since 1958, including many which concerned "actual life."[34] Of the twenty-four Leap-era films reviewed, only eight were cleared for continued circulation, while eight were suggested as candidates for additional editing, and the remaining eight were slated for immediate and permanent withdrawal. The comments of Tianma Studio's leaders, addressed to the central Ministry of Culture's Bureau of Film Industry Management, provide a fascinating insight into beliefs concerning what had "gone wrong" during the Leap.

Even for films whose errors only warranted them a return trip to the cutting room, the list of indictments was extensive. Sections of *On the Xin'an River*, which had emphasized nonstop work schedules, were now seen as failing to

conform to proper standards for dividing labor and leisure. A segment from
Little Masters of the Great Leap Forward, which portrayed a scheme for
eradicating illiteracy in seven days, was labeled "boastful" (*fukua*). Other
films had depicted visions of prosperity and technological achievement: a pig
for every *mu* of land; super-abundant rice, fish, and cotton yields; a cannery
whose standards of productive efficiency "overtook America" (*gan Meiguo*).
However, in 1962, such claims were not understood as inspirational, but
rather were labeled "unrealistic," "impractical," and "adventurist."[35] Whereas
many Leap-era films had cast negative light on "conservative" party secre-
taries and mocked old peasants who opposed the Leap's utopian schemes,
these same mocking depictions were now criticized as "undemocratic" and
"disrespectful" to post-Leap policies. Most of the eight films targeted for per-
manent removal from circulation were documentary-style features. Because
the Leap was now seen as a failure, cultural officials advocated taking a scal-
pel to unsightly representations that had once served as emblems of utopian
promise:

> Many films we have inspected are documentary-style features on industry
> and agriculture that were written and produced based on "real people and real
> events." These documentary-style features were relatively prompt in reflecting
> the imagery of major developments in socialist construction since 1958... [yet]
> at the same time that they reflected the objective "mainstream" (*zhuliu*) of this
> development, they also unavoidably reflected the shortcomings and errors which
> existed [as part of] contemporary, objective reality.[36]

Voluntarism, once seen as a catalyst for social change, had become a liabil-
ity. The effects of this post-Leap "clean-up" on filmmakers were mixed.
Some actors who had participated enthusiastically in the Leap, or had been
chosen for prominent roles, found themselves snubbed for major parts there-
after because their faces might remind audiences of this failed experiment.
For those behind the camera—directors, writers, and cinematographers, for
example—participation in Leap-era filmmaking was often simply another
career stepping-stone or opportunity to display political loyalty.[37] Others, as
a result of their time spent in the countryside, saw the Great Leap Forward as
a failure; production went on, but cynicism set in.[38]

In what sense, then, did these films serve the politicized objective of
"shaping" mass opinion? In what sense can they be considered propaganda?
For observers like us, living in liberal democracies today, it might seem that
what marks Leap-era films as propagandistic was their constant promotion
of selfless and cheery activism in the service of a state-mandated develop-
mentalist agenda. Within the context of film or art, this kind of repetition and
naïve idealism might strike us as unpleasant or absurd. Yet these films were

not intended as such, and likely not viewed in this way at the time. Hopefully our examination has suggested ways in which people might have experienced the production and viewing of these films as engaging, inspiring and even entertaining. By exploring both the distinctive generic form of Leap-era films—their novel mixture of documentary elements with feature-film storylines that blurred fact with fiction, reality with utopia, and present with future—and the particular historical moment they occupied in the building of China's film infrastructure, this chapter has aimed to make the varied historical reality of experiencing these films comprehensible.

Though the strained optimism seems the most glaringly propagandistic aspect of Great Leap Forward films, their removal from circulation during the early 1960s suggests another, perhaps more fundamental characteristic of the propaganda system: film, and other cultural forms as well, were used to represent a kind of map of the possible. Propaganda, in the end, was aimed at communicating ideas about what kind of reality was desirable, and created by party planners who sought to determine how ordinary citizens should view their world. Once the disasters of the Leap required a return to more prudent policies, cultural propaganda had to follow suit. Suddenly the party's earlier endorsement of spontaneous initiative as the engine of transformation was not only revoked but disparaged. In defining Leap-era films in terms of the limitations they possessed (political or esthetic), we fail to see how they might have appealed to audiences precisely because they represented something new that depicted one's familiar surroundings, and even the viewer herself, as existing on the cusp of a profound transformation leading to future prosperity. Propaganda's most salient feature lies not only in the effort to impart this sense of possibility, but also in periodically revoking it.

NOTES

1. Sheryl Tuttle Ross, "Understanding Propaganda: The Epistemic Merit Model and Its Application to Art," *Journal of Aesthetic Education* 36, no. 1 (Spring 2002), 17. For a more general discussion of wartime propaganda and the cinema, see Nicholas Reeves, *The Power of Film Propaganda: Myth or Reality?* (London: Cassell, 1999).

2. Timothy Cheek, *Propaganda and Culture in Mao's China: Deng Tuo and the Intelligentsia* (Oxford: Clarendon Press, 1997), 15. See also Chang-tai Hung, *War and Popular Culture: Resistance in Wartime China, 1937–1945* (Berkeley: University of California Press, 1994).

3. Julian Chang, "The Mechanics of State Propaganda: The People's Republic of China and the Soviet Union in the 1950s," in Timothy Cheek and Tony Saich, eds., *New Perspectives on State Socialism in China* (Armonk: M.E. Sharpe, 1997), 76.

4. Ibid., 80.

5. Ci Jiwei, *Dialectic of the Chinese Revolution: From Utopianism to Hedonism* (Stanford: Stanford University Press, 1994), 140.

6. Then and now, Great Leap Forward construction projects remain landmarks of socialist progress. The Ming Tombs project was second in publicity only to the massive project to expand Tiananmen Square into the world's biggest public square as well as the site of the Great Hall of the People. The project was also featured in another musical film of the same era, *Ming Tombs Capriccio* (*Shisan ling changxiangqu*, Beijing Film Studio, 1958).

7. Wang Yunman , "Zhide zhongshi de 'Shuiku shang de gesheng'" [*Song on the Reservoir*: A Worthwhile Film], *Renmin ribao*, July 3, 1958: 8.

8. Mao Zedong, "Speech at the Supreme State Conference (excerpts)" (January 28, 1958), in Stuart Schram, trans., *Chairman Mao Talks to the People, Talks and Letters: 1956–1971* (New York: Pantheon Books, 1974), 92–93.

9. Maurice Meisner, "Utopian Goals and Ascetic Values in Maoist Ideology," in *Marxism, Maoism, and Utopianism: Eight Essays* (Madison: University of Wisconsin Press, 1982), 118.

10. "Zhonggong zhongyang guanyu jin zhong ming chun zai nongcun zhong pubian kaizhan shehuizhuyi he hongchanzhuyi jiaoyu yundong de zhishi" [Chinese Communist Party central directive concerning the rural socialist and Communist education movement to be launched everywhere this winter and next spring] (August 29, 1958), in Zhonggong zhongyang xuanchuan bu bangong ting, Zhongyang dang'an guan bianjiu bu, ed., *Zhongguo gongchan dang xuanchuan gongzuo wenxian xuanbian, 1957–1992*, ([Beijing]: Xuexi chubanshe, [1993]), 104–105.

11. Ibid., 106.

12. Gao Weijin, *Zhongguo xinwen jilu dianying shi* (Beijing: Zhongyang wenxian chubanshe, 2003), 171.

13. Fang Fang, *Zhongguo jilu pian fazhan shi* (Beijing: Zhongguo xiju chubanshe, 2003), 229. In scientific and educational film (*kejiao pian*) production as well, filmmakers blurred the line between fact and fiction, or the real and the desired. If they were successful in this regard, this was due at least in part to strength in numbers. During 1958, the number of these films produced was equal to the entire national output between 1951 and 1957—a total of 137 individual titles. Many were manufactured by provincial studios which had been set up for the purpose once the Leap was underway.

14. BJMA, 1-24-10 (November 1958), Anonymous. "Beijing shi wenhua gongzuo huiyi zongjie fayan yaodian" [Important points from a summary speech on cultural work in Beijing municipality], 1.

15. Author interviews, Beijing, June 2005.

16. Author interview, Beijing, June 2005.

17. Author interview, Beijing, April 2005. These "satellite films" were also called "leap forward films" (*yue jin pian*).

18. Author interview, Beijing, March 2005.

19. Author interview, Beijing, April 2005.

20. Author interview, Beijing, March 2005.

21. SXPA 232-190 (n.d.), Zhongguo renmin gongheguo wenhua bu, "Guanyu cujin dianying faxing fangying gongzuo Dayuejin de tongzhi" [Great Leap Forward circular concerning the acceleration of film distribution and projection], 1.

22. Gao Weijin, *Zhongguo xinwen jilu dianying shi*, 165.

23. SXPA 232-205 (1959), Shaanxi sheng dianying faxing fangying gongsi, "1958 nian 7 zhi 1959 nian 6 yue dianying faxing fangying gongzuo zongjie baogao" [Summary Report on Distribution and Projection Work, July 1958 to June 1959], 5.

24. Ibid., 6.

25. Ibid., 9.

26. Ibid., 10.

27. Author interview, Beijing, April 2005.

28. BJMA 101-1-690 (n.d.), Beijing shi zong gonghui xuanchuan bu, "Beijing shi zong gonghui ba nian (1951–1958) dianying fangying gongzuo zongjie" [Summary of eight years (1951–1958) of film projection work in the Beijing municipal federation of trade unions], 15.

29. "Pochu mixin, jiefang sixiang, dadan chuangzao: ba xinwen jilu dianying de fangying gongzuo tuixiang gaochao," *Dazhong dianying* 13 (July 11, 1958), 24.

30. Shaanxi sheng dianying faxing fangying gongsi, "1958 nian 7 zhi 1959 nian 6 yue dianying faxing fangying gongzuo zongjie baogao," 1–2.

31. Li Duoyu, *Zhongguo dianying bai nian, 1905–1976 (shang bian)* (Beijing: Zhongguo guangbo dianshi chubanshe, 2005), 279.

32. Ibid., 9.

33. Author interview, Beijing, May 2005.

34. SHMA B3-2-109 (May 23, 1962), Shanghai Tianma dianying zhipian chang, "Baogao" [Report], 1. A similar inspection of scientific, educational, and documentary films produced between 1958 and 1961 took place approximately two months later. See SHMA B3-2-109 (July 7, 1962), Shanghai shi dianying ju, "Baogao" [Report], n.p. Both documents were submitted to the central Ministry of Culture.

35. SHMA B3-2-109 (May 23, 1962), Shanghai Tianma dianying zhipian chang, "Baogao," 4–5.

36. SHMA B3-2-109 (May 26, 1962), Shanghai Haiyan dianying zhipian chang, "Guanyu yingpian jiancha de baogao" [Report concerning film inspections], 1.

37. Author interview, Beijing, January 2005.

38. Author interview, Beijing, March 2005.

Chapter 13

Images, Memories, and Lives of Sent-down Youth in Yunnan

Xiaowei Zheng

In 2006, I lived in the city of Chengdu in southwestern Sichuan Province. My apartment was about a mile west of downtown, in a building off a small alleyway. The alley was noisy during the day and quiet at night, much like any other urban residential area in China. At first, there seemed to be nothing special about it. However, as time passed, an unusual teahouse caught my eye. Set in a three-room condo on the first floor of a building about a hundred meters from where I lived, this teahouse was always bustling. Almost every night, a group of middle-aged men and women congregated, chatting away about household chores, reading evening newspapers, and playing Mahjong.

Like most Chinese cities, Chengdu is changing fast—state-owned factories laying off workers, suburban farmers losing their land, and house prices skyrocketing far past what an ordinary resident could easily afford. The teahouse regulars are just like their fellow Chengdu residents, striving hard to make a living and survive the changes. They are among the most ordinary of people. Without asking, I would never have known who they were—that all of them as teenagers had packed their suitcases, left home, and spent eight precious years on a rubber farm in the border region of Yunnan Province. They were just some of the vast number of urban people sent to the countryside over the course of the Mao era (see Brown's chapter in this volume). More specifically, they were among the twenty million middle school and high school graduates sent to the countryside for reeducation between 1968 and 1979, and still more specifically, among the one hundred and forty thousand who worked in the Yunnan Construction Corps on China's southern border.[1] Having negligible power or status, their past is of little interest to their neighbors, siblings, or even their children. In this highly pragmatic city, few people pay attention to their history; only in this little teahouse do they have a place to recollect the past and share some old memories.

The people I met in the teahouse all belong to a special generation in the history of the People's Republic of China. Born between 1947 and 1955, they have experienced a life trajectory marked by sharp ups and downs closely tied to Chinese politics. In 1966, when Mao sought to reinvigorate China's revolutionary culture and curb the influence of Liu Shaoqi and other "moderates" among the party leadership, he turned to China's youth to be vanguards of the newly conceived "Cultural Revolution." Many urban youth jumped at the chance to become "Red Guards." When the Red Guards were disbanded in 1968, some of these same youth responded enthusiastically to Chairman Mao's call to join the "Up to the Mountains, Down to the Countryside" movement and rushed to settle in China's rural areas, where they were to learn from the peasants and put their schooling to work for China's "new socialist countryside." Others resisted the call but found themselves compelled nonetheless by a state anxious both to find occupations for a boom generation of urban youth and to quell the extensive havoc, no matter how "revolutionary," the Red Guards had wreaked in the cities. The majority of them did not return to the cities until the late 1970s, having "lost" their youth and needing to cope with a now-unfamiliar urban life.

I had the good fortune to make friends with some of these former "sent-down youth" (the standard term for young, urban people sent to the countryside) and talk with them in depth about their experiences. They have generously shared their memories with me and provided me with precious photos, sketches, paintings, and posters that they have carefully kept from the Yunnan years. These artifacts not only help visualize the stories they tell, but also offer a serious challenge to the one-dimensional picture that prevails in the dominant narratives about the lives of sent-down youth. The tales they relate in the teashop also speak in compelling ways to the role that visual images play in producing history and memory. In this essay, I seek to answer the questions: How do people remember the Up to the Mountains, Down to the Countryside movement? What role do visual materials play in depicting the lives of sent-down youth? How do these most ordinary sent-down youth reflect upon and come to terms with their past, and, how do these memories interact with their lives today?

DOMINANT LITERATURES: A "SCARRED YOUTH" VERSUS "NO REGRET FOR THEIR LOST YOUTH"

Before getting to know these former sent-down youth, my understanding of their experiences was heavily shaped by the existing literature written on the subject, in which two rather different depictions are most prevalent. On one

side is the depressing, critical depiction, where sent-downers were the political victims of the ailing autocrat Mao Zedong and his wicked cronies. As part of the human tragedy in the "ten years of chaos" of the Cultural Revolution, the lives of sent-down youth were filled with massive violence, unfairness, and cruelty. On the other side is the uplifting portrayal of their rural experiences, where sent-down youth were heroes and heroines. They sacrificed their adolescence on the altar of duty; they were idealistic and charismatic, and when looking back from the present, they "have no regret for their lost youth."

The bleak representation of sent-down youth originated in works of "scar literature" that emerged soon after the end of the Cultural Revolution in 1976. The genre focused on the disastrous experiences of sent-down youth, intellectuals, and persecuted officials during the Cultural Revolution. In order to expose the inner wounds inflicted by the Cultural Revolution, writers of scar literature lamented their past sufferings and angrily denounced the crimes committed by the so-called "Gang of Four" (leading members of the radical faction during the Cultural Revolution). In the late 1970s, scar literature helped people express grievances long restrained; thus, it quickly gained popularity and defined public memory of the Cultural Revolution in China at that time.

The total condemnation of the Cultural Revolution is also the norm in English-language writings. This is particularly noticeable in autobiographical memoirs, a genre that blossomed in the 1980s and 1990s and generated several bestsellers in the United States and other countries. Written in English and geared to the interests of a Western audience, these memoirs, with only few exceptions, proffer horror stories of Maoist China in which "the Orient is seen seeking salvation from an exalted Occident."[2] The narrators generally appear as heroic and moral individuals while they invest others with the role of persecutors. As literature scholar Chen Xiaomei observes, "These memoirs read like stories of survival, culminating in the obligatory happy ending in America or Europe."[3]

Accounts emphasizing the horrors of the Cultural Revolution commonly incorporate images that emphasize the mob mentality that supposedly prevailed among youth. Typical examples found in history textbooks include photographs of throngs of young students waving the "little red book" of quotations from Chairman Mao in support of their godlike hero Chairman Mao and shots of humiliated cadres and professors forced to bow their heads low to withstand the attacks of their youthful assailants (Figure 13.1). In many well-liked literary writings, such as Jung Chang's *Wild Swans* and Liang Heng's *Son of the Revolution*, this visualization is so strong that the mere mention of the Cultural Revolution is enough to bring to mind images of torture and deprivation.

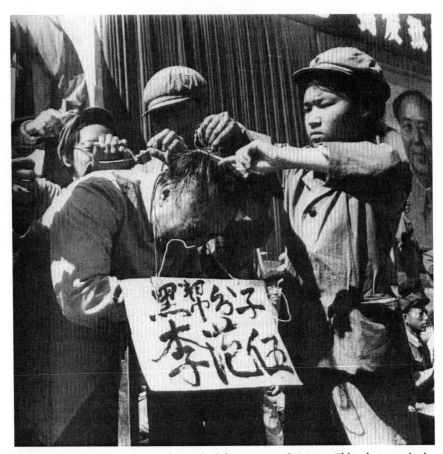

Figure 13.1 Red Guards attack provincial governor Li Fanwu. **This photograph, by photojournalist Li Zhensheng, appears in his celebrated English-language book *Red-Color News Soldier* (London: Phaedon, 2003) and a web exhibit by the same name, and has toured museums throughout Europe and North America. It also appears in a popular U.S. textbook on modern Chinese history, Jonathan Spence's *The Search for Modern China* (New York: Norton, 1999, plate between p. 662 and p. 663). Such images dominate representations of the Cultural Revolution for Western audiences and produce a very one-sided understanding of what the Cultural Revolution meant and how people experienced it.**

China's public memory of sent-down youth underwent an abrupt shift in the 1980s. As scholar Qin Liyan explains, "Disillusioned with post-Cultural Revolution urban life, the site of their previous suffering (rural China) now appeared to former sent-down youth as a paradise." The countryside was then imagined by former sent-down youth to be "wholesome, peaceful, and uplifting" in contrast to the "bewildering, corrupting, and empty" urban life

they later faced.[4] It was at this moment, in 1983, that the novella *Snow Storm Tonight* by Liang Xiaosheng came to the scene and instantly attracted public attention with its uplifting optimism. It not only won a government-sponsored award, but was also broadcast on national radio, adapted into a TV mini-series, and "anthologized in high school textbooks as a model of thematic correctness and artistic perfection."[5] This novel, together with similar works produced by other former sent-down youth, helped construct a new image of sent-down youth as heroes and heroines.

Photographs played a crucial role in shaping the new public image of sent-down youth and their rural experiences. The early 1990s witnessed numerous photo exhibits honoring sent-down youth, which in many cities sparked a craze for "the culture of sent-down youth." In 1991, following an extremely successful 1990 Beijing photo exhibition honoring former sent-down youth in Heilongjiang Province, a group of Chengdu former sent-downers put together a photo display in the Sichuan Provincial Museum to celebrate the twenty-year anniversary of their departure for Yunnan.[6] The chief organizers were former sent-down youth who had held high positions in the countryside as "sent-down youth cadres." After serious discussion, they decided to set the tone of the show with the uplifting title, "Having No Regret for Their Lost Youth." Quoting from the Russian poet Alexander Pushkin, they chose the subtitle, "All suffering will be left behind, and the past will become a beautiful memory."[7] The photographs they selected appeared to confirm the truth of such "beautiful memories," as shown in Figure 13.2.

In this image, former sent-down youth are presented as cheerful young men and women, physically strong and healthy, their labor light and easy to shoulder. With smiles on their faces, they look happy and satisfied, merrily contributing to Chinese socialism. Moreover, the photograph suggests that their ideals and political conscience give meaning to their labor. The caption reads, "Youth is beautiful only when dedicated to the people; life is brilliant only when sacrificed to the revolution." With such ideals, what regrets should sent-down youth have? Clearly, images like this celebrate the official values of the Cultural Revolution, namely, unconditional sacrifice, loyalty, and collectivity. In fact, just as in Figure 13.2, many of the exhibition's photos originated in widely circulated pictorials published during the Cultural Revolution era. Ever since the beginning of the Up to the Mountains, Down to the Countryside movement, great numbers of pictorials, art books, and film documentaries celebrated the lives of sent-down youth. Moreover, every single battalion, regiment, and division in the Yunnan Construction Corps supported a propaganda team that actively produced many laudatory propaganda photos of sent-down youth. According to former sent-down youth and amateur historian Xie Guangzhi, despite the food deficiency in Yunnan, every propaganda team was equipped with a camera and rolls of film.[8] This also

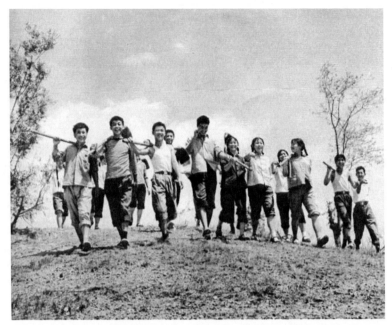

Figure 13.2 **This image originally appeared in a pictorial about the Cultural Revolution. Former sent-down youth Xie Guangzhi remembers offering to put it on display for a 1991 exhibition on sent-down youth held in the Sichuan Provincial Museum in Chengdu. The caption beneath reads "Youth is beautiful only when it is dedicated to the people; Life is bright only when it is dedicated to the revolution; It is a heavy burden and a long journey to become a worthy revolutionary successor; We will move forward following the course directed by Chairman Mao." Provided by Xie Guangzhi and used with his permission.**

explains the disproportionally large number of "happy" pictures of sent-down youth at a time when cameras were too expensive for almost any ordinary person to own: propaganda teams would produce only happy photographs, and few others had the means to produce any photographs at all.

Despite the two dominant literatures' radically different depictions of the experiences of sent-down youth—one as scarring, the other as glorious—more fundamentally they share much common ground. Whether as victims or as loyal followers of Mao, sent-down youth appear in these writings as passive subjects rather than as active agents in their own lives. Even more troubling is that, in both literatures, the narrators are always from the elite. Scar literature is mainly concerned with and written by intellectuals, persecuted officials, and sent-down youth from elite family backgrounds. After the Cultural Revolution, they returned to the center of Chinese politics and culture. The English-language memoirs reveal this yet more clearly: their

authors, like Liang Heng and Jung Chang, were able not only to study foreign languages during the Cultural Revolution but also to go abroad to the United States and Europe afterward. Such experiences were privileges far out of reach for most Chinese people. Furthermore, the proponents of the "no-regret" account were fortunate in that they either received recommendations to attend college (and thus left the countryside early), as Liang Xiaosheng did, or held positions of power as sent-down youth cadres in the Construction Corps, as was the case with the organizers of the 1991 Chengdu exhibition. Missing are the voices of the more ordinary sent-down youth.

LIVES AND MEMORIES OF THE ORDINARY
SENT-DOWN YOUTH

Unlike elites, ordinary sent-down youth had to think first about feeding their bellies and helping their families. Going to Yunnan was not about following the teaching of Chairman Mao or being idealistic. When they wanted to return to the city, their families were not powerful enough to open any "back doors." Regarding the sent-down youth cadres' having a "no-regret" attitude as "ridiculous" and condemning the tone of the scar literature as "oversimplified," the more ordinary sent-down youth have their own unique memories of the past.[9]

Going to Yunnan

"You could find no way to avoid going to the countryside," says former sent-down youth Deng Xian. Deng's family background was politically unfavorable and resisting the movement would have brought much trouble to his family.[10] Besides, after graduating from middle school and lingering in Chengdu for a while, he could find no job in the city. Fellow sent-downer Zhang Qingcong recalls, "You could not even get a job sweeping public restrooms in Chengdu."[11] In the mid-1950s, China experienced a baby boom. In the 1970s, these baby boomers grew up and created serious employment pressure. Former sent-down youth Xu Shifu recalls that the state's response in Chengdu was that "in each household, one out of three children and two out of five children must go to the countryside." Xu had five siblings. Moving to Yunnan would alleviate the severe food shortage in his home, so Xu felt proud to go.[12]

Leaving the city was an inevitable fate for these Chengdu middle school graduates. However, they did have one choice, at least. They could go to either a production brigade in the countryside or a construction corps in the Yunnan border region. Organizationally, a construction corps belonged to the

People's Liberation Army. At a time when the army held indisputable authority in China, joining a construction corps offered students enormous glory and prestige—at last they could wear the much coveted green army uniform and even get issued a rifle! Also, students in a construction corps were workers (*zhigong*) rather than peasants (*nongmin*), and were guaranteed a monthly salary and grain ration. Every month, each student received a rice ration of 38.5 *jin* (42.4 pounds) and a salary of CN¥ 28.5. At that time, 38.5 *jin* of rice was a third more than that of a regular middle school student and a salary of CN¥ 28.5 was even higher than that of a skilled worker in a Chinese factory.[13]

Images played a critical role in helping students make up their minds. Many young people believed what they saw in state-produced documentaries and pictorials: working on a construction corps in Yunnan was sublime (Figure 13.3, see website). Stories they heard from recruiters reinforced these tempting images. As a corps cadre spun the tale: "Yunnan is a place where you carry bananas on your head and step on pineapples wherever you go."[14] To a student who dreamed of "having an apple all to himself," Yunnan threw an irresistible lure.[15] After the successful propaganda campaign, the state soon began sending students to Yunnan. In 1971, from April to July, large groups of Chengdu middle school graduates filled the trains running along the Chengdu-Kunming line. When the train started down the track, many sobbed. But their sorrow did not last long. As soon as the train left suburban Chengdu, it became "a sea of cheerfulness." After all, they were just teenagers, bursting with expectations.[16] High-spirited students rushed toward the unknown, far-away land. Even though going to Yunnan was not an entirely free choice, they still felt considerable thrill and enthusiasm. And Yunnan was waiting for them . . .[17]

Life in Yunnan

It took seven days before they finally arrived at Mengding Farm in Gengma County, Lincang Prefecture of Yunnan Province. As they traveled, they noticed that "the roads were getting worse—from rails, to paved streets, and at last dirt roads"—and "the vehicles were getting smaller—from trains, to trucks, and in some places horse carts."[18] These sent-down youth were rather dumbfounded upon seeing their new home. Having regarded themselves as "construction corps soldiers," many had imagined that they would be living in tidy "two-story military dormitories, equipped with electric lights and telephones." Instead they faced one-story bungalows made of earthen bricks, only kerosene lights for illumination, and no telephones.[19] Even more disappointing was that they did not see many PLA soldiers; rather, those who welcomed them were farm workers who "wore shorts, stood barefoot, and waved their hands."[20]

After a lighthearted first week, the heavy manual labor started and the students' excitement quickly evaporated. Their job was to plant rubber trees and drain rubber sap. But before they could begin planting, they first had to strip the hills of vegetation (*pifang*) and carve out level terraces. For many sent-downers, *pifang* was the exhausting job they got after their arrival. Xu Shifu vividly remembers that to encourage hard work, cadres of Xu's company created a slogan, "Fighting in the Red May." The month of May was marked by several important revolutionary anniversaries, so students dared not slack off. Xu recalls, "We were competing with each other and worked so hard . . . After an entire month of tree-cutting, our bodies looked deformed and our bones felt disjointed." However, after May, the cadres just created a new slogan, "Struggling in June and July."[21]

The sun shines brutally in the high altitudes of the Yunnan Plateau. With insufficient water to drink while working, many sent-downers fainted in the field.[22] Zhang Qingcong remembers, "We had determined to embrace the hardship and be a "piece of kindling" [in the revolutionary fire]; however, embracing that hardship was merely a lofty ideal. When we faced the actual difficulties, we were paralyzed and did not know how to react."[23] The grueling manual labor was never recorded in any propaganda photographs, nor was the pain of constant hunger. Once they started working in the field, they found that 38.5 *jin* of rice was far from enough because they had almost no meat to eat with it. On average, they each received a meager diet of 0.2 *jin* of meat every month. Faced with such mundane problems, their revolutionary enthusiasm vanished. Yunnan was beautiful, yet its beauty was outweighed by the pain sent-down youth suffered. The constant hunger made some of them lose their principles: they started to steal chickens belonging to farm workers. Xu Shifu created a jingle to summarize their situation of that time: "Isn't it hard? Let's steal a chicken and boil it. Isn't it tiring? Let's blanket our heads and take a nap."[24] Some even stopped thinking that stealing chickens was wrong. Feeling collectively exiled, these young men and women had to try their best to deal with life on their own.[25]

As these sent-down youth strove to obtain physical necessities, they also tried to enrich their cultural lives. However, most nights their time was occupied by tedious political classes. Many felt suffocated. Zhang Qingcong remembers, "On Mondays, Wednesdays, and Saturdays, there were meetings organized to study Mao Zedong thought and Marxism-Leninism; and on Tuesdays, Thursdays, and sometimes Saturdays, there were special meetings for Communist Party and Youth League members." And there were other boring meetings to endure. "First, the company leader coached sent-down youth on the new central directives and discussed issues regarding our own company. After he was finished, the platoon chief spoke; then the general affairs officer. After the officer's lengthy report on logistical matters, it was

already nine or ten o'clock at night and we were all yawning, bored to death."
Whenever he sat through a political meeting, Zhang felt his "youth was mur-
dered" and his "life foolishly consumed."[26] To live through such absurdity,
sent-down youth had to find other things that made sense of life.

Zhang Qingcong found that meaning in art. Using pens, pencils, and
scissors, he avidly recorded the beauty around him. In creating a world of
his own, his life became meaningful. He looked forward to Sundays when he
could go out and draw or make paper-cuts of the landscape of Yunnan, his
sent-down friends, and what he saw as the unpretentious beauty of the Dai
and Wa minority people (Figure 13.4).[27] Serene and peaceful, real and touch-
able, creating these images offered Zhang immense consolation and happi-
ness. In sharp contrast to the forever correct didactic propaganda pictures,
these images finally provided him with something full of personal feeling and
offered him a hideaway to relax and be himself. It was in Yunnan that Zhang
developed his own view on art: "Art is the truthful recording of the beauty of
nature and the attempt to present it in melodic strokes." He then realized how
"awful" his previous works were, when he had "simply mimicked the images
from those Cultural Revolution posters."[28]

Of course, not everyone was as lucky as Zhang in having artistic talent. But
another sent-downer, Yang Quan, tells me, "We all need to learn to appreciate

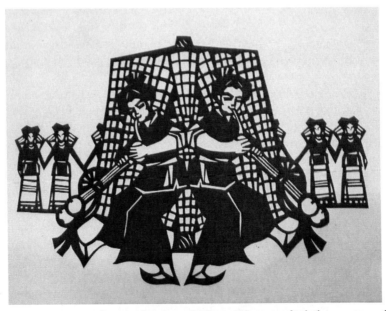

**Figure 13.4 Paper-cut by sent-down youth Zhang Qingcong depicting a group of Wa
nationality women dancing.** Reproduced with permission of the artist.

the beauty and pleasure of life so that we can live through the unlivable." This, he says, "is human nature." Yang loved to look at the Dai village nearby and its special architecture. "The Dai's two-story bamboo house feels so light Every day at sunset, I would watch the cooking smoke curling up over the bamboo house and listen to the sounds of life." [29] For Yang Quan, contemplating these beautiful scenes was the highlight of his day. Yang also brings my attention to the basketball hoops that were nearly "ubiquitous in every battalion." "As long as there was a small patch of flat ground, we would construct a wooden basketball hoop and play basketball."[30] Sent-downers tried to experience joy whenever and wherever they could. Against the backdrop of political absurdity, they creatively fought against dull routines and pursued a life they found meaningful.

Going Back to the City

Beginning in 1973, the desire to return home spread like a contagion among sent-down youth in Yunnan.[31] With the political shifts following the fall of Lin Biao in 1971, a large number of imprisoned cadres were released and gradually returned to power. Children of these cadres were able to exercise their political leverage and started to go back to the cities. In 1973 alone, using either formal or informal methods, a total of 4711 sent-down youth left Yunnan farms. Also in the early 1970s, Chinese colleges resumed operation, but personal recommendation became the only avenue for entrance. Of course, this benefited the children of party cadres the most. As Deng Xian observes, "Starting from 1973, the reopening of the city severely stratified us sent-down youth. After that, we totally lost our enthusiasm for labor." People asked, "Why do you get to return? Why are you going to college, while I have to stay? Didn't I work much harder?" Coming from a politically "bad" family background, Deng Xian had no chance to go to college. Quotas were reserved only for those from politically "good" families.[32] Deng felt abysmal agony, fury, desperation, and a sense of inexorable doom. Zhang Qingcong watched his well-connected dorm mates departing one after another, leaving more and more empty beds. He admits, "I really envied those cadres' children." Now, with so many people having broken their pledge to "settle at the Yunnan border forever," it all seemed like a kind of bitter joke. Zhang remembers, "Life at that point was like a banquet abruptly finished, a dream cruelly awakened."[33]

After 1973, the relationships among sent-down youth deteriorated drastically. Being recommended to college was a life-changing privilege. But to be recommended, besides coming from a good family background, one also had to be on good terms with the corps leaders. Because the recommendation quota was as slim as one percent, competition for the leaders' favoritism was

ruthless.[34] The unpredictable future and insurmountable gap between city and countryside crushed many budding romances. Many people learned to control their feelings. "Because I would never want to raise a child in such a place, I held back my emotions and decided not to have a boyfriend," says Chen Lijun. In fact, Chen had fallen deeply in love with someone, and was still tearful when talking about it thirty years later.[35]

In 1976, Mao died and the Cultural Revolution ended, but for many urban youth the ordeal of sent-down life continued with no end in sight. In late 1978, with a rapidly growing number of sent-downers rushing back to the city, those who were left behind became more depressed than ever. They had no powerful parents, useful connections, or adequate knowledge to pass the reinstated college entrance examination; going home was a remote dream. In November 1978, a sent-down girl died in a medical accident during childbirth. Strikes broke out on almost every farm in Xishuangbanna Prefecture, another region of Yunnan Province where many sent-downers stayed. More than ten thousand people joined these strikes. On December 8th, one-hundred and twenty representatives from seventy farms in Xishuangbanna gathered and decided to go to Beijing to appeal directly to the top national leader, Deng Xiaoping, with their demand—the right to return home.[36] On December 27th, twenty-eight representatives arrived in Beijing, where they met Vice Premier Wang Zhen. Wang did not accede to their demand; rather, he threatened to label them "counterrevolutionaries" and forced the representatives to sign a pledge to persuade the striking youth to resume work.[37] Strikes in Xishuangbanna went flat.

However, the strong desire to return home kept spurring radical actions at other Yunnan farms. On December 10, 1978, the All China Sent-Down Youth Working Meeting produced a memo stating, "From now on, all sent-down youth at the border region farms shall be treated as *workers* in state factories. They will *not* enjoy the special policies made for sent-down youth elsewhere."[38] This suggested that sent-down youth in Yunnan would probably stay there forever, like any other tenure-track workers in Chinese factories. When the news was broadcast at Mengding Farm on 24 December, it stirred deep anxiety and instant turbulence. On December 25th, Chengdu sent-downer Ye Feng led a demonstration in Mengding's streets. Venting their enormous frustration, they shouted, "We are sent-down youth, not farm workers! Give back my urban residency permit (*hukou*)!"[39] Sent-down youth at Mengding at first just planned to go on strike, but after they heard that the state council's investigative team had arrived at Yunnan, some decided to upgrade it to a hunger strike. This was a well-calculated decision at a very critical moment. Having dealt with numerous work teams from the local government, they believed that only direct intervention from the center could solve their problems and they would do anything to get the attention of the

investigative team. "Seeing, not hearing, is believing. We were all anxiously waiting for the investigative team," hunger strike leader Xu Shifu recollects.[40] Another strike participant remembers reasoning, "If we take the risk, we still have a slim chance to win; otherwise, we will certainly lose."[41] At this time, sent-down youth cadres distanced themselves from the agitators, but they did not do anything to prevent the strike from happening.

The hunger strike was skillfully organized and carried out. Everyone who participated did so voluntarily. To prevent chaos and avoid being accused by the government of "stirring up a revolt," leaders of the hunger strike committee formed a picket corps, enforcing discipline among strike participants. The picket corps not only disciplined strikers, but also guarded the armory and granary to prevent looting. The strike committee picked the Mengding rest house as the place of action, since they could lock the big iron gate and thereby ensure control. Moreover, to make sure nobody sneaked in food, every single participant was carefully body searched.[42] On January 6th, at 4 p.m., the iron gate was locked. Inside the gate were 211 strikers, who followed Xu Shifu's lead to kneel down and swear their oath. Xu recalls, "Determination may not be the right word to describe how we felt; it was sheer desperation."[43] Standing outside were their friends, lovers, and school-mates. As time passed, some fainted from hunger. Those who stood watching sobbed in pain. The hunger strike committee was clear-minded. Several key leaders stayed outside, and they kept calling the state council to demand its investigative team come to Mengding immediately. On January 8th, in the fiftieth hour of the hunger strike and with more than twenty people in comas, another hunger strike leader, Zhou Xingru, finally got a firm reply from the state council that its investigative team was leaving for Mengding that night. The students had won their first victory and decided to resume eating for the time being. On January 10th, Vice Minister of Agriculture Zhao Fan led the central investigative team to Mengding. At the headquarters of Mengding Farm, Zhao asked farm cadres and sent-down youth cadres to implement the new directive from Beijing, explaining, "The center has decided to treat the sent-down youth with leniency."[44]

At 4:30 p.m., Zhao Fan arrived at the Mengding rest house and met with the striking sent-down youth who had been waiting anxiously for him. Zhao was shocked by what he saw. His first greeting of "Hello, young farm workers!" immediately incensed the youth. They angrily shouted back: "We are sent-down youth, not farm workers!" Suddenly, people in the front row knelt down, followed by hundreds of others behind them (Figure 13.5). Together, they shouted the slogan repeatedly, "We want to go home! We want to go home!"

The strikers' perseverance and determination exhibited their strong desire and ability to change their fate. They had created a visual spectacle for the

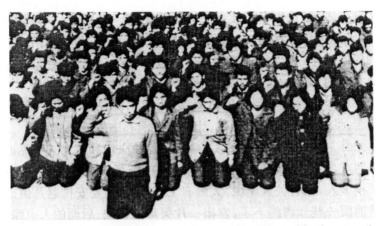

Figure 13.5 In a repeat performance of their confrontation with Zhao Fan six days earlier, sent-down youth kneel down and swear an oath to continue their hunger strike on January 16, 1979. This photograph, taken by a sent-down youth from Shanghai, offers a strikingly different window into how youth experienced the Cultural Revolution from those presented in Figures 13.1 and 1.9. Here, youth are active historical agents pursuing their own agenda, and not simply following state orders. Provided by Xie Guangzhi and used with his permission.

central investigative team as they collectively knelt down before it. Kneeling in China is always associated with obeisance and submission, and kneeling down in front of some unfamiliar authority shows both desperation and determination to win a concession from that authority. Here at the Mengding rest house, the sea of hundreds of strikers, many crying and many with their fists raised, created tremendous pressure on Vice Minister Zhao Fan. It was highly effective. Zhao Fan recalls, "I was faced with a petition, a strike, a sit-down, a hunger strike, a 'circling of the cadres.' And then the strikers knelt down in front of the investigative team . . . After talking to them directly, I could feel what the matter really was." Zhao continues, "Although I was already sixty-two years old, I could not hold back my tears . . . Such a scenario was not something that could be stirred up by several trouble makers."[45] The sent-down youth were resolute. They wanted a definite answer from Zhao and asked him to assert his take on whether they should return home. Zhao gave these words: "Not as a representative of the center or the investigative team, but rather as a parent of a sent-down youth, I say that you should all go back home!"[46] Only with such words was Zhao let out of Mengding Farm.

The photographs that allow us to travel back to that historic occasion and see the actions of sent-down youth do not exist as a matter of course. Rather, the sent-down youth who stood outside the iron gate and took those pictures was himself engaged in a daring form of political activism. After years of

saving, he was finally able to afford an expensive camera for his own use. This amateur photographer recognized the critical moment and shot four rolls of film of the hunger strike scene. These photographs went through two rounds of censorship, once when he left Yunnan and again when he entered his home city. But the returning photographer still managed to save thirty-six pictures with which to remember the sent-down youth's vital struggle.[47] In these photos, the sent-down youth looked serious, determined, and heroic, not because they were sacrificing their youth for the state, but because they were bravely fighting for their own lives. When compared with the euphoric images produced by state-sponsored propaganda teams, these rare photographs are harsh and unbeautiful, yet they are all the more valuable because they allow us a glimpse into the not-so-rosy real lives of sent-down youth and preserve a memory that would otherwise have been effaced by existing power structures.

The Mengding hunger strike led directly to the quick resolution of the sent-down youth problem in Yunnan. Zhao did keep his promise and immediately reported what he saw to the state council. Sent-downers mocked the investigative team as "becoming sensible only after being threatened."[48] Soon, "returning home" swept like a storm across all the state farms in Yunnan. "We rushed back to the city like rabbits," recalls Zhang Qingcong. "Everyone was packing and fleeing as quickly as they could."[49] Once more, they sat on the trains between Chengdu and Kunming. However, the formerly happy and naïve faces had disappeared; instead, they had become dark-skinned, much changed, grown-up men and women.

LIVING WITH MEMORIES

By the end of 1979, ninety-seven percent of sent-down youth in Yunnan had returned to the city. Having lost their youth, they had to cope with a now-unfamiliar urban life. From the very beginning, sent-down youth were caught between ideals and reality, principles and survival. First, going to Yunnan was not simply an idealistic decision responding to Mao's call to settle in the countryside. Students did feel a sense of glory, but they also had serious material concerns: they needed to relieve the economic pressure on their families and go where they could find employment. However, after the harsh reality had dampened their enthusiasm, they still sought something meaningful that would allow them to live through "the unlivable." Along with pain there was happiness, among the absurdities there were serious searches for meaning, and after all the disappointments they had suffered, sent-down youth learned what they wanted from life and how to achieve it. To them, Yunnan is a paradox much more complicated than the one-dimensional

stories found in either formulaic "scar literature" or "no-regret" accounts. So many of their memories of youth are rooted in Yunnan, and they always want to go back; but when they go back to visit, they "just want to escape as quickly as possible."[50]

Over the years, sent-downers have sometimes spun tales about their youth in Yunnan and told these beautified stories to their children. The stories provide them with warm feelings and comfort as they move through middle age. They also take solace in the spiritual support and companionship they offered one another in the countryside and seek to keep these relationships alive. On April 15, 2006, three thousand Chengdu sent-down youth attended a gathering to commemorate the thirty-fifth anniversary of their departure for Yunnan. The event included song and dance performances by the former sent-down youth themselves. Several days later, at the sent-down youth teahouse, the performers were still proudly talking to me about the "sensation" they had caused.[51]

As I interview these ordinary sent-down youth, I find that remembrance has multiple functions and its meaning changes over time. For sent-down youth, recollecting helps them formulate their own history. Even more important to them today, looking at old pictures and reminiscing holds them together as a community. Sent-down youth's reactions to photographs are also changing with the passage of time. Nowadays, when they look at the well-posed and artificially arranged propaganda photos, they do not show much dislike. Rather, the pretty images, though very unrealistic, remind them of their adolescence and of how strong, attractive, and youthful they used to be. Even those who have ridiculed the "no-regret" attitude of former sent-down youth cadres still want to stress the commonality of sent-down youth as a whole, to maintain friendships with those former cadres, and to sustain their community.

The year I met them, 2006, was the thirtieth anniversary of the end of the Cultural Revolution. The party-state of the People's Republic of China has been reluctant to launch a serious reflection on this unusual historical period, and the official evaluation of the Cultural Revolution has remained virtually unchanged since the early 1980s. In 1981, in its official conclusion regarding the Cultural Revolution, the reformist regime emphasized the full accountability of the previous political regime with the intention of letting bygones be bygones. Nevertheless, the past lives on and is never forgotten. Former sent-down youth actively reconstruct and share memories in ways that help them to live their present lives. Images play very important roles in both the reconstructing and sharing of those memories. Photos highlighting mob mentality and propaganda shots of smiling teenagers continue to circulate extensively, and each offers a glimpse of the past. But such images are very selective and fail to capture the richness of the participants' experiences. The

ordinary sent-down youth were also active agents in creating images of their lives in the countryside, both through idealized paintings and paper cuttings and stark, truthful photographs. By preserving these images and circulating them, they have worked to reconstruct their own histories and define their own lives.

NOTES

1. Deng Xian, *Zhongguo zhiqing meng* [Dreams of Chinese Sent-down Youth] (Beijing: Remin wenxue chubanshe, 1993), 22 and 79.

2. Chen Xiaomei, "Growing Up with Posters in the Maoist Era," in Harriet Evans and Stephanie Donald, eds., *Picturing Power in the People's Republic of China: Posters of the Cultural Revolution* (Oxford: Rowman & Littlefield Publishers, 1999), 102.

3. Ibid., 102.

4. Liyan Qin, "The Sublime and the Profane: A Comparative Analysis of Two Fictional Narratives about Sent-down Youth," in Joseph W. Esherick, Paul G. Pickowicz, and Andrew G. Walder, eds., *The Chinese Cultural Revolution as History* (Stanford: Stanford University Press, 2006), 260.

5. Ibid., 255.

6. Deng Xian, *Zhongguo zhiqing meng*, 43.

7. Deng Xian, *Zhongguo zhiqing meng*, 1.

8. Interview with Xie Guangzhi by the author, 30 March 2007. All names appearing in this paper are real. Most interviewees' names have already appeared in preexisting publications and all interviewees have agreed to allow me to use their real names.

9. Interview with Xu Shifu by the author, 15 April 2006.

10. Interview with Deng Xian by Chen Xiaonan, December 2004. Chen Xiaonan is a reporter of Phoenix TV Station in Hong Kong. In 2004, Chen systemically interviewed former sent-down youth in the Yunnan Construction Corps and produced a television documentary *Qingchun wansui* [Long live youth].

11. Interview with Zhang Qingcong by the author, 18 April 2006.

12. Interview with Xu Shifu by Chen Xiaonan, December 2004.

13. Interview with Zhang Qingcong by the author, 18 April 2006. Interview with Yang Quan by the author, 17 April 2006.

14. Interview with Yang Quan by the author, 17 April 2006. Interview with Xu Shifu by Chen Xiaonan, December 2004.

15. Interview with Zhang Qingcong by the author, 18 April 2006.

16. Interview with Deng Xian by Chen Xiaonan, December,2004.

17. Interview with Zhou Meiying by the author, 17 April 2006. Interview with Deng Xian by Chen Xiaonan, December 2004.

18. Interview with Chu Bingxing by Chen Xiaonan, December 2004.

19. Interview with Shao Jinming by the author, 19 April 2006.

20. Interview with Zhang Qingcong by Chen Xiaonan, December 2004. Interview with Chu Bingxing by Chen Xiaonan, December 2004.

21. Interview with Xu Shifu by Chen Xiaonan, December 2004.

22. Interview with Yang Quan by the author, 17 April 2006. Interview with Deng Xian by Chen Xiaonan, December 2004.

23. Interview with Zhang Qingcong by the author, 18 April 2006.

24. Interview with Xu Shifu by Chen Xiaonan, December 2004.

25. Li Jianzhong, *Huimou, sikao, pingshu—Zhongguo zhiqing* [Memory, Reflection, and Evaluation of the Chinese sent-down youth] (Beijing: Guoji wenhua chubanshe, 2005), 258.

26. Interview with Zhang Qingcong by the author, 18 April 2006.

27. Interview with Zhang Qingcong by the author, 18 April 2006.

28. Interview with Zhang Qingcong by the author, 18 April 2006.

29. Interview with Yang Quan by the author, 17 April 2006.

30. Interview with Yang Quan by the author, 17 April 2006.

31. Interview with Zhang Qingcong by the author, 18 April 2006.

32. Interview with Deng Xian by Chen Xiaonan, December 2004.

33. Interview with Zhang Qingcong by the author, 18 April 2006.

34. Interview with Zhang Qingcong by the author, 18 April 2006.

35. Interview with Chen Lijun by the author, 18 April 2006.

36. Li Jianzhong, *Huimou, sikao, pingshu—Zhongguo zhiqing*, 564.

37. Interview with Xu Shifu by the author, 13 April 2004. Though no official publication mentions the content of this meeting with Wang, Xu Shifu told me that "Wang was said to decide that this is a conflict between 'class enemies and the people' and that strikers would be treated as enemies."

38. Emphasis added. Document "Zhiqing gongzuo sishi tiao" [Forty points on the work about sent-down youth], quoted from Deng Xian, *Zhongguo zhiqing meng*, chapter 3.

39. Yang Quan, "1978–1979 nian Mengding: Yunnan zhiqing da fancheng de qianqian houhou" [Mengding from 1978 to 1979: the Returning to the City Movement of Sent-down Youth in Yunnan] manuscript, 2.

40. Interview with Xu Shifu by the author, 13 April 2006. Interview with Xu Shifu by Chen Xiaonan, December 2004.

41. Interview with Yang Guoding by Chen Xiaonan, December 2004.

42. Interview with Xu Shifu by the author, 13 April, 2006. Interview with Xu Shifu by Yang Quan, 2004.

43. Interview with Xu Shifu by Chen Xiaonan, December 2004.

44. Zhao Fan, *Yi zhengcheng* [Remembering my journey](Beijing: Zhongguo nongye chubanshe, 2003) 211–212. Interview with Zhao Fan by the author, May 30, 2006.

45. Zhao Fan, *Yi zhengcheng*, 216.

46. Interview with Xu Shifu by the author, 13 April 2006.

47. Interview with Xie Guangzhi by the author on 31 March 2007.

48. Xu Fa, *Wo suo zhidao de zhiqing gongzuo* [The work on sent-down youth that I know] (Beijing: Yawen chubanshe, 1998), 100.

49. Interview with Zhang Qingcong by the author, 18 April 2006.

50. Interview with Zhang Qingcong by the author, 18 April 2006.

51. Interview with Yu Zhiping by the author, 19 April 2006.

Chapter 14

Wild Pandas, Wild People

Two Views of Wilderness in Deng-Era China

Sigrid Schmalzer and E. Elena Songster

The fall of the Cultural Revolution radicals in 1976, followed by the rise of Deng Xiaoping in 1978, produced fundamental changes throughout China's political, economic, social, and cultural spheres. This chapter explores one specific aspect of this transformation: the dramatic shift in both official and popular Chinese understandings of nature. China had developed policies to address environmental issues as early as the 1950s, but during the Mao era the goal of conservation was to protect resources valuable to the state. The arrival of the post-Mao era saw a new understanding of nature as an endangered wilderness with inherent worth and in need of protection. While the concept of the endangered wilderness became widely accepted in the 1980s, it did not resolve into a single vision. Rather, two distinct views emerged that reflected two very different perspectives on the broad changes China was experiencing under Deng Xiaoping's rule (1978–1997). One was the idea that a new state strengthened by scientific modernization and economic reforms could rescue the wilderness from crises brought on by nature's intrinsic fragility. The other presented the wilderness as threatened, rather than protected, by state-supported modernization efforts.

In order to capture these two very different perspectives on the landscape of state-wilderness relations, we will ask you to imagine that you have in front of you two telescopes. The first directs our gaze onto efforts to save the giant panda from starvation. Through official, state-produced documents on panda preservation, we obtain the state's view of the power of modernization to protect the wilderness. The second telescope focuses on the search for a legendary, Bigfoot-like creature called *yeren*. Through popular science writings, fiction, and poetry about *yeren*, we gain the perspective of critical intellectuals, who see the power of modernization to destroy the wilderness.

We use telescopes as a metaphor to make explicit the reflexivity of this volume's approach. Like the people we study, modern historians inhabit a "visual culture." Metaphors of visuality abound in our writings. We talk about people in history "constructing images," "outlining visions," and "sharing views" even when there is nothing literally to "see." Historians also sometimes use such language to explore the way we go about the very act of studying the past. For example, we may talk about different "perspectives" on historical events or about using a small episode as a "window" onto larger historical changes. In adopting "telescopes," we are raising specific questions about the powers and limits of historical sight. A telescope zooms in on an object in a circular field of vision while rendering the larger context invisible.[1] Similarly, a specific body of historical sources may provide rich detail about one subject from one perspective while leaving out many related subjects and oppositional viewpoints. Thus, we will need to return in the conclusion to the question of what each telescope (panda rescues and *yeren* explorations) does and does not reveal about Deng-era China. To what extent does a focused examination of a specific case offer insight into an historical era? Are there limits to such visions, and if so, can we overcome them?

TELESCOPE #1: PANDAS IN CRISIS, MODERNIZATION TO THE RESCUE

1976: A Crisis in Nature

In early 1976, local and provincial government agencies sent urgent reports to the Ministry of Agriculture and Forestry in Beijing that giant pandas were dying in abnormally high numbers.[2] State officials had good reason for concern. Since the 1950s, pandas had been lovingly adopted as a national symbol, and during the early 1970s, they came to be called China's "national treasure." The Chinese government gave pandas as diplomatic gifts to cultivate good relations with other nations, an act that transformed pandas into international symbols of China's value. "Panda diplomacy" became increasingly important when China joined the United Nations in 1971 and began the process of renewing relations with the United States. Early in the People's Republic, newspaper descriptions of the "fat," "comical" animals with "milk white fur" and "delicate little round ears," together with photographs of the Beijing Zoo's captive pandas, had won people's hearts, and in 1976 this image of the giant panda was still embedded in people's minds.[3] Many Chinese companies had adopted this robust, round giant panda as their logo. Now government reports spoke of pandas that were thin and decrepit with lackluster coats indicative of some debilitating illness.

The pandas' plight was hardly the biggest difficulty facing the government in 1976. Three top leaders died that year: Zhou Enlai on January 8, Zhu De on July 6, and Mao Zedong on September 9. The same year also saw what is still history's most devastating earthquake: on July 28, more than 240,000 people perished in and around Tangshan. Despite the magnitude of these challenges, however, the national government responded with remarkable speed and resources to increasingly urgent reports of ailing and dying pandas.

Embracing the panda as a symbol of China brought with it the responsibility of keeping it alive. As a national symbol on the brink of disaster, the giant panda had the power to capture the attention of officials at every level of government. As a sickly wild animal, it conjured a new sense of the wilderness as vulnerable and in need of rescue. The process of mobilizing scientific, political, and economic resources to intervene in the crisis created a new state view of the wilderness not as daunting or exploitable but as vulnerable.

One of the earliest signs of a panda crisis described in these government documents occurred in Pingwu County, in northern Sichuan province, when a man brought a "weak and disoriented" panda to the county forestry bureau. The county then delivered it to a zoo for recovery.[4] During the course of their work in the mountain forests, lumber workers, local villagers, and forestry officials soon began encountering panda corpses.[5] Typically, they spotted dead pandas lying on their sides in the grass or slouched in the snow, emaciated and with fur that was unusually coarse and dull.[6]

These disturbing images prompted county governments to organize search teams to determine the scale of the crisis. One such group led by a local resident in Gansu encountered an adult panda that "could still move, but did not flee when they neared. The local guide approached it and even pinched its ear, but the giant panda had neither the strength nor the will to resist." Autopsies gave local and national officials a more detailed picture of what ailed the pandas—starvation. Experts discovered that the pandas' "stomachs were empty or without food, there was no fat, the livers had assumed a grassy quality, not even a centimeter thick, and the abdomen was full of water."[7] Other pandas, not yet dead, seemed to be feeble or oddly tame—walking unsteadily, appearing out in the open, sometimes approaching villages. Each report contributed to a new perception of China's "national treasure"—a suffering, weak creature that had lost many of the characteristics of a wild animal, including the ability to fear and dissuade human approach.

Concern quickly traveled from local officials up the political ladder to Beijing. The central office of the Ministry of Agriculture and Forestry called on a large number of political and scientific bodies to form a "United Survey Team," which proceeded to collect extensive data on each death and the surrounding ecology. Even more remarkable was the monetary investment and sacrifice to which the local and national governments were willing to commit.

In addition to caring for pandas—and reimbursing and rewarding local residents for their efforts—the government actually halted all lumber activity in the area, at a cost of millions of yuan.[8]

The state's response to the crisis was to bring science and political authority together in an effort to manage nature. National and local government agencies used legal measures to restrict activities thought to be harmful or disruptive to the pandas. These included bans on hunting (except of potential panda predators), the use of hunting dogs in the wild, the skinning of or tampering with panda corpses, and any activity that might result in habitat destruction.[9] The state intervened also by removing pandas from the wild in order to rehabilitate them in captivity.[10]

The sheer scale and intensity of the United Survey Team's investigations was another way in which the state demonstrated its power to cope with a crisis of nature. In keeping with the "high modernist" character of the Chinese state in this period, officials and scientists sought to render nature "legible" to science through extensive and detailed data collection.[11] Survey participants meticulously recorded all relevant data in order to offer more scientific, or at least more systematic solutions. Biologists and botanists who were recruited to participate in the surveys instructed other surveyors to register all pandas with a number, the commune area in which it was found, a detailed description of its immediate location, the time, the general environment, and the panda's sex, size, and apparent reason for death.[12] The combined efforts of the national United Survey Team and the provincial and local rescue and investigation operations determined that a mass bamboo die-off in the region lay behind the deaths of the pandas, which were dependent on bamboo as their dominant source of food.[13]

In its response to the panda crisis, the Chinese government entered into a new relationship with nature, becoming an intermediary in the workings of the wilderness. Past efforts to manipulate, improve, or even conquer nature addressed the intersection between human society and nature, altering nature for the convenience of humans (Figure 14.1, see website). Projects such as digging canals to ease transportation, diverting rivers to maintain a village, and filling in lakes to grow crops all centered on the human community.[14] But now the Chinese government and local residents were attempting to improve the relationship between the wilderness and wildlife. Nature was failing, and Chinese officials considered it their duty to step in, figure out where nature was going wrong, and fix the problem.

1983: A Crisis in the New Economy

When in 1983 another panda crisis emerged, the Chinese state was in a still better position to demonstrate its ability to intervene and assist nature, and

certain state agencies were even able to capitalize on their newfound economic power. Beginning in 1978, Deng Xiaoping had prioritized economic development, a distinct break with the Mao era's emphasis on political movements. Deng took as his platform the "Four Modernizations," a commitment to developing agriculture, industry, science and technology, and national defense. Under Deng, the government also encouraged small-scale entrepreneurial ventures, first in the countryside and later in the urban areas, and transformed the economy along the lines of "market socialism."

In 1983, reports of dying bamboo surfaced in another mountain range, the Qionglai Mountains of southern Sichuan Province. That year, the concern about starving pandas did not compete with other monumental events and human catastrophes for attention. This favorable timing, combined with a growing economy, set the stage for a much bigger campaign to save the pandas. No longer just a problem for the modern state to address, the giant pandas became a national cause. Flush with its new economic power, the state mobilized still greater resources to research the situation (Figure 14.2), mitigate a flawed nature, and rescue this precious wild species. At the same time, the new spirit of entrepreneurial economics encouraged a frenzy of fundraising that did little for pandas but greatly profited government agencies.

The Ministry of Forestry used every form of media in a public appeal for financial contributions to prevent a panda starvation catastrophe. This strategy was entirely different from anything the state attempted in 1976. Despite the death of more than one hundred pandas, the 1976 bamboo die-off did not appear once in People's Daily (Renmin ribao). In contrast, more than thirty articles on bamboo die-off and panda rescue efforts appeared in this same paper between 1983 and 1984.[15] Front-page articles celebrated "scientific" rescue techniques despite the lack of a single actual rescue to report.[16] Popular magazines and books also depicted the crisis pandas faced and rescue efforts by heroic common people (Figures 14.3 and 14.4, see website). A peasant brought a panda that had wandered into his house to a government holding station. Another peasant reported that a panda killed his goat, yet he restrained his dogs and did not harass it.[17] Some stories made international news, such as the group of neighbors who encountered a sickly panda that had fallen off a cliff and who then "went on a nineteen-hour trek carrying the panda on a light tractor to the county seat fifty miles away."[18] These stories helped those who could merely send funds envision more clearly the plight of the panda and the stalwart efforts their compatriots were contributing to the same cause. Citizens responded from all over China with letters of concern and monetary contributions.

In state-sponsored media accounts, popular fund-raising for the panda reflected the entrepreneurial genius of China's young schoolchildren and the generous hearts of China's poor. The Number Ten Middle School in Beijing

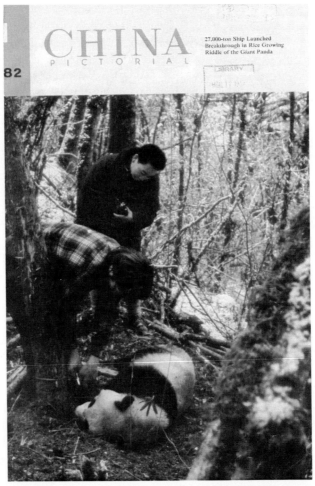

Figure 14.2 Scientists place a radio collar on a giant panda in the mountains of Sichuan in 1982 as part of a five-year behavioral study on wild pandas. The image appeared on the cover of *China Pictorial* 1982 (no. 1), a state-produced magazine published in Chinese and many other languages; it provided the voice of the Chinese state with a colorful, appealing face for popular audiences. Media attention like this helped prepare the public for the state's massive campaign to mobilize resources to save the panda.

recruited 530,000 students to pledge one *fen* (one penny) for each day of their winter holiday to the cause of saving the "national treasure." Each student wrote her or his name in a pledge book to be sent with the money collected.[19] Endearing photographs of children collecting and donating money for the treasured pandas, as seen in Figure 14.5, often accompanied these stories and inspired similar efforts in other parts of the country. The power of such

Figure 14.5 This photograph of school children raising money to save giant pandas appeared in *People's Daily* (Renmin ribao), China's most important state-sponsored newspaper, on 9 May 1984.

newspaper images, both textual and photographic, lay in the apparently spontaneous actions of the figures depicted, who were expressing potent feelings of compassion and self-sacrifice. In Figure 14.5, the schoolchildren also seem to be innocently employing creative marketing strategy and an entrepreneurial spirit in keeping with China's new economic ethos.

Funds always seemed to flow for the panda—a testament to nationalistic sentiment. Teenage railroad workers appealed to their coworkers to contribute to the cause with the slogan, "Love your nation, love the national treasure, save the giant panda."[20] Dong Zhiyong, the vice-chair of the Ministry of Forestry, reported that he was particularly moved when all of the inmates at a labor camp in Jiangsu province in southeast China dipped into their meager stashes and collected 180 yuan (about US$90) to donate to the cause of saving the giant panda. The money was enclosed in a letter that read, "We offer this donation to help the giant panda and as an expression of our deep love for our nation. With this concrete action we are correcting our mistakes and walking in a new direction."[21] Although it is difficult to confirm the authenticity of all of the stories of model citizens rising to the cause, many such instances certainly occurred.[22] And regardless of the literal truth of each account, the stories worked to support the state's effort to promote an image of widespread popular response to panda starvation.

While media images portrayed needy and suffering pandas alongside valiant and generous citizens, the fund-raising itself quickly turned into a fiasco. State agencies no longer pursued the scientific approach to fixing nature (however problematic it may have been) but focused instead on promoting a

popular cause that proved unexpectedly profitable. Some scientists questioned the logic behind rescue efforts or criticized the ongoing fund-raising as unnecessary, but to no avail.[23] Peking University biology professor Pan Wenshi was an early and persistent critic, but his complaints fell on deaf ears.[24] Some concern rose from the public about how the funds were being spent, but state agencies quickly consoled the critics and solicited still more funds.

In response to growing popular interest in the amount and allocation of donations, officials from the Chinese Wild Animal Protection Association, a subsidiary organization under the Ministry of Forestry, asserted that while they were unable to account for funds that went directly to the Ministry of Forestry or straight to local governments in panda territory, they planned to set up a trust fund for donations "for the next generation," presumably of pandas.[25] Critics to this day continue to raise doubts about where the funds went.[26] But tracing the funds and determining responsibility has proven difficult. References to placing donations in trust accounts belied the notion that the pandas faced a crisis and urgently needed the funds. A few years later, articles in scientific journals and other publications demonstrated that the 1983 panda starvation crisis ultimately had been no more than a threat. But by that time, the government had quietly closed the case as a successful effort to rescue the starving pandas that the generosity and patriotism of China's citizens made possible.

Deng's market reforms enabled broad segments of society to have money to give, and the entrepreneurial ethos encouraged such fund-raising efforts. But this new system had no checks to prevent corruption. The 1983 campaign to save the pandas was at base a demonstration of the state's ability to summon nationalistic fervor, channel such fervor through the new economic culture, and then bolster its own power by enriching government agencies. The sources explored here also include critical voices that call attention to the state's failure to manage nature and protect wild animals. These critics accepted the idea that a strong, modern nation should be able to care for the wilderness, but they questioned whether the state had fulfilled this responsibility. Turning to the second case study, we will discover a very different kind of challenge—one that rejects entirely the notion that modernization is beneficial to the wilderness.

TELESCOPE #2: *YEREN* IN DANGER, MODERNIZATION TO BLAME

The Legendary Yeren Becomes Endangered

Pandas were not the only symbols of endangered wilderness to emerge during the mid- to late-1970s. In 1974, a local official in the mountainous

region of Shennongjia in western Hubei Province (bordering Sichuan) began documenting sightings of mysterious creatures called *yeren*.[27] Literally "wild people," *yeren* are similar to North America's Bigfoot and the *yeti* of the Himalaya. They have been known by many names in different times and places in Chinese history. Never, however, had the creatures received as much systematic attention as they did beginning in the late-1970s. As the restrictions of the Cultural Revolution loosened, an explosion of popular science books and magazines provided an ideal medium for spreading stories of *yeren* encounters. And with the renewed "friendship" between the U.S. and China, scientists and science hobbyists alike were exposed to the sizable literature on Bigfoot then sweeping the United States by storm.

In 1977, reports of *yeren* sightings in Shennongjia spurred scientists at key institutions to organize large-scale scientific expeditions reminiscent of those deployed the previous year on behalf of the starving pandas. In addition to ecologists and zoologists, paleoanthropologists were mobilized: their job was to determine whether *yeren* represented living descendants of the fossil anthropoid ape *Gigantopithecus* and thus a kind of "missing link" in the human family tree. Scientists worked with local people to interview peasant eyewitnesses, collect material evidence, and, most importantly, hunt for a live specimen. The hope of finding a living *yeren* was strong enough that a sculptor accompanied the expeditions with artistic skills poised to capture the creature's likeness.[28]

Throughout the Mao era, the state had sought to use science to assert its control over an unruly nature—to tame nature's violent temper and harness its valuable resources.[29] The militaristic and authoritarian response to *yeren* reports in the early years perpetuated the notion that science should conquer nature (Figure 14.6, see website). *Yeren* trackers carried guns and were prepared to use them, and in the early expeditions a large number of soldiers accompanied the scientific teams. If some scientists doubted the existence of *yeren*, local people were ready to step up to the plate to bring in the evidence, dead or alive. One *yeren* hunter, Li Guohua, set off in 1977 to kill a *yeren*, bring its head to the scientific institute, and ask the scientists whether they still harbored doubts.[30]

Yeren also represented another kind of wildness that the state sought to subdue. Not only did rural people perceive them as dangerous in the manner of wild animals, but the state also saw a hazard in the "superstitious" stories rural people told about them. Scientists and state officials hoped to demonstrate that the supernatural creatures of legend were in fact respectable members of the primate order. This would strike a blow for modern science over "primitive superstition."[31] Thus, the initial responses to the *yeren* sightings often reflected firmly entrenched antagonisms both to the wilderness of nature and to the wildness of culture.

At the same time, however, a very different attitude toward *yeren* was emerging. The state response to the 1976 panda crisis had created an interest among scientists in rare animals and wilderness. Scientific research and writing transformed *yeren* from frightening monsters in peasant folklore into a precious and vulnerable species in need of state protection.

Pandas were clearly very much in the minds of the scientists conducting investigations into *yeren*. One biology professor noted that people had discovered fossils of pandas and of *Gigantopithecus* in the same areas, what he termed an "ancient 'panda-*Gigantopithecus* belt.'" He suggested that the survival of *Gigantopithecus* through the eons could likely be explained in much the same way biologists explained the persistence of pandas: both had adapted to changing nutritional resources. Like pandas, he continued, *Gigantopithecus* (or *yeren*) were now on the verge of extinction. Protecting them was "an issue of great international significance in terms of politics, philosophy, and science."[32] Similarly, another scientist cited the possibility that *yeren* lived in Shennongjia as a compelling reason to create a nature reserve there.[33] While there were many other good reasons to do so (including the existence of golden monkeys in the area), talk of *yeren* certainly added to the excitement over the idea, and in 1983 the reserve gained official approval. Such calls to save from extinction a creature whose very existence was not yet proven demonstrated the change in scientists' and officials' views of the wilderness that had taken place with the 1976 panda crisis.

Putting the Wild back in Wilderness

In other ways, however, *yeren* were quite different from the pandas who shared their battle with extinction. *Yeren* were neither cuddly like healthy pandas, nor weak and dependent like sick pandas. Even when perceived as endangered, they remained dangerous and wild. The cover of a book of short stories published in 1988 vividly demonstrates the way beauty, savagery, and power could come together in popular *yeren* imagery (Figure 14.7). When it came to celebrating the *wild* in wilderness, nothing was quite so powerful as *yeren*.

As symbols of the past, the primitive, and the wild, *yeren* offered a formidable challenge to modern civilization in general, and to the Deng state in particular. Using *yeren* to reflect on savagery was a means of re-envisioning the Four Modernizations as threatening to nature. The wilderness became a way of examining modern civilization and finding it wanting.

By the mid-1980s, writers of elite and popular literature began identifying in *yeren* a potent symbol of primitive purity in contradistinction to the ravages of modern society. The most famous of these was Gao Xingjian, who won the Nobel Prize for Literature in 2000. His 1985 play *Yeren* captured

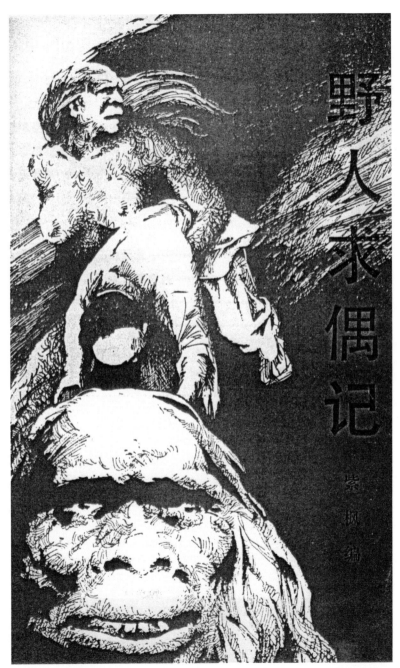

Figure 14.7 The cover of a book of short stories including Song Youxing's 1985 story "A *Yeren* Seeks a Mate." From: Zi Feng, ed. *Yeren qiu ou ji* [A yeren seeks a mate] (Beijing: Zhongguo minjian wenyi chubanshe, 1988).

the emerging significance of the creatures for Deng-era Chinese society, and his later novel *Soul Mountain* (*Lingshan*) expanded on some of these themes. Gao and other writers did not dwell on the *yeren* as savage beasts or dangerous superstitions; rather, they highlighted the *yeren*'s primitive human qualities and the ancient wisdom that legends about them preserved.

In a short story by Song Youxing, "A *Yeren* Seeks a Mate" (*Yeren qiu ou ji*), first published in 1985, a female *yeren* abducts a human man to sire her child (Figure 14.7). When the man escapes with the child, the *yeren* dies of a broken heart. The use of a "wild person" as a symbol of human sentiment was striking to contemporary readers, who wrote letters to the author about their emotional reactions. A "single male" reader found the female *yeren* to surpass the human women of his experience in womanly virtue, while a "woman worker" said she "really empathized with this warm-hearted *yeren* girl."[34] One published review even criticized Song for making "the *yeren* seem more human than the human."[35]

Yet this was precisely the strength of *yeren* symbolism. As "wild people," *yeren* served as perfect subjects for exploring humanity and civilization. When the protagonist of Gao Xingjian's novel *Soul Mountain* arrived in Shennongjia in the early 1980s, he wondered, "when the world is becoming increasingly incomprehensible, where man and mankind's behavior is so strange that humans don't know how humans should behave, why are they looking for the Wild Man [*yeren*]."[36] An answer may be found in Zhou Liangpei's 1986 poem "I Am *Yeren*" (*Wo shi yeren*), in which the *yeren* "I" tells the reader: "If we look at one another, we will see who still retains a tail / You are my bright mirror, and I am yours."[37]

Yeren helped all three of these writers to reflect on social and political values. The suitability of *yeren* as a "bright mirror" lay first of all in their own primitiveness and thus their immunity from the evils associated with "civilization." But it lay also in the connection between *yeren* and the "traditional" cultures that had preserved them in legend.[38] Zhou Liangpei's poem frequently refers to *yeren* through such images of the distant past as "the history book," "the life fixed in prehistory yet still living today," and "the not-yet-civilized wildness." Evoking the Daoist classics, he explained, "I only fear that people's hearts are not ancient; it is a modern anxiety / The search for searching often resides in returning to the origin / The art of art often resides in going back to truth."[39] Gao Xingjian was engaged in a similar search for origins when he wrote *Yeren*. A character in the play gave voice to Gao's concern for mountain shamans whose rituals Gao associated with "the origins of Chinese theatre." "These days sorcerers are a rare commodity. If we want to understand the past, we must respect them and try to understand their ways. Like Wild Men, they are dying out fast."[40] Another character suggested: "We could link [*yeren*] with mankind's evolution and countless

folktales and legends and help to explain these myths. Perhaps we can give a new lease of life to some of those old stories, and . . ." At this point, we are told, the speaker's "excitement turns to sorrow."[41] Gao feared that legends themselves faced extinction. If rehabilitating them through science was their best hope for survival, this was a sad state of affairs.

Intellectuals in the Deng era widely shared the interest Zhou and Gao expressed in primitivism, and changes in official policy regarding minority nationalities actually encouraged it. While still pursuing assimilation, officials began once again to encourage ethnic minorities to identify as such by wearing traditional dress and speaking their mother tongues (although only in addition to standard Mandarin).[42] Accompanying this policy change was an intellectual movement known as "roots-searching" (*xungen*). In the late 1970s and early 1980s, the arts of minority nationalities inspired an artistic renaissance. Han Chinese filmmakers and novelists of the 1980s also eagerly tapped the subject of minority nationalities, whose "primitive" lives appeared to offer far more freedom than modern society permitted.[43] For writers like Zhou and Gao, *yeren*'s wildness and association with "primitive" cultures evoked a similar sense of freedom. Sex played a big part in this primitivism: Han people delighted in imagining the liberal sexuality of minority nationalities, and *yeren* imagery likewise reflected this interest, which is apparent in recurrent fictional and scientific references to female *yeren* breasts, in addition to the vivid depictions of voluptuous *yeren* in images like Figure 14.7.

The use of *yeren* to question "civilization" from the perspective of "wild people" was one link between the romantic primitivism of roots searching and the seeds of an environmental movement in China. In Gao Xingjian's play, *yeren* served as spokespeople for the forests. In one telling moment, an ecologist responds to news of a logging road under construction by asking, "What would our Wild Man think about that?"[44] Zhou Liangpei's poem echoed this concern. He spoke of Shennongjia as "trees full of ancient mosses" threatened by the "felling circle pressing closer." He warned, "Cutting down [trees], capturing [wild animals], the great mountain falls into a terror from which it has no power to save itself."[45]

Yeren trackers have also come to work directly for environmental protection. Li Guohua and Yuan Yuhao both participated as lay members of the 1970s *yeren* investigations; both went on to work for the Shennongjia nature reserve (Li as a photographer and popular science writer, and Yuan as a ranger). In the years *yeren* tracker Zhang Jinxing has spent camping in the wilderness in pursuit of his quarry, he has increasingly modeled himself explicitly on Jane Goodall, both in his immersion style of research and his commitment to educating the public about the importance of saving the wilderness (Figure 14.8).[46]

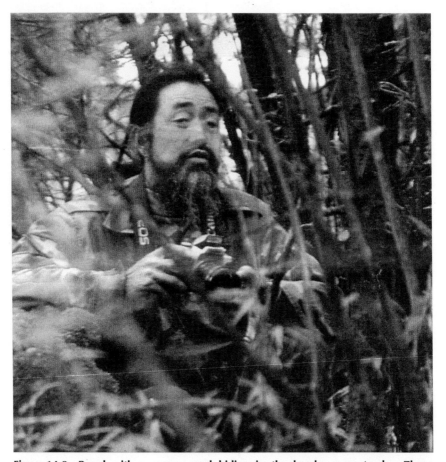

Figure 14.8 Posed with a camera and hiding in the brush, *yeren* tracker Zhang Jinxing is blurring the distinction between seeker and quarry, human and *yeren*. The photograph, by Sahid Maher, appeared in Anne Loussouarn, "What's Out in the Woods?", *City Weekend*, trial issue (2000), 9. *City Weekend* is a popular newspaper for foreign residents of Beijing. Zhang Jinxing's appearance in an "expat" newspaper, together with the many articles about the North American Bigfoot in post-Mao books and magazines, testify to the transnational character of cultural phenomenon of interest in *yeren*/yeti/Bigfoot.

For many of the most devoted *yeren* hunters and popularizers, saving the environment has come to mean saving themselves, and searching for *yeren* has meant searching for their own souls. The poet Zhou Liangpei sought a "primeval soul not stained by the dirt of custom." Zhou and others found such a soul by returning to nature. Li Guohua, who in the late-1970s claimed to want to kill a *yeren* and bring its head to the scientific institute, said a decade later: "My life came from nature, and I might end my life going

back to nature. It's as if my soul has been possessed by nature, possessed by *yeren*."⁴⁷ Nature offered a space away from the troubles of civilization to find oneself again. "In the pathless forest, to be lost does not count as being lost," said the poet Zhou Liangpei.⁴⁸ Zhang Jinxing has foresworn shaving his beard until he finds a *yeren*; his increasingly wild appearance adds to the jokes (which he encourages) that he has himself become the very thing he seeks (Figure 14.8).⁴⁹

Yeren thus reversed the accepted civilized/savage binary. The all-too-human capacity for destruction was labeled "savage," and people were called upon to reshape themselves in the image of nature—as caretakers of the forest that once sheltered our tree-dwelling ancestors. To quote once more from the poem "I am Yeren": "I seek your protection, you seek my shelter / Heaven and earth are inverted and spinning in karmic retribution."

HISTORY: ONE PICTURE OR MANY?

Pandas and *yeren* offer two "telescopes" through which to view the Deng-era Chinese wilderness and the Four Modernizations. Both reveal a perspective that wilderness has inherent value. This is a perspective quite different from earlier attitudes that characterized nature as a force to be conquered or a set of resources to be exploited. But beyond this shared recognition of the value of wilderness, the two views are very different. Through the first telescope, representing mainly state-sponsored documents on endangered pandas, we initially see a robust state using modern science and market economics to steward China and its wild pandas through the end of the twentieth century and into the twenty-first. This is a "high modernist" vision: modern political, scientific, and economic structures can make the world a better place. When we sharpen the focus, however, we begin to see a flaw: over-eager to engage in entrepreneurial economics, the state fell prey to corruption. Through the second telescope, representing mainly popular science and literary writings on the legendary *yeren*, a very different picture emerges. We see environmentalists critical of the state's emphasis on modernization. They claim that economic development threatens to destroy the wilderness, leaving people spiritually bereft. In place of modernization, they call for people to embrace the pure, primitive, and liberating values symbolized by *yeren*. Thus, if we look only at the writings on *yeren*, the Deng era appears not as a time of "high modernism" but as a renaissance of primitivism.

What does it tell us about the historian's craft if every time we look at a different case we get a different perspective on history? To begin with, it indicates that historical sight is limited by the subjective perspectives of the people we study and by the historians' subjective decisions about what cases

to select. Does this mean that history is inevitably subjective? We will close by offering two possible answers to this question, which represent two common philosophies about history.

Some historians would suggest that by bringing together our two cases (the pandas and the *yeren*), we arrive at a more reliable understanding of the Deng era. This would be like taking two telescopes and creating a single pair of binoculars. The advantage of binoculars is the advantage of having two eyes instead of one. The resulting stereoscopic vision provides a wider field of view and also makes possible depth perception, replacing a flat image with a view in three dimensions. Similarly, some historians would argue that by bringing two cases together we can achieve the stereoscopic vision necessary for a more complete picture of history. We could bring together the view of modernism (from the panda case) and the view of primitivism (the *yeren* case) and conclude that only in historical periods dominated by the drive to modernize do people seek solace in the so-called "primitive." Thus the apparent contradiction between the modern and the primitive is actually the very essence of modernism.

But other historians would disagree, saying that the two visions are irreconcilable: through the panda telescope, we see nature as a state management project, and through the *yeren* telescope we see nature as a refuge from the very notion of state management.[50] They would conclude that the two different pictures reflect the enormous gaps between the perspectives found in state-produced sources and those in sources authored by intellectuals critical of the state. This is an increasingly common way of thinking about history, which denies that we can ever get beyond the many individual stories and arrive at one coherent, inclusive account. Supporters of this idea might propose replacing the "binoculars" metaphor with that of the kaleidoscope: our view of history shifts depending on what we look at and how we position ourselves.

Your answer to this question may well depend on how you see history—as a single, knowable entity, or as an elusive changeling that appears differently to each who seeks it.

NOTES

1. We thank Jeremy Brown for suggesting this language.
2. Archival forestry documents from Sichuan Province and Pingwu County between February and April of 1976.
3. Guo An, "Wo guo zui da de dongwu yuan—Beijing dongwu yuan," *Renmin ribao* [hereafter, RMRB], May 6, 1956: 3; Zhou Jianren, "Guanyu xiongmao" [About pandas], RMRB, July 6, 1956: 8.

4. Sichuan sheng, Pingwu xian, Geming weiyuanhui, "Guanyu baohu da xiong-mao de jiji tongzhi" [Urgent notice concerning protecting giant pandas], *Pingge fa* 76, no. 12, February 10, 1976, 1; Jiang Tingan, "Zai da xiongmao de guxiang" [In panda country], *Bowu* 3 (November 1980): 15.

5. Sichuan sheng, Mianyang diqu linye ju wenjian, "Guanyu jiaqiang dui da maoxiong xiankuang guancha he dui jianzhu kaihua siwang hou de huifu qingkuang jinxing diaocha zongjie de tongzhi" [Concerning the strengthening of the observation of the present giant panda situation and the survey of advancing of the post bamboo flowering and die-off recovery], *Dilin jingying* 76, no. 32, March 13, 1976.

6. Yang Ruoli, Zhang Fuyun, and Luo Wenying, "1976 nian da xiongmao zainan xing siwang yuanyin de shenlun" [Probing into reasons for the 1976 catastrophic death of giant pandas], *Acta Theriologica Sinica* 1, no. 2 (December 1981): 128.

7. Yang, Zhang, and Luo, "1976 da xiongmao siwang yuanyin," 128.

8. PRC, Nonglin bu [Ministry of Agriculture and Forestry], "Guanyu jiaqiang da xiongmao baohu gongzuo de jiji tongzhi" [Urgent notice concerning giant panda protection work], *Nonglin* 76, lin zi no. 20, March 16, 1976, 1. Qian Danning, ed., *Pingwu xianzhi* [Pingwu county gazetteer] (Chengdu: Sichuan kexue jishu chuban she, 1997), 505–506.

9. National and Pingwu county archival forestry documents from February to April of 1976.

10. Jiang Tingan, "Zai da xiongmao de guxiang," 15–16; Yang, Zhang, and Luo, "1976 da xiongmao siwang yuanyin"; Zong Zhaomin, "Da xiongmao siwang yu dizhen de guanxi" [The relationship between giant panda death and earthquakes], unpublished paper, 1; Xie Zhong and Jonathan Gipps, *The 2001 International Stud-book for Giant Panda [sic], Ailuropoda melanoleuca* (Beijing and London: Chinese Association of Zoological Gardens and Bristol Zoo Gardens, 2001), 18–20.

11. James Scott, *Seeing Like a State: How Certain Schemes to Improve the Human Condition Have Failed* (New Haven: Yale University Press, 1998). Scott characterizes "high modernism" as a commitment on the part of the state to reshape nature along "rational" lines to fit perceived human needs, and a confidence that such efforts will result in continued, linear progress. Reshaping nature, according to Scott, has first required making nature "legible" within the framework of modern science.

12. Sichuan sheng, *Pingge fa*, 5.

13. Sichuan sheng, *Pingge fa*, 6.

14. Mark Elvin, *The Retreat of the Elephants: An Environmental History of China* (New Haven: Yale University Press, 2004), 116, 460; Judith Shapiro, *Mao's War against Nature: Politics and the Environment in Revolutionary China* (Cambridge: Cambridge University Press, 2001), 115–120.

15. RMRB, January 1975-January 1985.

16. RMRB, August 17, 1983: 1.

17. Dong Zhiyong, "Qiangjiu 'guobao' da xiongmao" [Saving the 'national trea-sure' the giant panda] interview by journal reporter in, *Yesheng dongwu* [Chinese Wildlife] 3 (May 1984): 1.

18. Christopher S. Wren, "Bureaucracy and Blight Imperil China's Pandas," *New York Times*, July 3, 1984: C1.

19. RMRB, February 24, 1984: 3.

20. RMRB, March 16, 1984: 1. Here the term *"guobao"* or "national treasure" specifically refers to the giant panda. The term was coined during the Nixon visit to express to the United States that the gift of giant pandas was a gift of something precious and treasured in China.

21. Dong Zhiyong, "Qiangjiu 'guobao' da xiongmao," 2.

22. Interviews conducted by Songster.

23. George B. Schaller, *The Last Panda* (Chicago: University of Chicago Press, 1993), 202, 204–205.

24. Pan Wenshi, interview with Songster, 2001.

25. Yin Hong, "Zhongguo yesheng dongwu baohu xiehui fu zeren tan,"3; Wren, "Bureaucracy and Blight Imperil China's Pandas"; Christopher S. Wren, "Chinese Official Denies Gift for Pandas was Sidetracked," *New York Times*, October 17, 1984: A19.

26. Wren, "Bureaucracy and Blight Imperil China's Pandas"; Wren, "Chinese Official Denies Gift."

27. Some of the material on *yeren* included here is drawn from Sigrid Schmalzer, *The People's Peking Man: Popular Science and Human Identity in Twentieth-Century China* (Chicago: University of Chicago Press, 2008).

28. Zhao Zhongyi, interview with Schmalzer, November 5, 2002.

29. See Judith Shapiro, *Mao's War against Nature: Politics and the Environment in Revolutionary China* (Cambridge: Cambridge University Press, 2001).

30. Stories about Li Guohua are among the most common in Deng-era *yeren* literature. See, for example, Liu Minzhuang, *Jiekai "yeren" zhi mi* [Solving the *'yeren'* mystery] (Nanchang: Jiangxi renmin chubanshe, 1988), 164–67.

31. Shang Yuchang, "Cong Zhu Feng diqu 'xueren' kaocha tanqi" [Talking about yeti investigations from the Mount Everest area], *Huashi* 3 (1979): 8; Yuan Zhenxin and Huang Wanbo, "'Yeren' zhi mi xiang kexue tiaozhan" [The "*yeren*" mystery poses a challenge to science], *Huashi* 1 (1979): 8; Liu Minzhuang, *Jiekai 'yeren' zhi mi*, 100; Song Youxing, *Yeren de chuanshuo* [Yeren legends] (Hongkong: Xianggang haiwan chubanshe, 1986), 3.

32. Wang Bo, *Yeren zhi mi xin tan* [New investigations of the *yeren* mystery] (Chongqing: Kexue jishu wenxian chubanshe, 1989), 115–16.

33. Zhou Guoxing, "Shennongjia 'yeren' kaocha" [Investigation of Shennongjia *yeren*], *Kexue shiyan* 2 (1979): 30.

34. Song Youxing, *Yeren de chuanshuo*, 105, 108.

35. Wang Ping and Lü Xue, "Guangxi 'tongsu wenxue re' diaocha ji" [An investigation of Guangxi's "popular literature fever"], *Wenyi bao* 2 (1985): 40.

36. Gao Xingjian (Mabel Lee, trans.) *Soul Mountain* [Lingshan] (New York: Harper Collins, 2000 [1990]), 364.

37. Zhou Liangpei, *Yeren ji* [A *yeren* collection] (Beijing: Hua xia chubanshe, 1992), 97. The "tail" here is symbolic only. In legends and eyewitness accounts, *yeren* do not have tails.

38. Claire Huot, *China's New Cultural Scene: A Handbook of Changes* (Durham, N.C.: Duke University Press, 2000), 91–125.

39. Zhou Liangpei, *Yeren ji*, 96–99.

40. Gao Xingjian, "Wild Man: A Contemporary Chinese Spoken Drama," trans. Bruno Roubicek, Asian Theatre Journal 7, no. 2 (1990 [1985]), 192, 239.

41. Gao Xingjian, "Wild Man," 244.

42. June Teufel Dreyer, *China's Forty Millions: Minority Nationalities and National Integration in the People's Republic of China* (Cambridge: Harvard University Press, 1976), 237–47.

43. For this point, see Ralph Litzinger, *Other Chinas: The Yao and the Politics of National Belonging* (Durham, N.C.: Duke University Press, 2000), 231.

44. Gao Xingjian, "Wild Man," 201.

45. Zhou Liangpei, *Yeren ji*, 97–98.

46. Li Guohua, interview with Schmalzer, April 17, 2002; Yuan Yuhao, interview with Schmalzer, April 16, 2002; Zhang Jinxing, interview with Schmalzer, April 18, 2002; Zhang Jinxing, *Zheng zuo Gudaoer, yong tan 'yeren' mi* [Striving to be like Goodall, bravely exploring the 'yeren' mystery] (Beijing: Zhongguo kexue tanxian xiehui, 2002), 4.

47. Gene Poirier and Richard Greenwell, *The Wildman of China* (New York: Mystic Fire Video, Inc., 1990). My translation differs somewhat in style, though not in meaning, from that provided in the film.

48. Zhou Liangpei, *Yeren ji*, 98.

49. Interviews with Schmalzer, 2002.

50. James Scott, *Seeing Like a State.*

Chapter 15

Contextualizing the Visual and Virtual Realities of Expo 2010

Susan R. Fernsebner

In the months leading up to "Expo 2010 Shanghai," the first official world's fair to be held in China, advertisements for the event abounded. Promotional video created under the auspices of the Chinese Communist state declared the exposition a celebration of achievements in "urban civilization," noting the theme of the event itself as "Better City, Better Life." State promoters promised that the Expo would display the potential for a "harmonious coexistence between humans and nature in the cities of the future."[1] Meanwhile the official Expo mascot, a blue creature named "Haibao" (海宝), promoted the coming event as a fun-filled spectacle in his[2] own public appearances, video, and a serial television program (Figure 15.1). A Fall 2009 edition of the official *Expo Shanghai Newsletter* offers similar promotional rhetoric. The lead story notes that a city-wide tourism festival, "an entertainment extravaganza," would take place in conjunction with Expo 2010, and attendees could purchase enticing multi-event ticket packages. Other articles in the newsletter note the Expo's upcoming displays of Chinese jade "and its 8,000-year history" by a Taiwanese organization, as well as opportunity for all to appreciate the "grassland beauty" of Inner Mongolia that would be displayed at the fair. The same newsletter also heralds the upcoming "virtual Expo online" through which all individuals worldwide with access to the internet could tour the halls of the exposition from the comfort of their very own home.[3] This array of celebratory images for Expo 2010 advertises a greater China, including politically contested territories, as well as the new position held by the People's Republic of China on a global stage.

The author wishes to thank Michael G. Chang, Joshua Goldstein, and Sigrid Schmalzer for their comments and suggestions on an earlier draft of this chapter.

Figure 15.1 Haibao, mascot of Expo 2010, welcomes visitors to the Pavilion of the Future. Haibao's gender has been debated, though the consensus seems to be that Haibao is male. One official introduction categorizes Haibao as being of "a boyish character." His hobbies are listed as "taking baths and dancing" while his favorite beverage is "coffee-tea," said to help him maintain his energy for greeting exposition visitors. His height, in the same quick-facts introduction, is listed as "can be as high as he wants." From: Personal collection of Susan Fernsebner.

The content of this publicity, moreover, is intricately linked to the evolving methods of its propagation. These methods include a potent mix of new and long-existent media, including print, television, digital media and internet venues, and through these channels an overlap with state propaganda itself. Indeed, in Expo 2010's imagery we find a grand-scale example of the Chinese Communist state's adoption of corporate methods of advertising, particularly in the realm of visual culture, and the state's own appropriation of popular culture and entertainment.[4] As such, Expo 2010 provides an opportunity to explore the ways in which the Chinese state and its corporate partners have set forth publicity as a more subtle form of propaganda, and to investigate a related phenomenon, namely the relationship between state and popular images in Chinese social, cultural, and political discourse.

The Chinese state mobilized publicity for Expo 2010 as a symbol of China's twenty-first-century modernization. Much of this publicity was

aimed directly at a Chinese domestic audience and shared not only via television and print periodicals, but also through the realm of "new media," including websites, popular video pages, and social networking venues. Indeed, these venues were celebrated by the fair's promoters, who heralded Expo 2010 as the first fully online world's fair. Yet ironically, even as the state utilized the internet to promote Expo 2010 and its own political message of "harmonious development," the emergence of digital media itself also placed the ability to disseminate alternative images into the hands of millions of Chinese "netizens" (individuals using the internet) to share their own commentary and critique.[5] While the Chinese state seeks to mobilize and control a public discourse, ordinary people have mobilized similar tools to offer alternative presentations. Returning to a point made in this volume's introduction, if the state seeks to "see" and control a citizenry, an examination of Expo 2010 and the new media accompanying it reveals that seeing is indeed a "two-way street."

This chapter will explore the complexities of Expo 2010 and its broader social and political context through visual traces of the fair itself. These traces include images and video created by the event's state and corporate sponsors as well as other images and scenes from diverse sites that summer. Indeed, there were—and still are—multiple realms for experiencing Expo 2010: not just the Expo fairgrounds and pavilion architecture, but also the surrounding city in which it was located, Shanghai. The three main sections that follow will offer historical background for the event and its conception, a close analysis of the visual evidence (including an online video game and a feature video drama) from two popular Expo pavilions, and finally a look at alternate images of the event, its impact on local communities, and its implications for the analysis of state-society relationships in China today.

EXPO 2010, MARKET REFORMS, AND VISIONS OF A NEW GLOBAL ORDER

Shanghai's Expo 2010, like the Beijing Olympics of 2008 (Figure 15.2, website), served as a sign of China's arrival in the twenty-first century. Expo promoters celebrated the event not only as China's first official world's fair but also as a sign of China's new position in a global economy. The Expo advertised claims to Chinese technological innovation as well as twenty-first-century concerns for matching economic development with proclaimed aspirations of environmental sustainability. The joint bureaucratic and private sector sponsorship of the event parallels a similar partnership in engineering a Chinese economy, one in which an authoritarian state plays a dominant role in guiding developmental planning and strategic investment while

corporate interests have capitalized upon related market reforms, particularly since the late-1990s.[6] Indeed, amid the past decade's economic boom in China, the categories of state and society, consumption and identity often appear blended. The Chinese Communist Party, through its state apparatus and corporate sponsorship, has utilized an ever-expanding realm of visual spectacle to tie Chinese identity to new products, technologies, and Nationalist celebration.

Expo 2010, as presented by its organizers, symbolized the changing nature of a global economy and China's rising power as a nation that would lead the world through technological innovation and an enlightened approach to global problems. In promoting the event, organizers of Expo 2010 broadcast new concerns for sustainability and environmental preservation in concert with the growing demand to bring the standards of living associated with "development" to the broadest population. Indeed, China itself has come to represent these inherently global challenges. Despite its success in both industry and, increasingly, higher-end technical and consumer production, the People's Republic is home to obvious economic disparities, particularly between urban and rural sectors, and faces increasing challenges of a rapid urbanization that has accompanied economic reform. In 2005, China witnessed an urbanization rate of roughly 43 percent. Looking ahead, China's urban areas are projected to be home to 60 percent of its population, with an additional 100–200 million rural residents moving to cities by the year 2020.[7]

Exposition organizers and state officials, speaking to these issues, promoted urban and sustainable development as one of the event's main themes and advertised it as one of the event's two unique "innovations" as a world's fair. This theme was supposedly crystallized in the "Urban Best Practices Area" that would stand among the Expo's many halls as a celebrated arena for exhibition of different global cities' own projects in creating a better "quality of urban life" for their citizens. Here, Expo 2010 organizers envisioned an international stage for comparing diverse achievements in technological development and environmental sustainability. The outcome during the run of the Expo itself was indeed diverse. In many cases, other advertised attractions seemed to supplant the original theme focus for the Urban Best Practices Area. While different cities offered exhibits on water management, recycling, and open improvements in communication technologies for urban spaces, many (including some of the same exhibitors) also highlighted tourist attractions. Video displays offered a preview of the sights one might enjoy upon visiting a locale while performers and artisans arrived to share local culture through music and the arts. Many city exhibit centers also offered opportunities to win prizes, with football (a.k.a. soccer) souvenirs offered by city display centers such as Liverpool and Madrid earning particular attention.[8] Tourism and consumption often were brought to the fore while displays of technology and new approaches to urban issues served as a background to advertised tourist attractions.

Expo 2010's organizers also heralded a second "innovation" and "achievement" in their staging of the event, namely the always-available "Online Expo." (Figure 15.3, website) Here, designers offered the Expo itself as an object of mass consumption, ever-ready for the eager individual who wished to possess his or her own entry ticket. Advertised via video preview and, even a year after the event itself, still available via the World Wide Web, the Online Expo offered access to a virtual expo fairground. Its designers framed this online tour as an experience of the fair that would allow viewers to escape the trouble of crowds, queuing, and travel in the muggy Shanghai summer. A preview advertised the Online Expo as an "everlasting virtual exhibition that prolongs and spreads the legacy of the world expo" and as a means by which the "excitement will be with you anywhere, anytime!"[9] The Online Expo thus supposedly defied both space and time via its twenty-four-hour availability to anyone with access to the World Wide Web.

While many who toured the physical site of the Expo that summer complained of the long lines for entrance to popular pavilions—where wait times routinely exceeded five hours—the Online Expo pavilions promised instant gratification. In many respects, this promise echoed the official Expo theme of a "Better City, Better Life." Like the ideal future city that the fair advertised, the Online Expo would supposedly allow an individual to experience every moment in full comfort. A virtual guide would "accompany users" as they toured digital, 3-D spaces at the fair while ensuring that their online visit was "meaningful and entertaining."[10] The promise of easy consumption, celebrated in terms of "excitement" and instant availability, served as a dominant theme. Online Expo presentations included concerns for enlightened approaches to creating that "Better Life," while at the same time folding these into the flash (literally, in their programming) of media for the individual-as-consumer. At the same time, the online message set forth a very specific vision of development itself. A survey of two Online Expo pavilions and the visual presentations they offered reveals a conflation of corporate and bureaucratic messages intended to entertain, instruct, and promote loyalty to their sponsors, both the Communist state and its capitalist agents. At the same time, they also show a progression in which consumer identification with the advertised object equates to loyalty to the nation itself.

VISUALIZING THE FUTURE: IMAGES FROM THE OIL PAVILION AND GM-SAIC

One of the most popular draws at Expo 2010 was the vibrantly lit "Oil Pavilion." (Figure 15.4, website) China's three largest oil corporations, all state-owned, erected this Oil Pavilion as a 3,600-square-meter cube with LED

screens covering its exterior walls.[11] The shimmering lights of the building changed color as Expo visitors passed by, offering a particularly effervescent scene in the evening hours, while short videos were also presented on an exterior screen.[12] "Oil Baby" (*shiyou baobao* 石油宝宝), a sugary cartoon figure with a head that appeared as a golden drop of oil, served as its mascot host, both in person and online (Figure 15.5).[13]

Inside the hall, visitors toured displays intended to advertise the ways in which oil contributed to the production of staple items and consumer needs, including clothing, food, housing, transportation, and objects of everyday amusement. Designers framed industrial production via objects of consumption and glitz: race cars, snazzy interior decor, and fashion. Moving through these displays, visitors subsequently could enjoy the Oil Pavilion's own "4-D" theater and its special effects while watching a film that portrayed oil's apparent contribution to humanity's "wonderful future". A final display zone offered murals, images, and dioramic displays of oil production as well as the theme of a "green" environmental future presented as a product of the fine engineering of these oil companies. Before leaving, visitors would also pass by a wall solely dedicated to displaying the three corporate logos and then, finally, a locale at which visitors might record their own impressions of the pavilion and its theme, namely "Oil: Extending City Dreams."

Just as the Oil Pavilion advertised the apparently essential value of oil to a comfortable and environmentally conscious future, its online displays offered additional avenues for visitors to explore the same message. Furthermore, the online venue for the Oil Pavilion, like its 4-D theater, sought to draw visitors into the drama of the display itself. There they would be participants in the consumption of a smoothly dictated understanding of the Chinese oil industry as compatible with an environmentally sound future for the planet and as an object of pride for the nation.

In addition to offering visitors a virtual tour of the pavilion itself, the Oil Pavilion also presented its own video game for online visitors to play.[14] Here, visitor-players would inhabit the mascot persona of Oil Baby in an attraction designed to both amuse and educate. The game begins with little Oil Baby waking up inside a house, which is visible in cross-section, alongside a television set, air conditioner, overhead lamp, sink, door, and windows. The house, labeled "HOME," sits before a hillside crowned with green foliage as well as a "MARKET" and unlabeled power plant. Three garbage cans with varied symbols for recycling and waste disposal stand outside on a grassy slope, not far from a blue river connected to the floor of the home by a pipe. Skies are blue and bright clouds float by. Players can utilize a panel in the upper left hand corner of the screen to control the Oil Baby character, turning appliances on and off, opening windows and shades, and managing (or mismanaging) trash. Gauges on the lower right of the screen indicate

the state of the environment as well as energy supplies and their use toward exhaustion (Figure 15.5). Controlling Oil Baby, players must maneuver through a series of decisions and actions over a fixed period of time, determining which appliances to use in the course of the day and which vehicles (e.g., car versus bicycle) to utilize in running to the market. Oil Baby can stay inside with the television on and play video games, or head outside to catch butterflies. Oil Baby also has the challenge of sorting different items for recycling after enjoying a midday meal, the latter stage offering its own options in size ranging from a modest dinner or large meal all the way up to a near-banquet. Depending upon a player's decisions, Oil Baby might survive happily until the end of the game or, quite easily, might fall into either of two failing outcomes. As Oil Baby, players may mistakenly overuse the allotted energy, leaving themselves gasping for breath and falling unconscious on the floor of the "HOME." Or, even more dramatically, Oil Baby can leave the environment wasted through misuse, with the trees on the hill falling barren, the grass and stream outside turning to dry stone, and, just after a puff of smoke billows from the recycling cans, the entire mountain above

Figure 15.5 The Oil Baby online game from Expo 2010's Oil Pavilion. Controls for home appliances are at the upper left, while recycling cans, and meters for consumption and conservancy are at the fore and right. The clean blue river, green lawn, and foliage indicate Oil Baby is carefully conserving at the moment, though important energy decisions await. From: http://www.cnpc.com.cn/syg/ssize/index.html [accessed 20 August 2011].

Oil Baby's "HOME" collapsing upon the poor creature. Oil Baby's world, if not correctly managed, literally falls apart. The disaster, of course, remains a cartoon, and Oil Baby's planet can be returned to its original pristine status with a simple reset of the game. The endeavor is largely one of amusement rather than substantive education.[15]

Amusement at the virtual Expo, as in its land-based original, was linked not only to a supposed education about living responsibly, but also directly to consumption, and through consumption, to identity itself. If the Oil Pavilion's designers worked to draw the individual viewer into a digital frame through cartoon gameplay, the General Motors-Shanghai Automotive Industry Corporation (GM-SAIC) took the process a step further, reinventing the human individual as the very object advertised in its own 3-D film. Here, this joint state-private corporation celebrated the automobile simultaneously as consumer object and as source of social identification, one tied to a vision of the Chinese nation as a new global power for progress and enlightenment.

The film, "2030, Xing!" follows the stories of three pairs of people, carried by their cars, through a dramatic and joyous day.[16] As the film starts, an omniscient voiceover tells viewers that "twenty years in the future, cars not only shorten the distance between us, they also shorten the distance between our hearts." Viewers then follow three pairs of people amid their own vehicular and personal travels. These pairs include a "world famous" musician concerned for his grown daughter, who is blind; a husband and his extremely pregnant wife (who will go into labor while on a walk and be rescued by a computer-controlled vehicle in which she will safely give birth); and finally an estranged couple whose reunion serves as the culmination of the film. These stories overlap through quick cuts as the audience follows alongside and from within 3-D flying vehicles. Visual effects and slick editing weave the characters' dramas through scenic views of an imagined future city, a realm that has perfectly blue skies, clean beaches, and ocean waves; the city here is a place where highways and high-rise architecture stand within an immaculate environment (in unmistakable contrast to the currently alarmingly polluted conditions of many of China's cities, Figure 15.6, website). Corporate promotion is woven throughout, including dramatic plugs not only for GM-SAIC's vehicles but also its OnStar subsidiary.[17] In the final scenes all three pairs of human characters are reunited thanks to their GM-SAIC vehicles, including the estranged boyfriend and girlfriend who share a loving moment on a beach alongside their respective automobiles. As the music and credits conclude, we are treated to one final shot of the girlfriend's car joyfully spinning around the boyfriend's, the human drivers nowhere to be seen. Anthropomorphized hot rods have taken the humans' place in their own affectionate partnership as simple residents of a perfect Chinese and global future, their attendant pollution and usage of limited natural resources

conveniently forgotten in this fictive presentation of cars as pleasant stand-ins for their human drivers.

These two very popular pavilions and their media presentations garnered a broad audience during and after the Expo. We might ask, however, what this corporate-sponsored and state-sanctioned imagery obscures as it seeks to represent China's soon-to-be-realized future. These images, like many sanctioned by the state at Expo 2010, conflate individual desire and personal fulfillment with conformity in the name of a greater China. They suggest that the profitable development of Chinese oil and automobile industries will bring Chinese individuals a personally fulfilling future (a premise familiar in the United States as "what's good for General Motors is good for America"). They accomplish this by repeatedly conflating consumer and object, such that drivers become cars, and the natural resource we call "oil" becomes a cuddly animated icon that players inhabit in a role-playing video game. How do the lived experiences of Chinese people differ from the picture presented within this frame of state-corporate ideology? How did audiences respond to these images or even manipulate them to produce alternative depictions? To further our analysis of visual culture and new media related to Expo 2010, we must place these promotional images in context, juxtaposing them with alternative scenes also found in the broader stream of mass media, digital and otherwise.

ALTERNATE FRAMES: URBAN DEVELOPMENT, INEQUALITIES, AND DISLOCATIONS

Almost immediately following Expo 2010's grand opening on the first of May, alternate images of the Expo appeared. One example can be found amid concerns about crowds, lines, and ticket availability in the event's opening weeks.[18] While Expo visitors waited unhappily in hours-long queues in oppressive summer heat, internet users in Hong Kong began to share their own images as spoofs of the fair. Tweaking illustrations from favorite electronic games, cinema, and advertising, they presented epic scenes of fantasy heroes fighting their way to the Expo's celebrated China Pavilion while grasping the much-sought "reserved ticket" for entrance there.[19] Satirical images portrayed a buxom female warrior waving streams of said tickets before the viewer (and wearing the tickets as well) and heroic figures from Chinese history and literature, such as General Zhang Fei, with reserve tickets flying from their robes and armor (Figure 15.7). Far from serving as an enlightened arena for comfortable progress and social harmony, the exposition was satirized (not entirely inaccurately) as a scene for contests of endurance and access.

Figure 15.7 Satirical image of the heroic Zhang Fei competing for reserve tickets for Expo 2010. From: http://www.zonaeuropa.com/20100505_1.htm [accessed 31 August 2011].

These satirical images of Expo 2010 were part of a wave of visual and textual material shared across China via social networking sites, video and blogging pages, and traditional news outlets. As we explore this rich field of digital traces and their broader context, we also gain a view of the gap between state-endorsed images advertised in Expo 2010's productions and China's current realities. Indeed, while images such as that presented in the GM-SAIC video offer a view to a pristine future that is supposedly just within reach, life in China today is significantly more complex. During the decade leading to Expo 2010, Chinese citizens witnessed the rising costs of basic necessities, including food, housing, education, and health care as social services diminished and inflation rose with new market reforms. Common people also encountered new problems as their old homes and neighborhoods

were demolished in the name of urban development. Expo 2010 served not only as a venue for state promotion, but also unintentionally as a staging ground for economic and social dislocation.

In the months leading up to the event, even as Expo publicity was promising a "Better City, Better Life," demolition of neighborhoods for the construction of the Expo 2010 fairgrounds inspired public protest. In February 2010, local Shanghai residents, including many who lived in neighborhoods that would be reconstructed as the Expo site, protested forced eviction from their homes. These residents sought financial compensation while also critiquing what they believed to be the collusion of officials and developers in profiteering.[20] Such protests have become increasingly common in China in recent years, particularly with now-famous images of "nail-houses" (solitary homes defended by their occupants even as their neighborhoods are bulldozed around them for redevelopment) proliferating in the mainstream press and on the internet (Figure 15.8, see website).[21] Older neighborhoods in the Pudong area—the same territory east of the Huangpu River where a broad portion of Expo construction took place—were rapidly torn down in broad stretches as Expo buildings (temporary in their own right), new skyscrapers, condominiums, and shopping centers were rapidly constructed. The process was, and is still in many areas, a complex one.[22] Half-torn sections of older neighborhoods might survive, temporarily, and coexist with the construction. The city itself, as the Expo's diverse messages attest, is a rapidly changing environment; but while Expo 2010's official images focused solely upon the bright prospects of urban renovation, the attendant realities of the changing city as a site for social dislocation lay, literally, just underneath or beside these images and structures (Figure 15.9).

As the built environment of the Chinese city has been reinvented during the decade leading up to Expo 2010, so too has the visual media environment, with the proliferation of new venues enabling the expression of diverse viewpoints of a broader citizenry, both Chinese and global. Many Chinese people have begun to use blogging and online video sites to disseminate opinions, images, and homemade videos as a means to share their own perspectives and critiques, as well as to debate in a public discourse that transcends (even if only momentarily) state management. The satirical deployment of images on the internet in China is far from confined to the topic of Expo 2010. The dramatic fire at the newly constructed China Central Television (CCTV) complex in Beijing in 2009 was quickly followed by several "mashup" images that went viral as netizens merged pictures of a burning high-rise with those of attacking monsters and spaceships (Figure 15.10, see website).[23] Similarly, the July 2011 high-speed train crash in Wenzhou prompted graphic imagery and direct critique of state failures, much of which appeared (and then in many cases disappeared) from online video sites such as Youku and

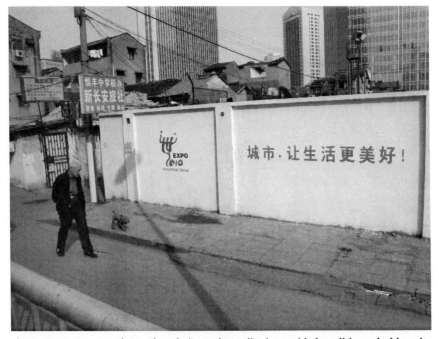

Figure 15.9 A scene from Shanghai's Pudong district amid demolition of older city neighborhoods in 2009. The freshly painted wall advertises next year's coming Expo 2010 and its slogan, which was officially translated into English as "Better City, Better Life." From: Personal collection of Susan Fernsebner.

Tudou, as well as the Chinese microblogging site Sina Weibo.[24] The use of new media by today's netizens parallels earlier and ongoing forms of popular commentary, such as those seen in Xiaowei Zheng's study of the stories and visual artifacts shared by the sent-down youth of the Cultural Revolution (1966–1976).[25] While subject to state control and active censorship, digital media offers a live stream for real-time negotiation of concerns among Chinese citizens, state leaders, and a broad range of institutions subject to state influence, including corporations, official news agencies and journals, and educational institutions. These sites also provide scholars with a valuable range of sources to juxtapose with the officially sanctioned imagery.

An exploration of the imagery associated with Expo 2010 reveals the complexities of what the state is seeking to show and what it is seeking to hide. Juxtaposition of the official and unofficial images that surround Expo 2010 in turn suggests a highly complex relationship between state and society. As both the state and its critics adopt cutting-edge methods in new media, this relationship is being constantly renegotiated within the realm of media-promoted consumption and representation. Although the state has

joined forces with corporate interests to harness the power of mass media, individuals are also using new technologies of communication to present their own images of China to a mass market, as it were, of citizens. Visual media—new and old, sanctioned and unsanctioned—thus serve diverse social and political actors in their efforts to articulate a Chinese identity and in their struggles over the appropriate roles of state and society in defining China's future.

NOTES

1. "Gala of World Civilization: World Expo 2010 Shanghai China" video presented at the official Expo 2010 Shanghai China website. http://en.expo2010.cn/documents/hqxcp.htm [accessed 9 September 2011]. For CCTV (China Central Television, a state-managed broadcast network) coverage of Expo 2010, including the opening ceremony, see the videos available at: http://www.cctv.com/english/special/expo/live/index.shtml [accessed 20 December, 2013].

2. See "Haibao Revealed in a Cartoon Series," in the *Shanghai Daily* and its exposition supplement, "Expo Insight" (7 September 2009). http://en.expo2010.cn/pdf/insight/0907.pdf [accessed 17 September 2011].

3. *Expo Shanghai Newsletter*, no. 32 (17 September 2009). http://en.expo2010.cn/pdf/newsletter/32.pdf [accessed 9 September 2011]. The basketball event also received significant television news coverage; see for example: http://www.youtube.com/watch?v=lnjX6QhZ6xo [accessed 20 December 2013].

4. For an exploration of this broader process, see Geremie R. Barmé, *In the Red: On Contemporary Chinese Culture* (New York: Columbia UP, 1999), particularly "CCPTM & Adcult PRC," 235–254.

5. In July, 2011, the China internet Network Information Center (CINIC) reported the number of Chinese Internet users as having reached 485 million. See CINIC, "Zhongguo hulian wangluo fazhan zhuangkuang tongji baogao," http://www.cnnic.net.cn/hlwfzyj/hlwxzbg/hlwtjbg/201206/t20120612_26719.htm (accessed 20 December 2013).

6. For a discussion of state dominance amid economic development and market reform see Alvin So, "Rethinking the Chinese Developmental Miracle," in Ho-fung Hung, ed., *China and the Transformation of Global Capitalism* (Baltimore: The Johns Hopkins UP, 2009), 50–64.

7. Barry Naughton, *The Chinese Economy: Transitions and Growth* (Cambridge: The MIT Press, 2007), 128. China's current population is over 1.3 billion people.

8. Expo news coverage offers the story of one winner, Zheng Jianfang of Fuzhou, who was awarded a Liverpool FC ball with signatures of team players in honor of his arrival as the 250,000th visitor to that city's exhibition. A fan of the team, Zheng noted that he was willing to withstand the long queue for the pavilion because he had heard, as the story reports, that it had "lots of fun things to do." See "250,000th visitor to Liverpool Pavilion wins signed ball," http://en.expo2010.cn/a/20100712/000004.htm [accessed 20 August 2011].

9. Shanghai 2010 "Online Expo" Official Preview, http://www.youtube.com/watc h?v=4nBEHF6Hgb4&feature=youtube_gdata [accessed 20 December 2013].

10. The virtual guide was none other than Haibao, Expo 2010's merry blue mascot. Shanghai 2010 "Online Expo" Official Preview.

11. The three corporate sponsors were the China National Petroleum Corporation (中国石油天然气集团公司), the China Petrochemical Corporation (中国石油化工集团公司), and the China National Offshore Oil Corporation (中国海洋石油总公司).

12. The official Oil Pavilion site, including an animated image of its shifting colored appearance at night, can be found at: http://expooil.cnpc.com.cn/cn/EXPO2010_Shanghai/sbhsyg/ . Artists renditions associated with the design of the building can also be found at http://en.expo2010.cn/a/20090420/000007.htm [both sites accessed 20 August 2011].

13. The formulation of "Oil Baby" as the mascot for the pavilion is explained as "oil represents oil and gas, while baby means growth and hope."

14. The Oil Pavilion's interactive online site can be found at the following address: http://www.cnpc.com.cn/syg/ssize/index.html [accessed 20 August 2011]. For the online game itself, simply click the option on the right of the screen that's offered there.

15. Chinese state officials have shown a concern for resource preservation and have urged individuals to conserve energy. In 2005, even as preparations for Expo 2010 were already underway, Jiang Yingshi, director of Shanghai's Development and Reform Commission, warned of limited resources and the city's need to recognize "the importance of saving energy and natural resources whenever possible." Xinhua news service, http://news.xinhuanet.com/english/2005-01/19/content_2479384.htm [accessed 20 December 2013]. Meanwhile, there are a growing number of online games on themes related to sustainability and consumption that one might compare to the Oil Baby game offered by China's own petroleum corporations for Expo 2010. See, for example, the online alternate-reality game (ARG) entitled "World Without Oil" by Jane McGonigal and Ken Eklund as well as the satirical Flash game entitled "McDonald's Videogame: I'm Playin' It" by Mollieindustria. Many thanks to Caitlin Murphy for bringing these titles to my attention.

16. The English-language version of "2030, Xing!" was, as of August 2011, available at either of the following links: http://www.gmexpo2010.com/en/videos/17701 or http://www.tudou.com/programs/view/utd7IBJDrL8/ [accessed 2 February 2014].

17. OnStar, founded in 1995, offers navigation, communication, and security service for vehicles. It currently operates in China as a joint venture managed by SAIC and China Telecom.

18. For an overview of English-language media coverage of these and other problems at the time of the Expo's opening day, see "Crowds Endure Waits as Shanghai's Expo Opens" at *The China Digital Times* (1 May 2010). http://chinadigitaltimes.net/2010/05/crowds-endure-aaits-as-shanghais-expo-opens/ [accessed 2 February 2014].

19. See http://www.zonaeuropa.com/20100505_1.htm [accessed 3 February 2014] for a collection of these images.

20. Malcolm Moore, "Middle Class Protesters March over World Expo Threat to Shanghai Homes," *The Telegraph* 8 February 2010. Moore notes a Shanghai city government response that asserted that an "open and transparent" process was in place for both resettlement and compensation, with, according to the state, 99.64

percent of 18,452 relocated households having signed a relocation contract. http:// www.telegraph.co.uk/news/worldnews/asia/china/7189446/Middle-class-protestors-march-over-World-Expo-threat-to-Shanghai-homes.html [accessed 3 February 2014]. For more on tensions over urban property issues amid both Expo 2010 and the 2008 Beijing Olympics, see You-tien Hsing, *The Great Urban Transformation: Politics of Land and Property in China* (Oxford: Oxford UP, 2010).

21. One of the most famous of these nail-house cases was in Chongqing between 2005 and 2007. A variety of media presented coverage, including *China Daily* [http:// www.chinadaily.com.cn/china/2007-04/03/content_842221.htm] and *The New York Times* [http://www.nytimes.com/2007/03/27/world/asia/27china.html] [Links above accessed 3 February 2014.] One anonymous creator has also produced an online visual record in a map of reported property seizures in China. See "China's Blood-Stained Property Map," *The Wall Street Journal*, (29 October 2010) at http://blogs. wsj.com/chinarealtime/2010/10/29/chinas-blood-stained-property-map/ [accessed 3 February 2014].

22. Such tensions have been seen most recently in the protests by villagers from Wukan who achieved global attention in their successful stand-off with local officials over a protested land sale. See the *China Digital Times* for full coverage: (http:// chinadigitaltimes.net/china/wukan/). For an insightful commentary on the flexibility of state control of media coverage of such protests, see Ian Johnson, "Do China's Village Protests Help the Regime?" http://www.nybooks.com/blogs/nyrblog/2011/ dec/22/do-chinas-village-protests-help-regime/ [both accessed 3 February 2014]

23. For collections of these images, see http://chinadigitaltimes.net/2009/02/ chinasmack-cctv-fire-funny-photoshops-by-chinese-netizens/ and http://www. chinasmack.com/2009/pictures/cctv-fire-funny-photoshops-by-chinese-netizens.html [accessed 3 February 2014].

24. See, for example, http://v.youku.com/v_show/id_XMjg3OTE2NTQ0.html [accessed 3 February 2014]. For an immediate report after the train crash on state efforts to control media coverage, see David Bandurski, "China Media Muzzled After a Day of Glory," China Media Project website (31 July 2011) http://cmp.hku. hk/2011/07/31/14332/ [accessed 17 September 2011]. Sina Weibo can be found at http://weibo.com. The video sites Youku.com and Tudou.com are similar to YouTube, the latter being popular in the United States and abroad as a free-of-cost video-sharing site. Weibo.com has been compared to both Twitter and Facebook as a site that allows registered users to share personal news, opinions, conversations, and more. While these sites are censored by the state, significant material that has appeared on (and been erased from) these venues can also be found reproduced on open, aggregate sites such as the *China Digital Times*, Global Voices Online, and that of the China Media Project. See "Further Reading" notes for links.

25. Political satire and parody have a long history in China and indeed in many authoritarian regimes. For a study of one particular form called "slippery jingles" (*shunkouliu*), see Perry Link and Kate Zhou, "*Shukouliu*: Popular Satirical Sayings and Popular Thought," in Perry Link, Richard Madsen, and Paul Pickowicz, eds., *Popular China: Unofficial Culture in a Globalizing Society* (Oxford: Rowman and Littlefield, 2002), 89–110.

Index

About the Contributors

Jeremy Brown received his Ph.D. from UCSD in 2008 and is now Associate Professor of History at Simon Fraser University. His first book was *City vs. Countryside in Mao's China* (2012), and he is currently conducting research for a book on the politics of accidents in the Mao era.

Michael G. Chang received his Ph.D. from UCSD in 2001 and is now Associate Professor of History at George Mason University. His first book, *A Court on Horseback* (2007), examined the politics of Qianlong's imperial tours; he is writing a second book on political networks in the Qing imperial court.

James A. Cook received his Ph.D. from UCSD in 1998 and is now Associate Director of the Asian Studies Center at the University of Pittsburgh. His research interests include the impact of Overseas Chinese on the development of modern China and the environmental history of northwestern China.

Madeleine Yue Dong received her Ph.D. from UCSD in 1996 and is now Professor of History at the University of Washington. She is the author of the book *Republican Beijing* (2003) and numerous articles on late imperial and Republican-era China, and she is co-editor of three volumes on modern Chinese history.

Joshua Goldstein received his Ph.D. from UCSD in 2000 and is Associate Professor of History at University of Southern California. His first book, *Drama Kings* (2007), examined Peking Opera in the Republican era; his

current research focuses on the social, economic and environmental history of recycling in China.

Susan R. Fernsebner received her Ph.D. from UCSD in 2002 and is now Associate Professor of History at University of Mary Washington, where she specializes in modern Chinese material culture in the historical context of capitalism and colonialism. She is also the editor of the website Gulou. tumblr.com ("Drum Tower").

Christian Hess received his Ph.D. from UCSD in 2006 and is now Assistant Professor of History at Sophia University in Tokyo, where he is completing his first book, a transnational history of Dalian under Chinese, Japanese, and Russian rule. His next project is on comparative urban history in East Asia.

Matthew D. Johnson received his Ph.D. from UCSD in 2008 and is Assistant Professor of East Asian History at Grinnell College. His scholarly research and writing focus on issues of culture and politics, war and society, U.S.-China transnational relations, and contemporary Chinese media and cinema.

Lu Liu received her Ph.D. from UCSD in 2002 and is now Assistant Professor of History at Ithaca College. She has published articles on population displacement and women's activism during and after WWII in China. Her current research focuses on the social and political implications of wartime refugee crisis.

Cecily McCaffrey received her Ph.D. from UCSD in 2003 and is now Associate Professor of History at Willamette University, where she teaches East Asian history. Her research, which has appeared in *Modern China*, focuses on popular resistance and state-society relations in late imperial China.

Andrew D. Morris received his Ph.D. from UCSD in 1998 and is now Professor of History at California Polytechnic State University, San Luis Obispo, where he specializes in the modern history of China and Taiwan. His most recent book—*Colonial Project, National Game* (2010)—examines baseball in Taiwan.

Charles Musgrove received his Ph.D. from UCSD in 2002 and is now Associate Professor of History at St. Mary's College of Maryland. His research focuses on urban history in China and Taiwan. His first book is *China's Contested Capital: Architecture, Ritual, and Response in Nanjing* (2013).

Sigrid Schmalzer received her Ph.D. from UCSD in 2004 and is now Associate Professor of History at UMass Amherst. She published her first book, *The People's Peking Man*, in 2008 and is currently completing a book manuscript titled "Red Revolution, Green Revolution: Encounters with 'Scientific Farming' in Socialist China."

Elena Songster received her Ph.D. from UCSD in 2004 and is now Assistant Professor of History at St. Mary's College of California. Her first book, on the panda as a national icon, is under contract with Oxford University Press; her new research focuses on snow leopards and medicinals from nature.

Zhiwei Xiao received his Ph.D. from UCSD in 1994 and is now Associate Professor of History at California State University, San Marcos, where he specializes in the history of film in China. His research has appeared in *Modern China*, *Twentieth-Century China*, *Asian Cinema*, and numerous other journals and edited volumes.

Xiaowei Zheng received her Ph.D. from UCSD in 2009 and is now Assistant Professor of History at UC Santa Barbara. Her articles have appeared in *Late Imperial China* and *Twentieth-Century China*, and she is completing a book manuscript on political culture, protest repertoires, and nationalism in early twentieth-century China.